how you look at it

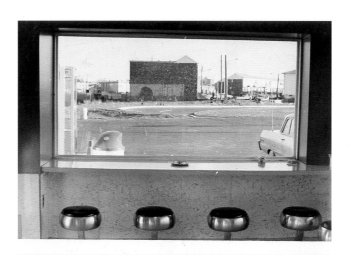

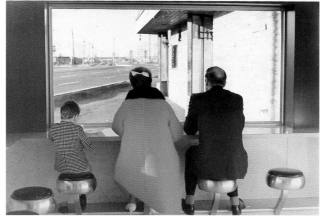

Thomas Weski

Heinz Liesbrock

Distributed
Art Publishers

how you look at it

PHOTOGRAPHS OF THE 20th CENTURY

How you look at it. Photographs of the 20th Century
Sprengel Museum Hannover, 14.5.–6.8.2000
Städelsches Kunstinstitut and Städtische Galerie,
Frankfurt am Main, 23.8.–12.11.2000

How you look at it. Photographs of the 20th Century has been organized
jointly by the Sprengel Museum Hannover and EXPO 2000 Hannover GmbH
and sponsored by the Niedersächsische Sparkassenstiftung.
The exhibition is the Museum's contribution to the World Exposition EXPO 2000.

Editors	Thomas Weski, Heinz Liesbrock
Design	Claudia Ott, Düsseldorf
Translations	Fiona Elliott, Hugh Rorrison
Copy editing	Catherine Schelbert
Lithography	Art Publishing, Troisdorf
Printing and binding	Druckerei Uhl, Radolfzell

First published in the United States of America in 2000 by D.A.P./Distributed Art Publishers, Inc. New York

For Inquiries please contact: D.A.P./Distributed Art Publishers, Inc. New York
155 Sixth Avenue, New York, NY 10013–1507, Tel: 212 627 1999 Fax: 212 627 9484
ISBN 1-891024-21-3
Printed and bound in Germany

Contents

Acknowledgments

We cordially thank all the artists and lenders who have entrusted their work to us. We are particularly indebted to Dietrich Hoppenstedt for his steadfast interest and ongoing help. His successor Klaus Rathert continued to support the project in the same spirit. We thank Monika Hallbaum for her constant and reliable collaboration and her unfailing support. We also thank the following for their encouragement, their fruitful contacts, and their constructive ideas:

Andreas Balze
Ola Billgren
Gottfried Boehm
Dietmar Elger
Christine Frisinghelli
Heiner Hachmeister
Antonio Homem
Volker Kahmen
Walther König
Ulrich Krempel
Leonore Leonardy
Saundra Lane
Claudia Ott
David Reed
Jock Reynolds
Jeff Rosenheim
Michael Schmidt
Ulrike Schneider
Sabine Schulze
Tom Stromberg
Oliver Wick

Lenders

Bernd und Hilla Becher,
 Düsseldorf
Dr. h. c. Ernst Beyeler
 Galerie Beyeler, Basel
Prof. Dr. Klaus Bußmann
Dr. Erich Franz
 Westfälisches Landesmuseum,
 Münster
Connie Butler
 The Museum of Contemporary
 Art, Los Angeles, California
Lutz Caspar
 Sammlung Landesbank
 Baden-Württemberg, Stuttgart
James T. Demetrion
 The Hirshhorn Museum & Sculpture
 Garden, Washington, D.C.
Liliane & Michel Durand
 Collection Liliane & Michel
 Durand-Dessert, Paris
Ute Eskildsen
 Fotografische Sammlung
 Museum Folkwang, Essen
Patrick Faigenbaum, Paris
Hans-Peter Feldmann, Düsseldorf
Michele Foulatier
 Caisse des Dépots et Consignations
 Mission Pour le Mecénat et l'Action
 Culturelle, Paris
Jeffrey Fraenkel
Frish Brandt
 Fraenkel Gallery, San Francisco,
 California

Bernhard Fuchs, Düsseldorf
Peter Galassi
Darsie Alexander
 The Museum of Modern Art,
 New York
Victor Gisler
Luigi Kurmann
 Mai 36 Galerie, Zürich
Ingvild Goetz
Rainald Schumacher
 Sammlung Goetz, München
Sarah Greenough
 National Gallery of Art,
 Washington, D.C.
Prof. F. C. Gundlach, Hamburg
Andreas Gursky, Düsseldorf
Karen E. Haas
 Lane Collection
 Museum of Fine Art, Boston,
 Massachusetts
Rolf Hengesbach
 Räume für neue Kunst, Wuppertal
Prof. Dr. Wulf Herzogenrath
Dr. Andreas Kreul
 Kunsthalle Bremen
Prof. Dr. Christian von Holst
Dr. Karin von Maur
 Staatsgalerie Stuttgart
Dr. Jörg Johnen
 Galerie Johnen & Schöttle, Köln
Dr. Thomas und Ulla Katzorke, Essen
 Sammlung Ulla Katzorke

Dr. Thomas Kellein
Dr. Jutta Hülsewig-Johnen
Kunsthalle Bielefeld
Gunilla Knape
Hasselblad Center, Göteborg
Wilmar Koenig, Berlin
Bernd F. Künne, Hannover
Dr. Susanne Lange
Gabriele Conrath-Scholl
August Sander Archiv
SK Stiftung Kultur der Stadtsparkasse
Köln
Heinz Lohmann, Trude Hofmann
Sammlung Lohmann Hofmann,
Münster
Boris Michailov, Berlin
Bernard de Montgolfier
Françoise Reynaud
Musée Carnavalet, Paris
Anthony Montoya
Paul Strand Archive, Aperture
Foundation, Millerton, New York
Eva M. Morat
Morat – Institut für Kunst und
Kunstwissenschaft, Freiburg
im Breisgau
Barbara and Howard Morse
Collection Barbara and Howard
Morse, New York
Weston Naef
The J. Paul Getty Museum,
Los Angeles, California
Nicholas Nixon, Brookline,
Massachusetts

Klaus Rathert
Monika Hallbaum
Niedersächsische Sparkassenstiftung
Hannover
Michael Roßnagl
Siemens Kulturprogramm
Siemens AG, München
Thomas Ruff, Düsseldorf
Prof. Dr. Uwe M. Schneede
Dr. Christoph Heinrich
Hamburger Kunsthalle
Prof. Dr. Klaus Schrenk
Staatliche Kunsthalle Karlsruhe
Per Skarstedt
Skarstedt Fine Art, New York
Ileana Sonnabend
Antonio Homem
Sonnabend Collection, New York
Thomas Struth, Düsseldorf
Pierre Théberge
Ann Thomas
National Gallery of Canada, Ottawa
Shomei Tomatsu, Nagasaki
Roland Wäspe
Kunstmuseum St. Gallen
Adam D. Weinberg
Addison Gallery of American Art,
Philipps Academy, Andover, Massachusetts
Ann und Jürgen Wilde, Zülpich
Karl Blossfeldt und
Albert Renger-Patzsch Archiv

and others who wish to remain
anonymous

Patron's Preface

How you look at it, the title of the important exhibition of photography being shown at the Hannover Sprengel Museum as part of the world exposition EXPO 2000 is well chosen. For photography, as no other medium, has shaped our view of the twentieth century and influenced our social and aesthetic perceptions. I think one can confidently say that, in so doing, it has changed the world. In the same way as August Sander's view of the Weimar Republic is for us more authentic than most history books, we have also learned to see Paris at the turn of the century through the lenses of Eugène Atget and Brassaï. By the end of the thirties Walker Evans's *American Photographs* had provided a perceptive analysis of modern democracy. In the fifties Robert Frank's photo series *The Americans* with its unvarnished account of everyday life in America came as a shock to the complacent Eisenhower idyll.

The use of a documentary style to describe reality unites photographers like Diane Arbus, Robert Adams, and Michael Schmidt. Their presentation of social conditions in the seventies and eighties had a considerable influence in strengthening my political engagement.

The artistic photography of the last hundred years cannot, of course, be limited to the practitioners dedicated to recording reality, but nevertheless the decision by curators Thomas Weski and Heinz Liesbrock to focus on this tradition is compelling. It is here that the great themes of the last century are mirrored: mobility, urbanism, politics, technology, and communications; here new possibilities open up that invite us to reflect deeply on our view of the world. For this reason it is not individual photographs that are at the heart of the exhibition, but thematically complex groupings of the work of outstanding photographic artists. The result is a dialogue between historical and contemporary work which is complemented and enhanced by positions adopted in painting and sculpture by such distinguished artists as Pablo Picasso, Edward Hopper, or Bruce Nauman.

The convincing principle behind the exhibition was not the only reason why I accepted instantly, upon being offered the patronage of *How you look at it*. The Sprengel Museum stands next to the state chancellery in Hanover, and I have had a close connection to it since my time as Minister President of Lower Saxony. I have spent many happy hours in the collections and am proud to say that the museum is one of the few major European institutions where photography as a serious art form has been consistently collected and exhibited.

I should like to single out the Niedersächsische Sparkassenstiftung for thanks. Without its sponsorship *How you look at it. Photographs of the 20th Century* would not have been possible. I wish the exhibition every success.

Gerhard Schröder
Chancellor of the
Federal Republic of Germany

Foreword

Like no other medium, photography has become part of our everyday perception of the world. There is no event, no journey that is not documented with the aid of a camera, enabling us, in the most literal sense, to hold on to each moment of experience and enjoy the promise of conserving a "true picture" of every moment forever. This means of keeping a personal historical record daily produces millions of images and views of the world. The language of these images is instantly accessible, and no moment is so fleeting that it cannot be recorded "for eternity."

While hundreds of thousands of pictures are being snapped at the world exposition, the Sprengel Museum Hannover, as a partner of EXPO 2000, and in collaboration with the Niedersächsische Sparkassenstiftung, is showing the world as seen by photographers who have established original positions in creating a photographic record of reality. Alongside a retrospective survey of the highpoints of artistic photography in the twentieth century, it has been possible, by including the work of younger photographers, to sharpen our perception of contemporary modes of seeing. In this way, parallel to the themes of EXPO 2000, a panorama of the highest artistic and formal quality brings together central questions and perspectives of the century which has just drawn to a close. Contemporary history is revealed not just historically, but from a contemporary angle.

This is not done by means of the medium of photography alone, but in dialogue with the older forms of artistic expression, painting and sculpture. The title of the exhibition is telling: it not only points out the photographer's subjective point of view, it also challenges visitors to choose standpoints of their own, to recognize that their perception is equally subjective, and to learn to see. The exhibition makes this view possible while at the same time expanding our perception of the world.

Tom Stromberg
Artistic Director
Cultural and Events Program, EXPO 2000

Sponsor's Preface

Since its establishment in 1985 the Niedersächsische Sparkassenstiftung has, alongside its support for regional activities, been committed to fostering outstanding projects in the fields of traditional and modern art that promise to have a special impact and to establish Lower Saxony's credentials as an art center of national significance. Besides supporting major exhibition projects in the museums of Lower Saxony, it has secured important collections for the region. With its partners the Foundation has bought large groups of works by Felix Nussbaum, Max Ernst, and Kurt Schwitters. These now feature prominently in the collections in the museums of Osnabrück and Hannover. Parallel to this the Foundation has from its inception also developed its own initiatives. One of the most important has been building up a collection of its own with German art since 1945 as its main theme. Important works from this collection have been placed on loan in the museums of Lower Saxony, and at the same time the Foundation has developed exhibition projects based on the collection. With the collaboration of local Sparkasse branches, these have been shown in a number of towns. "Painters of New Objectivity in Hannover," and "The Language of Color" an exhibition of color-oriented painting in Germany from the sixties to the present, are two examples of such projects.

How you look at it. Photographs of the 20th Century, the exhibition which was proposed to us by Thomas Weski and Heinz Liesbrock, fits neatly into this program. The exhibition, with its stress on a photography of visible reality, combines high artistic aspirations with clear social and historical awareness. Taken together these photographs record the varied developments in this century. They depict changes in our towns and landscapes, but also in transportation, in technology, and in our private lives. They reflect our ineradicable roots in history and mirror the global consequences of individual decisions in a present which changes so fast that it often seems to raise more questions than it answers. When one looks closely at global tendencies, a savings bank with its local roots also provides such a link between tradition and renewal.

Photography, as a much appreciated art form, is enjoying a regular boom. It has given us especial pleasure to support this exhibition because the Sprengel Museum is one of the few in Germany that from an early stage, starting in the seventies, has been a committed supporter of artistic photography. With its concentration on great achievements in photography in our century, the exhibition can in a certain sense be understood as a coda to that engagement, and it can only further underline the Sprengel Museum's prominence. In addition, in the course of preparations since 1997, we have adopted international photography as a new

area in our collection program. This has created the first collection of artistic photography in Lower Saxony, and with rigorous attention to content, that collection will develop its own unmistakable profile. With the opening of *How you look at it* some of its treasures will be presented to the public for the first time.

The exhibition is a joint project of the Sprengel Museum Hannover, EXPO 2000, and the Niedersächsische Sparkassenstiftung. I offer my heartfelt thanks to both partners, and to the curators of the exhibition, Heinz Liesbrock and Thomas Weski.

I wish the exhibition the success it deserves.

Klaus Rathert
President of the Niedersächsische
Sparkassenstiftung

Preface

"Daguerre's process completely fulfills all the requirements of art by bringing certain basic principles of painting to such a pitch of perfection that it must become an object of study for even the most thoroughly trained painter. The pictures that are obtained by this process are remarkable for their perfection of detail as well as for the richness and harmony of the overall effect. Nature is reproduced here not only with truth, but also with art." (Paul Delaroche, 1797–1856)

The reactions of contemporary artists to the invention of photography in the nineteenth century were varied and contradictory: even the question of whether photography was actually an art was long debated. Ever since the invention of photography, the medium has been a major factor in the development of our modern imagery. Today it is obvious and self-evident that photography is close to and indeed part of the fine arts. Within the history of photography in the twentieth century, with its proliferation of positions, styles, and signatures, the significance of mechanically and optically produced images is unquestionable. Photographers have created many of the images that we carry around in our minds as permanent components of modern imagery.

The exhibition *How you look at it. Photographs of the 20th Century* delves into the sources of these images in quite exemplary fashion. Using selected positions of individual photographers, it offers an extended survey in time that, with some 500 items, constitutes an extraordinarily intense study of the photographic reality of the last century. The curators, Thomas Weski and Heinz Liesbrock, have limited their choice to photographs in the tradition dedicated to the description of reality. Their selection runs from Atget via Evans to Gursky. But the exhibition also includes selected positions from painting and sculpture in the twentieth century as part of its discourse. Since the photographs are not hung chronologically, but in mutual dialogue, they invite comparative viewing; artistic media are grouped and combined in accordance with an approach that the Sprengel Museum has been experimenting with in its own collection since 1995.

It is not by chance that the exhibition is taking place in Hannover in 2000, the year of the EXPO. Many important friends and partners worked with us from an early stage to bring this project about. Thanks are due to all of them today, above all to Federal Chancellor Gerhard Schröder who has agreed to be its patron. It was Tom Stromberg, the Artistic Director of the Cultural and Events Program of EXPO 2000, who had the idea for the project, and he has funded it partially through EXPO. Most important support for the project came from the Niedersächsische Sparkassenstiftung. Here we must thank Dr Dietrich Hoppenstedt, the President

of the Deutscher Sparkassen-und Giroverband, for his extended support. As former president of the Niedersächsische Sparkassenstiftung he made this project possible and largely financed it through that institution. We are especially indebted to the current President of the Niedersächsische Sparkassenstiftung, Herr Klaus Rathert, who has taken an on-going interest in the project to ensure its success. Our cordial thanks go to Frau Monika Hallbaum, head of the Fine Art Support Section at the Niedersächsische Sparkassenstiftung, for her dedicated and harmonious collaboration in setting up the exhibition.

The two curators of the exhibition, Thomas Weski of the Hannover Sprengel Museum and Heinz Liesbrock, have achieved a quite special take on the twentieth century. They took on the complex tasks of designing and developing this exhibition, of selecting from the multiple perspectives on art and photography in the twentieth century, of exploring these in their preparations, and, finally, of investing the exhibition with energy and life through the interaction among the photographers. Thanks are due to the publishers, Oktagon Verlag, who enabled the catalogue in both a German and an English edition, and also to the authors of the essays, Gerry Badger, Thomas Wagner, Peter Waterhouse, Heinz Liesbrock, and Thomas Weski for expanding the exhibition in their discussions in the accompanying book.

In the Sprengel Museum a dedicated team has worked on this project and its presentation to the public. Ulrike Schneider as scientific assistant took over the running of the exhibition office; Gabi Sand worked out a comprehensive scientific program to accompany the exhibition; Leonore Leonardy organized an intensive public relations operation for the project. Our thanks also to the restorers, the registry, and the administrative staff (Rita Heine, Martina Mogge Auerswald, Ulrike Reuther, Brigitte Nandingna, Ingrid Mecklenburg) and to colleagues in the workshops and on the museum's hanging team for the extraordinary efforts they have put in during the year.

The exhibition will move after Hannover to the Städelsche Kunstinstitut in Frankfurt and this will add to its impact and bring in a new public. We thank Sabine Schulze, Director of the Department for 19th and 20th Century Painting for her initiative and close cooperation in this. The exhibition in Frankfurt, which will run from October 2000 to January 2001, will examine the suggested questions and relations in a redesigned presentation and will pursue a line of enquiry which will be of particular significance for the further development of the arts.

Ulrich Krempel
Director, Sprengel Museum Hannover

Foreword

In Gustave Flaubert's 1881 *Dictionary of Accepted Ideas*, it says under the rubric photography, "Will make painting obsolete. (See daguerreotype)." And under daguerreotype it says, "Will replace photography. (See photography)." This did not happen! Painters still paint. In Frankfurt we have only to glance over the fence into the studios of the neighboring Städel School to see this. The painted image has not historically been superseded by the technical image. Painting is, however, now unthinkable without its engagement with the new technical media. That painting and photography have a parallel history, that they exist alongside one another and achieve comparable artistic results is the basic theme that runs through the works selected for *How you look at it*.

The concept seized our imagination as soon as we saw it: a survey of artistic photography from the late nineteenth century to the present day, set against the painting and sculpture of the same period. There has never been a comparative exhibition as systematic as this with some 40 photographers and over 500 works, beginning with Atget and Charles Sheeler then going via August Sander and Walker Evans to Michael Schmidt and Andreas Gurski, and parallel to this selected works by Degas, Beckmann, Hopper, Bacon, and Rothko, and ending with Martin Honert and Thomas Schütte. We were so taken by this pioneering concept that we responded to the organizers' request for a loan with a counter-request to take the entire exhibition here to Frankfurt. We offer heartfelt thanks to Ulrich Krempel for enabling us to make the change from being lenders to participants in such a swift and unbureaucratic manner.

For the Städel Institute this exhibition is a first meeting with the medium of photography, so we are particularly delighted at the exceptional quality of the exhibits, and we are proud to be part of such a thoroughly prepared and well thought out exhibition. It is due in particular to the personal selection by the two curators, Heinz Liesbrock and Thomas Weski, that the aesthetic dialogue between photography and painting goes beyond plain comparisons of content, and style enters the sphere of the history of ideas. Viewers at a second showing in Frankfurt will now also be able enjoy the knowledgeable and imaginative connections they establish between the various groups of works. We thank the lenders for permitting the exhibition to be transferred in its entirety.

The presentation of the exhibits assembled for *How you loo at it* represents a new departure in exhibition practice for the Frankfurt galleries. With a spectrum ranging from the fourteenth century to the present, the collections in the Städel Institute and the City Art Gallery consist predominantly of masterpieces of painting. With a Graphic Collection covering the

same period the main thrust of our work is researching and mediating exceptional achievements in the classical genres. The aim that governs our acquisition policy and our exhibition projects is to trace comparable artistic strategies through the centuries. Photography has not been integrated before into the chain of communication that links the ages. Taking part in this exhibition project offers us the chance to participate in a new dialogue. In common with our colleagues we too will now trace the stages by which photography, cross-fertilized by the traditional genres, discovered its own artistic language. We hope that the public in both Hannover and Frankfurt will find this exhibition a feast for the eyes.

Herbert Beck
Director, Städelsches Kunstinstitut
and Städtische Galerie

Sabine Schulze
Director of the Department
for 19th and 20th Century Painting

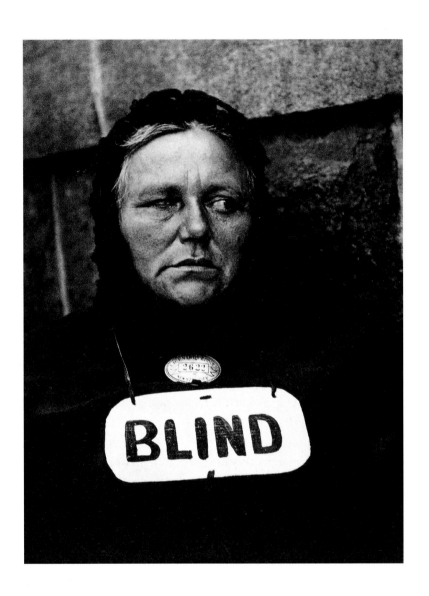

Paul Strand
Blind Woman, New York 1916
© 1971 Aperture Foundation Inc.,
Paul Strand Archive

No Scrawling, Scratching, and Scribbling on the Plate

<div align="right">Thomas Weski</div>

When the Kodak box was introduced in 1885 with the advertising slogan "You push the button, we do the rest," the practice of photography with artistic aspirations found itself in a situation where it had to distinguish itself not only formally but also technically from this popularization of the medium. While in the beginnings of photography only specialists could master the cumbersome techniques it involved, now everybody could take pictures: with picture-taking technique reduced to a minimum, the hand-held camera user could concentrate on reacting quickly to what the situation offered. Spontaneous shooting led to a new photographic aesthetic, the snapshot.

The simplification of the photographic process and what were felt to be its trivial pictorial results, as well as dissatisfaction with the way professional photographers only used the medium for commissioned work, led amateurs of photography to wage a long campaign for the recognition of photography as an art form. It was not simply to be used imitatively; pictures were to be produced which would appeal as a reminder of painting. As early as 1886 Peter Henry Emerson had published his widely read article "Photography: A Pictorial Art," in which he justified the artistic legitimacy of photography with its similarity to painting. It was no longer the direct reproduction of reality as practiced since the beginning of photography that these photographers, who now called themselves amateur photographers, aspired to, but the manipulated, reworked print in which the artist's signature was clearly discernible. Manipulation of this kind was not possible in the early days of photography because the daguerreotype was so sensitive that no retouching was possible. It was only with the collodion process in 1852 that the retouching of portraits first appeared and then became the rule. In order to make a clear distinction between themselves and the professionals, amateur photographers resorted to more and more refined techniques like the platinum, carbon and bromoil processes so that their work was "as far removed from the work of the despised 'snapshotters' as possible, looking more like pastel sketches or charcoal drawings than photographs."[1] Emerson called this sort of photography "pictorialism" and thus invented a brand name for an international movement that was to dominate photography for several decades. As with other technological innovations, such as printing or the automobile, in photography, after a brief phase when the new and specific aesthetic prevailed, the need arose to make it resemble the external form of the technique it had displaced. Printed books came to look like

manuscripts, automobiles like horse-drawn coaches, and photographs like paintings, though in the case of photography professional and private photographers kept the tradition of "pure photography" alive in portrait photography and souvenir pictures, even if at that time the potential artistic merit of these was not recognized.

Organized in clubs and groups that behaved almost like sects, the pictorialists were "unshackled by the chains of commerce… [and] had the freedom to produce truthful and meaningful work." They wanted "to free photography from its documentary and technical stranglehold and to use it as a more impressionistic and flexible tool." [2] Whether this stress on an individual artistic signature achieved through manipulation of the photographic print was necessary as a marker for authorship in photography seems from today's point of view to be going back over old ground, for as early as 1851 Francis Wey had pointed to individually imprinted artistic authorship as proof that photography was art: "The influence of the individual is so clearly discernible that an experienced connoisseur can tell from a single glance at a print who the maker is." [3]

Above all in Germany, England, and America, the pictorialists with their painterly photographs dominated the public image of the artistic avant-garde until long after World War I. From 1980 the American photographer Alfred Stieglitz was long predominant as the mentor and spokesman of this movement. The touch of impressionism in his pictures of New York quickly established him as the leader of a national brand of pictorialism, which he also supported in the photographic publications of which he was editor, first in *Camera Notes*, which published international photographers like Gertrude Käsebier, Edward Steichen, and Clarence H. White, then in *Camera Works*, which was the first magazine not only to use photogravure for high quality illustrations, but also to define itself in primarily visual terms.

The last edition of the magazine, in 1917, was dedicated by Stieglitz to the American photographer Paul Strand, a pupil of Lewis Hine, whose documentary photographs on the themes of child labor, poverty, and immigration at the turn of the century caused a stir and led to political change. Like Hine, Strand used photography without manipulating the original image. His early work divides into two groups: on the one hand his photos are characterized by a hitherto almost unknown degree of figurative abstraction, on the other hand his portraits show the people he portrays in a clear and penetrating form. If it was pictorialism with its hand-crafted artifacts that for almost thirty years constituted the artistic photography of the avant-garde, Paul Strand's photos marked the change from a pictorial and "soft" photography to a hard and pure application of the medium, a change in which Stieglitz joined him because the "pictorialist groups eventually fragmented, owing to petty infighting and over-stringent adherence to achieving painterly effects, for the excessive concentration on the minutiae of technique led to a loss of overall photographic vision." [4]

Of course even in the period of pictorialism's absolute dominance, there were voices which spoke against the tendency of this sort of photography to transfigure its subject. This is how Sadakichi Hartmann defined the concept of "straight photography" as early as 1904

in the magazine *American Amateur Photographer*: "'And what do I call straight photography,' they may ask, 'can you define it'? Well that's easy enough... compose the picture you want to take so that the negative will be absolutely perfect and in need of no or but slight manipulation. I do not object to retouching, or dodging, or accentuation, as long as they do not interfere with the natural qualities of photographic technique. But brush marks and lines, on the other hand, are not natural to photography, and I object, and always will object to... scrawling, scratching and scribbling on the plate."[5]

The pictorial result of "straight photography," the new avant-garde photography, differed from pictorial photography not only in the formal sense; they also documented photographers' growing interest in social reality, which led them to reject a mannered notion of *l'art pour l'art*. Image sharpness, clarity of theme, and photographic precision were now to be the parameters of the work of the next generation of photographers. Its representatives, like Edward Weston or Ansel Adams of the Group f/64, gave it such a restrictive character that at a later time, when its regulations had degenerated into mere doctrine, there was once again a rebellion.

Edward Steichen
Self-portrait 1901

We can only surmise whether the attention to the realities of the world in photography was also the result of World War I, with the first deployment of the machinery of modern warfare and its consequences, but it seems more than probable in the light of the objective, social-critical, and surrealist painting that emerged in response to the changed political and social conditions for European photographers—especially in Germany. In Europe too, artistic photography emancipated itself from painting and began to consider the qualities that were specific to the medium. In 1924 Gustav Hartlaub coined the expression "New Objectivity" (*Neue Sachlichkeit*), a category which, in the realm of photography, applied particularly to Albert Renger-Patzsch and August Sander. Renger-Patzsch also saw his attempt to devise an intrinsically photographic approach as a counter-proposal to surrealism, "in which the absurd, the terrible, and the contradictory are elevated into a worldview."[6] And he concluded, "Let us leave art to the artists and attempt with the means of photography to create photographs that can stand up on their photographic merits—without our having to borrow from art."[7]

The peak of Albert Renger-Patzsch's photographic work was the publication in 1928 of his photographs of objects and concrete things under the title *Die Welt ist schön (The World is Beautiful)*. In their pure, understated, and consciously objective form, his "photos of details of technical apparatus, industrial products, and natural organisms are examples of a form of

1 In: Pam Roberts, "Alfred Stieglitz, 291 Gallery and Camera Work" in: Simone Philippi and Ute Kieseyer (eds.), *Alfred Stieglitz, Camera Work, The Complete Illustrations 1903-1917*, Cologne, 1997, p. 7. 2 Roberts, p. 9. 3 Francis Wey, "Über den Einfluss der Heliographie auf die Schönen Künste," quoted in: Walter Koschatzky, *Die Kunst der Photographie,* Salzburg and Vienna, 1984, p. 140. 4 Roberts, see note 1, p. 75. 5 Quoted in: Beaumont Newhall, *History of Photography from 1839 to the Present*, London, 1984, p. 167. 6 Walter Koschatzky, *Die Kunst der Photographie*, Salzburg and Vienna, 1984, p. 297. 7 Albert Renger-Patzsch, "Ziele" in: *Das deutsche Lichtbild, Jahresschau 1927*, Berlin, 1927, p. 18, reprinted in: *Albert Renger-Patzsch, Meisterwerke*, Munich, 1997, p. 16.

...seeing which equates objectivity and order with beauty, and technology with art." [8] Many of the photos had arisen in the context of advertising, which explains why the photographer has produced eloquent, perfectly formed single images—a procedure which he only abandoned for a posthumously published series of landscapes from the Ruhr.

In contrast to Renger-Patzsch, August Sander, who was twelve years his senior, made pictures in the painterly style at the beginning of his professional career, when he was a portrait photographer. He entered them successfully in international competitions. After World War I Sander joined the so-called Rhineland progressives. His conception of photography was permanently altered by discussions within this group of artists. Although until 1921 he was still making fuzzy Bromoil prints, [9] he had abandoned all aspirations to art photography by the following year in order to practice "exact photography," as he called it. [10] This also found expression in the use of technical paper which has a smooth, glossy surface and thus permits a commensurate transfer to the print of the visual information stored in the negative. "It brought out every detail, nothing was embellished and nothing concealed. Any painterly effect was completely absent. Sander ... was ... enthusiastic." [11] The reproduction of his models and their surroundings in a way that was both precise and appropriate to the material, and the fact that his photographs could be read as a basis for comparative viewing, is one of the definitive criteria in August Sander's ambitious project for a sociological survey in photographs, a photographic record of man in the 20th century, as the project in "7 groups according to class" [12] was called when its publication in 45 portfolios was announced.

From 1924 August Sander pursued the artistic concept, begun in 1910, consistently and with emphasis: starting from the already existing peasant groups, he expanded his concept to embrace other groups of the population. The aim was a photographic cross section of all classes, professions, and spheres of life in the Weimar Republic. Kurt Wolff, the publisher of Albert Renger-Patzsch's *Die Welt ist schön*, published the portraits in 1929 as *Antlitz der Zeit (Face of the Times.)* The book had an introduction by Alfred Döblin and served as a miniature model for the projected portfolios, though these were never realized because of the seizure of power by the National Socialists in 1933. Sander's division of society into hierarchic structures did not fit into the ideological worldview of a classless society. In 1934 the remainder of the edition was confiscated and the plates destroyed. Sander nevertheless pursued his idea of portraying all of society; he photographed *Gefangene Politiker des Nationalsozialismus (Politicians Imprisoned by the National Socialists)* and made a series of portraits of persecuted Jews.

8 Renger-Patzsch, bookjacket blurb. 9 Ulrich Keller (ed.), *August Sander: Men of the Twenties Century,* Cambridge, Mass., 1985, p. 25. 10 Ibid. 11 Ibid. 12 Ibid. p. 7. 13 Koschatzky, p. 279. 14 Bertolt Brecht, "Kurze Beschreibung einer neuen Technik in der Schauspielkunst, die einen Verfremdungseffekt hervorbringt" in: *Gesammelte Werke*, vol. 15, Frankfurt, 1967, pp. 341ff, quoted in Keller, p. 42.

Three of the outstanding publications of photography in the 20th century appeared within two years of one another in Germany. Albert Renger-Patzsch's *Die Welt ist schön* and Karl Blossfeld's *Urformen der Kunst (Prototypes of Art)* had been published in 1928, before August Sander's *Antlitz der Zeit*. Blossfeld who had discovered photography in the course of his art studies took objective close-ups of plants. His aim was to demonstrate the influence of natural forms on the composition of artistic or architectural works. With a neutral background, isolated from their environment, a variety of plants taken in sharp close-up form an iconography of natural archetypes. The fact that the appearance of the plants was occasionally manipulated by Blossfeld in order to make their formal qualities stand out in no way detracts from their documentary aura. Blossfeld had worked at his concept without recognition for years as a university teacher in Berlin before his first one-man exhibition attracted widespread attention in 1926. This subsequently led to the publication of *Urformen der Kunst* in 1928.

All three publications are the result of objective photography whose point of departure is a precise description of the object. Blossfeld, Sander, and also Renger-Patzsch were opposed to the already prominent "Neues Sehen" (New Vision), "and they consciously abstained from dynamic composition with unconventional angles or hard contrasts of light and shade. Whereas Albert Renger-Patzsch's *Die Welt ist schön* was a collection of attractively composed individual photos, the published work of Sander and Blossfeld derived an additional quality from the possibility of comparative viewing. In the case of Blossfeld this entailed the derivation of culturally created forms from their models in nature. Sander's series, for which he had established the criteria of "seeing properly, observing and thinking" can also be read phenotypologically as a series of portraits of social prototypes. "That Sander's pictures were for the most part posed and excellently arranged to this day makes it clear that photographic documents, too, can theoretically be manipulated and, as a consequence, tell more than the truth. His work as a whole, however, cannot be overestimated." [13]

It is Sander's intentional exposure of the relationship between photographer and model through obvious arrangement and fastidious composition that enlists the viewer as a partner with equal rights. In *Menschen des 20. Jahrhunderts (People of the 20th Century)*, which appeared in 1980, Ulrich Keller points out parallels to the "alienation effect," which Bertolt Brecht used as a feature of his stage directions in order to "induce in the audience a critical attitude to the events being presented." [14] The fact that this "sociology without words" (Alfred Döblin) turns out to be the most complex project within these three style-setting undertakings in German photography in the twenties is due to the way the series are constructed, "since the sequential presentation of the pictures is handled in masterly fashion to illuminate the theme from all sides and make available to the viewer readings and levels of comprehension which lie outside the range of decorative or anthologizing picture selection. That Sander was a pioneer in opening up the "third dimension" in photography should be noted

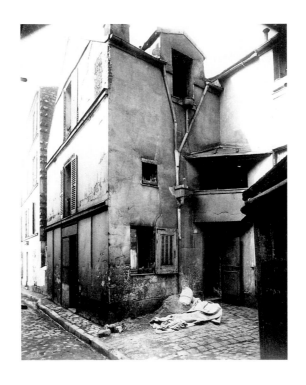

Eugène Atget *Montmartre,
coin rue St. Rustique, Paris* 1922
© Photothèque des Musées
de la Ville de Paris / Joffre

here in passing. Only possibly Atget had explored this territory before him, and that only spo-
radically and in unpublished albums, which were, we can be sure, not known to Sander." [15]

Eugène Atget came to photography at the age of forty-two, after various other employ-
ments. His lifelong subject was the documentation of Old Paris at the turn of the century. He
made a living from selling city views and architectural photographs to painters, architects,
tourists, and the authorities. His pictures show the old town of Paris—its streets and build-
ings, but also the palaces and gardens of the capital—all of which were threatening to disap-
pear as a result of extensive renovation. The already visible signs of the relentless rise of
modernity in the shape of automobiles or changing human fashions do not feature in Atget's
mostly deserted scenes. But he did integrate the first signs of early capitalist society into his
photographs, in the shape of street advertising and shop-window displays, and "his interest
in the signs of life was evident. He loved the dedicated artistry of previous generations, and
the houses stand in his photographs like theatrical sets; at any moment somebody might
step on stage." [16] Besides the urban views, there are many pictures of architectural details,
but also photographic inventories of the window displays of various shops which provide
exact information about the goods available at that time.

In 1907 the Bibliothèque Historique de la Ville de Paris commissioned Atget to make a
comprehensive documentation of the old town in Paris. Atget shot with an 18 x 24 cm plate
camera using a tripod and then made contact prints from the negative on printing-out paper.
This elaborate photographic process—the camera is big and heavy, ruling out any sponta-

neous reaction to a given scene—compelled the photographer to proceed slowly, which, however, contributed significantly to the quality of his pictures. The American painter and photographer Man Ray, who claimed to have discovered Atget, offered "to lend Atget a little hand camera. But Atget would not hear of it: he complained that 'the snapshot' went faster than he could think… '*trop vite enfin*,' too fast."[17] His deliberate working method arose out of very conscious considerations and resulted in a slow, permanent, and photographically exact rendition of his immediate surroundings. His concentrated, formal transcription transcends the purely documentary. For this reason the surrealists saw in his pictures photographic forerunners of their own movement and, in 1926, facilitated for Atget the first publication of his photographs in *La Révolution Surréaliste*. Although Atget regarded himself as an artist, he did not see himself as a member of this artistic movement, but as a purveyor of documents for museums and for the authorities, as well as a provider of images for artists, *documents pour artistes*.

After he had completed his commission in 1909, at the time when August Sander was beginning to assemble his thoughts on *Menschen des 20. Jahrhunderts*, Atget ordered his photographs thematically in albums, each with about 60 prints, accompanied by short explications. There were collections dedicated to "*La Voiture de Paris*" with carts, coaches and horse-drawn trams, but without automobiles, to shop-signs, and to old Parisian boutiques with attractive wrought-iron bistro facades, to *Zoniers*, rag and bone men, hawkers, and Gypsies in the *Zone*, as the derelict periphery of Paris was called."[18] Whether these albums were sale catalogues or had some artistic purpose is not known.

Atget did not see himself purely as a picture maker, but as an *auteur-éditeur*.[19] In applying the word author to his photographic work, he was appropriating from literature the concept of the artist whose personal style identifies him unmistakably as the creator of his texts. Atget's photographs, which are at first sight seemingly authorless, are in fact informed by a consistent style principle, which uses the visual idiom of documentary photography, but allows two readings, namely as factual photographic description and as artistic self-expression in dialogue with the world, so that "as far as is possible in the genre of architectural photography, his work [mirrors] his biography in general terms."[20] What he called his *documents pour artistes* were more than source material for artist colleagues and documents for the authorities; they were cherished because they transformed the "soul" of Paris into imagery. The photographer Berenice Abbott, who was assistant to Man Ray, recognized their artistic merit and bought prints from Atget. After his death she acquired parts of Atget's archive, of which he had said: "This assemblage, artistic and documentary in character, is now complete. I can say I possess all of Old Paris."[21]

15 Keller, p. 62. 16 Wilfried Wiegand, *Eugène Atget: Paris*, Munich, 1998, p. 12. 17 Julien Levy, *Memoir of an Art Gallery*, New York, 1977, p. 91, quoted in: Newhall, p. 197. 18 Wiegand, pp. 14ff. 19 Keller, p. 73. 20 Wiegand, p. 12. 21 Eugène Atget, letter to the director of the art department in the Ministry of Education in Paris, relating to the purchase of part of his archive, which subsequently took place in 1920. Quoted in Wiegand, p. 17.

When Walker Evans spent a year in Paris in 1926 he saw photographs by Berenice Abbott in Shakespeare and Company's bookshop, but he only met her when he was back in New York. There, two German friends, the artist Hans Skolle and Paul Grotz, encouraged him to take photography seriously. Evans still viewed it as his "left-hand hobby." [22] He borrowed a small camera from Grotz, and Skolle, who painted in the style of New Objectivity, recommended the camera as an instrument for seeing objectively. In photography Evans turned against the painterly and later purist approaches of Alfred Stieglitz and saw Atget, whose prints Berenice Abbott had shown him in 1930, as the example to follow. Evans began to photograph everyday life in America. From Baudelaire he learnt that the age he lived in had a deportment, a glance, a smile of its own, and from Flaubert he adopted the notion of the seemingly authorless work of art. "I think I incorporated Flaubert's method almost unconsciously, but anyway I used it in two ways: both his realism or naturalism and his objectivity of treatment. The nonappearance of the author. The nonsubjectivity. That is literally applicable to the way I want to use the camera and do." [23]

In 1930, a year after the opening in New York of the Museum of Modern Art, the first museum to unite painting, architecture, graphic arts, design, photography, and film as areas within its collection, Evans was commissioned to photograph sculpture exhibitions for the museum. One of MoMA's consultants at that time was Lincoln Kirstein, in whose magazine *Hound and Horn* Evans in 1931 published a review of recent books on photography. With the telling title "The Reappearance of Photography," the review can be read as his personal photographic manifesto. He praised Atget's photographs: "His general note is a lyrical understanding of the street, trained observation of it, special feeling for patina, eye for revealing detail, over all of which is thrown a poetry which is not 'the poetry of the street' or 'poetry of Paris,' but the projection of Atget's person." He considered Renger-Patzsch's *Die Welt ist schön* a superficially attractive book. "Renger-Patzsch's hundred photos make a book exciting to run through in a shop and disappointing to take home." And he recognized the artistic concept behind August Sander's *Antlitz der Zeit.* "*Antlitz der Zeit* is more than a book of 'type studies'; a case of the camera looking in the right direction among people. This is one of the futures of photography foretold by Atget." Evans closed his article with a description of Sander's photographic concept which was simultaneously a formulation of his claims for his own photographic work: "It is a photographic editing of society, a clinical process; even enough of a cultural necessity to make you wonder why other so-called advanced countries of the world have not also been examined and recorded." [24]

In the mid-thirties Walker Evans began to carry out his own project "to compose a critical portrait of America's historical present, at once resolutely unspectacular and shockingly

22 James R. Mellow, "The Incandescent Center" in: James R. Mellow, *Walker Evans*, New York, 1999, pp. 43ff. 23 Walker Evans, quoted in Mellow, p. 118. 24 Walker Evans, "The Reappearance of Photography" reprinted in: *Unclassified. A Walker Evans Anthology, Selections from the Walker Evans Archive*, New York, 2000, pp. 81ff. 25 Belinda Rathbone, *Walker Evans, A Biography*, New York, 1995, p. 158.

real." [25] Part of the time Evans used a large-format plate camera and made contact prints from the negatives. The pictures produced by this type of camera are laden with detail and invite minute study. Evans also took pictures with a miniature camera and incorporated these sketch-like photographs into his long-term project. In doing this he looked on his photographs as visual raw material; in some cases he would radically crop his prints in order to achieve the desired statement. This procedure was directly opposed to the purists' line: "Cropping was a heinous crime in the eyes of artistic photographers like Stieglitz and Weston—picture-creation, defined as the work of genius, ought to succeed at a stroke, not be touched up subsequently. Evans thought differently; his camera work only achieved its full significance after critical revision." [26]

Evans was not interested in the presentation of perfect individual pictures, but in pictures sequenced in a photographic essay. In 1938 the Museum of Modern Art decided to mount a one-man show of pictures it had bought from him. The director of the museum made it clear that this first-ever exhibition of the work of a photographer would be accorded the same significance as a retrospective for any other artist. The exhibition was to be accompanied by a catalogue and Evans began, along with Lincoln Kirstein, to select the plates. "Both ... were determined to give the utmost attention to the sequence of images in the book." [27] Both were admirers of the films of Sergei Eisenstein and Dziga Vertov and were familiar with the techniques of film montage. The photographs were presented in the book that accompanied the exhibition in 1938 in two separate series. The first part of *American Photographs* shows "the physiognomy of a nation," while the second part shows the "continuous fact of an independent American expression." [28] With *American Photographs* Evans had made the first art book to be published in the history of photography. For the first time a photographer had control over selection, ordering, and layout of his pictures. "In photography self-interpretation and self-editing ... can be an integral part and in fact 'the third dimension of the pictures.' Perhaps no other photographer in the 20th century knew this better than Walker Evans." [29] But there were naturally also critical voices at the time. The American photographer Ansel Adams wrote to the painter Georgia O'Keeffe, Alfred Stieglitz's wife, "I think the book is atrocious." [30] The fact that Evans was addressing a public with literary interests, rather than the circle of photographic purists who thought only in terms of the perfectly executed single photograph, is borne out by the blurb Evans wrote for the book, in which he challenged the reader "to look at the illustrations in the order in which they were printed." [31]

For the exhibition of his photographs Evans brushed aside the normal convention of letting the museum curators do the hanging. On the evening before the opening Evans and Kirstein retired to the exhibition hall and spent the night doing the hang. Next morning the director found his exhibition already hung. "Evans and Kirstein had arranged one hundred

26 Ulrich Keller, "Walker Evans 'American Photographs'—Eine Transatlantische Kulturkritik" in: *Walker Evans, Amerika, Bilder aus der Depression*, Munich, 1990, p. 71. 27 Rathbone, p. 159. 28 Newhall, p. 246. 29 Keller, "Walker Evans," p. 61. 30 Rathbone, p. 166. 31 Rathbone, p. 161.

photographs around the wall in a continuous horizontal line. The smaller photographs were framed or simply overmatted: the larger prints were mounted on board and pasted flat on the wall with rubber cement." [32] In *American Photographs* Evans deals with various subjects: the significance of the individual in the mass, the role of the colored population, the role of women, relations between the sexes, mankind's new mobility, the growth of advertising, and the meaning of poverty and wealth, to name but a few examples from his enormously complex description of society. Amenable to any number of readings, the richness of meaning in this pictorial essay explains its unabated actuality. Although the pictures can be read from today's viewpoint as historical documents, when viewed as a series they offer each succeeding generation a basis on which to analyze modern mass society in its contemporary form. Its continuing fascination and timeless universality derive from Evans's ability to shape the signs of the visible world into autonomous pictures which are determined by aesthetic laws alone.

In 1938 Walker Evans began to photograph the passengers in the New York underground with a hidden camera. Shortly afterwards, when the Second World War was already raging, he produced penetrating portraits of his fellow travelers that had an almost existentialist feel. For this series, which he first published in 1966 under the title *Many are Called*, he cited in particular the presentation of social conditions in the works of Goya and Daumier as his model. Above all Daumier's "Third Class Passengers" served as an example. "These people thrown together by the timetable do not speak to one another, they compensate for the enforced physical contact by maintaining an inner distance. The great isolation sets in… Everyone for himself, alone with his worries…" [33] In the subway portraits Evans shifts the perspective to the peripheral, to what might be considered unworthy of record, to another facet of the description of everyday life, and in this way paints a psychological portrait of the "ladies and gentlemen of the jury" as Evans called his anonymous models.

Evans furnished the basis for later generations of photographers' understanding of themselves not only with his practice of photography, but also with the precise definition of his own photographic method. His photographs are always both successful, perfectly composed individual pictures and also documents of the time. At first glance they look like representations of the visible world, in keeping with the agenda of documentary photography to duplicate visible phenomena. The "this is how it is," the recognizability, the identity of motif and image guarantee its success. Pictures that are subordinated to this strict set of rules have to be comprehensible, easily categorized, and available for comparison if they are to function as documents. Walker Evans was interested in precisely these aspects of documentary photography. He wanted to inscribe clarity, precision, and legibility into his form of photography. His pictures were not to have an obvious artistic signature superimposed on the image, but

32 Rathbone, p. 162. 33 Günter Metken, "Lauter Reisende dritter Klasse," *Süddeutsche Zeitung*, no. 240, 1998. 34 Walker Evans, "Interview with Leslie George Katz" in: *Art in America*, March/April 1971, reprinted in: *Walker Evans, Incognito*, New York, 1995, p. 18.

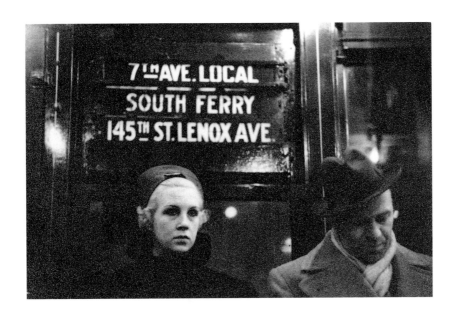

were on the contrary to expose that image for study and analysis. In this way a cool, personal signature was inscribed in his pictures, which he himself described as "documentary style." Walker Evans summed up this idea in an interview in 1971: "Documentary? That's a very sophisticated and misleading word. And not really clear … The term should be 'documentary style.'" [34]

Beyond that, the identifiable individuality of the artistic process is determined by the photographer's conceptual treatment of his choice of motif, location, and available light, in other words, the activity of the artist as *auteur* in conjunction with his input as *éditeur* who determines the selection, ordering, displaying, publishing, and distribution of his photographs according to his personal concept. Photographs which wholly fulfill the concept and cite the documentary style derive their particular quality from the disparity between motif and image, from the artistic construction erected on the foundation of the reality described. What is meant is not simple duplication, but the desire to highlight the specific, the unsaid, the particular against the background of the familiar, and to do so by adjusting the point of view. Seemingly well known and taken as a piece of documentation at first glance, it is only after a while as one looks at them, that these photographs reveal their quality and in consequence gain acceptance as artistic statements in a dialogue with the world. Because pictures like those of Walker Evans do not function as attractive in the first instance, but require viewers to work at understanding them, they reverberate longer and effect enduring changes in our perception of the world.

When Robert Frank met Walker Evans shortly after his arrival in New York, Evans recognized in the other man's photos his own understanding of photography and supported Frank's application for a Guggenheim Scholarship. With the grant, the Swiss photographer traveled the length and breadth of America in 1955–1956 in order to photograph it with the

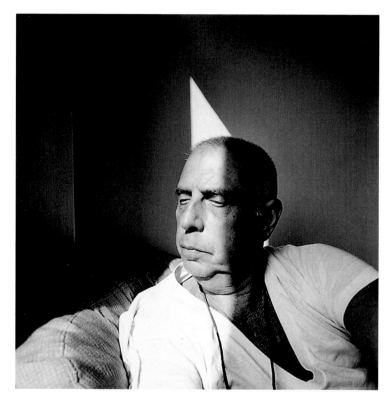

Lee Friedlander *Montréal* 1997

fresh eyes of a European: "I speak of the things that are there, anywhere and everywhere—easily found, not easily selected and interpreted. A small catalog comes to the mind's eye: a town at night, a parking lot, a supermarket, a highway, the man who owns three cars and the man who owns none, the farmer and his children... The uses of my project would be sociological, historical and aesthetic." [35] Evans encouraged his younger colleague after his return to publish his photographic project in book form, and helped him to sequence the illustrations.

Cultured America reacted with shock when the book was published, first in 1958 in France and then in 1959 in the USA. Their criticism can be put down to the still prevalent view of photography as expressed, for example, in pictures by the then accepted "master photographers" who inhabited an almost closed circle of high art. With their aspirations to technical perfection and their so-called previsualization of the motif, they gently terrorized photography. Serious photographers worked according to these rules, about which Frank cared not a jot. Besides his radical, personal imagery, his content too was criticized. Pictures taken in black and white with available light stood formally in stark contrast to the color photos of the mass media and expressed an emotional but critical and unadorned view of an American society, which was disinclined to have a mirror held up to it by an outsider. Only from this distance in time can we perhaps see the interest in his fellow human beings that is contained in the *photographie vérité* of Robert Frank. In the American edition, Jack Kerouac formulated in one sentence the outstanding feature of his work, namely the radical subjectivity of his gaze: "To Robert Frank I now give this message: You got eyes." It is this artistic principle, combined with a complex narrative structure that has made Frank's distinguished work an example for many photographers after him. *The Americans* and his mentor Walker Evans's *American Photographs* have become the ultimate photographic art books of the 20th century.

When John Szarkowski became curator of the Museum of Modern Art in New York in 1962, he changed the existing exhibition policy. It had previously been dedicated to the purist form of photography, which was distinguished by strict composition, absolute mastery of photographic technique, and a tendency to exaggerate the significance of content. Against this photographic convention whose works operated within a closed, rigidly dogmatic visual system, John Szarkowski set his own selection of contemporary photographers. These rebels—Diane Arbus, Garry Winogrand, and Lee Friedlander—belonged to the personal-documentary school, a style Szarkowski particularly favored. They turned traditional standards upside down in that they did not document in the classical sense, but formulated their own unconventional view of the world in a manner akin to the subjective attitude developed by Robert Frank. For their work they used medium size and above all miniature cameras, with

35 Robert Frank in his application for a Guggenheim Grant, reprinted in: Jeff L. Rosenheim and Douglas Eklund, *Unclassified. A Walker Evans Anthology*, New York, p. 89.

which they could react spontaneously. They found their claim to intrinsiqually photographic qualities and to an individual authorial perspective prefigured in the work of Walker Evans, for whom Szarkowski had organized an extensive retrospective in 1971.

The distinguishing features of these photographers were a practice of photography that was personal but not private, and an understanding that the authenticity of the photograph is a construct which will have lasting value only if the images are aesthetically resolved. At a time when reporting journalism was experiencing a last flourish before television took over the function of reportage, their attitude appeared to many as a provocative cop out. "I don't have anything to say in any picture … I photograph to find out what something will look like when photographed." [36] With this statement Winogrand supported Szarkowski's curatorial thesis which was aimed at liberating photography from restrictive regulations. "Photography is a picture-making system … It seems to this writer that the best photographers today are full of confidence, sure that the new open position will again be the site of adventure. They have learned that the art of photography is no more (or no less) than photography done wonderful." [37]

When John Szarkowski exhibited the American photographer William Eggleston in color-saturated dye-transfer prints, a process at that time used especially in advertising, prints which moreover appeared to be snapshots of the photographer's immediate environment in the US South, the press reacted violently. One critic called the pictures "perfectly banal … perfectly boring, certainly" and came to the conclusion that "… these pictures belong to the world of snapshot chic." [38] Eggleston's critics overlooked the fact that the artist had simply developed a "snapshot style" for his work, following on from Walker Evans's definition of a "documentary style." The finesse in the photographic idiom of his pictures, which are clearly not snapshots, lies in the fabrication of familiarity with the means of souvenir photography: color, central composition characteristic of 35mm pictures, and seemingly banal motifs. However, only at first sight do these qualities mask the coldness of the social situations Eggleston is analyzing with his camera. The detached transposition of the everyday in the form of a psychogram of the American middle class, and the ability of the objects in the photographs to communicate a supplementary level of meaning via the interplay of color and form, make Eggleston's pictures into metaphors for alienation from the world.

We can now take stock of the artistic achievements in the field of direct photography by the end of the sixties and the beginning of the seventies. These were: the pictorial essay with the arrangement of pictures in series; the construction of a comparative view by means of a typology; the artistically validated use of photographic styles; the abandonment of latently formulated pictorial hierarchies, which led to a new interest in the everyday, in the supposedly banal, in social outsiders; the subjectivization of the gaze as author of photographic

36 Garry Winogrand, quoted in: Gene Thornton, "The New Photography—Turning Traditional Standards Upside Down," *ArtNews*, April, 1978. 37 John Szarkowski, "Photography: A Different Kind of Art," *New York Times*, Sunday Magazine, 14 April 1975. 38 Hilton Kramer, "Art: Focus on Photo Shows," *New York Times*, 28 May 1976.

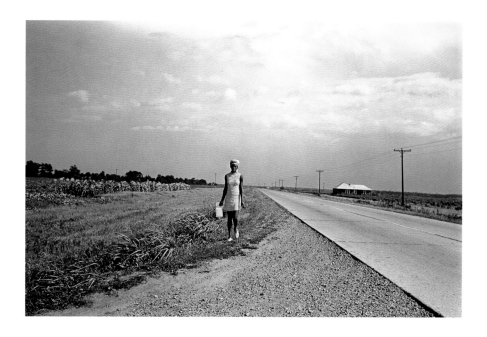

William Eggleston *Near Minther City and Glendora, Mississippi* 1969–1970

images, the introduction of the printed art book; the artist's exertion of control over the hanging of exhibitions, and, finally, the integration of photography into the domain of the museum.

If one considers further that Walker Evans, when he was working in Cuba in 1933, did not himself photograph the deplorable conditions under the Machado regime, but made photographic copies of press photos which showed beatings and victims, and later published them under his own name, one can speak of the first exploitation of existing photographic material with artistic intent. With this form of redeployment and displacement Evans can be considered a pioneer of "appropriation art." The above-listed criteria describe the work of subsequent generations of photographers and their forms of presentation and publication until the rise of digital photography at the end of the 20th century, without in any way diminishing their individual artistic achievements. The instrumentation at their disposal was now defined and was to be expanded by the photographers, who would work in depth, develop intensive and complex long-term projects, and would either radically objectivize or radically subjectivize their visual idiom, or even go further and develop new forms of presentation.

In the mid-sixties artists like Dan Graham and Ed Ruscha began to exploit the descriptive potential of photography in order to illustrate their own concepts. The invention of original images was not their prime concern. Their pictorial objective was rather to translate their thoughts and theories into visualized terms. The results were simple documents which consciously disregarded the rules of photography as art. Although the numerous typologies of anonymous industrial architecture by the German artists Bernd and Hilla Becher can be categorized as conceptual art, they also stand in the tradition of documentary photography

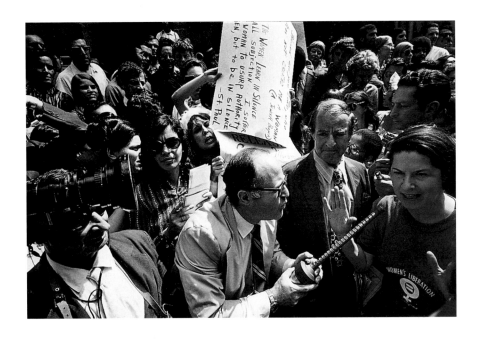

and are furthermore products of a masterly command of technique, both in the taking and in the printing of the images. Over a period of forty years they have brought to fruition a long-term project that is unique in the annals of photography. Without visibly adjusting their artistic signature, they not only photograph details of industrial architecture, which they arrange into typologies to permit comparative viewing, they also shoot extensive series of industrial premises that are doomed to disappear as a consequence of commercial deci-sions. What appear to be neutral, objective and authorless photographs turn out to be laden with information as single images that illustrate industrial history and have a discernible individual signature—qualities that are revealed only to a closer look, unlike the formal impact of these photographs when assembled into tableaux. The alternation between ab-straction and concrete content makes this artistic catalogue of the nuts and bolts of our industrial heritage unique not only aesthetically but also as a document of cultural history.

Also oriented towards this objective form of photography, although their early work in-volved existing forms of photography and presentation, are Thomas Struth, Thomas Ruff, and Axel Hütte, the first generation of students from Bernd Becher's photography course at the Düsseldorf Kunstakademie. From the mid-eighties they introduced the format of paintings into photography. Technical developments enabled giant format color prints to be made and displayed, complete with frames and especially designed mounts. This opened up a new form of reception for the photographic image. In their pictorial idiom they initially aligned themselves with the so-called New Topographics before developing their highly regarded individual approaches. In 1975 an exhibition under this heading assembled works of photog-raphers who specifically rejected the personal and radically subjective pictures of the leading

photographers of the day and wanted to relate to the American documentary photographers who had worked to commission in the 19th century. These early photographers were often employed by geologists to journey into unexplored areas of America. Their pictures were photographic documents, but at the same time, despite the comprehensibility demanded of them, were also in some cases skillfully composed photographs. The New Topographics, to whom, among others, Stephen Shore, Lewis Baltz, Nicholas Nixon, or Frank Gohlke belonged, and with them as the sole Europeans, Bernd and Hilla Becher, wanted to direct attention to subject matter again and away from the personal signature. In contrast to photographers like Friedlander and Winogrand, they did not use hand-held cameras, but preferred large-format cameras for their minute rendition of detail. They were interested in photography with this degree of precision because they wanted to let objects speak for themselves. "The world is infinitely more interesting than any of my opinions about it." [39] Beside other comprehensive series, Nixon has since 1975 carried out a long-term project with his wife and three sisters-in-law which is, like the Bechers' work, intended for comparative viewing. It, too, is unique in the annals of photography. An annual group portrait of the sisters shows the viewer the aging process in a progressive chronological sequence. Like all good art, this work asks more questions than it answers. It offers the viewer the chance to experience the passing of time against a background of factual description and thereby reflect on human existence in concentrated form.

Robert Adams *Newly occupied tract houses, Colorado Springs* from the Series *The New West* 1974

Another member of the New Topographics was Robert Adams, who at the time of the exhibition had been working for more than ten years on landscape change in his hometown of Denver. Adams was the first photographer to integrate ecological awareness into his numerous series. The realization that the natural resource of landscape is finite was new at that time, particularly in the USA, where the myth of unlimited landscape was still cherished. In his many published series Adams again and again pointed out the consequences of the inroads of civilization, of increasing industrialization and urbanization, as well as the attendant changes in the natural and cultural landscape. Despite his declared message, Adams's work is never predominantly moralizing, but always carefully composed and photographed with the greatest respect for the subject. His use of artistic means to demonstrate an altered concept of landscape, his attitude to the practice of photography, his accompanying texts, and his constant search for new angles of approach to his subject add up to an unusual synthesis of topographical description, metaphor, and autobiography, which in this form is unique in the history of photography and has great potential as a precedent.

Many of these photographers, like Adams, Baltz, and Shore, who were developing a "new objectivity," but also Friedlander and Eggleston, who worked in the personal-documentary style, were exhibited at the end of the seventies and the beginning of the eighties in Germany at a photography workshop conducted by Michael Schmidt in Berlin. They were also

39 Nicholas Nixon, quoted in: William Jenkins, *New Topographics: Photographs of a Man Altered Landscape*, George Eastman House, Rochester, N.Y., 1975.

Michael Schmidt
Untitled from the Series
Waffenruhe (Cease-fire)
1984-1987

invited to give talks. This presentation of their work was very influential for the younger generation of photographers. Alongside Bernd and Hilla Becher, Michael Schmidt belongs to the outstanding representatives of German post-war photography. Schmidt was born in Berlin in 1945 and his work and biography are closely connected with the city. He has repeatedly subjected his direct urban and social environment to photographic scrutiny, each time with a different accentuation. In contrast to the work of Bernd and Hilla Becher whose formal idiom is very consistent, Schmidt reinvents himself for every new project. Nevertheless, the stringency of a consistently applied, subjective point of view, which takes reality as an opportunity to create original photographic images in the documentary style, has led to a continually developing and always recognizable artistic signature. In his work he does not foreground the description of reality, but the artistic statement that takes visible reality as basic material for a photographic image, which can then develop an autonomous character of its own. A highpoint was Schmidt's 1987 project *Waffenruhe* (*Cease-fire*), which was conceived as an exhibition plus a book and drew a disturbing, dark psychogram of the divided city of Berlin. Schmidt's new work *Frauen* (*Women*) is an examination of the external appearance of young women. Photographed, occasionally naked, in front of a neutral background, they reveal a process of self-discovery through their presentation, gesture, and dress. This self-discovery is primarily defined in terms of these externals and their effect on others. Alongside their individual naturalness, a simultaneous dependence on how they are perceived by others can be discerned in details that show how their external appearance conforms to the norms of their contemporaries. The young women's dialectical balancing act between individuality and social conformity is astutely analyzed in a coherent series of skillfully composed single images.

Against this practice which achieves artistic constructs by the simplest of means, we can set the work of Andreas Gursky. For several years, he has been producing digitally reworked, in the purest sense artificially expanded images, derived from photographic source material. His inner, imaginary pictures are a presence that is not entirely congruent with the real world. "In the Rhine picture, the situation is the same. I was not interested in an extraordinary, possibly picturesque part of the Rhine, but in the Rhine in its most contemporary manifestation. Paradoxically the authentic picture of the Rhine is not to be found on location, and it takes a fictitious construct to capture the idea of a modern river's course."[40] This statement makes it clear that it is no longer a matter of the direct photographic examination of a visible phenomenon, but of an illustration of an idea of the world that is largely detached from reality. Since the power of existing motifs is no longer trusted, pictures have to be technically

40 Andreas Gursky, quoted in: "...im Allgemeinen gehe ich die Dinge langsam an," extracts from a correspondence between Veit Goerner and Andreas Gursky, 1998, in Text Supplement to the Catalogue, *Andreas Gursky, Fotografien 1994–1998*, Kunstmuseum Wolfsburg, 1998, p. 5. 41 cf. Roland Barthes, *Camera Lucida, Reflections on Photography*, London, 1988, p. 81, "A sort of umbilical cord connects the body of the photographed thing to my gaze..." 42 Barthes, p. 76.

adjusted to conform to an artistic concept. If direct reproduction by digital technology expands, classical photography will no longer be connected, as by an umbilical cord, with its referent. [41] If analogue photography has to rely on "the necessarily real thing which has been placed before the lens, without which there would be no photograph," then digital photography, like painting, "can feign reality without having seen it." [42] Owing something to the pictorialism of the early 20th century which rejected the direct image, deeming it artistically inadequate, a new form of art photography is developing here, which combines real and fictitious components to form original images, whose autonomous character proves to be a cross between photography and painting. This new art photography, with the potential perfection of its partially synthetic product, stands in direct contradiction to the imperfect images of direct photography. The latter takes its images—which can exert continuing fascination—and its quality from the examination of an imperfect world and continually confronts viewers with the instability of their own existence. And digital photography, the future of photography: it astounds viewers. Will it also touch them and give them pause for thought?

Translation: Hugh Rorrison

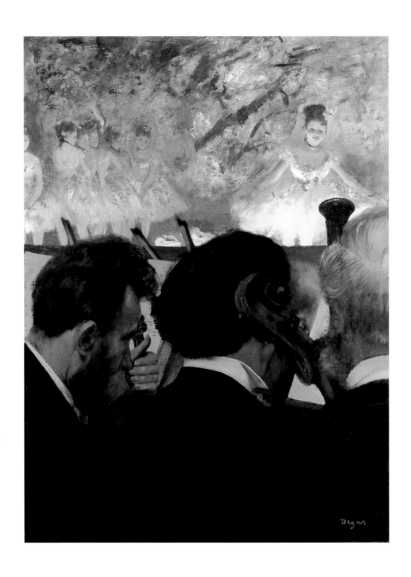

Edgar Degas
Musiciens à l'orchestre 1872

The Barely Visible Visible
Perspectives on Reality
in Photography and Painting

Heinz Liesbrock

"You can take a good picture of anything." Garry Winogrand

I

As the 20th century drew to a close the realization dawned that the history of the visual arts in that century could not be adequately contained within the unilinear stylistic concepts which have long determined how we viewed it. This belated insight has been acquired, in its last decade, not only through historical reappraisals such as typify the turn of a century, but also through international political upheavals and groundbreaking technological and economic change, which have recalibrated our understanding of the situation of the individual, and his artistic and intellectual output. This has brought what were long considered the by-ways of artistic expression into sharper focus than ever before, specifically those areas that do not fit seamlessly into the putative *voie royale* of modernism, which sees the development of art purely as the stately progress of abstraction and self-referentiality. As we understand it today, the art of this century is characterized by a multiplicity of forms and by fundamental contradictions, doubts, reversals, and repetitions. Within this development, manifold realisms have equivalent status with positions which define themselves in expressly personal terms and resist incorporation into broader streams of development. In retrospect minimal art, which emerged in the sixties, appears to have produced the last group of artists whose understanding of themselves was determined by the strict notions of development implied by artistic modernism, and in this they saw themselves as the final phase of a teleological process.[1] The swift turnover of artistic isms which followed, and the philosophical concepts of postmodernism and deconstructivism which largely dominated intellectual discourse at the end of the century, finally put paid to any notion of historical coherence in which we might act as autonomous, self-conscious subjects.[2]

The widespread acceptance of photography as a form of artistic expression, and the understanding of the specific possibilities and achievements of photography as a medium are presumably also due to realignments within our understanding of history and the erosion of certainties long cherished as axiomatic. Photography has had a visible presence in exhibitions and specially dedicated departments of important museums of art in the USA since

about 1950: the prelude to this development was Walker Evans's exhibition *American Photographs* in the New York Museum of Modern Art in 1938. However, in the museums of Germany and Europe it only made its entry around 1985, where it was at first grudgingly recognised as a form of visual art alongside painting and sculpture. Up to that point photography in the European context was only worthy of notice in forms where it could be read as an aspect of traditional artistic modernism. In this connection surrealism (photocollage) and constructivism (photogram) were important points of reference.[3]

The new awareness of photography in Europe was initially focused in particular on a group of young German photographers who had studied at the Düsseldorf Academy of Art under Bernd Becher. Their course embraced the technical, historical and artistic aspects of photography, but in addition to this the Düsseldorf Academy, which in the years from the end of World War II until the eighties was at the heart of contemporary developments in the arts, offered a variety of stimuli that went beyond the traditional field of photography. In this invigorating working environment these artists integrated questions of the painterly representation of reality into the discourse of photography. We can also assume that in the growing popularity of photography there is a diffuse element of mourning for the loss of pictorial structure in the field of painting. The "Düsseldorf School" of photography stands for large format color pictures and covers the genres that are traditionally associated with painting, namely portrait, cityscape, landscape, and travel view.[4] At the same time these photographs are characterized by a conceptual contradiction. They rely on the power of the visible while simultaneously questioning it. They avoid indulgence in sensual appearances either by building up a conceptually organized archive of predominantly banal everyday forms, or by using series of pictures to delineate a canon of differing views of an object and thereby underline the questionable nature of any monolithic perspective on reality. The ability to appear sensual while critically undermining the immediacy of the picture or its reliability as representation seems to lie at the heart of the appeal of these pictures today.

1 For views on work and history expressed by a few practitioners of minimal art, cf. Bruce Glaser, "Questions to Stella and Judd" in: Gregory Battcock (ed.), *Minimal Art, a Critical Anthology*, New York, 1968, pp. 148–164; Donald Judd, "Specific Objects," in: Donald Judd, *Complete Writings 1959–1975*, Halifax and New York, 1975, pp. 181–189. 2 For an account of this complex, see Wolfgang Welsch, *Unsere postmoderne Moderne*, Weinheim, 1988; Jean François Lyotard, "Answering the Question: What is postmodern?" in: Jean François Lyotard, *The Postmodern Explained to Children: Correspondence 1982–1985*, Univ. of Minnesota Press, 1992; Manfred Frank, *Was ist Neostrukturalismus.* Frankfurt, 1983. 3 Cf. Rosalind Krauss, Jane Livingston (eds.), *L'Amour fou, Photography and Surrealism*, New York, 1985; Floris M. Neusüss (ed.), *Das Fotogramm in der Kunst des zwanzigsten Jahrhunderts*, Cologne, 1990; Herbert Molderings, "Lichtjahre eines Lebens. Das Fotogramm in der Ästhetik Laszlo Moholy-Nagys" in: *Laszlo Moholy-Nagy, Fotogramme 1922–1943*, exh. cat., Folkwang Museum, Essen, 1996. 4 It is significant in the reception of these photographic works that they are frequently discussed in the context of traditional developments in painting, while their obvious connections to the history of photography scarcely feature. Cf. "Ein Gespräch zwischen Andreas Gursky und Bernhard Bürgi, 6. Januar–11. Februar 1992" in: *Andreas Gursky*, exh. cat., Kunsthalle Zurich, 1992; Hans Belting, "Photographie und Malerei. Der photographische Zyklus der 'Museumsbilder' von Thomas Struth" in: Thomas Struth, *Museum Photographs*, Munich, 1993; Uwe M. Schneede, "Ohne Titel" in: *Axel Hütte: Italien*, Munich, 1993.

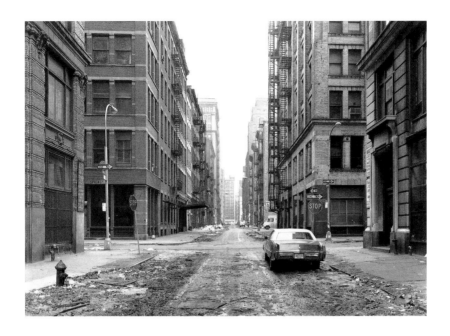

Thomas Struth
Crosby Street New York, Soho
1978

II

The reception of these photographic positions has another more far-reaching significance. In their realistic and descriptive ductus, in their homage to the idea of the mimetic image, they point towards a fundamental issue which photography has kept alive in the twentieth century, in contradistinction to the main strand of artistic developments, namely the question of whether any engagement with visible reality is aesthetically sustainable. If the language of abstract form and its attendant self-referentiality represent the standard scale against which we assess art, then the central concern of photography is its dependence on the factual, is indeed the concrete representation, in its multifarious facets, of the world we live in. If we look at photography in the majority of its manifestations, its essential postulate seems to be that to look at a person's face, and then to clarify the experience of this look by transforming it into an image, can be of great significance; furthermore, that it is worthwhile to convert objects in their seemingly random constellations into images in order to bring their historical layering to the surface; and finally, that pictures of towns, landscapes, various modes of transport, and travel are not simply a reproduction of the known, but are on the contrary allusions to a spiritual reality which is only revealed when the visible is touched by the ordering hand of the artist. They tell of a subliminal stream of ideas, memories, and emotions through which an age reveals its specific reality. In photography we find this visible aspect of our world as a language in which our century confronts itself and relates to a more far-reaching historical dimension.

The postulated antagonism between figurative and abstract art over which theorists and artists have long wrangled to establish their position has now exhausted its power to con-

Sigmar Polke
Untitled (Geneva) 1970

vince. We have understood that no general criteria can be found for the trustworthiness of an artistic language, nor for its radical scrutiny of its own presuppositions, none, that is, which would apply globally to a specific formal language. The expressive power of art can only be determined in relation to the individual work. But although the tension in this antagonism has relaxed it remains true that photography, with its stress on visible phenomena and their peculiar recognizability, places a prominent question mark against the validity of an abstractionism that occasionally succumbs to convention and dogma and has exhausted the possibilities of self-referential variations on formal models. In the face of this, photography looks like a reservoir of authentic new findings, a bearer of the message that "this is how it is," beside which all fictions pale into insignificance.

How you look at it takes the strand of photography predicated on visible reality to be the mainstream of the medium and the heart of its contribution to the history of art in this century. Thus, without wishing to contest their aesthetic relevance, certain forms have been excluded from our field of focus, such as the photogram (which perhaps presents the inherent qualities of the medium most clearly), painterly adaptations of photography, or the possibilities of theatrical self-presentation. The fact that Sigmar Polke and Cindy Sherman are represented by selected groups of works points to the wide spectrum of possibilities within artistic photography and underlines the seriousness with which artists have used photography in the context of differently weighted modes of expression.

The exhibition takes as its historical point of departure Eugène Atget, who stands at the point where photography clarified its expressive possibilities within the canon of the visual

arts. Atget rediscovered the heritage of photography with its saturated reproduction of reality in the early days when it was wholly conditioned by the charm that lies in capturing the visible and seeing it slowly deposit itself like a shadow of reality in the image. Quite objectively, rejecting any tendency to historical romanticization, he devised a language of memory, which dispensed with all effects copied from painting. For Walker Evans, his American successor, these pictures revealed the potential inherent to an aesthetic of photography, namely objectivity combined with a personally defined concept of beauty: "Suddenly there is a difference between a quaint evocation of the past and an open window looking straight down a stack of decades."[5] For the history of photography after Atget the contribution of North American artists is of particular importance. In their work the development of an artistic grammar of visible forms achieves paradigmatic status. The fixed points in this American contribution are marked in the exhibition by the names Paul Strand, Walker Evans, Robert Frank, and William Eggleston. They stand for central stages in the development of a specific visual language for photography, but they also indicate the fundamental significance of photography for the emancipation of American art from European culture, which had served as the definitive model until far into the twentieth century. It is in photography that America discovered itself: specifically, the idiom of mass culture, a picture of anonymous humanity, and a typology of collective dreams. The role of photography in this movement towards independence is as weighty as the role of abstract expressionism, as demonstrated by artists like Garry Winogrand, Diane Arbus, Robert Adams, Lee Friedlander, Stephen Shore, and Judith Joy Ross, who represent various developments within American photography up to the present day. In this section of the exhibition, in which we have also placed photographers who continue to work today in terms of a concept they defined long ago, we find August Sander, Albert Renger-Patzsch, Karl Blossfeldt, Brassaï, and Hilla and Bernd Becher, representing central European positions in the modern development of the medium. Just as the older section orders the terrain of photography according to a proposed range of artistic standards, and pinpoints certain key aspects in the contributions of the individual photographic authors, a similar orientation is targeted in the field of contemporary photography. This makes it possible to trace thematic strands (landscape, town, human figure) from the beginning of the century up to the present day, through a series of shifting perspectives, initiated, for example, by the breakdown of the fixed rules of genre. Finally, with the confrontation of Andreas Gursky and Michael Schmidt in the last room of the exhibition, analogue photography and the digital treatment of the image are juxtaposed as the two fundamental possibilities of the medium for today—a meeting that also highlights the difficulty of assessing the future of the medium at this time.

Walker Evans
Child in Backyard 1932

5 Walker Evans, "The Reappearance of Photography" in: *Hound and Horn*, no. 5, Oct–Dec. 1931, reprinted in: Jeff L. Rosenheim and Alexis Schwarzenbach (eds.), *Unclassified. A Walker Evans Anthology*, Zurich, Berlin, New York, 2000, p. 80.

III

How you look at it seeks a dialogue between photographic positions. It does not take the form of a chronological summary, but has recourse to undercurrents, to connections that cut across generations. In consequence, instead of clustering contemporaries in single rooms, past and present are repeatedly placed in direct confrontation. Presented in a survey the photography of the twentieth century seems to follow a course of organic development, unlike the painting of the period, which is characterized by clear breaks and express rejections of immediately preceding traditions. Photographic authors in this period also react with great sensitivity to the many changes in the world we live in, but their work remains more stable in its modes of presentation and in its aesthetic principles in the face of external change. Over wide areas it appears like an organic network, in which individual positions are woven together by multiple lines of influence, personal sympathies, and intentional continuations of what preceded them.[6] By making this network of aesthetic threads visible our exhibition goes some way towards correcting the hypostatization in the perception of contemporary photography that could be observed in the European context during the last decade. As it made its entry into the realm of museums which had previously been reserved for painting and sculpture, recent photography has been described, outside a somewhat restricted circle of experts, as being completely without antecedents. Its roots in the history of the medium, which were there for all to see, were ignored. It was able to appear groundbreaking and new because its relationship to the essential stages of photography's development in the twentieth century was known only to a few.

By extending the internal discourse in photography with selected examples of painting and sculpture which range from the late nineteenth century to the present day, the exhibition moves into *terra incognita*. It does this less at the points where the two media interlock—there are a number of well known precedents here—than in defining the basic situation and the cognitive interests that it implies. First, it should be established that this confrontation, as distinct from our account of the development of photography, is not intended as a systematic description. It is not based on any rigorous theory that aims to produce a comprehensive view of the relationship of painting to photography from a particular perspective. Previous pairings of painting and photography in books and exhibitions have mostly argued against the background of some such specific thesis, mainly in an effort to determine the ways in which photography influenced painting. Among these are the burst of new compositional strategies that was triggered, particularly in French painting, by the contingent picture-

6 In this connection, see Thomas Weski's essay in this publication, "No Scrawling, Scratching, and Scribbling on the Plate."
7 Cf. Max Imdahl, "Die Momentfotografie und 'Le comte Lepic' von Edgar Degas" in: Max Imdahl, *Gesammelte Schriften*, Frankfurt, 1996, vol. 1 (A. Jahnsen-Vukicevic, ed.), pp. 181–193; Bernd Growe, "Photographische Aufmerksamkeit, Edward Hopper, die Momentfotografie und Edgar Degas" in: G.W. Költzsch and H. Liesbrock (ed.), *Die Wahrheit des Sichtbaren. Edward Hopper und die Fotografie*, exh. cat., Folkwang Museum, Essen, 1992, pp. 72–82.

August Sander
City Children Vienna 1930

structures of instantaneous photography, but also the practice of referring to photographs as models for paintings, and investigations of the photographic work of artists whom we know mainly as painters,[7] such as Degas, Eakins, Bonnard, Sheeler, Brancusi, or Picasso. Finally, around 1970, the arrival of "photographisms," the use of photographic images and processes in painting, sculpture, and conceptual art, became the topic of the hour.[8] All these approaches look upon the younger medium primarily as an arsenal of gazes and strategies which can be expected to yield insights for understanding the older art form.[9]

The confrontation of painting, sculpture, and photography, attempted in our exhibition, is to be understood as an open field for research that presents a number of approaches. It is not intended to exemplify a single, consistent thesis. The intention is above all to instigate a real dialogue, not merely to present influences focused on a single direction. The parallel presentation of different media aims for "mutual illumination of the arts," to use a formulation coined by Oskar Walzel in the twenties. What will be clarified above all is that the development of photography as presented here is unthinkable without its participation in the general aesthetic discourse of modernism, as manifested in fine art, but also in literature.

8 For the reception of photographic modes of viewing, cf. Otto Stelzer, *Kunst und Photographie, Kontakte, Einflüsse, Wirkungen*, Munich, 1960; Aaron Scharf, *Art and Photography*, London, 1969. Important exhibitions on this theme were "Fotografische Bildnisstudien zu Gemälden von Lenbach und Stuck," Folkwang Museum, Essen, 1969; "Malerei nach Photographie," Stadtmuseum, Munich, 1970; "Medium Photographie, Fotoarbeiten bildender Künstler 1910–1973," Städtisches Museum, Leverkusen, 1973; "Malerei und Photographie im Dialog," Kunsthaus Zurich, 1977; "Photography in Contemporary Art," Walker Art Center, Minneapolis, 1992. 9 An exhibition conceived by the present writer and shown in 1992 in the Essen Folkwang Museum, "Die Wahrheit des Sichtbaren, Edward Hopper und die Fotografie," can be considered a precursor of the dialogue attempted here. There Hopper's paintings were seen alongside photographs by nine American photographers in a context of mutual explication.

Lee Friedlander
Buffalo 1968

Photography is a partner in a comprehensive intellectual discussion, from which it derives stimulating ideas, but to which it contributes its own specific angles of inquiry, which can then turn into catalysts for new developments in other arts.

Our choice of paintings and sculptures to partner the photographic positions is based on a broad spectrum of interferences. They share such interests with photography as the topography of the city, its accelerated social rhythms, and the language of fashion and advertising which in this context develops into an idiom with wide validity. Furthermore, basic modes of relating to external reality can be discerned in all media: contemplative and with a tendency to accumulate fragments of memory, or extroverted and with a tendency to stress the energy potential in the artist's body—perspectives that generate a spectrum of possibilities for formal pictorial structure and also for the handling of color. And works of art can also tell of the fractures in the development of their medium. In this situation they put aesthetic boundaries to the test by adopting radically new approaches, new designs for visual languages which in the first instance have only personal validity, or they articulate themselves by invoicing traditional lines, that via a re-vision can become an appropriate contemporary mode of expression. Finally, we frequently encounter positions that reflect on the potential cognitive status of the artwork. The question of the validity of the relationship between reality and the image, examined from a multitude of angles, is a constant theme in the art of our century.

Every work of art has a core of individuality that forbids us to look on it solely as a quarry for historical data, an abstract example of an artistic tendency. In this uniqueness various

strands of thought are woven together into a complex fabric with an immediate appeal. This is the locus of a particular ability to communicate which enables the artwork to be a partner to the viewer. This moment of individuality is never monolithic; it is determined by a complexity of signification, a potential for renewal that enables the work to respond to various thresholds of inquiry without losing its peculiar identity. If one wants to retain these multiple layers in an exhibition, a common context has to be established, which respects this self-reference within the individual works while at the same time developing the potential cross references. A dialogue has to be initiated which avoids diminishing the individuality of the partners. *How you look at it* therefore attempts to combine photographs, paintings, and sculpture in such a way as to unlock their potential. The partners in this dialogue among media have been chosen in such a way that possible influences and common interests are not always visible at first glance. Our object is to stress a related chord, not merely to foreground the obvious, such as, say, the duplication of the same subject in painting and photography. Common features should be clear, but an area of suggestivity and inexpressibility should remain. A real conversation, which does not merely circulate information, or exchange points of view and known facts, can open up a new horizon, can leave the partner's integrity intact while revealing it in a new light. This means that expressions of agreement must be complemented by questions and even unresolved issues to which there are still no answers: a potential that can lead to fresh insights as the discussion is continued in a different context. For this reason our placement of the works alludes to the central point of the argument, but is also determined by other underlying meanings. What appears in the first instance to be merely a hint then crystallizes, as the exhibition progresses, into a clear and factual statement. In this way things previously seen appear in retrospect with quite different weightings.

In actually grouping the works our concern is not family resemblances between different media, as favored by academic art historians, who address such concerns as parallels in the history of ideas, common theoretical bases, or proven concrete exchanges between authors. The exhibition aims to go beyond these generalizations, intends to posit elective affinities, valid connections between works understood in their individuality, works that do not stand for theses. Precisely this stress on the unique, unmistakable attributes of partners can illuminate common traits and lead to a form of mutual explication that elaborates the previous state of knowledge. From Goethe's novel *Elective Affinities* we know that connections between adult individuals, which go beyond what tradition prescribes and attempt to redefine their personal histories, require patience and have to overcome complications. They do not blossom in the first moment; the relationship describes a curve which may be determined by attraction and repulsion in equal measure. This is how many visitors to our exhibition may feel when they see works grouped together which have their roots in entirely different historical and cultural precincts. The integration of abstract positions from painting may not seem immediately comprehensible either, but the common pictorial energy of the works on display

Mark Rothko
Untitled (Light Plum and Black) 1964

will undoubtedly invest the exhibition with a compelling cohesion. Paintings by artists like Mark Rothko, Franz Kline, or Ellsworth Kelly establish points of tension in juxtaposition with the prevailing notion of photography's recognizability, which could indicate that the image in photography has its own special characteristics and is not simply the unproblematic reproduction of the visible. At the same time photography will clarify the way paintings incorporate world and will show that they owe their particular form to concrete horizons of experience and in fact constitute a confrontation with reality.

In the rooms of the exhibition the paintings will achieve a form of emblematic concentration. Paintings are capable of striking a tone directly through the impact of color, formal simplification, a direct painterly signature, and even sheer size, and this basic tone, together with the paintings' expressive pictoriality, will feed into the visitors' appraisal and interpretation of the photographs. Photography has for long phases of its history used small formats, producing pictures that could easily be held in the hand. It is characterized by a wealth of detail and visual concentration, and therefore, in contrast to painting which we take in by *sight*, requires a viewer who is prepared to *read* the images, to decode objects, to determine their position in space in relation to one another. These differently structured modes of approach, will, we hope, complement one another in the exhibition and merge into a common, persuasive note that will guide and support viewers' attention. In this way possible readings will be suggested, rather than directives issued. Viewers are encouraged to exploit their capacity to see with their own eyes and, in reflection, to interrelate what they see. They are another partner in this dialogue.

IV

This confrontation of different media is based, apart from the validity of concrete connections, on the understanding that painting, sculpture, and photography partake in equal measure in the central paradigm of aesthetic modernism, in particular in the "iconic turn" which crystallized in the course of the nineteenth century and quintessentially distinguished the art that followed it from the centuries of development that preceded it.[10] What is meant is the fundamental change in the understanding of the image which is now understood as a vehicle for meaning in its own right. This definition relieves the image of its traditional task of representation. It interprets reality in a language of its own which cannot be directly rendered into other forms of expression such as, for example, words. Precisely the fact that this genuine language of the image is not codified demands that we constantly reappraise its bases, and sets many revisions in train.

10 The concept of the "iconic turn" appears in Gottfried Boehm, "Die Wiederkehr der Bilder" in: Gottfried Boehm (ed.), *Was ist ein Bild*, pp. 13–17. The term describes a phenomenon that relates not only to fine art, but also to the metaphoric nature of language and to the progressive use of images to express philosophical ideas since Nietzsche. This gradually develops (in Wittgenstein, for instance) into a critique of language, which considers the erosion of the one-dimensional relationship of language to reality and concludes that it is "in need of metaphor" (Hans Blumenberg).

Anyone who wishes to appraise the essential achievements of photography in the last century and view it in conjunction with the development of painting should be clear about this constellation and its context in the history of ideas. Every field of intellectual expression in this epoch—art, literature, music, and philosophy—is equally involved in this revolution.[11] The new paradigm that emerges unequivocally in the second half of the nineteenth century finds apposite expression in Friedrich Nietzsche's discovery of the "perspectivity" of our understanding. This means the end of a concept of truth which claims to determine reality in all its aspects with all-embracing validity. In its place Nietzsche proposes—and in this he gives expression to a fundamental experience of his time—a multiplicity of competing perspectives which splits the *one* world, as it had until then perhaps existed, into a ring of facets with no recognizable common point of reference. "In as much as the word 'cognition' still has any sense, the world is knowable; but it is to be *understood* differently, there is no meaning behind it, but innumerable meanings."[12] Nietzsche's diagnosis describes the dawn of an epoch, and the conflicting feelings of a profound change of mood reverberate in these sentences. This new mood is characterized by insecurity in the face of the loss of a unitary view of reality which embraced all diverging experience as part of a closed worldview; Nietzsche's words also reveal the suspense felt at the first sight of a newly emerging horizon, beyond which the possibility of another *sense* is visible: a terrain of understanding as yet untouched by tradition and crumbling dogmas, a free space in which a *new* definition of what reality might actually be is conceivable.

This situation of departure from a unitary concept of reality, and the concomitant rise of a world of enigma, can be traced with particular clarity in the fine arts. The end of this traditional order manifested itself in the late nineteenth century in the rapid disintegration of pictorial genres whose validity had been unchallenged for centuries. The hierarchical division of painting and sculpture into portraiture, history painting, still life, or landscape could only even seem to make sense so long as they corresponded to valid aspects of individual experience. Traditions in the history of ideas paled into insignificance just as rapidly as the various strands of iconographic tradition in which they had found expression. This general erosion of all traditional conventions eventually led to the disintegration of the subject in painting. What we observe in Cézanne's painting is the loss of an agreement built up over the years about the quality of such entities as nature and things and man. This is why his art is no longer governed by the representation of an unquestionably valid external world, but is concerned with the visual realization of an *experience*. The works do not record different aspects of the artist's personal history, but relate to an essential reality; they inform us that man's view of the world has become unstable, that patterns of recognition have lost their hold and degenerated into empty conventions. Gone are any fixed points of reference in the external world,

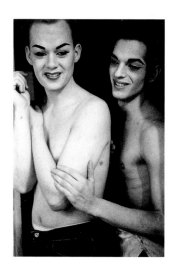

Diane Arbus
*Two Female Impersonators
Backstage, N.Y.C.* 1962
Copyright © The Estate of
Diane Arbus, LLC

11 Cf. Heinz Liesbrock, "Eine Lehre des Sehens" in: *Einleuchten*, exh. cat., Deichtorhallen, Hamburg, 1989, pp. 13–18.
12 Friedrich Nietzsche, *Werke*, Munich, 1955, vol. III (Karl Schlechta, ed.), p. 903.

or any empirical data that the beholder might organize according to a central perspective in order to convert this experience into images. In the case of Cézanne, and in this he stands for an entire generation, unproblematic mimesis gives way to expressiveness of vision. He wants to look at external phenomena as if with new eyes, unburdened with cultural conventions, in order to track down their ever changing, never static appearances. He considers it his task to transform the changing face of reality, without freezing it, into the language of the image. For artistic photography, too, the significance of this new, expressive vision cannot be overestimated.[13]

Since Cézanne, if not before, artistic modernism has been attempting to develop a valid language for this new, inchoate experience. An artistic picture can no longer be a replica of reality, but must, in Cézanne's words, create a "parallel" reality, which conforms to the particular laws of the medium.[14] Tradition offers no model for how such a parallelism might look. Cézanne's repeated fresh starts in front of his motifs, his constant reservations about the validity of his efforts, the series of unfinished pictures, all these things are signs of a situation in which there is no real certainty, since the burden of defining one's endeavors rests wholly on the individual artist. By beginning in such a moment from scratch and breaking completely with history, the old relationship of things and their designation is shattered, whether in the sphere of painting or of literature. Every artistic formulation is therefore fraught with doubts which question the very possibility of meaningful utterance. The most concise description and diagnosis of the fundamental situation of artistic modernism is to be found in H. v. Hofmannsthal's "Chandos Brief" (Chandos Letter) of 1902: "My case is, in brief, this: I have completely lost the ability to think or speak coherently about anything... Everything fell apart, the parts fell into more parts, and nothing could be contained in a concept any more. Single words drifted around me; they dissolved into eyes which stared at me and at which I had to stare back: they are whirlpools and looking into them gives me vertigo, they turn irresistibly, and one passes through them into the void."[15]

Anyone setting out to make an artistic statement under these conditions was testing the firmness of the terrain underfoot with each step. No single element, no syntactic linkage of the signs existed in advance. The picture therefore had to reflect the conditions under which it came into being. Artistic language scrutinized its elements and the assumptions behind them in the process of formulating them. As viewers we experience this meeting of world and image as language-*creation*; the picture confronts us with its own genesis. As cognitive

13 For the prehistory and theoretical bases of this new vision in the nineteenth century, cf. Max Imdahl, "Cézanne–Braque–Picasso. Zum Verhältnis zwischen Bildautonomie und Gegenstandssehen" in: *Gesammelte Schriften*, Frankfurt, 1996, vol. 3 (G. Boehm, ed.), pp. 303–380; Konrad Fiedler, "Über den Ursprung der Künstlerischen Tätigkeit" in: *Schriften zur Kunst*, (G. Boehm, ed.), Munich, 1991, vol. 1, pp. 111 ff., see also the editor's Introduction, especially pp. LXVIff. 14 For Cézannes position, cf. Kurt Badt, *Die Kunst Cézannes*, Munich, 1952; Gottfried Boehm, *Paul Cézanne, Montagne Sainte-Victoire*, Frankfurt, 1988; *Paul Cézanne. Vollendet–Unvollendet,* exh. cat., Kunstforum Bank, Austria/Kunsthaus, Zurich, 2000. 15 Hugo von Hofmannsthal, "Ein Brief" in: *Gesammelte Werke*, (B. Schoeller, ed.), Frankfurt, 1979, vol. 7, pp. 465ff.

Roy Lichtenstein
Little Aloha 1962

forms in their own right, painting and sculpture were under quite special pressure. Artists as individuals were working in a field of uncertainty which offered them few points of reference outside their personal stock of experience. They faced a demand for constant revision of what they had hitherto achieved. The art of the epoch, which we now often reassuringly call "classical modernism," as if it had only historical relevance, is in fact a vital laboratory in which many approaches were tried out in order to determine what there was to say and what means might be used to say it. In the face of such an acute situation, it is hardly surprising that, say, the history of painting since the impressionists today appears to be an unbroken chain of revisions and innovations. A rapid succession of movements in painting established positions, which were frequently to be dismissed as anachronistic by the very next generation. Impressionism, cubism, futurism; then Duchamp's dismissal of painting and its rebirth in the abstraction of Kandinsky and Malevich (significantly in 1913 in both cases); and finally the dethroning of the European tradition by Abstract Expressionism in the USA, and its denunciation in turn, again in the form of an orbituary for painting as a whole, by Minimal Art and Pop Art. Every generation seems to be seeking a valid form of expression, and in the process falls out with its predecessors.[16] Despite a certain calculated strategy with which every young generation evidently attracts attention by expressly denouncing the art of its immediate predecessors, it is impossible to overlook an exceptionally serious cognitive earnestness; existing art is radically scrutinized, there are constant returns to basics in order to re-utilize them in mapping out new paths.

V

Photography in the twentieth century is also characterized by a similar turnover, by experi-
mentation with modes of expression on still uncharted terrain. From Atget to Evans we can
observe a process by which photography at first hesitantly but then emphatically became
established as an unmistakable artistic idiom in its own right. In doing so, it has had to for-
mulate its attitude to both its own short history and to painting, in whose shadow it had
stood as a mere supplier of empirical material, its telos being to become as like painting as
possible. The new medium's point of departure in its quest for self-discovery is however
quite different from that of modern painting. For photography, it is not a matter of rejecting
its own tradition, of turning its back on its own history in order to make a new start. Its dis-
covery of its own authentic modes of expression in the first decades of the twentieth century
can rather be described as a recollection of its own heritage. Artists like Atget, Strand,
Sheeler, and Sander found crucial indicators for a grammar of photography in harking back
to the early days of photography—to the inimitable pictorial form derived from the faithful
rendering of the visible, especially from the sheer facticity of the human face. These made it
possible for them to develop a valid picture of their own times.[17] They sought to mediate a
direct, objective view of the world they lived in, in a form that would allow its particular en-
ergies to emerge clearly. They all saw themselves as witnesses on a threshold between the
end of a historical line that goes back centuries and the nascent rise of a new social reality.
They wanted to record the old, as it passes away, for the future, which would otherwise have
no image of it, and at the same time to bring order into the signs and phenomena of the new
for the first time.

The privileged locus in which past (history), present, and future converge directly is the
great city. It is not by chance that modern photography has Paris and New York as god-
parents. Photography needs an environment in which the vitality of the present appears at
full intensity in the architecture, in new forms of transport, and other manifestations of an

16 A comment of Mark Rothko's from the sixties expresses his exasperation with the constant race for artistic innovation
and its predominance in the definition of the contemporary. "These young artists are about to murder us." Quoted in James
E.B. Breslin, *Mark Rothko, A Biography,* Chicago and London, 1993, p. 425. 17 The idea of an early blossoming of photo-
graphy, followed by decline with the advent of pictorialism in the late nineteenth century, and then by the subsequent reco-
very of artistic possibilities triggered by Atget, has persevered as accepted historical wisdom and is found in: Walter Benja-
min, "The Work of Art in the Age of Mechanical Reproduction" in: Walter Benjamin, *Illuminations,* Hannah Arendt, (ed.), New
York, 1968; and Gisèle Freund, *La Photographie en France au XIXème siècle. Essai de sociologie et d'esthetique*, Paris, 1936.
Cf. also Rolf H. Krauss, *Walter Benjamin und der neue Blick auf die Photographie*, Ostfilden, 1998, pp. 20ff.
18 August Sander's Cologne also belongs, mutatis mutandis, in the context of the advanced modernity of the great cities.
Although it is more accurately a provincial town, the dislocation of cultural and social traditions that was caused by the
experiences of World War I was very pronounced there. Cologne is the main city of the Rhineland which was demilitarized
and detached from the *Reich* from 1918 to 1925, so that it saw itself as a frontier station between Germany and France. It is
both an administrative center and a center of industry with significantly high bourgeois and proletarian elements in its
population. Cologne is also a center of the arts with international connections, particularly to Paris. It hads a high level of
unemployment as a result of inflation and the economic crisis. Sander taps the energy of its peripheral groups, and
develops a keen eye for both aesthetic matters and crumbling social bonds, all of which finds expression in the artistic
order underlying *Menschen des 20. Jahrhunderts.*

emerging mass society. At the same time it partakes of the artistic saturation of these loci, in which both aesthetic traditions and the specific energies of modernism exist side by side.[18] The desire of these artists to bear witness cannot be stressed enough. Their pictures show them to have been remarkably close to the new phenomena, their gaze is focused directly on the object. The depiction of this closeness was their main aim. A synthesis of objectivity and personal vision is their achievement. What is needed for this is an aesthetic of directness, a language of form which, metaphorically, is delivered to the artist by the object itself. The obstacle to achieving this aim was the "artificial" vision of an academic style of photography, whose aim, under the banner of "pictorialism," was to imitate the ductus of painting. A mis-construed impressionism led to the *sfumato*-effect and empty suggestiveness. The pictoria-lists' variations on established patterns were not produced in a spirit of critical appraisal that might emerge from confronting the actual present with the specific qualities of the medium. Painting and photography have their common point of reference in the rejection of an effete concept of art, which attempts to sublimate the void in its own experience with metaphors and symbols. The express objectivity of such photographers as Strand and Sheeler, directly addressing everyday things that were all around and which people thought they knew well, must have seemed just as strange to a New York public, whose vision in 1916 was condi-tioned by academic high art, as the formal dismemberment of the object in cubism.

Charles Sheeler
Bleeder Stacks—Ford Plant 1927

In the light of this basic definition the emergence of art photography in the twentieth century can be seen to form a continuous line of development. Every renewal of its expressive possi-bilities has clearly developed from a confrontation with this basis and from the steps that follow. In photography the development of a voice of its own takes place in dialogue with the history of the medium. However this history of photography in practice is not a closed situation, it contains tensions related to a variety of sources. One of these is coming to terms with the other arts, another the impulses deriving from technical innovation. The choice of camera is always a programmatic statement for a photographer. A person who uses a large-format camera of a sort that was in principle already available in the nineteenth century favors a different vision from that offered by a handy miniature camera which is instantly ready for use in any situation. The aesthetics of photography experienced a sudden surge of development in the second half of the sixties when color photography became a widely avail-able means of expression with the introduction of large laboratories which could produce prints within a short time. The possibilities of color brought a hitherto unknown dimension to picture making.

Besides the self-reflectiveness of photography, the integration of its history and the con-ditions imposed by the medium on actual working practice, the central operative factor in its artistic development is its close linkage to visible reality. The rhythm in which the develop-

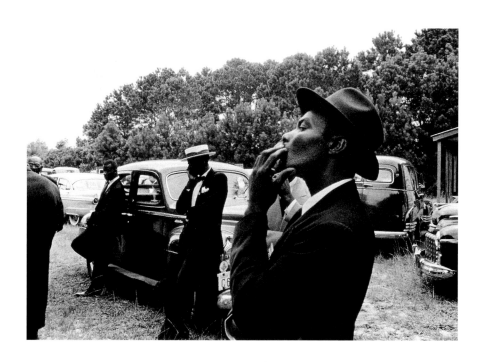

Robert Frank
Funeral–St. Helena, South Carolina
1955/56

ment of a genuinely photographic language has proceeded is closely bound up with changes in the social world and the underlying history of ideas. However the real achievement of photography lies not in direct reproduction of concrete events or factual data, such as wars, political leaders, natural catastrophes, or industrial marvels, but in its analysis of their effects, in the deeper dimensions of change, which are not visible in events reported in the news: changes in social rhythm, in linguistic forms and signs, in the "lingo" of life. This essentially non-explicit development in photography's response to the external world can be recognized by anyone who compares the *American Photographs* and the *Subway Portraits* which Walker Evans took in the second half of the thirties, with *The Americans* by Robert Frank, which were taken from about 1955. What we see at first is the common ground that derives from Evans's exemplary pictures: a complexity that, precisely because of his close-up technique, suffuses the most disparate social phenomena. Observation and analysis of the visible reveal the implicit language which the object itself cannot express. However, the difference, that is, the new tone of Frank's work quickly becomes apparent. It lies in a change in the rhythm of the photographic gaze, a penetrating acceleration of perception. If we describe Evans as an exact but coolly detached observer, then Frank gets extraordinarily close to the phenomena. His point of view seems to move with them, the intensity of his pictures derives from their ability to give this restlessness a valid form.[19] Besides the distinct personal temperaments that seek expression in every work of art, the difference between the pictures by these two artists also reflects the changing social reality in the USA and the shifts in a range of important cultural paradigms that could be discerned after 1945.

Being oriented towards visible reality dynamizes the artistic development of photography, but at the same time gives it a special constancy. This obligation to the external world gives rise to a specific aesthetic and to a related concept of authorship. All the photographers in this exhibition are fundamentally searching for a visible point of equilibrium, at which the external world and their own personal preferences and inclinations will be in balance. The artists step behind the visible phenomena and tend to dissolve into the formal structures of their pictures. They are there, but not expressly there. What we have here is a process of clarification within a given framework, not a sketch for something entirely new, as in the act of musical composition, or, if more obliquely, a sketch for a painting. The photographer Stephen Shore describes the retreat of the subject in the face of the complexity of the visible as a process of creating order in an unstructured stream of visual stimuli. "In bringing order to this situation, a photographer solves a picture more than composes one."[20] The artist's will to form finds a barrier in the dead weight of "nature," an incorruptible instance that cannot be by-passed. Based on the conditions of his own work, Shore traces the fine line that separates the claims of the external world from artistic autonomy. To illustrate his procedure he refers to a text written by Witter Bynner in 1929, in his introduction to an anthology of Chinese poetry of the Tang dynasty. Shore finds the aesthetic principle of photography clearly set out in Bynner's description of the procedure employed by Chinese poets. "Chinese poetry rarely trespasses beyond the bounds of actuality. Whereas Western poets will take actualities as points of departure for exaggeration or fantasy, or else as shadows of contrast against dreams of unreality, the great Chinese poets accept the world as they find it in all its terms, and with profound simplicity find therein sufficient solace. Even in phraseology they seldom talk about the things in terms of another, but are able enough and sure enough as artists to make the ultimately exact terms become the beautiful terms."[21] This extraordinary cognitive status of the visible world can be said to be the center around which the pictures in our exhibition move in different orbits. In this center an instance is recognized which must remain untouched by subjective form. Photographic artists develop their artistic criteria in deference to the visible and communicate their will to form as a message from the visible itself.[22] In the same way Walker Evans, following Gustave Flaubert, describes his mode of working as the retreat of the author behind the objectivity of the visible.[23] The camera and the author combine into an anonymous entity: "The secret of photography is, the camera takes on the character and personality of the handler. The mind works on the machine."[24]

20 Stephen Shore, *The Nature of Photographs*, Baltimore and London, 1998, p. 23. 21 Ibid., p. 23. 22 Cf. "'That you o'erstep not the laws of nature.' Stephen Shore's Bildkonzept" in: Heinz Liesbrock (ed), *Stephen Shore: Fotografien 1973–1993*, exh. cat., Westfälischer Kunstverein, Münster, 1994. 23 "I know that Flaubert's esthetic is absolutely mine. Flaubert's method I think I incorporated almost unconsciously, but anyway used it in two ways, his realism and naturalism both, and his objectivity of treatment; the non-appearance of the author, the non-subjectivity." Leslie Katz, "Interview with Walker Evans," *Art in America*, vol. 59, no. 2, pp. 82–89, reprinted in *Walker Evans. Incognito*, New York 1995, p. 11. 24 Ibid., commentary on the photo *Debris*. 25 Quoted in Felix Baumann, "Vorwort" in: *Pierre Bonnard*, exh. cat., Zurich and Frankfurt, 1984, p. 10.

William Eggleston
Greenwood, Mississippi 1973

The close connection between the aesthetic process and the external world walks a tight-rope. It can easily fall prey to the suspicion of trusting blindly to the glitter of sensual phenomena, to the failure to recognize the inadequate grip that their surface appearance—for this is all we seem to have—offers within modernism to cognitive reflection. A well-known dictum of Picasso's, talking about his colleague Bonnard to whom he attributed just such an uncritical attitude, illustrates the critique against any retrogressive attachment to tradition and the visible, leveled by modernism, which essentially aimed to create out of its own substance and to determine the rhythm of its own development. "Bonnard is in reality not a modern painter at all. He submits to nature, he doesn't go beyond it… An excess of sensibility makes him like things one just shouldn't like."[25]

In explaining their own manner of working, a range of artists have spoken against the notion that photography rests on a naïve cognitive basis and simply surrenders to the visible. According to them their aesthetic approach would regard any purely documentary form of representation of the visible with skepticism. They require the artist to bring order to reality and not merely produce a diffuse replication of the visible, which no longer bears any clearly declared or defined relationship to the reality it purports to represent. Anyone who fails to develop a personally distinctive perspective on phenomena falls victim to a gullible belief in pure document, and the visible thus represented dissolves into a stream of nondescript images. "Reality is not totally real,"[26] Walker Evans once pronounced; and William Eggleston declared, "I am at war with the obvious." These views are very close to Giorgio Morandi's notion of *cosidetta realtà*, so-called reality. As Morandi put it, "I believe that nothing can be more abstract and unreal than what we actually see."[27]

The specific background problem behind photography's attempt to uncover the "truth of the visible" lies in the diffuse omnipresence of images that appear in inconceivable numbers and in every conceivable medium. They all claim to represent reality, their omnipresence suggests that their information, available as it is at all hours, contains a valid statement. Pictures claim to be a true copy of reality, but they are blind, a flickering surface with no message other than their own appeal, revealing to us precisely nothing. What we traditionally think of as reality is dissipated in them and loses that power of uniqueness that prevailed in the conventional notion of the picture. This diagnosis of images running on empty rings as a constant bass note in cultural criticism in our century, and the parallel development of the photographic image can be seen as a contrasting foil to it. It stretches from Walter Benjamin and Siegfried Kracauer to Vilém Flusser and to the postmodern concept of simulation, in which image and reality become indistinguishable.[28]

It is in this sense that William Eggleston describes the practical initiation that led to his aesthetic concept, and we can take it as a description of the point of departure for modern photography as a whole. In the late sixties he spent the night in one of the first industrial laboratories watching the flood of amateur color snapshots as the developing machines incessantly spat them out.[29] From his dismay at this sight he then began his attempt to incorporate this vacuous flood of undifferentiated images into a personal aesthetic concept, which would enable him to take pictures that would really be informative. This describes both the dilemma and the challenge of artistic photography: it has to engage pictures intended only as an identifiable record of the visible in order to transcend them.

Because reality does not come structured with ready-made meaning, everything hinges for the photographer on defining a point of view: factually in a choice of location for the camera and metaphorically in an intellectual position through which a personal capacity for selection can be expressed. From the unbroken continuum of images and the innumerable possibilities of the gaze the photographer must, through the viewfinder of the camera, define a segment so as to transform the visible and make its deep structure and an otherwise invisible measure transparent: it is an art of reduction and emphasis. The image is bounded by a frame, the world is not. The external prerequisites for this view are quickly enumerated: where do I stand, what segment of the visible world do I select with my camera, what do I

26 Quoted in L. Kronenberger (ed), *Quality: its Image in the Arts*, New York, 1969. My attention was drawn to this quotation by Stephen Gronert's essay, "'Reality is not totally real'. The Dubiousness of Reality in Temporary Photography" in: *Great Illusions. Demand/Gursky/Ruscha,* exh. cat., Kunstmuseum, Bonn and MoCA, North Miami, 1999. 27 Quoted in E. Roditi, *Dialoge über Kunst,* 2nd ed., Frankfurt, 1991, p. 187. 28 Walter Benjamin, *see note 17*; Siegfried Kracauer, *"Photography," Mass Ornament: Weimar Essays*, Cambridge, 1995; Vilém Flusser, *Für eine Philosophie der Fotografie,* Göttingen, 8th ed., 1997; Jean Baudrillard, *Simulacres et Simulations*, Paris, 1981. 29 Cf. Richard B. Woodward, "Memphis beau," *Vanity Fair*, October, 1991; Thomas Weski, "The Tender-Cruel Camera" and Ute Eskildsen, "A Conversation with William Eggleston" both in: *William Eggleston*, exh. cat., Gothenburg, Zurich, Berlin, New York, 1999. 30 John Szarkowski and Hilton Als, "Looking at Pictures," *Grand Street*, no. 59, 1996.

focus the lens on, how much exposure does the film get? "You have to decide where the edges are, where to stand, when to push the button. And that's it. The rest is subtleties."[30] Photography also hides its center in a laconic put-down. But in this segment a specific intellectual energy takes shape, an inner image of the complexity of reality, and the capacity to make this visible in an iconic structure. It aims less for meaning and commentary than for evidence. The thing and its image become indistinguishable.

Translation Hugh Rorrison

August Sander *Boxer* 1929
Die Photographische Sammlung/
SK Stiftung Kultur – August Sander Archive Cologne
© 2000 VG Bild-Kunst, Bonn

The Art that Hides Itself—
Notes on Photography's Quiet Genius

Gerry Badger

Throughout the development of twentieth century photography, there has been a consistent and obdurate tendency which has perhaps been underrated within the general scheme of things. It is a tendency so fundamental as to be taken absolutely for granted, largely disregarded, and certainly little remarked upon. It is a characteristic which is invariably in fashion, but is inherently unfashionable. It is, I would submit, at work in a fair proportion of this publication. Some of those recognized as being amongst the medium's greatest practitioners have their work defined by this trait to a large degree. For others, it has proved a contributing factor in their relative neglect. This I term the "quiet" photograph—the art that hides itself. I propose to examine the notion of the "quiet" photograph, and the "quiet" photographer, for the issues raised take us to the heart of the matter in any consideration of photography's genius. And, as Thomas Weski has written, many still tend to dismiss photographs in which there is little overt sign of mediation by the photographer between world and image. "Because photographs that are produced in this way have an effect of simplicity, aesthetics for a long period regarded them as being mere documents, and they were not recognized as independent forms of original artistic expression."[1] It is demanded of the photographer-artist not only that he or she should mediate, but that he or she should be seen to mediate.

Consider the following quotations, both decidedly double-edged in their implications, yet crucial to our understanding of the "quiet" photographer. The fashion and portrait photographer, Richard Avedon, neatly defined the root of the photographic art. "The limitation and the grandeur of photography," he stated, "is that you are forever linked at the hip to the subject."[2] Being a photographer of classical mien as well as a photographic philosopher of considerable acumen, Avedon took care to stress that this endemic condition was first and foremost the medium's glory, but many have stressed the negative aspect. They have sought to sever this inconvenient union and divorce the medium from documentary reality—some by means of darkroom manipulation, some by fabricating predigested tableaux, and now, an increasing number by utilizing the seductive alchemy of computers.

It was possibly photographers of such deviant tendencies that Pablo Picasso had in mind when he remarked there were two professions whose practitioners are never satisfied with what they do—dentists and photographers. "Every dentist would like to be a doctor, and every photographer would like to be a painter,"[3] he said, a wild generalization, to be sure, but

given the current climate in the photographic world one might wonder. It seems that an ever increasing number of photographers today would concur with Picasso's playfully barbed remark. Many seem not only dissatisfied, but positively ashamed of the photographic medium—at least in its classic form. They attempt to exchange the essentially phenomenological nature of the medium for the currently fashionable, and more easily traded commodity of the so-called postmodern "conceptual" approach. They even deny being photographers altogether, exchanging that simple, honorable calling for the sobriquet of "artist utilizing photography"—a conceit which seems presumptuous in the extreme, for surely "art" is not a genre but a qualitative judgment. "Artist" not a self-proclaimed profession but a peer-given accolade, and one not lightly earned. Some photographers—such as those in this exhibition—are assuredly artists, whatever the particulars of their practice. Many others are not, a qualification which certainly can be made about practitioners in other media.

Of course, Avedon's idea of the "limitation and the grandeur" of photography is both daunting and challenging. It is to take a narrow path, strewn with obstacles. The making of creditable art, whatever the medium, has never been easy, and gets harder with each passing decade, as every possible combination of musical notes or words, every possible story or literary plot, every possible juxtaposition of shape and color, would seem to have been tried and tested somewhere by someone, to the point of exhaustion. As we stand at the beginning of the millennium it would seem that art in the twenty-first century will increasingly become a question of refinement and consolidation rather than discovery and invention, a matter of tiny, even micro steps rather than giant strides. It could be argued that this daunting state of affairs applies particularly to photography. Every conceivable subject has been photographed many times over—even the surface of the moon—and the condition that ties photographers to a strictly monocular view of the superficial aspect of the subject matter before the lens reduces considerably the scope for "new" expression. The many who seem to disdain photography might ask a single crucial question. Countless photographers have stood before a tree, or a rock, and made straightforward records of these subjects—do we need another photographer to do the same, or at least produce something that displays only an infinitesimal variation on what others have done before? Some commentators, indeed, are already beginning to talk about "photography after photography."

I firmly believe that the answer, with regard to photography as much as any other medium, must be a resounding "yes," for if such approbation invites innumerable pale imitations of what has been done before and done better, someone nevertheless will always mine an apparently exhausted seam and find gold. They will take an old story, an old theme, and produce something fresh—fresh, that is, in terms of an authentic, creative response and not in terms of superficial novelty, for it is relatively easy to create the appearance of freshness

1 Thomas Weski, "Expeditions to Explored Areas" in *Stephen Shore: Photographs 1973–1993*, Munich, 1994. 2 Richard Avedon, quoted in *The Evening Standard*, London, January 19, 1993. 3 Pablo Picasso, quoted in Françoise Gilot and Carlton Lake, *Living with Picasso*, Penguin Books Ltd., Harmondsworth, Middlesex, 1966, p. 80.

without the substance. The seductively graphic and willfully odd will always find a ready audience. Paradoxically, for those who truly appreciate the photographic medium, one of its great virtues is its so-called "limitation." More often than not, a direct, "simple" record of the subject in hand—the way of the "quiet" photographer—produces a result that is more profoundly fresh than any attempt at visual novelty made by utilizing the many tricks of the trade. If photography deals directly and honestly with life, it has every chance to be fresh and "new", for the surface of life itself is infinitely variable, renewable and renewing. For confirmation of that, just look at the many "simple" photographs in this exhibition. That should return us to Avedon's point with quite a different appreciation from those who see only the medium's limitations. The concreteness of photography, its awkward specificity, *must* surely be its glory, for can we ever tire of looking at a tree, the sky, a human face?

So what exactly do I mean by the term "quiet" photograph, or "quiet" photographer? It is a difficult notion to define with any exactitude, partly a question of style, more a question of voice. To begin with, it means essentially what it suggests, that the photographer's voice is not of the hectoring kind, that his or her artistic persona from first to last is modest, self-effacing. The egotistical mediation of the determinedly expressive *auteur* is politely shunned. The quiet photographer focuses upon modest rather than determinedly grand subjects, eschews quirky tricks of technique or vision, and (perhaps crucially) presents the work in a modest way. It is difficult to consider a photograph two meters wide to be a "quiet" photograph, no matter how calm, meditative, unadorned or quiet its subject matter, no matter how much it meets the criteria in other ways. The American photographer Lewis Baltz defined the principal criterion when he talked of photographs that appear to be "without author or art."[4] He was writing about the New Topographical School of the seventies, that loose grouping of American photographers who actively explored the notion of minimal mediation and "non-style." The New Topographers for the most part adopted a stark, frontal, classic approach which could be characterized as "non-style,"[5] but not all of them were quiet photographers by any means, for it is not style alone that makes a "quiet" photographer.

Let us, however, briefly consider the question of style. It is one of the more vexing issues confronting the photographer of ambition and serious intent. Every photographer needs to get his or her work noticed, and the most immediate, therefore most conventional way of achieving this is to formulate an instantly recognizable style, an individual voice. It is, they say, the squeaky wheel that gets oiled, the loudest, most obvious voice that gains instant attention, though the stentorian clamor might not necessarily be heeded in the long run.

4 Lewis Baltz, review of Robert Adams, *The New West: Landscapes along the Colorado Front Range* in: *Art in America*, vol. 63, no. 2, New York, March–April 1975, p. 41. 5 *New Topographics*, organized by William Jenkins at the International Museum of Photography at George Eastman House, Rochester, New York in 1975, showed the work of Robert Adams, Lewis Baltz, Bernd and Hilla Becher, Joe Deal, Frank Gohlke, Nicolas Nixon, John Schott, Stephen Shore, and Henry Wessel Jr. The exhibition, which used the word "topographic" to define a notion of lucid, dispassionate, "nonjudgmental" objectivity in the work, was notable for looking back to the directness of early landscape photography.

Nevertheless, every artist must develop some kind of authorial consistency, or else the work is formless—and form, in one way or another, must always be the artist's goal. There are, of course, many ways of cultivating this necessary state of affairs, some of which are consciously, even artificially grafted on to the corpus of the work, others which emanate from deep within the photographer's persona, as ineffable as his or her subconscious. It is safe to say that the style each individual eventually settles upon—a creative calling card—is a complex melange of conscious and unconscious elements, carefully considered or completely intuitive, imported from the "outside" or dredged up from "within."

The great problem with style is that it is essentially reductive, a refining of the look of a work so that each single image relates formally to another. Style, indeed, might be defined as the formal establishment of constraints by the artist—be they technical, formalist, conceptual, or contentual. Think of almost any major painter or sculptor of the twentieth century (for style is largely, though not exclusively, a twentieth century issue), and you can name a few key works which define the style, all others emanating from or revolving around the keys. Only the very greatest individuals, those with huge artistic personas and imaginations to match—like Picasso or Duchamp—escape the straitjacket, or the discipline of style, and then sheer force of personality rather than the more usual stylistic traits becomes the "style." The rest of us are confined to plowing narrower furrows, although the narrow furrow can contain its depths, as we might see if we consider, for example, the relatively limited Braque in relation to the protean Picasso.

For Susan Sontag, photography presents particular stylistic problems by its very nature. Indeed, Sontag even sees contradictions in the notion of the photographer as *auteur*. Where for example, she asks, is the authorial consistency in the work of the nineteenth century photographer, Eadward Muybridge? Muybridge is known for his landscape photographs of Panama and Yosemite, his studies of clouds, and, most notably, for his investigation into human and animal locomotion.[6] While each body of work exhibits stylistic consistencies in itself, there is nothing, she argues, to connect the Yosemite landscapes with the movement studies if we did not know that they were by the same author. Thus style in photography, concludes Sontag, would seem to be more a by-product of subject matter rather than authorial treatment. And up to a point she is absolutely correct, which is why many photographers adopt a consciously reductive stance in relation to subject matter. They become known for focusing upon a particular subject, or they adopt a particular technique, deliberately restricting the choices open to them in the search for style.

So it might be noted that what might be termed the Rothko tendency, the desire to distil and refine an imagery of rigidly finite scope, has been a popular trait in modern photography. It is especially marked in current photographic circles, promoted in part by the postmodern interest in serial imagery, but also, I believe, by the exigencies of style. Thomas Ruff, for in-

6 Susan Sontag, *On Photography*, Farrar, Straus, and Giroux Inc., New York, 1978, pp. 134–135.

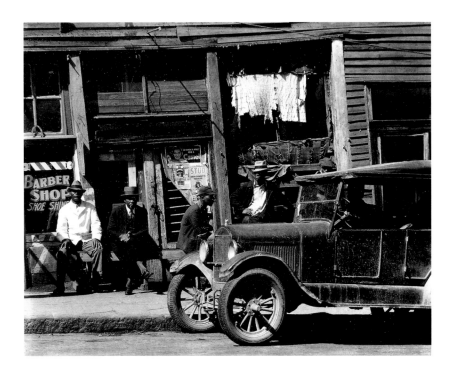

stance, repeats essentially the same photograph over and over again in long series. And Bernd and Hilla Becher's choice of subject matter, viewpoint, and technique is so refined and reductive that a very strong authorial stamp indeed has been established, almost to the extent of proscribing their subject matter, far less their approach, for anyone else. Understated, calm, meditative—certainly—but "quiet," not in the least. The images of both Ruff and the Bechers positively proclaim that they are predestined for eloquently serial hanging in the dazzling white restraint of the contemporary gallery space.

Neither "understated" nor "quiet" are adjectives which could be utilized to describe another well-used strategy by photographers in search of authorial recognition. Many photographers who prefer to roam over a conceptually diverse range of subject matter nevertheless recognize the need for stylistic consistency. So they pull subject diversity together in the darkroom by adopting moody printing techniques, usually rendering anything from social realism to landscape or nude in bold black and white tones. Graphic ebullience writ large. "Operatic" is the word for photographs like these. They create instant mood, a certain illusion of style, and rather self-conscious mediation between reality and image. "Arty" might be another word, and while one would hardly deny that the photographic medium, in some hands, is capable of high art, this essay would contend that the "art" of photography frequently does not lie in the hands of the self-proclaimed arty photography—despite popular conception, and even critical opinion to the contrary. Stark *chiaroscuro* does not often equal profundity.

There is another, relatively recent tactic in the attention grabbing stakes. It is now almost *de rigeur* for exhibition photographs to be enlarged up to mural size, whether they are technically suitable for such extremes of enlargement or not—though to ignore the shibboleth of technical perfection for its own sake is not altogether a bad thing. Some work undoubtedly gains from being printed big, but much does not, and examples abound of imagery being pushed beyond its natural limits. If it is a mediocre image as a 10 by 8 inch print, it might be superficially more impressive in a print measuring 10 by 8 feet, but physical presence should not be the sole criterion and should not confused with artistic gravity. That is the kind of thinking behind some of the worst excesses of the nineteenth century salon exhibition. Upon reflection though, is the bombastic ethic of the salon so far removed from *certain* postmodernist strategies?

It should be clear from the preceding that the "quiet" photograph is not to be confused with that key tenet of photographic modernism—the notion of the "straight" photograph, where an "unmanipulated" print is made from a negative that has not been "tampered" with to any degree. By definition, the quiet photograph must always be a "straight" photograph, but the "straight" photograph is not necessarily a "quiet" photograph. An example that straight is not necessarily "quiet" might be the master of the bravura American landscape, Ansel Adams.

As the American academic, Alan Trachtenberg, has written, whether talking about pictorialists or modernists, "artists utilizing photography" or experimentalists, commercial hacks or pretentious photojournalists, the desire to "deny" photography is as endemic and as irresistible as Picasso inferred: "Art-photographers tried every trick available to get away from the embarrassing literalness of their medium. Fortunately, enough practitioners continued simply to record, for the sake of the miracle when a good, clear image comes up in the printing bath, or to have faithful pictures of what things and people look like."[7]

It is with those that this essay concerns itself, with those photographers who will not restrict themselves to the drastically limited subject or the rigidly prescribed pictorial schema, who eschew flamboyant printing techniques or refuse to print to mural size—those photographers who will not "shout" by drawing attention to style in any way. I believe it is high time that we celebrated them, for they have chosen—and it is a matter of deliberate choice, guided by sensibility and temperament—to take a potentially difficult road. The "quiet" photograph, by definition, does not court popularity and easy plaudits. And yet, to understand the ideology of the "quiet" photographer is, I would maintain, to come close to an understanding of photography's singular qualities.

A guiding spirit for much of the work in this exhibition, and, it must be said, a veritable patron saint of "quiet" photographers is Eugène Atget. Indeed, Atget was not simply a modest presence within the boundaries of his own images. Outside the small coterie of clients in Paris who provided him with a living that could also be termed "modest," his name was hardly known until just before his death except as a simple purveyor of *documents pour artistes*.

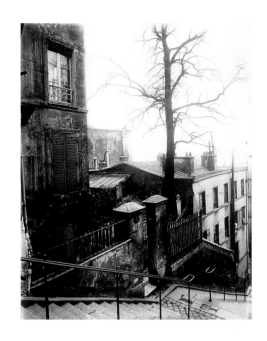

Eugène Atget
Montmartre, maison
2 rue du Calvaire Paris 1921
© Photothèque des Musées
de la Ville de Paris/Joffre

By the time a monograph of his work was published in 1929, some two years after his death, he had been "discovered" by the Parisian avant-garde, half the contents of his studio had been sold to America, and some of his images had been selected for inclusion in the influential *Film und Foto* exhibition in Germany. Nevertheless, for a modernist like Edward Weston, a self-conscious formalist looking to promulgate photography's position in the "arts," Atget's voice was still a little too muted, the mediation too slight. When he was given a copy of Atget's monograph, Weston, who had heard good things of the Frenchman, wrote of his disappointment in his daybook: "I had expected a flame, but found only a warm glow."[8]

For some today, Atget remains a "difficult" photographer, despite John Szarkowski's glowing characterization of him as "perhaps the best example of what a photographer might be."[9] Many commentators, particularly postmodern theorists concerned with "contextualization," see Atget's elevation to the very top of the art photography pantheon as a kind of modernist conspiracy, the "fraudulent conversion" one might say—largely for the sake of modernist aesthetic theory—of a purely functional journeyman, a maker of "documents", to the status of modern photography's Paul Cézanne.[10] Of course, there are complicated issues here, involving critical ideologies, but let me say two things about Atget that seem self-evident. Firstly, he *has* been an enormous influence upon much of the work seen here. And

7 Alan Trachtenberg, "The Artist of the Real" in: *Afterimage*, vol. 6, no. 5, Rochester, New York, December 1978, p. 10.
8 Edward Weston, in Edward Weston, *The Daybooks of Edward Weston: California*, Horizon Press, New York, in association with the George Eastman House, Rochester, 1969, p. 202. 9 John Szarkowski, from the wall label to *Atget*, an exhibition shown at The Museum of Modern Art, New York, Dec. 1, 1969–Mar. 22, 1970. 10 See, for example, Molly Nesbitt, "The Uses of History" in: *Art in America*, New York, February 1986; Rosalind E. Krauss, "Photography's Discursive Spaces" in: *The Originality of the Avant-Garde and Other Modernist Myths*, The MIT Press, Cambridge, Massachusetts and London, 1986.

secondly, there is the fundamental paradox that, despite his reputation and influence, his work is still a little too muted for many tastes. I have heard numerous photographers express disappointment in the work of Atget. So a brief look at his "art" might clarify the ideological position of the "quiet" photographer, and help to define a fundamental aspect of photography's specific genius.

In a considered and well balanced recent essay, the critic John Stathatos asked the following question whilst musing upon the critical dilemmas plaguing the "two cultures" of contemporary photography—postmodernism and modernism. He wondered whether photography, "reduced or promoted to the rank of raw material and thereby completely absorbed into the insatiable maw of contemporary art, retains an independent identity beyond its purely functional roles—does it, as it were, still preserve any specific and particular qualities?"[11]

His answer was that it does, thanks to the medium's "profoundly anarchic character" and "its unique relationship with reality, a relationship which has little to do with 'truth,' visual or otherwise, but everything to do with the emotional charge generated by the photograph's operation as a memory trace."[12]

A "memory trace." It is a shrewd expression, and more pertinent than such out-and-out modernist terms as "pure" photography or meaningless flights of fancy like "light shadows," for it locates the photograph firmly within the realm of human experience. A memory, of course, can be as fleeting and insubstantial as a shadow, but there are different kinds of memory, some of which, unlike shadows, are persistent, obdurate, and enduring. There are fond memories, not-so-fond memories, repressed memories, false memories, shared memories, race memories, cultural memories. Photography subtends all of these, for as soon as the shutter is tripped, the resultant image reveals only that which is already past. The picture is subsumed instantly under the aegis of history and becomes the subject of memory. And yet the photograph is not memory, it is only a trace of memory. As Roland Barthes wrote, "not only is the Photograph never, in essence, a memory, but it actually blocks memory, quickly becomes a counter-memory." The issue is not "a question of exactitude but of reality."[13] The photographic trace provokes the certainty that something existed, yet it is only a simulacrum of reality and not reality itself. An infinite, circular equation, the answer to which must be (if we are dealing with a "true" photograph) that the power of authentication exceeds the power of representation. This is the quality I would like to explore in Atget—a quality I shall term "thereness."

Photography's relationship with reality—so simple, so profound, yet so damnably slippery —is as "unique" as Stathatos avers. The pleasures of good photographs derive principally from an encompassing of that relationship within the image. Photography, more than any

11 John Stathatos, "Positively Art" in: *02 Exposed*, supplement to *Tate: The Art Magazine*, London, January—April 1998, p. 5.
12 Ibid. 13 Roland Barthes, *Camera Lucida*, Jonathan Cape Ltd., London, 1982, p. 91 and p. 80.

other art, is the "art of the real." We might characterize it so with perhaps a hint of irony as we enter an age when, courtesy of computer wizardry, we can generate a thoroughly "unreal," yet convincing reality at the touch of a button. But even the photographic unreal makes more of a point by referring to the real. Nonetheless, the good photograph—that is, the "true" photograph, for the "photo-hybrid" is here to stay and after one-hundred-and-fifty years it is perhaps time we gave it a new nomenclature—embodies an understanding of the medium's link with a baseline of authenticity. Note: "authenticity," not "truth." This understanding may be an intellectual one, or it may be intuitive, wholly unconscious. As serious photographers know, the simple snapshot, made by a child, may distil this ineffable quality more readily than the self-conscious attempt to produce photographic art. For the snapshot is concerned only with the fundamental task of representing reality. It demonstrates first and foremost a desire merely "to recognize and to boast," as Walker Evans put it.[14] The first great quality in photography, therefore, is "thereness," which is, I would propose, a primary goal of the "quiet" photographer. By no means every photograph exhibits it. Indeed, at its freshest it is much rarer than one might suppose but can take a photograph a very long way as a potent image. Roland Barthes defined it with admirable brevity, writing about an image of the Alhambra taken by the early photographer, Charles Clifford: "This old photograph (1854) touches me: it is quite simply there that I should like to live."[15]

"Thereness" is a sense of the subject's reality, a heightened sense of its physicality, etched sharply into the image. It is a sense that we are looking at the world directly, without mediation. Or rather, that something other than a mere photographer is mediating. The camera alone perhaps, windowing the world without art or artifice, or that mysterious power itself—reality—given form and shape by the magical conjunction of chemical surface and light. Such a feeling, such artlessness, when present in the photograph, can of course conceal the greatest photographic art. "Thereness" is seen at the opposite ends of the photographic spectra, in the humblest holiday enprint as much as the most serious art photograph, in the snapshot-inspired, dynamic, small camera candid as much as the calm, meditative, large camera view. Those photographs which conjure up a compelling desire to touch the subject, to walk into the picture, to know the photographed person, display "thereness." Those photographs which tend towards impressionism, expressionism, or abstraction can be in danger of losing it, or never finding it—although there is no inviolate rule about this. "Thereness," in short, is a quality that has everything to do with reality and little to do with art, yet is, I would reiterate, the essence of the art of photography. Walker Evans, whose own work (like that of Atget) could be called upon to define "thereness," wrote the following about a photographic postcard—an image taken by a journeyman of modest talent and probably modest aspirations, but an image possessed of this one essential quality: "Made as a

14 Walker Evans, "The Snapshot" in: *Aperture*, vol. 19, no. 1, Aperture Inc., Millerton, New York, 1974, p. 95. 15 Barthes, see note 13, p. 38.

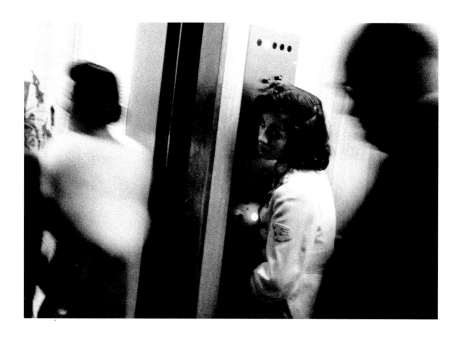

routine chore by heaven knows what anonymous photographer, the picture survives as a passable composition, a competent handling of color, and a well-nigh perfect rendering of place." [16]

The quality of "thereness" is seen not only in static, sharply rendered views, but also—perhaps more so—in photographs of people. To see a blurred, impassioned Thomas Carlyle in the flesh is amazing. However indistinct, Mrs. Cameron's equally impassioned transcription is as fine a rendition of creative energy and human vitality as has been made. To look directly upon the young, handsome Conspirator Payne, shortly to be hanged for his part in the assassination of President Lincoln, is powerful stuff indeed. He looks so young, so resigned, so contemporary. No wonder Barthes rightly remarks, "this is a strictly scandalous effect. Always, the Photograph astonishes me, with an astonishment which endures and renews itself, inexhaustibly." [17]

But not only those who might be the subject of public scandal, the rich, the famous, the infamous—those who populate the pages of our history books and might readily attract our prurient interest—have "thereness" conferred by the camera. Consider E. J. Bellocq's Storyville prostitutes, each and every one a sharply defined individual, and no object of lubricious spectacle. We do not know their names. Nor do we know the names of Paul Strand's heartbreaking blind woman, nor August Sanders' congenial boxers, nor Robert Frank's sad-eyed lady in a Los Angeles elevator, nor Judith Joy Ross's Vietnam Memorial visitors. Yet I at least am affected by an overwhelming sense of something I cannot quite define, a sense of fellow feeling perhaps, an urge maybe to share a glass of wine with them and know their stories, a compelling need to reach out and touch the real—and equally, to be touched by the real.

But we are talking of single images, irrespective of photographer intent. It might seem that almost any photograph can contain such qualities, by sheer accident. Any photograph must surely gain the luster of temporal fascination, irrespective of photographer intent, if we wait long enough. Indeed, photographs only a decade old begin to acquire the patina of long ago and far away. Clearly, almost any photographer, knowingly or unknowingly, can take a photograph displaying "thereness" on these terms, a quality which will only be enhanced as time adds an alluring melancholia to the image. That, as I have already intimated, takes us a long way, but only photographers of serious intent can venture beyond that, beyond the single startling, poignant, beautiful photograph, for that requires a body of work. So let us turn back to photographers rather than photographs and examine the work of Eugène Atget as a corpus. He is an infallible benchmark. His oeuvre is as large and as representative as that of any other photographer. It is as dense and as replete with meaning as anyone's. Not every photograph of Atget's displays "thereness" in equal measure, nor has the formal efficacies to detain us overmuch. We might hazard a guess that perhaps only one picture in every seven to ten is consumed by the quality that critic Max Kozloff termed "loveliness," and John Szarkowski "grace"—that subtle rightness in lighting, camera placement, perspective, and spatial rendition which goes much of the way to ensure a photograph is "there." But certainly there is more than enough "thereness" in Atget to maintain our interest and compel us to ask what it all means. "The projection of Atget's person," opined Walker Evans.[18] "Atget's time honored sense of the world," stated Kozloff.[19] "The spirit of his own culture," ventured Szarkowski.[20]

Yes.... yes... yes... and amen to all that, but how is it made manifest? Or, putting it a slightly different way, what in essence is the "knowledge" that Atget gives us? Well, if we are talking about Parisian or French culture in the abstract, or great "ideas," perhaps not very much on the surface of things. The abstractions of history or philosophy, the complexities of human psychology, even the emotional resonance of painted marks, as set down by say Zola or Proust, Degas or Monet, were beyond Atget. They are not what photography is about. Yet only Atget, only the photographer with his magic black box, could conjure up *actuality*. Only photography can replicate the face of reality and take us *there*. That word again, and if it states the obvious, it defines the essence. The value of Atget, of Evans or Frank, of Lee Friedlander or Robert Adams, of many other photographers, and of countless single photographs is that we are taken there to feel a particular moment, to see a particular sight, to meet an individual—in a particular place at a particular time. "If photography is impotent with

16 Evans, see note 14, p. 95. 17 Barthes, see note 13, p. 82. 18 Walker Evans, "The Reappearance of Photography" in: *Hound and Horn*, vol. 5, Concord, New Haven, Conn., October–December 1931, p. 126. 19 Max Kozloff, "Abandoned and Seductive: Atget's Streets" in: *Afterimage*, vol. 13, no. 9, Rochester, New York, April 1986, p. 17. 20 John Szarkowski, "Atget and the Art of Photography" in: John Szarkowski and Maria Morris Hambourg, *The Work of Atget,* Vol. 1: *Old France*, The Museum of Modern Art, New York and The Gordon Fraser Gallery Ltd., London, 1981, p. 18.

regard to general ideas (to fiction)," wrote Barthes, "its force is nonetheless superior to everything the human mind can or can have conceived to assure us of reality." [21]

Here I must take issue somewhat with Barthes. The first part of that statement contends that "photography is impotent with regard to general ideas." Certainly, the photograph does have its conceptual limitations, but the superficial aspect of things, if perceived with intensity, can tell us much, and not only superficial things—a state of affairs which is compounded when one places single photographs in pertinent conjunction with other single photographs. Without exception, all of the photographers in this exhibition have conceived of their work in terms of series, particularly the "quiet" photographers, who have tended to see the intimacy of the book rather than the rhetoric of the wall as the medium's "natural" home. If photographs are impotent, photographers—some photographers at any rate—assuredly are not. One might just as well ask what "ideas," in an abstract sense, are present in the work of Monet or Cézanne? A body of work by a photographer with sufficient guile and perceptive intelligence can give us much food for thought, a lot more to cogitate upon than merely meets the eye. As Lewis Baltz has said, it might be more useful to consider creative photography in literary rather than visual terms, as "a narrow but deep area lying between the cinema and the novel." [22]

I return though, to that other pertinent phrase coined by Lewis Baltz: "without author or art." It will serve to bring the notion of the "quiet" photographer into a more contemporary focus. In reference to *New Topographics*, Baltz was describing a documentary ideal, and relating the work of the "new topographers," to that of the "old topographers," to such nineteenth century photographers of the American West as the exemplary Timothy O'Sullivan, whose stark expeditionary landscapes appeared to fulfill the non-authorial criterion to perfection. Until rescued from obscurity in the 1930s (rather improbably it might seem) by the far-from-quiet Ansel Adams, [23] O'Sullivan's empty, unflashy landscapes had been regarded—rather like Atget's—as rather dull and unlovely, plain pictures taken for a plain purpose, for purely functional, documentary reasons, without any attempt at self-expression on the part of their maker. Although it has been demonstrated recently that, contrary to received wisdom, the degree of authorial mediation in O'Sullivan was quite considerable, [24] for the young landscape photographers of the mid-seventies, the imagery of the early western photographers amply fulfilled its role as a model for a photography which was less about authorial gesture and expression, and more about "seeing." That is to say, about replicating the world with the maximum degree of transparency and drawing minimal attention to itself as either artifact or work of art. Clearly, there are parallels here with the work of Atget.

Coupled with an interest in early topographical photography, some of the "new topographers" were also influenced by ideas culled from conceptual art practices, relating to "auto-

Lewis Baltz
Untitled from the Series
Candlestick Point
1984–1988

21 Barthes, note 13, p. 87. 22 Lewis Baltz, quoted by Mark Haworth-Booth in afterword to Lewis Baltz, *San Quentin Point*, Aperture Inc., Millerton, New York, 1986, p. 63. 23 See Beaumont Newhall, "This Was 1937" in: *Popular Photography*, vol. 60, no. 5, New York, May 1967, p. 144. Having invited Ansel Adams to participate in his exhibition, *Photography 1839–1937*, at New York's Museum of Modern Art, Newhall writes: "He replied to my invitation with enthusiasm. Not only did he send his own photographs, but he brought to my attention the photographs of the Southwest by a 19th century photographer known only to me by his Civil War photographs: Timothy H. O'Sullivan." 24 See, for example, Joel Snyder, *American Frontiers: The Photographs of Timothy H. O'Sullivan, 1867–1874*, Aperture Inc., Millerton, N.Y., 1981 and Rick Dingus, *The Photographic Artefacts of Timothy O'Sullivan*, University of New Mexico Press, Albuquerque, N.M., 1982. Both authors demonstrate convincingly that O'Sullivan's images were not composed spontaneously, taking their cue entirely from what was in front of the camera, but were in fact the product of complex cultural ideas regarding the land, its formation, and its representation.

mative" photography. These ideas derived once more from photography by anonymous journeymen—Atget again being a key figure—but rather less directly, filtered through surrealism, conceptualism, and notions of serial imagery, where viewpoint and subject choices were made at "random" in an attempt to limit the authorial role. William Jenkins' exhibition, *New Topographics*, which has been a seminal influence on photography from the mid-seventies until today, considered work in this conceptual vein as well as imagery influenced directly by early documentary photography. It should be stressed, however, that the two tendencies produce work which is very different in concept and intent, though to the uninitiated or the careless it may look almost identical. But that of course is one of the perennial problems of photographic criticism. To many people still, a photograph is a photograph is a photograph. However, the results derived from these differing philosophies—and their considerable consequences in terms of both marketplace and critical appreciation—may be characterized as follows. One is derived essentially from an appreciation of and adherence to photography's documentary roots, the other is embedded deep within the history of twentieth century art practices. As Jenkins pointed out in his introduction to the *New Topographics* catalogue, the difference between artist Ed Ruscha's *Twentysix Gasoline Stations*, or the Bechers' cooling towers, and photographer John Schott's series documenting hotels along Route 66 is both fundamental and significant. Schott himself, acutely aware of the distinction, summarized it with admirable brevity. "...they (Ruscha's pictures) are not statements about the world through art, they are statements about art through the world."[25]

It would follow that, if a photographic image proposes some kind of proposition about art, it will not fall within our remit for the "quiet" photograph, for no image dealing essentially with art rather than the world is devoid of making a noise about art, of existing "without art." Indeed, we have already observed this in the work of the Bechers and Ruff or, for that matter, of Thomas Struth or Andreas Gursky or numerous other "artists utilizing photography," who derive from the "typological" tradition established by the Bechers at the Düsseldorf Academy of Fine Arts. And of the original American participants in *New Topographics*, it is interesting to note that it is Lewis Baltz, arguably the most programmatic member of the group at the time, who made the most calculated shift from photography to art. Baltz moved to Europe—a perhaps not insignificant factor—and now makes photographic "installations" for specific gallery spaces, eschewing neither author nor art in the process. Stephen Shore, Robert Adams, Frank Gohlke, and Nicholas Nixon, however, have continued to make photographs, and eminently "quiet" photographs at that.

Perhaps, without being too dogmatic about it, we are beginning to propose a possible cultural divergence here between an essentially American and European way of considering

25 John Schott, quoted in William Jenkins, *Introduction to New Topographics: Photographs of a Man-Altered Landscape,* George Eastman House, Rochester, 1975, n.p. 26 Iwona Blazwick, "Preface" to James Lingwood and Jean-François Chevrier, *Another Objectivity,* Institute of Contemporary Arts, London, 1988, n.p.

Judith Joy Ross *Untitled*
from the Series *Easton Portraits*
1988

the photographic image—despite cross-cultural influences and the establishment of the postmodernist hegemony in America. We certainly can point to the differences between what one might crudely term painterly and photographic approaches to the photograph. For example, the yawning chasm dividing the notion of the "quiet" photograph from its corollary, the "conceptual document" was never better illustrated than in an exhibition organized by James Lingwood and Jean-François Chevrier for London's Institute of Contemporary Arts in the late 1980s, an exhibition with a predominantly European focus. Entitled *Another Objectivity*, the exhibit proposed, in the words of Iwona Blazwick, a notion of art using photography that "refuses equally the consolations of manipulation, nostalgic lyricism, and an uncritical fascination with the simulacrum, and which does not accept the orthodoxies of critical and institutional life which divide description from fiction, the act of recording from creation."[26] Having produced in that statement a definition that—to my mind—would have served serious documentary photography quite as well as conceptual photography and "photo painting," what the show actually delivered for the most part was *big* prints—large photographs of often banal subject matter by such leading exponents of the "Artists Utilizing Photography" movement as the Bechers, Thomas Struth, Craigie Horsefield, Hannah Collins, and John Coplans. The muralist syndrome writ large. There was, however, a conspicuous exception to this grandiosity, in terms of both conception and presentation. In the midst of this display of the photographic "size queen" tendency and precisely programmed, preconceived *auteurism*, the work of Robert Adams shone out by virtue of its modest and clearly intuitive approach—

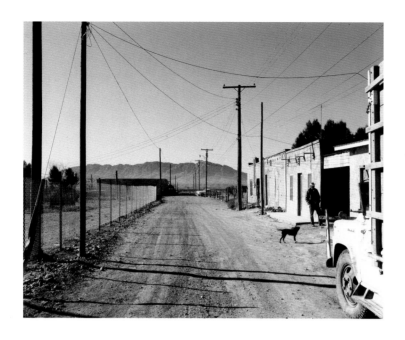

Stephen Shore *Presidio, Texas, February 21,* 1975

the "quiet," one might say, trumping the clamorous, and "photography" being clearly differentiated from "art," although whether that was the curators' precise intention I am far from certain.

The quiet photographer then, remains a photographer, not an artist, and would seek to be recognized as such, though undoubtedly seen to be practicing an independent form of artistic expression. The crucial difference remains one of voice. The voice of the "quiet" photographer remains modest because his or her referent is not the art scene, but the world. For example, the Bechers' enormous catalogue of industrial structures, though it may function as an extremely valuable documentary archive, nevertheless is not "about" these structures— it is essentially "about" an issue of aesthetics. Whereas the *New West* images of Robert Adams are primarily "about" environmental ravages in the Colorado Front Range. This is not to say that the Bechers are unconcerned about the things they record, nor that Adams is oblivious to the "look" of his images, but that their prime concerns are fundamentally different. And in Adams' case, and that of others I would characterize as "quiet" photographers, this does not predicate an "uncritical fascination with the simulacrum," as Iwona Blazwick avers, nor a "division of description from fiction." One might add that it is not a question of differentiating between a mirror and a window upon the world—the successful photograph by the serious, quiet photographer is most likely to be a complicated amalgam of mirror and window, an ineffable struggle between subjectivity and objectivity. Like anyone else wrestling with this tricky medium, the "quiet" photographer is totally assured of the fact that a simple, straightforward act of recording is anything but. The "quiet" photographer, however, will not draw undue attention to that process, nor, for that matter, to the process of appre-

hending the resultant image by the viewer. The goal of the "quiet" photographer is an elusive one, the illusion of transparency, but not a dumb or mute transparency. Quiet photographs do not lack a voice, but that voice is always calm, measured, appropriate, reasonable—even when at the service of strongly held political opinion.

In the catalogue accompanying the *New Topographics* exhibition, Nicholas Nixon made the oft-quoted statement: "The world is infinitely more interesting than any of my opinions concerning it. This is not a description of a style or an artistic posture, but my profound conviction."[27]

That statement is an essential plank in the quiet photographer platform, but it should not be misconstrued. At the time of the exhibition, two of the critical buzz words defining the work in the show were "nonjudgmental" and "neutral." Such adjectives, and Nixon's aphorism, coupled with similar observations from fellow *New Topographers*, would seem to indicate that the "quiet" photographer has little interest in what he or she photographs, that the world is simply grist to the image mill, that the results of their labors will be baldly asocial, or ahistoric, that the photographic will mean nothing in relation to the world, only to itself as an image or artifact—the classic high modernist position in fact.

Yet if we think of the work of say Robert Adams, Nicholas Nixon, Judith Joy Ross, and Stephen Shore, or Walker Evans, Eugène Atget, and Lee Friedlander—essentially "quiet" photographers all—it is patently obvious that they care about the world they photograph. Indeed, the essence of the "quiet" approach is that the "world," the subject, is respected as much as possible, and the mediation—the interference—of the *auteur* kept to a minimum. Nixon's own photographs of dying AIDS patients are a case in point. As a "quiet" photographer, he scrupulously maintains the camera's inherent neutrality, keeping the emotional temperature on an even keel, knowing that there is emotion enough in the subject to make the point which he, as an artist, is trying to communicate. The "quiet" photographer, in other words, respects and trusts his subject—and for that matter, himself. By maintaining a discreet emotional distance from his subject, he allows it to tell its own story and, as the conduit for this story, is content, indeed insistent upon subordinating his own "story," if you like, subsuming it with that of the subject. The "quiet" photographer does not lack a voice, nor emotional engagement, but deliberately relegates it and allows it to emerge through the subject, rather than imposing it from the outside and thereby, to his mind, potentially confusing the issue. The quiet photograph is not necessarily a cool photograph, though its warmth may take a little time to emerge.

Let us take an extreme, yet pertinent example, not so far removed from Nixon's photographs of AIDS patients. If we were unfortunate enough to happen across a pile of corpses, one of those atrocities of war that still seem all too common, we could arguably

Robert Adams *Newly completed tract house, Colorado Springs* from the Series *The New West* 1974

27 Nicholas Nixon, quoted in Jenkins, see note 25, n.p.

take two primary approaches to the business of providing photographic evidence for the world. We could take what one might term the Gene Smith or Don McCullin approach and try to intensify the horror of the scene, firmly indicting those responsible. We could compose our images artfully in Pièta-like aspects, employ the stark, horrific close-up and dramatic *chiaroscuro*—do everything, in short, to force the issue into the minds of readers with (we perhaps arrogantly assume) the attention spans of gnats. Or we could take the "quiet" photographer approach and simply show dry facts, in a calm, measured way. Either approach will have its advocates—and its successes and failures (for it comes down, in the end, to photographer talent)—but the studied neutrality of the "quiet" photograph does not mean that the photographer lacks emotion or opinion. He or she just will not garnish or overlay the facts in an overly tendentious display of gratuitous subjectivity. As Heinz Liesbrock has written, in reference to Stephen Shore, the "quiet" photographer is seeking a delicate, almost imperceptible balance between subject and object, between record and image: "What he is attempting to achieve is a balance between the external world and the photographic author, or, to put it more precisely, an absolute point at which the photographer, with his personal tendencies and preferences, withdraws behind the visible world, and dissolves himself into the formal structure of the images—which also means, precisely, that he makes himself present in it." [28]

And Shore himself quotes Hamlet's injunction to "o'erstep not the modesty of Nature" plus the example of the Chinese poets: "Chinese poetry rarely trespasses beyond the bounds of actuality. Whereas Western poets will take actualities as points of departure for exaggeration or fantasy, or else as shadows of contrast against dreams of unreality, the great Chinese poets accept the world exactly as they find it in all its terms, and with profound simplicity find therein sufficient solace. Even in phraseology they seldom talk about one thing in terms of another, but are able enough and sure enough as artists to make the ultimately exact terms become the beautiful terms." [29]

Nevertheless, despite Shore's apparently uncritical acceptance of Oriental fatalism, he is still talking about art and the necessity of art to transcend. Whilst remaining exactly what it is, subject matter is also transformed into image. The "exact terms become the beautiful terms." "He makes himself present in it." Such a notion is not so far removed in fact and spirit from nineteenth century American transcendentalism, which of course had its own philosophical links with Oriental thought, including the mutual idea of the artist as a near anonymous but vital conduit—Ralph Waldo Emerson's "transparent eyeball." Shore, as an alternative way of putting across his photographic credo, might well have quoted George Santayama on the poetry of Lucretius: "The greatest thing about this genius is the power of losing itself in

28 Heinz Liesbrock, "That You O'erstep Not the Modesty of Nature" in: Shore, see note 1, p. 11. 29 Ibid. 30 George Santayama, quoted in John I. H. Baur, "American Luminism" in: *Perspectives U.S.A.*, no. 9, New York, Autumn 1954, pp. 90–98.

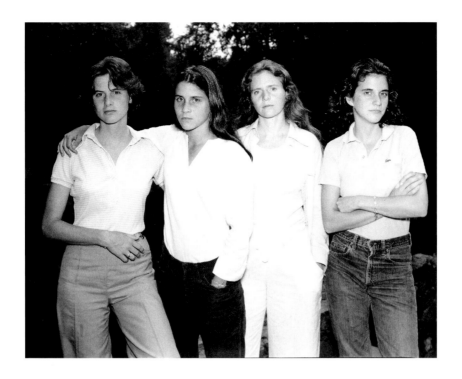

its object, its impersonality. We seem to be reading not the poetry of a poet about things, but the poetry of things themselves."[30]

That seems perfectly in accord with Shore's vision, and that of innumerable American "quiet" photographers, whose almost mystical regard for the integrity of the object and a "nonjudgmental" approach is part of a major, perhaps *the* major strain in not just photography, but American visual art over four centuries. It is not by chance that so many "quiet" photographers are American and afflicted by what Europeans tend to regard as a maddening reluctance either to practice intellectual aggrandizement or make overt political judgments in their imagery.

The "quiet" photograph then, might be considered as both ethic and aesthetic, for like any issue concerning the making of visual images, formal considerations are inevitably involved. The quiet photographer may share the kind of determined will towards "objectivity" with conceptual photographers such as Gursky or Struth, but if the means are congruent the end is divergent. The "quiet" photographer and the practitioners of the new conceptual objectivity may share, at the moment of taking, a predilection for what can be discerned as a hiding of the artist's hand. But whereas the objectivity of the conceptual photographer might be described as "active," a stylistic conceit, the objectivity of the "quiet" photographer is more accurately considered as "passive," an ethical imperative. Frank Gohlke has written of his desire to achieve what he terms a "passive" frame, in which the image appears not to have been composed actively, with any great forethought, but has happened naturally, as it were.

Lee Friedlander
Philadelphia 1968

The image reads as merely a part of the world with a boundary placed haphazardly around it, and there is a "sense of the frame having been laid on an existing scene without interpreting it very much."[31] This is very different from the strict, rigidly formalized framing characteristic of the conceptualists.

The sense of noninterpretation in the "quiet" photograph, however, which can be some-what discomfiting to many, is nevertheless basically formal. The primary involvement of this kind of photographer—transcending the merely formal—is with reality, and simple, unfettered reality can be uncomfortable. "Thereness," as Barthes confirms, is astonishing.

In the long run, we are talking simulacrum to a large degree but not, I would submit, an uncritical or unthinking simulacrum. Clearly, the objective conceptualist and the quiet pho-tographer share a number of mutual concerns, particularly revolving around photography's faculty to provide the simulacrum that is not a simulacrum and so on. The difference, as I have reiterated constantly, is one of emphasis and voice, but the importance of that subtle distinction cannot be over-emphasized. To make successful "quiet" photographs—particular-ly in a climate where, arguably, the world has been "overphotographed" and some would propose a photographic moratorium—is not easy. "Quiet" photographs demand a high degree of intellectual rigor, awareness, and purpose on the part of their makers—and I use the word *maker* rather than *taker* advisedly. Furthermore, "quiet" photographs also require work on the

31 Frank Gohlke, quoted in Jenkins, see note 25, n.p. 32 Lincoln, Kirstein "Afterword" to Walker Evans, *American Photo-graphs*, Museum of Modern Art, New York, 1938, pp. 188–189.

part of their viewers in order that their subtleties might be fully appreciated. The "quiet" photograph is neither document nor aesthetic object nor simulacrum nor fictional tale but a combination of all four, a different combination in the hands of every individual photographer. Its finer pleasures are perhaps not easily enjoyed, yet might be ruefully appreciated by anyone who has attempted—and who amongst us has not?—the nominally simple but endlessly slippery task of freezing reality with grace, economy, and authenticity.

As we stand at the beginning of a new millennium, it seems clear that the "quiet" photograph is a threatened species, but it was ever thus. It was always an unshowy breed, difficult and diffident, unused to the limelight, but by that token a stubborn and obdurate creature. As Lincoln Kirstein wrote over sixty years ago, good photography has modest yet enduring standards. Imagistic fashions and stylistic exaggerations come and go, excess and superficial profundity have their seasons, but the basic root of the photographic endeavor must continue to exert its fascination, heralded or not: "Always, however, certain photographers with a creative attitude and a clean eye have continued to catalogue the facts of their epoch... A large quality of eye and a grand openness of vision are the only signature of great photography and make much of it seem, whatever its date or authorship, the work of the same man done at the same time, or even, perhaps, the creation of the unaided machine." [32]

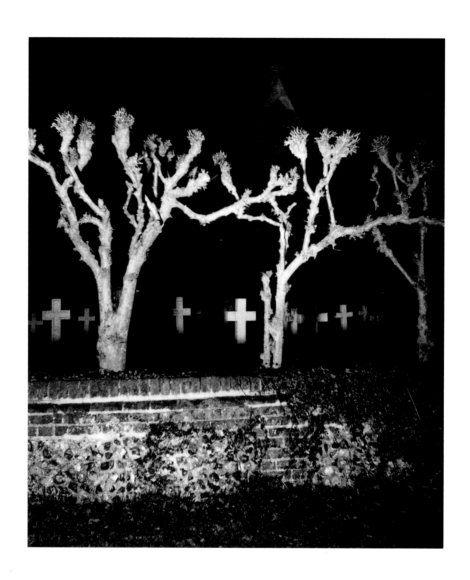

Bill Brandt
Magic Lantern of a Car's Headlights 1945
© Bill Brandt Archive Ltd.

Where the Rabbit Warms Its Belly
Thomas Wagner
On the Relationship between Photography
and Painting in the Digital Age

"Never trust general impressions old chap, concentrate on the details. I always look at a woman's sleeves first." Sherlock Holmes

IN THE HEADLIGHTS. "The Magic Lantern of a Car's Headlights" is the title of a series of black and white photographs that Bill Brandt took towards the end of the Second World War. They were published on March 31, 1945 in *Picture Post*. The pictures were taken at night and they show objects surprised by the sudden blaze of light, surrounded by an aura of darkness—a cemetery wall, behind it pollarded trees that blaze like petrified flames in front of simple crosses, a soldier in an army greatcoat with a beret on his head, a hitchhiker who looks like an angel pasted on the black cardboard of the night sky, and a rabbit cowering on the tarmac in the headlights' beam. Since this was the last of a series of so-called "wartime suites," the historical context in which they arose suggests that they should be read in relation to the long night of war and the ghosts of this existential eclipse. The image that sticks in the mind above all others is that of the rabbit. This is a mysterious, eerie picture despite its simplicity. In the onrushing car's lights, which briefly pierce the night-dark space and fade in the distance, the grassy left-hand verge of the road appears, any old verge, but a left-hand verge because we are in England where, as we know, they drive on the left. The rough and grainy road surface, which is presumably peppered with loose chippings, has patches, either of oil that has leaked or of tar that has seeped to the surface. In the center, the rabbit, stretched out to the gleaming tip of its tail, its ears cocked vertically, one eye visible, caught by the light, wide open—a creature rigid with terror in a shadowy world, presented to us by photography as an inexplicable stoppage or standstill in time.

In relation to the topic of war the rabbit, blinded by light, playing dead, takes on the character of a symbol for a historical catastrophe, which caused all living things to go rigid with fear. Is the rabbit guarding the dark entrance to hell, or has it simply been torn by the sudden blaze of man-made light out of its hiding place in the dark where it was warming its belly on the hot asphalt? Is it a sign of all creatures' indomitable will to survive, an incarnation of renewal and the continuance of life? There is another possible reading of the picture—if, that is, we can assume that every photograph, besides what it shows and how it shows it,

also provides self-referential information about the medium of photography, from which that photograph derives its peculiar character. Alongside the reading of the photograph as a multi-layered symbol, we then also have a reading as a self-referential text.

In the case of Bill Brandt's rabbit, the title of the series itself, with its mention not only of the "car headlights" but also, mysteriously, of "the magic lantern of the car headlights," suggests a quality of the medium. In a very personal inversion of light source and light-recording medium, the "magic lantern" or *laterna magica* thus becomes an analogue of photography. It is the eyes of the headlights that like seeing rays project the world visibly into the darkness and tear the objects out of their condition of unperceived obscurity. The subject here is the magic of the medium of photography itself. What is being described is the power of the light of recognition to lift creatures and objects out of the darkness of the lived moment and make them recognizable. The price of being visualized is of course being frozen; photography sees to it that the world, in becoming a picture, is frozen, literally mortified. The rabbit—the only living creature in the picture—thus becomes photography's heraldic beast. It plays dead as representative of the entire world of visible phenomena. And because the magic lanterns of photography have only a limited range, they show that photography can only ever encompass a certain segment of reality, which it carves out of the terrain of the unrecorded and unknown.

AUTOMATED BEHAVIOR. "As denizens of a photographic universe," writes Vilém Flusser, "we are used to photographs: they have become ordinary. We do not even notice most photographs because they have become obscured by habit just as everything ordinary in our surroundings is overlooked and only noticed when something changes. Change is informative, the habitual is redundant. What we are in the main surrounded by are redundant photos— and this although newspapers full of pictures appear daily on the breakfast table, new posters weekly in the streets, and new advertisements in the shop windows. It is precisely this constant change that we have got used to: one redundant photo displaces another redundant photo. Change as such is ordinary, redundant; 'progress' has become uninformative, commonplace. What would be informative, extraordinary, adventurous for us would be stasis: to get the same newspapers on the breakfast table every day or to see the same posters in the streets for weeks. That would surprise us, shatter us. The photos that routinely and continuously replace one another are redundant precisely because they are always 'new,' precisely because they automatically exhaust the possibilities of a photographic program. This is where the challenge lies for photographers: to stem this flood of redundancy with informative pictures."[1]

Another thing that needs to be considered is what Flusser calls the "gaudiness"[2] of our photographic universe, that is to say the sheer colorfulness of our surroundings, which

1 Vilém Flusser, *Für eine Philosophie der Fotografie*, 7th edition, Göttingen, 1994, p. 59. 2 Ibid., pp. 59ff.

would be a big surprise to our great-grandfathers, for in the nineteenth century the world was gray—the walls, the newspapers, the books, the shirts, the suits, and the tools. Today, by contrast, everything screams in every shade of color, but as Flusser puts it, "the screams fall on deaf ears." [3] We are used to the pollution of our visual environment, he suggests, and it bombards our gaze and our consciousness without being noticed and penetrates subliminal regions, where it goes to work and programs our behavior. In the Middle Ages for example the color "red" stood for the danger of being swallowed up by Hell. For us today a red traffic light also signifies "danger," but we are so programmed that we put our feet on the brakes without bringing our consciousness into play. "The subliminal programming of the colors in the photographic universe now causes only a ritual, automatic response." [4]

What Flusser describes as the main feature of the photographic universe—the stream of redundant photos as normality in a life habituated to turnover, and the ritual, automated character of our programmed perception and behavior—these are things that impinge directly and negatively on any artistic strategy working within the photographic medium. Living in a photographic universe of technical images could then mean that, beyond the surface phenomena of ideology and the politics of power and the market, painting and sculpture are no longer the predominant or prescriptive artistic genres. It is now photography that is seated on this throne,[5] although it remains trapped in ambivalence, vacillating between automatic record and subjective gaze. Of course, for Flusser, the photographic universe is only one of several machine-dependant universes,[6] and many may seem more threatening than the photographic variant, but this is precisely the one that serves as his model for post-industrial life.[7]

As inhabitants of such a photographic universe, we are confronted in particular by the problem that photographic images in fact conceal their meaning or, as Flusser would have it, their information. This causes problems in the decoding of photographs: "Anybody who writes must have mastered the rules of spelling and grammar. People who take snapshots have only to pay attention to the ever simpler instructions programmed on the output side of the camera. This is democracy in a post-industrial society. It means that the snapshotter is incapable of decoding photos. He considers the photos to be automatically replicated world. This leads to the paradoxical conclusion that the more people take pictures, the more difficult decoding them becomes. Everybody believes there is no need to decode photos, because everybody thinks they know how photos are made and what they mean." [8] Like a thick, padded coat or a caterpillar's cocoon, the photographic image is wrapped in seeming self-explanation. "To collect photographs," says Susan Sontag, "is to collect the world." [9] But we do not ordinarily decode reality as a photograph. It is self-explanatory, it remains fragmentary, alterable, contradictory, and it reveals its presence not as we contemplate it, but as we act it out.

3 Ibid. p. 60. 4 Ibid. 5 In the meantime photography is being ousted from the lead by the film medium. 6 Cf. Flusser, p. 68. 7 Ibid. 8 Ibid. p. 64. 9 Susan Sontag, *On Photography*, London, 1979, p. 3.

AGAINST PROGRAMMING. When photography is used in the realm of art, the problem of redundancy and diminished information content increases exponentially. An area of the photographic universe is staked out within which, we are expected to assume, all objects presented require to be decoded for their own sake. Since the objects in question are photographs, however, everybody also thinks there is no need to decode them because they are no more than "windows on the world," which are only there to bring an alien, otherwise unattainable experience of reality closer to us. Photography as art within the photographic universe of technical images is therefore called upon to break out of the everyday redundancy of unending images, to subvert the programmed behavior on the part of the camera, and as far as possible to generate new information. It can perhaps achieve this most easily by extending the range of its subjects or refining its ontological constitution in the areas of epistemology and perception theory.

The situation is further complicated by the fact that there is no longer only one form of photography since the opto-chemical process has now been joined by partially or wholly digital methods, as well as other variants and technical advances. A conceptual definition of what today constitutes the photographic only seems possible in terms of the techniques employed. It is hard to assess the extent to which the normal viewer of photographic images has already taken on board the possibility that a photograph is no longer automatically the shadowy trace of an optical phenomenon in the world, but the "shadowless" sum of digitalized and variously processed data. In the realm of art, however, "picture processing" is to be expected at all times. It is above all here that—parallel to the continuing existence of analogue photography—various hybrid methods of processing images have been established, which have turned the photographic image into a somewhat arbitrary product, a construct incorporating occasional quotations from reality. Since photography—in almost all of its manifestations—has in addition been extremely successful on the art market in the last few years, the question arises of whether and to what extent developments within photography have implications for the concept of art and for the prevailing understanding of what an artist might be.

THE LANGUAGE OF DETAIL. "The standards for art-critical assessment of photography were not brought into existence by photography." [10] But what nurse did stand beside the cradle of this medium when it was new? It is a fact that photography tried in the first instance to legitimize itself as a form of technical reproduction and an instrument for science. It was not long, however, before it began to establish its credentials as art and "made Painting... its paternal reference." [11] The "inventors" of photography were working towards the mechanization of a graphic process. They had in mind an automatic collotype, or drawings, lithographs, and etchings that would be made without the intervening hand of the artist. As was to be

10 Wolfgang Kemp, *Theorie der Fotografie*, Munich, 1980, vol. 1, p. 13. 11 Roland Barthes, *Camera Lucida, Reflections on Photography*, London, 1988, p. 30.

expected from these hybrid origins and from the history of photography's emergence, the first generation of photographers was characterized in equal measure by the activity and ethos of the scientist and the ambitions of the businessman. [12] In discussions of the question of photography's right to be called art, two particular areas played decisive roles: the problem of accuracy of detail and that of manipulation in the darkroom.

The first art critic to articulate the concern that photography, with its accuracy of detail, might have eliminated the idea was Jules Janin, who in 1836 said of Balzac's novels, "What detail!… Monsieur de Balzac entrances with his detail. If he makes one mistake, it is that he can omit nothing. In fact he spares us nothing, neither a cracked flagstone, nor a window-pane patched with paper, nor a fly soiling a barometer." What was first applied to prose description was soon as transferred to photography. Four years later the same author writes about the daguerreotype, "For so great is the power of this unwavering image maker that it records the blink of an eye, the creases on a forehead, the tiniest wrinkle on a face, the slightest twitch of a lock of hair. Take a magnifying glass! Do you see this little spot on the fine-grained background that is a little darker? That is a bird that was gliding through the air." [13]

With this, the photographic process displaces the author; like the realistic novelist, it has the capacity to depict both the world and its wealth of detail. If we return to Flusser's thesis that pure redundancy reigns within the photographic universe, it becomes clear that the perfectly detailed reproduction in the photographic image, which today seems to contain no information and to engulf us like a drug, in 1835 appeared to be "the [great] power of this unwavering image maker" and an almost universal optical memory. This was in particular the achievement of the daguerreotype, which could not be copied and therefore produced "originals." In 1839, with long exposure times of 15 minutes in bright sunshine, the technique was achieving a wealth of detail before which we today, knowing only 35mm photography, stand amazed.

Wolfgang Kemp has identified two conflicting attitudes to the problem. Did that wealth of detail—which was no less than the saturation of the image with particles of reality—conform to the criteria for a work of art which were valid at the time, or did photography's capacity for faithful detail discredit the medium in artistic terms? The painter Eugène Delacroix could state definitively: "Great artists concentrate our interest by excluding extraneous or senseless detail." [15] He sees photography's infinite capacity for detail as unartistic. He understands the unity of a picture to be the product of the artist's selection and transformation of his material. Art only comes into being when the viewer's eye is guided and ceases to wander

12 Cf. Kemp, p. 26. 13 Ibid., p. 13. 14 The question of how the invention of photography affected painting also applies to literature. The reproach made to the realists that their writing was nothing but a daguerreotype in prose was merely the converse of the incipient decline in the ability of text to evoke images. Cf. Bernd Stiegler, "Tote Bilder oder das Buch der Zukunft? Fotografische Illustrationen literarischer Texte im 19. Jahrhundert" in: *Fotografie gedruckt, Rundbrief Fotografie*, Sonderheft 4, edited by the working group "Fotografie im Museum" in the Museumsverband Baden Württemberg, in conjunction with the Sektion Geschichte at the Deutsche Gesellschaft für Photographie and the Sächsische Museumsverband, Göppigen, 1998, pp. 55-62. 15 Kemp, p. 14.

aimlessly from detail to detail, for this concentration and blurring of detail corresponds to the way we perceive nature. He considers the human eye lucky not to be able to discern tiny details like the blades of grass in a landscape or slight imperfections on the skin of a beautiful face. The function of the eye is to present those things to the mind that it ought to perceive. The mind then does not accept everything the eye transmits, but links the impressions to previous impressions, and this process is in turn subject to the seer's momentary disposition. In other words, the organs of the senses merely deliver material which our reason synthesizes into a unity. "The photographs which fascinate us most," Delacroix continues, "are those in which inadequacies have left certain free spaces where the eye finds rest and can concentrate on only a few objects." [16]

John Ruskin adopted a contrary position. He broke with the widely held rules of an older aesthetic according to which art had to be vague and poetic, and therefore could not be true to detail. With the analogy of literature in mind, he came to the conclusion that art was to be defined neither in terms of "omission of detail," nor only by the expression of what remains. On the contrary. Its entire power lay "in the clear expression… of what is unique and special." [17] This was equally valid for the visual arts. For Ruskin, details had no value in themselves since all artistic decisions have to answer to the highest principle of truth, but some details have truth in them and some do not, and this depends not on composition nor on the effect of the picture, but on its subject. Ruskin thus calls true details "talkative details," which communicate something about the history of the objects and are therefore significant signs and not random, trivial marks. Ruskin also subscribed to the thesis, that nature disposes of an endlessly detailed and at the same time informative language, which the artist must recapture, "if necessary against the demands of the picture."

It is such "talkative details" that structure the space of redundancy, and not the artist's arbitrary interpretative intrusion in his material. The detail is therefore what is attractive in a mostly uniform picture space, a charming and inevitable fact that eludes the viewer's control. Detail, Roland Barthes stresses, is "something" that rings a bell, that produces "a tiny shock" in the beholder. [18] Viewed historically, this debate about the complexity of the image or its compositional unity did not lead to an understanding of photography which would have integrated its commitment to detail into a more comprehensive understanding of the medium. In consequence photography failed to develop an aesthetic, enabling it gradually to reduce its dependence on painting. The historical reasons for this are many. The representatives of photography were above all *parvenus* who had to fight for social recognition and standing, much like painters in the fourteenth and fifteenth centuries. Where the latter in their day felt a kinship with poets, humanists, and scientists, the photographers now took painters as their models and designed their work to correspond thematically, stylistically, and theoretically to the established art form. In their need for security they did not adopt controversial positions, but "aspired to the respectable middle range of values" [19]. This has scarcely changed to the present day.

INTERVENTION IN THE DARKROOM. The question of the status and function of manipulation, too, still rumbles on. Indeed its relevance under pressure from modern technological innovation has become even greater. In the context of the discovery or rediscovery of so-called artistic techniques and fine printing processes during the last decade of the nineteenth century, the attention of photographers shifted increasingly from camera work to darkroom manipulation. With the bromoil print, for example, photographers had a medium to hand that permitted any desired effect. The wish to adjust negative and print by technical intervention that was appropriate to the medium, and not by overpainting, dodging, and masking, was old. As early as 1863 Louis Désire Blanquart-Evard observed, "What a huge change would affect photography if the photographer in the darkroom possessed the freedom to treat the camera obscura's image like a true and beautiful sketch which requires the inspiration of the artist to perfect it." [20] Transformation of the general impression on a grand scale was permitted and encouraged, even or particularly when traces of manipulation in the shape of brushstrokes were left visible. Once again the imitation of high art, particularly painting, is obvious. Robert Demachy, the spokesman of French art photographers, viewed darkroom techniques as the only chance to practice photography as art: "The skilled photographer and the amateur can both achieve the same result if the latter sets up his tripod at the same place as the expert and takes his picture at the same time with the same exposure, and if both develop the negative and the positive without any manipulation. Who can then tell which is the artist's photo and which the other? Now imagine that the artist prints his negative with the gum bichromate or bromoil process or develops a platinum print with glycerin! Even if the amateur uses the same process one print will bear the signature of the artist from the treatment of the heavens to the treatment of the earth; the other print will be a mess. It was a man in each case who intervened. One made a work of art out of a beautiful picture, the other in all probability destroyed the beauty and certainly added no artistic value." [21]

The ability to manipulate the print therefore determines its artistic value. The photographic image alone possesses no such value, not even through the choice of motif, location, or lighting. It is determined by the artist's input alone, as he applies his processes in the new alchemist's kitchen, the darkroom. In this way artistic value in the age of technical reproduction remains tied to the skill of the artist's hand. His intervention is not via the camera, but through his subsequent treatment of the material that the camera can produce. Today's cult of "vintage prints," the "originals" printed by the hand of the master, derives from such a concept of art. [22] Now the darkroom has mutated into the black box of the computer. In this mythical location the alchemists of the digital age beaver away at making a distinction between themselves and the ubiquitous snapshotters. So in our day, too, the art photographer is not the translator of reality, but remains a creative interpreter of his material. This considera-

16 Ibid. 17 Ibid. p. 15. 18 Barthes, p. 49. 19 Kemp, p. 17. 20 Ibid. p. 22. 21 Ibid. p. 23. 22 In Sigmar Polke's photographs, for example, it is possible to follow how originals are created by darkroom reproduction methods, which both ironizes and confirms the myth of the creative artist.

bly modifies the sharpness with which reality, uncontrolled by the operator, can impose itself on the image. Yet we still believe in photographic images, though we know that they can lie. Even epistemological impregnation does not immunize viewers against deception, because the mechanics of picture-making seem to have a built-in guarantee for the truth of the image. Interestingly, we distrust painting for the exact opposite reason.

REPLICATION OR FREE USE OF SIGNS. Photographic works turn up nowadays in increasing numbers in exhibitions, museums, and private collections. In consequence, it is impossible to avoid the impression that the previously despised medium is welcomed with open arms mainly because it promises to fill gaps left by developments in more established forms of expression. Jeff Wall theatricalizes the methods of photo-journalists, Andreas Gursky conducts a discourse with painting in terms of the photographic image. But it is unsatisfactory to insinuate, as an explanation for this, that artistic photography is blithely filling a new vacuum because photography can offer a direct link between art and the world again, and thus an aesthetic experience related to the reality that is withheld by other artistic genres. This is notably the case in portraiture, landscape, and townscape, but also in themes like the human body and sexuality, which are increasingly finding their way into art via photography. The crucial consideration in any examination of the current tension between the photographic and the painted image is the relationship of the one to the other. For now that the frontiers of the genres have almost completely broken down, different types of picture are interacting with one another all the time.

For some time now, and with increasing frequency, works have been appearing in the field of painting in which photography's link to reality is crossed and blended with the compositional and manipulative repertoire of painting to fuse the two into a new amalgam.[23] The revitalization of genuine painterly positions, such as abstract gesture, structure, and paint has become the order of the day as a reaction to the disturbing power of the image in film and photography, and this return to tried and tested practice has contributed to the stabilization of painting.[24]

The key issue in the relationship between painting and photography has become the indexical sign, in other words the sign that possesses a material connection to its referent.[25] In a

23 Arnulf Rainer's overpaintings and Robert Rauschenberg's hybrid works can be cited as prominent examples. 24 In this connection one might think of Gerhard Richter's painterly blurring of photographs, which does take up painting's link with the world in terms of subject matter but then submits it to subjective treatment. This clearly underlines the mediated nature of the link with the world. Mechanical recording with its mass distribution has replaced the artist's perception. At the same time there are traces of a different sort to be found in Richter's "overpaintings." The way he overlays the photographic image with a hesitant, unfocused painterly touch could also be understood as a gestural reaction, an unconscious adoption of the indexical or—even as the incipient erasure of the same. In this way one might say that Richter uses the indexical quality of photography to reinterpret painting. 25 "Take for example 'it is raining.' Here the icon is the composite mental photograph of all the rainy days the thinker has ever experienced. The index is what he uses to distinguish *this* day from all other days in his experience. The symbol is the intellectual category by which he designates this day as rainy." Charles Sanders Pierce, *Semiotische Schriften*, Frankfurt, 1986, vol. 1, pp. 219-220. [back translation from the German]

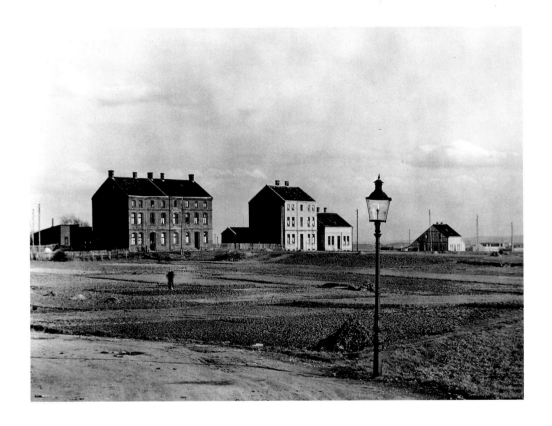

Albert Renger-Patzsch
Minors' Houses in Essen-Stoppenberg
1929

historical constellation in which the most recent form of artistic photography comes close to painting in format and composition, painting itself is again pinning its hopes on a quality it had lost, buried under countless histories, namely the visible trace of the movement of a hand. This has given rise to a very problematic alliance. For as artistic photography takes over elements of painting which are essentially less spontaneous than composed, it obscures the immanent power of the indexical, the unremitting truth of a visible scene or shape, which in becoming image has retained its connection with an event in the world, and which is therefore more than just an image created by the will of a subject. It is above all the digital form of artistic photography that, in relating to models in painting, has obscured the hitherto decisive material difference between the two media. With their hybrid mixture of illustration and freely applied signs, the identity of digital pictures rests on twin foundations: as painterly composition and as illustration, as historical reminiscence of painting and as document of the present. It is in this hybrid form that photography demonstrates its superiority over painting in an age that refuses to give up the heritage of the avant-garde while at the same time regarding it as outmoded. So artistic photography, at least in museum format, is structurally defined and determined by the relation it adopts within its images to painting.

DISINTEGRATION OF THE REFERENCE TO THE WORLD. In recent years, after its aspirations to the status of art had been discredited by mass exploitation, photography has regained its attraction for aesthetics and art theory largely because digital processing techniques have expanded its media potential. These now permit virtually unlimited manipulation of the medium. This has inevitably lead to the loosening, if not collapse, of a clear-cut connection between photographic image and world. The assumption that the world can theoretically be reproduced and that the truth of the visible is revealed in its photographic image was once as important for the development of photography as the invention of the equipment for photography. This idea is currently breaking down. Demand for new, often digital, forms of art photography is further stimulated by an art market, which has the idea that it must constantly send out new impulses in the realm of contemporary art. In this context the medium of photography provides a catalyst for the development of art which was otherwise grinding to a halt. If the rise of artistic photography at the end of the nineteenth century was interrupted by a quick succession of technical developments and their commercialization, the same thing seems to be happening today in reverse. Now as then, in an age of an almost over-powering art market, the public is playing a major role. But who uses digital photography these days? It is the new managerial elite in the media corporations, the creative staff in television, advertising, and internet services who have no love for the analogue medium. They show no sense of tradition because that would stand in the way of their claim to the novelty, uniqueness, and social significance of their own field of endeavor, along with the self-view they wish to propagate. It would also diminish their own future social value. The revival of the old rivalry between photography and painting and the adoption by both of the

"respectable middle ground" has contributed to the success of both. In painting it has produced a renewal of expressive abstraction as well as a style that dutifully reflects its own means. In photography it has produced high-gloss pictures that hover between the aesthetics of advertising and overblown documentation, with occasional forays into the gigantic inflation of trivia. Under pressure from all quarters as the only one of the new media with a future, painterly modes of representation and presentation and the associated myth of the artist have become the Trojan horse in whose belly photography has conquered the market and the museums.

But at the site of this scam photography changed. It appears now to have changed into a digital medium, which promises to save the old-style artist on the highest technical level. However, adopting the concept of the artist–creator as a marketing gambit—by way of historical update, as it were—again hampers the development of a photographic self-understanding that is based on precision of detail and an indexical relation to the world and yet does not neglect the subjectivity of the individual view of the world nor rend the echo chambers of the invisible. Instead photography is gambling—openly or covertly—on compositional and painterly effects. Instead of liberating itself from the constraints of creating form and becoming an instrument of exemplary perception, digital photography is reheating a program of leftovers as a surefire prospect for success. What seems to be at the cutting edge of technical advance proves to be aesthetically conservative and regressive in terms of art history and art criticism. It is not the spirit of experiment but a need to be recognized and accepted that dwells in most digitally equipped studios these days. It is important to bear this in mind if one is to avoid being taken in by a form of photography that poses as digital and tries to upgrade its artistic status by blocking the development of a genuine photographic aesthetic, solely because borrowing pictorial models that already exist in painting promises greater success.

If, however, one looks at digital photography against the background of the disintegrating identity of the subject emerging exhausted, rather than refreshed, from the flood of redundant images, then it can be seen as a protest against the postindustrial practice of surrendering to the rule of the camera and understanding photos as automatic reproductions of reality. Since indexical relationships to the world are being created en masse by the snapshotters of the world, any photography with artistic aspirations must be on the lookout for ways of differentiating itself, and these are to be found in the realm of the iconic and the symbolic. Of course in this case the decoding and analysis of individual photos moves from the recipient back to the producer, who now exploits the available technology to inscribe his/her reading of the world in the picture.

But whether one sees in digital photography only the renaissance of the creative subject or a form of resistance to the omnipotence of programmed perception, the atrophy of the indexical, of the direct, physical connection between the sign and its referent marches on. In the age of digital manipulation constructivity dominates perception. The consequence of this is a revaluation of the real whose consequences are only now dawning on us.

MUTATIONS OF THE IMAGE. With digital photography a kind of mutation of the image sets in, which begins to undermine the opposition of manipulation and freedom, in that it reduces manipulation to mere adjustments of strings of data. If previously the peculiar quality of a photograph was that everything in it was simultaneous and equivalent, then now the real appears as an object for treatment, not as an object to be simply looked at. Since the possibilities have increased of choosing freely between this or that form, between one coloration and another, the significance of the depicted object as part of a reality that eludes the grasp of random change has diminished. The notion of things drawn from reality or of visual givens fades in direct proportion to the increasing possibility of change. In a photograph by Weegee or Nadar one can find something terrifying or appealing or intoxicating because one cannot believe in the possibility of influencing its appearance or disappearance. You see it and you are seen by it. In the case of a digitally adjusted photo you recognize the inventiveness and compositional skill of the artist, but you know that the situation is not a "seeing" one. It is the *slowness* of analogue photography that removes the visible from control, and it is the *speed* of digital photography that removes control from the visible. Nature's crayon has a rival in the shape of the *Photoshop*. From now on we are producing in competition with nature.

THE DUPLICATION OF THE RABBIT. To come back to the rabbit in Bill Brandt's photograph. Tony Smith, the proto-minimalist, has a story that could throw some light on the rabbit on the roadway as the heraldic beast of analogue photography. The story's point of departure is a similar perceptual situation, even if there is no rabbit involved. [26] What he describes is a nocturnal drive on an unfinished New Jersey turnpike in the early fifties. In the beam of the headlights racing ahead of the car, the highway appears to come out of nothing. According to Smith, "The experience on the road was something mapped out but not socially recognized. I thought to myself, it should be clear that the end is art. After this, most paintings look a shade picturesque. You can't stick it in a frame, you have to experience it." Hal Foster recognizes in the impression that Smith had of the conventionality of art, the tendency of minimalists to transgress the institutional frontiers of art and cancel its autonomy. For Foster the minimalists were pursuing the strict replication of "an unframed event or object as it *happens* and just as it *is.*" The anecdote about the highway which arises momentarily out of the darkness stresses the moment of happening in a perceptual experience that cannot readily be integrated into the framework of conventional art. This is the same moment of pathos that we get in the "as it happened" of photography, even if the experience is purely linguistic and there is no photographic document to prove it. In both cases an event took place. But precisely this changes with the advent of digital photography. "The doubt that it perhaps didn't happen," writes Hubertus von Amelunxen, "that there may be places on the picture surface—

26 Cf. Hal Foster, "The Crux of Minimalism" in: Howard Singerman (ed.), *Individuals: A Selected History of Contemporary Art, 1945-1986*, Los Angeles and New York, 1986, pp. 162-183. 27 Hubertus von Amelunxen, "Fotografie nach der Fotografie" in: von Amelunxen, Iglhaut, Rötzer (eds.), *Fotografie nach der Fotografie*, Dresden and Basel, 1995, p. 123.

the concrete carrier of the object—that were never imprinted by photons, this existential doubt leads to a sense of terror. It is not what is depicted that strikes terror, but that it is possible to depict it."

The rabbit—a symbol of existential terror in the universe of analogue images and simultaneously the heraldic beast of traditional photography—lies rigid with fear in the parallel universe of cyberspace and no longer warms its belly on the hot asphalt. It no longer sits somewhere out in the world, but in the housing of a hot computer. It has become a different animal and now proclaims the terror of the medium and its possibilities. Out of the real rabbit, a virtual rabbit has sprung. Both rabbits, the old and the new, can now appear in the same museum, where they inform us that today and in the future we will be faced with picture after picture whose status we will have to determine. So photography—more than painting—has become the medium that will decide which concept of reality we in future ascribe to pictures and which to ourselves.

Translation Hugh Rorrison

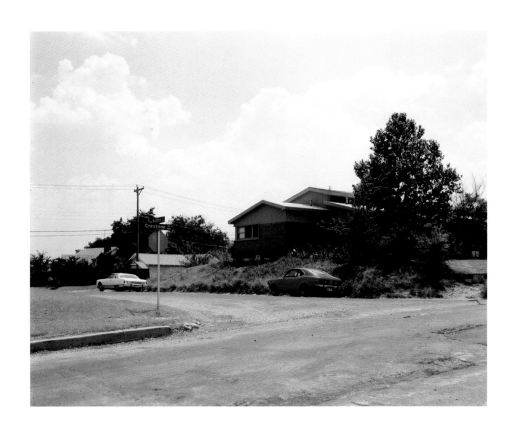

Stephen Shore *Sutter Street
and Crestline Road, Fort Worth, Texas
June 3, 1976*

The Roads

Peter Waterhouse

I was in the Juenna plains in my car. The spire of Dobrla vás was turning, the cottages with locked-up windows were turning and indoors a wardrobe, a table, part of a TV-set were turning; a computer averted its little face, the furniture warehouse Ratur did the same, the forest was a huge appearance, but it spun around just as the earth spins, almost as if the forest were taking a good turn, almost as if it were making progress, restoring itself and increasing, improving and growing more beautiful. A farm reflected in the rearview mirror moved from right to left. At first, the farm was tucked into the curved plastic frame, and to the right there was nothing and in this nothing the windshield and two other disproportionate elements, the road and the fields; the tiny mirrored farm began to slide to the left and beside it stood a tractor, then an orchard, then a billboard with a poster on it by one of the political parties, in large letters, here in the mirror in very small letters the word AIRTSUA, then the store in the distance; the farm and its counterpart the red warehouse store were now close to the left edge of the mirror, closer to the eyes, the eyes of the driver, myself; then the farm-house moved out of the picture and the warehouse store came closer. The driver was about to exclaim: Where is everybody, your farms and things are spinning, are you in school, are you handing in applications? It's Thursday morning, if only I could see somebody hanging around, someone smoking a cigarette, a drunkard. If only I could watch the postman speeding across the horizon between villages, if only I could discover his yellow Renault. The delivery of letters, the motorized postman knocking at the doors and on the kitchen windows, even on the church window, his greetings, his arm raised, the way he bends his back, the way he has of leaping towards his car and then his look and his turning back from the driver's window, his way of glancing backwards at those who have received letters, as if written by himself, by Andrej, shaken out of the mailbag by him early in the morning and sorted by villages and tied together in parcels for each hamlet and put into the trunk of the car, one two three four five six and more, and then delivered by car in person. No face ever looks out of the church windows the way Andrej looks out of his Renault window. *Autriche* printed on the mailbags. A surprising place each time for the name of the country. Much more attractive on these moving bodies than on the signs at the borders, in black letters: Republic of Austria. Why more attractive? Because the name on the bags did not define a territory? Because the name on each bag maybe defined only this bag? Defined? Was the

7

name identical with the bag and Austria, therefore, present here? And therefore everywhere, no not on mountains and in valleys, not next to Hungary, next to Germany, a different status, at times shaped like this mailbag, at cockcrow pulled out of the truck come from Klagenfurt by Andrej and heaved into the post-office. Looking like a bag of potatoes. Then, inside the post-office, behind the desk, the mailbag seemed to be a spot. It could be described as being curved inward like Austria's frontier. Spot on the floor behind civil servant Lipusch Zdravko, a neutral spot, insignificant so far, yet in the center of the world; a mere nothing but at the same time like an enormous lime tree in the fields and full of sunlight. No insignia. Sunken in thought about the bag and spot on the floor of 9123 Primus in the Juenna plains: was I right if I said to myself: how far away from a real post office is this republic, how far away from a real post and from this wide and empty crossroads? Empty? What did I see? What was everything that I was looking at? I was looking at the open lid of a garbage can. But what was I seeing? I was looking at a red car parking here, at the slip of paper stuck to the side window saying in capital letters: FOR SALE. But what was it? Did I see the red car and was it a red car? The white imprint on its tires: FIRESTONE. And what about the license plate: VK 205, the rest forgotten? Was this the end of the world? Not the eccentric and obvious end as described since Ipuver and Hesiod, but this kind of an end? Really? An end not in the way of destruction? What did the word end mean? This car an end? Firestone? The white stripes on the road? The bakery? The spider running across a signboard? Wasn't there a sense of *along, arouse, enter*—and what were these *a* and *en*? En, did it mean end? Firestone arousal—but not and never the prophesied dramatic end of the world? Did that mailbag on the floor deliver us? Were other names printed on the fabric, the name of the producer, the name of the material? Why such imprints like *Autriche* or the name of the producer, were they similar to the imprint that had been stamped and pressed into me? In place of an end, was there an *ante* impressed in me, a foremost; was there such a *foremost/fore-post* here on this intersection in the plains? In front? In front of what? Heading something, heading an army on horseback, vanguard on a battlefield? No. No? Spearhead? What was right in the front? Maybe, just like here, a single country crossroads or a post station—but what was this crossroads and this post station? Wasn't there a phrase "from end to end"? This is the end of the world, did that mean: here the world has turned local, has become a corner of the world, a place, a patch? On the floor of the post-office the world was being transformed into a spot? Had I arrived on a spot? Was I in front of a battlefield? What was there to be found right in the front? A crossroads in southern St. Primus with post office and bakery? I noticed someone walking in—in what?—in oversized trousers. Someone walked down one of the four roads, turned into the second of the four roads. His black hair looked heavy, a load. The man stood, then bent down; while he bent down, I gave the Firestone tires another look, he picked up a cigarette butt, put it in his mouth, blew smoke from his nostrils. Had the cigarette on the ground been alight? And why was it so? Why had I given the Firestone writing on the tires another look; and why was the man walking, standing, finding, smoking? Behind

the large window of a supermarket a woman was sitting at the counter reading a newspaper. What made the woman reading the Thursday edition of the *Neue Kronenzeitung* such a lively image? Was it a lasting image? And what about the election poster, what did the slogan there mean: No compromises with the boulevard press? Boulevard? Was that man over there smoking a cigarette on the boulevard? And the woman reading: was she making a compromise with the boulevard press? *Kronenzeitung*—The Crown, why such a name? The currency wasn't in crowns anymore. One crown, that was how much the newspaper had cost ninety years ago. Why not *Schillingzeitung*? Was there any newspaper called The D-Mark? Wasn't it charming to use an almost forgotten word as a name? Wasn't it lovely that the name of the paper reminded of something that no longer existed? Shouldn't we wave this newspaper around and shout: Look here, look here, here you can see something that no longer exists? I looked down the boulevard. Was someone coming? No one came. Why was no one coming? Where is everybody? What an enormous poster, but nobody passing by. Crown, not a bad word, at least an old coin. Crown and boulevard, maybe a secret translation of Bouvard and Pécuchet? No. No? Pecuniary? Peculiar? Pecu—cattle? What do we forget? What do we keep in mind? Crown, a word restored every day? Over there at the counter, the woman was sitting and reading the newspaper and no one was reading the billboard, except me. Didn't those words on the billboard arouse a curiosity for roads and cheap newspapers? In comparison to the severity, wasn't the newspaper innocent, road-like? And where did this word suddenly come from now: streetwalker? And the picture in my mind of a girl riding a bicycle, not thirty-five, not twenty-five, but seven years old? Beautiful word: streetwalker. And I myself: a streetboy? Or simply: a streetman? And the name of the street? And wasn't the street itself a kind of newspaper? Was there such an expression as: asphalt press? What did the road sign say? In the column on the left there were three names of villages, in the column on the right there were three distances. Thus, a name and a distance of a few miles belonged together. Didn't the sign seem as important as a newspaper page? The names Horizon Village and Dobrla vás, were they as important as blood and thunder? Were three miles as important as three years imprisonment? Could "life sentence" be written on the road sign? And what about: lifelong village? Why all these words, where did they come from? What were they doing? Today's headline—"Blind Muslim"—where did it come from? Weren't these two words like two different languages? Was it easy to be able to speak two languages? And the advertisement on the front page, consisting of merely one word: X-TREME. How should one pronounce it? The German letter was pronounced *ix*. Here in the newspaper it was maybe meant to be ex-treme. Ex? *Ix*? An English ex? A German *ix*, followed by an English treme? Everyone pronouncing the word had to shift between two languages, imperceptibly. And weren't the villagers doing the same? No, it was a little different here. Here speakers could shift from one language to the other within a sentence: *Ta tiedn ti prpelám refrigerator, will you be at home on Wednesday? Tiedn*—pronounced with a "d," here in these dwellings. Not pronounced with a "j," but with an "e." And to bring not *pripeljem*, but *prpelám. Ta tiedn ti*

prpelám refrigerator, will you be at home on Wednesday? One of those shifting sentences of Juenna. Place names could shift from one language to the other, too. Bleiburg for instance: Pliberk. Eberndorf: Dobrla vás. Eisenkappel: Zelezna kapla. And was there a definition for what was going on in the newspaper headline: US-Justiz? US, an abbreviation. How was it to be pronounced? German oo-ess or English you-ess (or you-wess)? Didn't the next word give the answer: Justiz, in German you-steetz? The first syllable in Justiz and the first in US, were they not identical? Was Ju U? Was the one the other? Was this a universal law: the one was the other? And what was the newspaper trying to express? Was it trying to say that the red Mazda parked here was a white Mercedes Benz passing by? Was this a new alphabet: A = B? Was the electricity mast a road sign? These dwellings, were they drawn by children? Seams filled with tar, were they shadows? Was the new alphabet written on a boulevard? Was there a new alphabet made of roads and lanes? Should I move to a patch of gravel, gravel on a repaired stretch of road, to discover the new alphabet? The road between these dwellings, was it beautiful? The car was red. But the windshield was a resplendence of the sky. The Mazda window was a sky image. The side window of the Mazda was a tree image. The other side window was the image of a substation at this crossroads. A man was standing in that image, that man was I. Man, that is saying too much, I was a resemblance of the substation, I was almost like a letter. A figure surrounded by an aureole, stern, in all seriousness, praised by the sun, with projecting ears and shirt collar, wrapped into the world, pictured on a Mazda window. Was this a new creed: praised by the sun / wrapped into goodness / pictured on a Mazda window / part of the new alphabet / on a Thursday / between alpha and omega / between substation and Mazda / between road and sky / under golden streetlights / wrapped into ribbons around a building-site / hair like packaging material / dwellings as if drawn by children / praised by the sun / praised by the sun / little man in a Mazda image / in the new paradise / arrows on the road like lightning / tar like soul / pictured and praised by the sun / praised by the sun?

Wind. It swept along the ribbons of the building site. They began to sway—maybe there had been a vibration before—they fluttered and sounded. These trills were beautiful. The ribbons with red and white stripes quivered. I thought: these trills are the new witnesses. Am I listening to the new world? Then the wind swept across a window blind. The trills produced by the blind were like those produced by the ribbons enclosing the building site. Why were the trills beautiful? Were they beautiful because they were two fountains? Was something emerging from the trills? I listened. Only trills. Was something emerging? Maybe a voice? What did it say here on this crossroads? The dwellings? The car passing by? The ADEG shop sign? A swing and a slide over there in the garden? The snack bar? The bakery? The self-service gas station selling no-name petrol?

I had the impression the voice was closer, very close to me; very, very close. Were the trills voicing me?

Were the trills generating me from trills? Over there the ribbon was warbling (almost translating). Was it sufficient to stand here and listen to all the lamellae of the window blind? The new testament began with words uttered by lamellae? Wind is speeding along the ribbons? And the lamellae are trilling? And the ribbons are trilling and flowing? I was standing on concrete slabs in front of an exchange office. Two of these were broken and had black cracks running through them. On the wall of the exchange office I noticed shadows of dogwood branches and they were about to split the wall. The ADEG shop sign over there crossed the macadam towards where I was standing—was I the continuation—was that so? Was I continuing to write ADEG? ADEG, similar and opposite to adieu? ADEG thus a welcome? And the name of the cashier was: Adele? And didn't to greet once upon a time mean: to scream, to rattle, to make someone cry, to produce tears and sounds? Those lamellae trills —they seemed to be issuing something. They were overflowing. Was it a voice? What was it telling me? Something like: speak up, ring out, cry? Were the trills telling me: sing? The trill, was it telling me: trill? Repeat? The trills coming from the building site, were they telling me: start trilling? Were they like birds? Did birds say: you can sing? Were the lamellae telling me: you are able to speak? Were they saying to me: you say? Was the ribbon suggesting language? Was it singing a song? Newcomer, now it's your turn to speak? Sing a song about the vinegar merchant passing by and about the toboggan club coach from Innsbruck going the other way? Now welcome the bakery. Use the word ADEG. You are to sing songs between the substation, the Mazda, and the red tennis-court. The vinegar merchant songs?

TV-images came to my mind, taken in a courtroom two years ago. A villager was charged with felony, he was about to be interrogated. The man had stood in the courtroom screaming, nonstop, sentences that ended in "no, thank you." Where had he found those "no-thank-yous"? Had he heard and seen them where I had heard and seen them, probably more often seen than heard them? Where had I heard the thankfulness or unthankfulness? Couldn't remember. But it was easy to point to where I had seen it frequently—on the yellow badges encircled by red characters: Atomic energy. No, thank you. Why "thank you" if it was only a simple "no" and there was no reason for thankfulness? So what kind of thankfulness was it? Was it non-thankfulness? The opposite of thankfulness in the guise of thankfulness? Irreverence hidden in the guise of being inclined towards a pleasing offer? Was it disrespectful unthankfulness? But I hadn't been able to detect disrespect in this formula—would have liked to. In the "no, thank you" I had detected bitterness—it was not a rejection—it was not a "no"—it was not about saying no—why such bitterness? Why did a young and joyful, happy, almost childish, well under twenty, passionate and curious protest need to utter such a bitter "no, thank you"? I had felt the anguish in the expression and had wondered: why anguish? Why not sweetness? Why anguish instead of thankfulness? Why anguish instead of new creeds, why not: Man in a Mazda / arrows and crossroads / between road and sky / wrapped in ribbons / hair like packaging material? Why didn't that four-letter-word ADEG make me

bitter, why was it so friendly and pleasing and easy to accept? Why did I discover—not invent, not create—voices here on this crossroads—praised by the sun/wrapped in goodness/pictured in a Mazda window? Why didn't I feel phantom pain? Why didn't I feel pain on this road, why wasn't I scared by cars and why on highways—formerly called "Adolf Hitler's roads"—did I feel no pain and anxiety? Had I no sense of danger? Or was it that the quivering lamellae and ribbons were simply stronger? A front door, a window, a Harley Davidson, for real or fake, peacefully chugging down the road—did they give assurance? What for? For the sweetness? Were these objects landmarks? And were cars non-stationary wonders? Why had that possibly very dangerous man begun to yell in court "Foreigners, no, thank you" and an entire catalogue of other furious "no-thank-yous"? Did I know of a sweet catalogue and testament? And could I find solutions on this crossroads?

A song came to my mind about a coach, a coachman, and a horse on the road in the green and rolling landscapes of West Riding—a Magna Charta Word—in the county of York-shire, a district that officially ceased to be in April 1974. Suddenly my father, ill and close to his death, had begun to sing a song about a coach carrying barrels along the lanes in a green country and bound for the villages and taverns. For the very first time I had heard my father's language, neither German nor English, his two colloquial languages. Suddenly a different language, never before spoken in our family, never used to address a person. His own language, while at the same time the language of an area: the dialect of Yorkshire—maybe the particular dialect spoken in Marsden, in Huddersfield, in Oldham, in—I didn't know where. A local language, local English, which here in southern Europe turned out to be his very own, a language deep inside. Never before had he spoken his deep language, but I at once felt: this is his deep language. For so many years, at least the span of my lifetime, he hadn't used the dialect of Yorkshire. What was I listening to? Was I listening to—if that is the correct word—assurances; that peacefully chugging Harley Davidson passing by and heading into the distance, had it reminded me of my father's dialect? (An assurance? Assuring what? The sweetness?) Reassuring were the sounds of the song; the words set a-, a-glow?, a-light? by these sounds, whether the long words, the short ones, the unknown, the secret; but more precisely speaking: their coloring reassured. The shades full of sweetness? Sweetness? Each little sound was beautiful and intimately his; thus all sounds were saying: this is mine, but not mine like my home, like my car, like my money, unlike my hopes, my opinions, not mine like my country and my passport; mine rather like my uniting with others, mine like my union, mine in the old sense of mean (linked). A language of sweetness, assurance, and union? Mine in the sense of delimitation? Therefore the many foreign (sweet) languages he had learnt throughout his life? Could this kind of possession only be something that belongs to everyone? My belonging belonging to all of us? My: everybody's? And in quite the same manner Mr. Harley Davidson had ridden through St. Primus on his motorcycle, had ridden through this other West Riding, expressing: this is my chugging: my chugging is enough noise for everybody. What is mine is what extends my limits? Such was the beautiful assur-

ance in the song of my sick father, intonated only once in that provincial hospital? And it was also a song full of his thankfulness, it was a way of thanking the green and purple gray landscapes and moors and stones and stone houses. Of thanking for...? For having received a limitless identity? Maybe a way, too, of thanking for the sounds of the song? The singing a means of thanking for the song? Speaking a Yorkshire dialect was thanking for that dialect? Pronouncing each individual little sound meant thanking each little sound? Was my father thanking the language spoken in Yorkshire, thanking what was his and everybody's, and was he maybe even thanking life? How do we thank life? Like this, with a song, by heart? No book at hand, no poem, nothing in writing, no author responsible—is it like having nothing? With my nothing I want to thank life? And I had witnessed this one minute only or maybe half a minute, maybe single minute of thankfulness? And one more question: is dialect an expression of love? Language is love? And vice versa: love is made of language? Dia— towards and across. All of a sudden I was convinced: dialect is a means of projection, language serves as a light. Serves as a light?

Minute or half a minute of farewell, too. I hardly understood the words of the song; some kind of a vehicle was rolling through the countryside of West Riding, maybe carrying barrels. What about the green, did the song consider it? Villages and taverns, did it mention them? The colors of the country, various grayish purples, were they mentioned? This little song sung to me for the first time was maybe sung to me for the last time. And maybe it was saying: you may not hear this song again for a long time. Certainly you will not find it here in Klagenfurt. You shall have to go to the villages where I used to be at home; but who will know it there; what is it called; who made it; was it written down; how will you inquire? Maybe: I am in search of an unknown song. I am in search of a song sung here by children around 1915. I am looking for a song, it's a song in a West Riding dialect. So, in that half a minute I heard a song that one day would return, "by itself," "when the time has come," and without my knowing. Maybe the situation in the ward was the following: what I am singing here, for myself and for you, will be gone for a long time and only come back under unusual and favorable circumstances, maybe never; or once upon a time it will give you a big surprise; now it is lost, but that only means: the day of surprise may yet come, may never come, may yet come. It won't be in Austria; it won't be in Germany; it won't be in Italy. Or nevertheless in Austria, nevertheless in Germany, and nevertheless in Italy? Maybe that little song from West Riding has spread out. Maybe it has spread as far as Friuli in Italy, and across the Karawank hillocks, right up to the alpine pastures. Maybe it is a song with no limits. Maybe it is meant to undo limits. Maybe I'm singing it here in this ward to raise myself up to the Karawank hillocks, to descend to Easter in Friuli and to cross to the pleasures of the tables in Slovenia.

Could it not persist; should I have taken notes on a slip of paper to preserve it? But I was reassured that the song was present, more present than in writing. It sounded harsh. I was to be no detective, I was not looking for clues, I was...? Wasn't I more alive if I took no notes?

Wasn't I stimulated by the end of the song; aroused by its not returning for a long time? But oh: in his voice there had been something incomparable to the lachrymose tone when he spoke German, incomparable to the operetta Viennese he had acquired—favorite word: unpleasant—and which I, light guest in this city, had acquired too; incomparable to the disciplined, occasionally angry postwar English he was able to speak—"there were probably more on the way"—"several messages had been sent out"—"he was a good man doing a most difficult job"—"could you describe the damage"—"oh, the Germans"—"miraculously, Moore got back"—"magnificent and awful retaliation"—; but in the voice of the song-singer or song-whisperer there had been resonance, certain elements had been reinforced and extended, the many r-sounds within one line had produced an extended, stretched, multiplied, overflowing, resonating 'r', and this extension, support, and stretching seemed to clear his voice, transforming it into "r" upon "r" upon "r"; there were deeper vibrations in his voice than I had known, in other lines there were other vibrations or counter-vibrations, and all vibrations together were expression. Expression was not what the song was about, coach and lanes and taverns.

Undulations of Yorkshire? Music of the spheres? Was dialect a basic resonance? What was a basic resonance? Was it basic proximity? Was it expressing what has been called "the confusion of spheres"? Was his song a composition of many spheres, word spheres, vowel spheres, consonant spheres, verse spheres, silent spheres? Was he singing to transcend—transcend what? To reach proximity? Was proximity far away? If it was a thousand miles away, was it nevertheless close by? Was he setting those tiny acoustic spheres of the song in motion to start the passage? The passage to proximity, to his village? Was he a translator of spheres? Was he then speaking to Mother, to his brother, to a school friend—was this his most glorious idea of language: it connected the spheres, it united this southeastern hospital and the village in England just like brother and sister were united when they played football in the garden. Do dialects associate the world differently? Was this a world with no expanse? Did "here" and "there" and "yonder" disappear? Was the country an amalgam—the small town of Bleiburg not eight miles away from Strasburg, but an ingredient of the Bleiburg-Strasburg plastic mass? Was the Bleiburg-Strasburg region a universe? Was dialect the instrument to discover the universe—the universe of Juenna? And what about me—I spoke no dialect, I only had my operetta Austrian. How was I to find the universe of Juenna?

Did spires in the universe rotate? Did farms rotate there? Did cyclists, tractors, school-busses, and children rotate in the garden of universal Juenna? Was it true that cyclists were neither "here" nor "there" nor "yonder," that spires were neither "here" nor "there" nor "over there," that tractors were neither "here on this field" nor "on that field" nor "on that other"? Did the spires and Fiats and Massey Fergusons, the cattle and the cyclists blend? How could I become part of this world? Obir and Petzen, the two mountains, twenty miles apart? Wrong? The two mountains participants of that mighty Obir-Petzen-match? And what about me? Was I playing the village games, bicycle games, tavern games, was I playing the bells,

playing the villages of Miklauzhof, Galicia, was I playing the highroad game and football on Sundays? The apple trees were not scattered across the country in villages and alongside fields—were they interwoven? Did the four lakes form one surface? An interplay of lakes? A match of apples and cherries? A cluster of parishes? And I was part of the world? Was I too in the province of Asia? How was I to find Asia, region between Bleiburg and Galicia? If someone were to ask Mr. Jerney Erwin, the decorator from Miklauzhof, where he lived and which way to take to get to his place, maybe his hesitant and doubtful answer would be: I'm at home just as you are at home, almost right here—on the shores of a mountain stream; your stream here is similar to mine; I live back there, it doesn't differ from here; I'm here now but I'm also back at home. If he were to be asked how many miles: miles? Oh, I don't calculate in miles. It's not close by, but it's not far away. Half way up a slope and as if not contained in distances. How to get there? You get there like the stream gets there and then continues to flow. You get there by having no intention, it's only a poor cottage; enter—no, you don't enter; the bench in the corner is always covered with flyers sent by the local bank, by our agricultural cooperative, by the socialist party and by ADEG, the supermarket, and by one of the media markets, not to forget this week's papers; I keep this and that in pails on the floor and I've hung the washing on the chairs. So how to get there? By following the washing lines and today's newspaper; by passing by the local bank; following the ADEG delivery truck, the postman swerving through this country in his yolky Renault. If someone were to ask Mr. Better, proprietor of a sawmill, about the exact whereabouts of his business, he might well answer: right here between us, between you and me, one of the elements between these farms and roads and hotels, a part of the harmony. On the other hand he might answer: if you set out from certain spots and places, you will find the way to my sawmill covered by a snowy layer of sawdust. There is a straight road with a white line on each side. On that road you will find a house, that seems to have slid from the shining tarmac into the maize field, and behind that house, only partly visible behind a depot, a caravan. Is this the place to set out from? For…? Well, for my sawmill. Be careful, there's a caravan to your left. And careful again: keep heading towards absolutely no landmarks. Then, to get to my sawmill, walk through the shade. Where the Telecom aerial is casting a shadow on the crossroads, you can wait, rest, ponder. Here you may leave the car and cast a shadow yourself. Is it necessary to choose a different approach to my sawmill in the afternoon? Do the houses and trees take different positions in the afternoon? Do the trees and gas stations in southern Carinthia shift? Are the farms big wandering bodies? Is my sawmill a wandering body? Are meadows heavenly bodies? Are there milky ways on the mountains? The way to my sawmill? No way. You have to put the thistle shrubbery behind you, then cross the tracks of the Bleiburg railway, then slip under the electric wire. Follow the gravel on which you will always find empty tomato cans and cigarette packs signifying that the sawmill is in this plain. Then a signifying stream. Encounter in every direction, recognition, passage, entrance, poetry, sawmills, assurance. Everything makes sense. You can hear southern Carinthian vil-

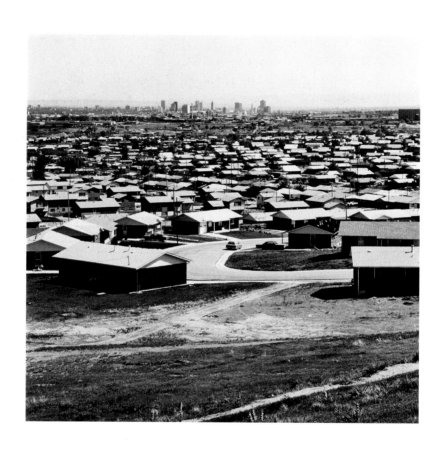

Robert Adams *The center
of Denver, ten miles distant*
from the Series *The New West* 1974

lage music. Embedded in this music, my little sawmill is playing its melody. Asking for the way to a certain house—where is the house of Mr. Lipuschnig—is like asking about the origin of the train whistle and the chime of the bells, and the answer is: everywhere; it is like asking about thunder rolling through the valleys and over them and along the mountain sides and into the town of Klagenfurt and into the ears of deer and horses and into the cowshed and into a village tavern and into the attics and into the waiting room at the station and towards Galicia and Miklauzhof and Weinberg and Vellach. A dwelling and a village, both resemble the way people speak, they are like words—like the word "Marenka" or like "day of the innocent children." It seems as if all the villages are being spoken, about to be intonated, and they have no fixed position; Miklauzhof and Zell Pfarre are verbal, they connect, give us promises, but you won't find them at predetermined locations. Cooperatively we dream Zell Pfarre. The soul is no part of the body. I listen to my neighbor speaking to his cattle, I can hear his soul. It sounds stronger than anything in me. You could say that our villages have names like Stable-door, Sparrow-noise, Watchdog-chain, Portable Radio, Hornets' Nest, Storm-and-rattling windows, Thecuckoo, Pegging Pegs, Electricwire-Ouch!, Mercedes Diesel, The Auxiliary Fire Brigade Discotheque, Hissing Toboggan. The names of the villages are confessions of love, pet names. We use them to give happiness a name. They are songs in the right moment. They no longer propose an "I" and a "we." Beehives. Parking lot. Garden fence. An undulating meadow. Pool of water. KTM-bikes. Cement mixer. Reversing garbage truck toot-toot-toot. Lipuschnig? Mr. Lipuschnig is in his Toyota, he's rolling, like thunder, between Galicia and Abtei in a countryside where people have no address. Hadn't I seen images before that led towards Asia? Where had I seen them previously? And here in the hospital ward little father, a song on his lips, went to Asia?

And I was in Juenna Universe in my car? Was I traveling in a red Volkswagen? Was I in a Mercedes Diesel? A Fiat? The meadows opened unto the unknown, open to one side as far as the Tauern Range, and as far as I didn't know where to the other side. The country stood ajar. What did that mean: ajar? Was it like a kiss? No? Like a consent to something in the distance? Was there an agreement with the mountains? The road to Jezersko crossing the road to Strasburg, was that an agreement? Was distance a sort of musical instrument and everybody allowed to blow into that long trumpet? Enormous pattern. So I pulled up on a supermarket parking lot and squatted on the curbstone. I felt many pleasures. A truck was passing through the village, I saw the name on the radiator grill and letters were missing, VOLVO became VO V. I enjoyed the innovation. It was one of the innumerable anonymous poems. VO V belonged to the imperceptible and undetectable world. Where should I go to find such a small poem? Where would a Volvo truck be driving that had lost two letters of the alphabet? In Sweden? In Texas? Was the promised land here? And spread across the parking lot—in an unfamiliar arrangement?—stood gable-shaped frames with chalk letters on them and posters fixed with adhesive tape. All these emblems—Sunkist 14.90—saw blades produced in USA—household ladders 12 rungs reduced price—onions 12 pounds—Rogaška

Slatina—and Gösser beer—and the yellow circle with a black telephone receiver suspended diagonally to indicate the public phone in the shop—and the letters in handwriting on the roof and the shop windows plastered with ads, the open passenger door of a van and FAST painted on the side of the van, the many good, low price, original, big, huge and mini and robust and fine and silent and salty and French and Spanish and sweet and ecological and natural and from Salzburg and from the High Tauern and from the Innviertel and from the Tirolian mountains—were they all different from what the Bible said? What did the Bible say? "The face of all the earth." And in the German Bible: *ergänzet die Erde.* Was this supermarket organized like Noah's Ark? Was it a refuge? Two of each; no, ten. Out in the fields stood the tabernacles, shrines, recesses, tiny taverns ("mini" taverns, "robust" and "fine"?). For what reason had they been built? Could one stay overnight in those tabernacles, shrines, tents? Had I ever spent the night in such a tent? Why all of a sudden did I have the impression of having stayed overnight once in a southern Carinthian field tabernacle and temple tent, squatting like I was squatting now on the curbstone surrounding the parking lot? "For he looked for a city which hath foundations." And why did I now spend the night, no, the day here on a parking lot? Crates were stacked along the building, empty soda water bottles in crates. They formed purple towers. Purple? Then my attention was attracted by three field tabernacles. They too were colored, but I couldn't tell whether the three frescoes were red. Were they blue? Was there a difference between red and blue? The color of dusk? Had it become dusk? From the purple towers I looked to the three shrines; from these back to the towers; and back again to the alcoves shining like lights, then back again to the purple light. By doing so I noticed something. What? Had the objects moved closer together? Had the tabernacles shifted? Were they inclining towards the crates? And was a distortion within the line of towers being mended? Was that high structure being corrected—by inclining it? Inclining it towards…? Was this side of the supermarket a slight variation—of what? Was this the moment in which slight variations began to show? Was I beginning to see? Was the inextinguishable beginning to show?

Children were on the parking lot. The oldest boy sat on his skateboard which he had kicked and propelled with his foot. One of the smaller children placed a portable radio beside the skateboarder. David Bowie began to sing. The children started to skip stretching their arms sideways and upwards and bending down low. Soon I could hear them breathing. The boy turned Bowie off. They all stood motionless. And they were holding their breath. At first I watched the motionless figures, then I looked out for the shrines. I could not find them right away, then found them, the "small," "sweet," "good," "original," and "silent" ones—in the words on the frames. Then the breathing returned, the radio played again, David Bowie sang, I looked, the children were skipping, stretching, bending down low. Was I to skip too? Were they gesturing to me? Now they stood motionless, Bowie's music was turned off. Bowie's music? The recesses out there, in which kind of music were they embedded, no, to which kind of music were they moving without holding their breath? Without holding their

breath—what did that mean? Did it mean: something was going in and out? Something came out of the tent and something went into the tent? The tents opened, stretched like a road to the High Tauern, the snow, and the reservoirs and to the villages and to the railway line and to the highway and to the Austrian frontier; but then everything returned to the tent, the tractor plowing the field and the driver on top creeping along inside the red-blue temple, a lane transformed into an inner path, the High Tauern glistened in the background of this little chamber, a pedestrian leaped into the enclosure; then the shrine was wide open again, ajar, it extended as far as the High Tauern, as far as Soboth and Rosental, and the farmer on his tractor returned to his field, his upper body swayed. In and out. Was a distortion being corrected? Was I, too, a person who is not holding his breath so that Rosental and tractor and Tauern and the roads of Juenna and the children on this parking lot inclined towards me, all of which I had to let go of again and let out and not hold onto? In which music was I? And now a song by Sting, the children skipped, stooped and turned in circles and then waved to cars passing—not to me—with their arms raised. Build a new republic here, a visible republic, because the old one was lost? Take possession of this territory? Take possession by…? By raising arms? And wasn't the old republic lost? Wasn't everybody holding their breath like these children of Bleiburg? Yet here, nothing was lost?

The child moved towards me. It sat down beside me on my curbstone bench. Was the world a melody? The child set a Playmobil figure on the ground, in front of itself – in front of us? A small Playmobil twenty-year-old wearing a helmet. The small twenty-year-old began to speak: "I can't wait for the lantern procession. How many days to go? I just had my birthday." In a different voice the child asked: "How was your birthday?" And the figure answered: "It was fun. We played, you know, you have to run in circles. As soon as the music is turned off, everyone has to stop and no one is allowed to move." The child took the figure, turned towards me, placed the figure on my knee, and it asked me: "And who are you?" "I am in charge of the lantern procession." "Really? And what do you have to do?" "I have to drive along the roads and check all the lanterns. Whether they're still there, whether they give enough light, whether new ones ought to be fitted." "But that's not a lantern procession. And why are you sitting here now?" "I like this place." "I like it, too. The ground is nice and even. I can drive my Playmobil here." "Where do you go in your car?" "Oh, I go to see my girlfriends. I go to see my girlfriends all over the world. In Africa, in Egypt, in America." The figure jumped from my knee. She stood looking at the soda water crates. "Did you know that I've got a sister?" This time I felt unsure to whom the question was addressed. The child took the helmet from the head of the girl. It said: "I've got a brother. Look, he's sitting over there. Look, look. You too, Mr. Lantern-maker, you too. How far is it to the lantern procession?" But I had wandered off; I jumbled a few things and words, I confused or translated the question and I understood: how far is it to my brother—and answered: "Only a few steps." And the child jumped up and began to sing: "Only a few steps to the lantern procession, only a few steps to the lantern procession…," and maybe something took place suddenly: the child ran

towards time. Towards time? Or it did something I was unable to do or quite on the contrary able to do? "Only a few steps to the lantern procession," was it making fun of that sentence, was it taking it seriously? What sort of a song was this? Did the child realize that I had spoken about its brother—and therefore it skipped towards the other children now? Or was the song intended to mean: any answer would have suited me. Five years; and she would have sung: five years to the lantern procession. Ten years; she would have sung about the ten years. Five minutes, three minutes, one minute; she would have sung about the minutes. She would have sung about seconds, too, and about one second. If I had said: I don't know; would she have sung "I don't know"? Did that mean: all answers were acceptable? All answers were right? Did that mean: everything was acceptable and right? A festivity far ahead in the future was as acceptable and right as an event promised to take place in two minutes? Was everything acceptable? Couldn't it be that she was making fun of me? Were these small people jugglers and clowns? The child was still repeating my right or wrong answer. Then someone shouted: "Go." The children began to somersault. Was this more mockery or was the situation becoming more serious? Was everything acceptable? A truck drove by on the road to Bleiburg, wardrobes, tables, chairs, and other furniture rocking on it; they rocked, juggled, were about to tumble, like a precarious construction. All answers acceptable? The pieces of furniture rattled and drummed along and the truck jumped. Rattling and drumming wardrobes and tables.

I had driven over the Juenna plains wanting to cross the border shortly after Bleiburg. I took a map out of the inside pocket of my blue sailing jacket and unfolded it and saw the names, the nameless names of this valley, Globasnitz, Smihel, Koprein, St. Nikolai, Lavamündung, Siebenhütten, Luscha. I raised my eyes and saw a signpost on the road with Bukovska vás, Slovenj Gradec, Podgorje, Lokovica, Poljana, Komisija written on it. When had I crossed the border and seen the tollbooth and the second tollbooth and the customs officers on one side and on the other side? Hadn't I intended to say to the customs officer while he turned the almost empty pages of my passport: Don't take your job so seriously; or had I wanted to say: You're taking it very easy, aren't you?—I have no business here, therefore I'm taking it easy, but you?, aren't you taking it too easy?, too lightly? The villages lay spread across the hills and along the roads, higher up was Lokovica, Bukovska vás, deep down lay Dravograd, Gradec, in a plain further south lay Ljubljana City. The last night of October drew closer, believed to be the night of the saints—but what were saints? I knew a different explanation— "the night set apart for a universal walking abroad of spirits, carnival time of disembodied spirits." Spirits? Did not the village windows, high up on mountains, sparkle by night like the eyes of spirits? Walking abroad? Walking on a wide plateau like someone walking on a road, like pedestrians walking on the banks of the road from village to village, on a surface as vast and wide as a parking lot, with arms stretched, outdoors, in fresh air, like skateboard kids, like children in parking-lot circus skipping and twirling to the carnival music of David Bowie.

On both sides of the road villages with shining windows and pedestrians with shopping bags in both hands, in the dusk children on Playmobil Esplanade, crowded and luminous buses going to Slovenj Gradec, me in my automobile—all dressed up for carnival, a whole lot of walking spirits, not long before October 31. The bazaar with its multitude of colors, enormous pumpkins, sweet peppers side by side, the stalls with bright lights, passengers waiting at the bus-stop—was it new year's tide, were these the Karawank carnival spirits of New Year?

Oct./Nov. 1999
translated in January 2000
finalized March 2000

Eugéne Atget

Edgar Degas

Ed Ruscha

Thomas Struth

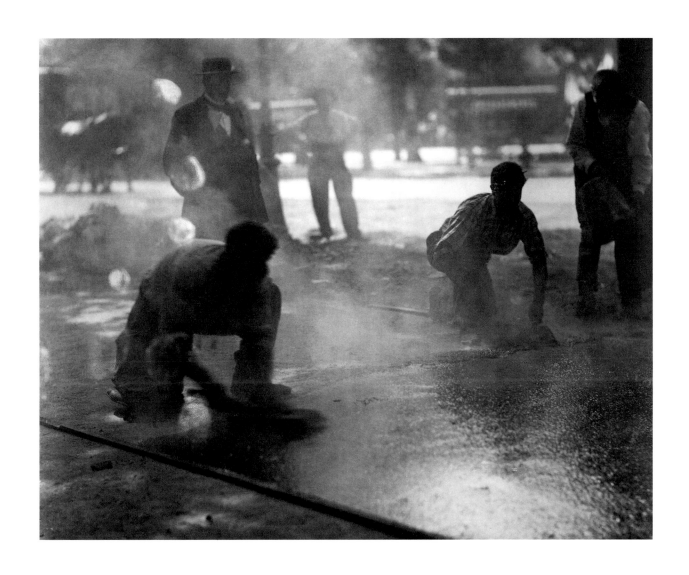

Eugène Atget
Asphalters 1899–1900
The Museum of Modern Art,
New York. Purchase
© 2000 The Museum
of Modern Art, New York

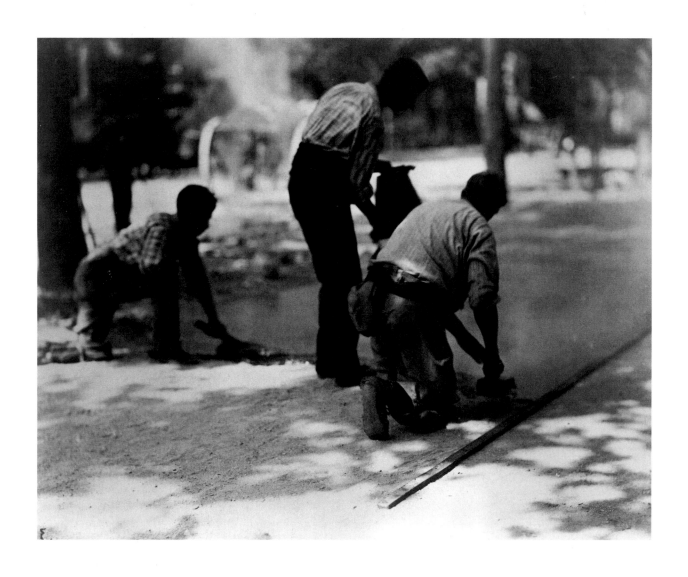

Eugène Atget
Asphalters 1899-1900
The Museum of Modern Art, New York.
Abbott-Levy Collection. Partial gift of
Shirley C. Burden
Copy Print © 2000 The Museum
of Modern Art, New York

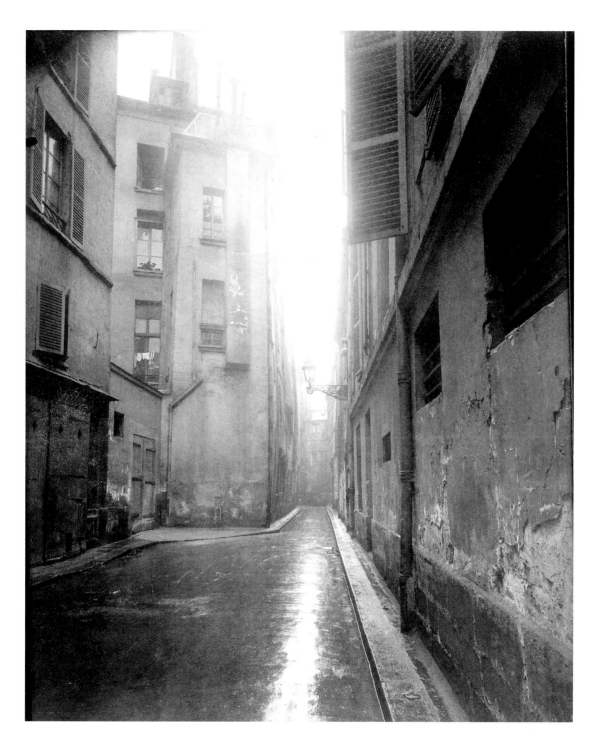

Eugène Atget
Rue de Nevers 1924
Musée Carnavalet, Paris
© Photothèque des Musées
de la Ville de Paris / Joffre

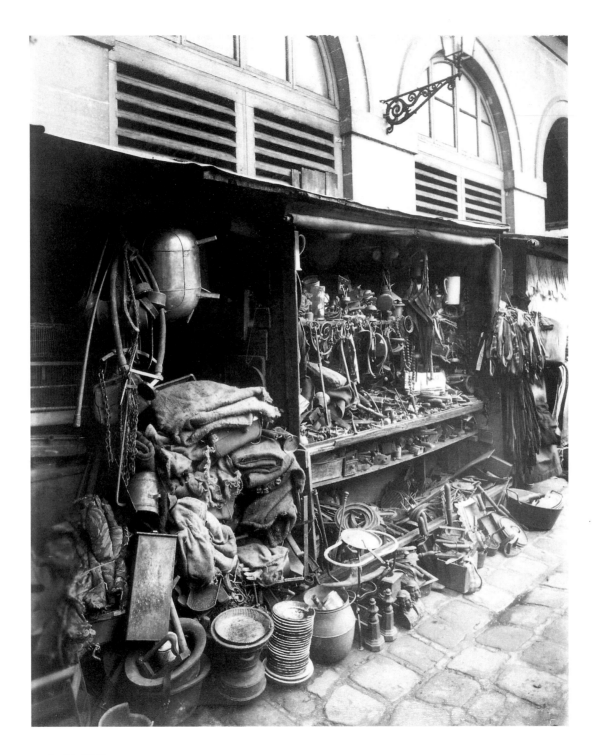

Eugène Atget
The Market at Carmes 1910
Musée Carnavalet, Paris
© Photothèque des Musées
de la Ville de Paris / Joffre

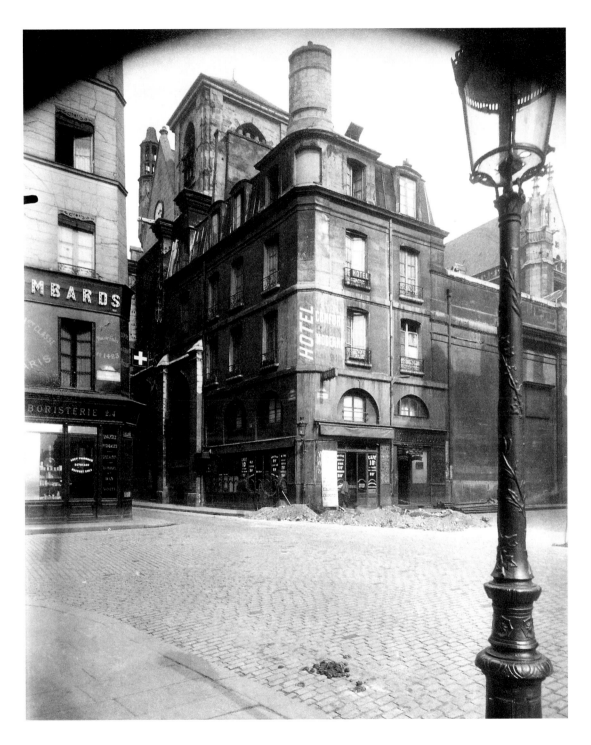

Eugène Atget
Corner of rue St. Martin and rue des Lombards 1924
Musée Carnavalet, Paris
© Photothèque des Musées
de la Ville de Paris / Joffre

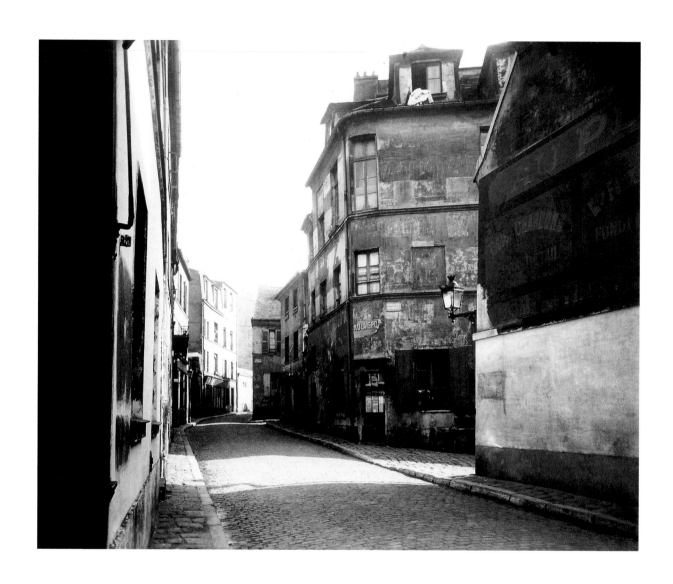

Eugène Atget
Rue Norvins 1922
Musée Carnavalet, Paris
© Photothèque des Musées
de la Ville de Paris / Joffre

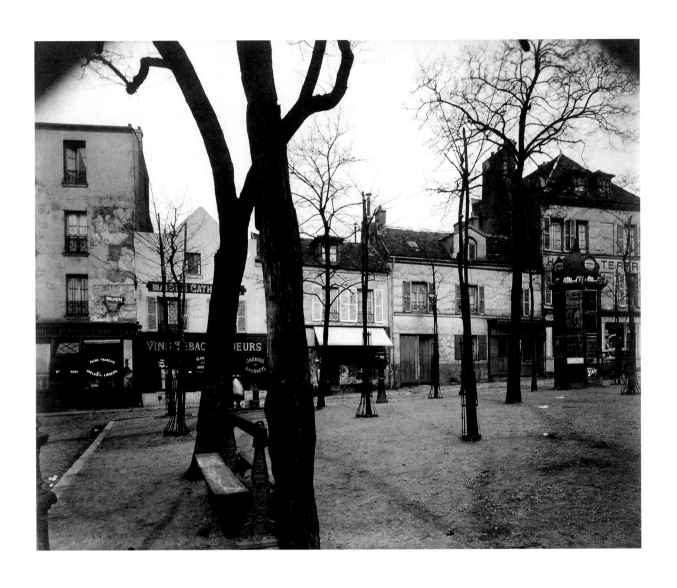

Eugène Atget
Place du Tertre 1922
Musée Carnavalet, Paris
© Photothèque des Musées
de la Ville de Paris / Joffre

Eugène Atget
Hôtel Maufréon, Staircase 1907
Musée Carnavalet, Paris
© Photothèque des Musées
de la Ville de Paris / Joffre

Eugène Atget
Doorknocker at la Madeleine 1907
Musée Carnavalet, Paris
© Photothèque des Musées
de la Ville de Paris / Joffre

Eugène Atget
Shop sign »Au franc buveur« 1922
Musée Carnavalet, Paris
© Photothèque des Musées
de la Ville de Paris / Joffre

Eugène Atget
20 rue de Varenne, Doorknocker 1911
Musée Carnavalet, Paris
© Photothèque des Musées
de la Ville de Paris / Joffre

Eugène Atget
Hairdresser, Boulevard de Strasbourg
Paris ca. 1905
Private collection

Eugène Atget
Naturalist, rue de l'Ecole de Médecine 1926-1927
The Museum of Modern Art, New York. Abbott-Levy Collection.
Partial gift of Shirley C. Burden
Print by Chicago Albumen Works, 1984
© 2000 The Museum of Modern Art, New York

Eugène Atget
Fête de Vaugirard 1926
The Museum of Modern Art, New York. Abbott-Levy
Collection. Partial gift of Shirley C. Burden
© 2000 The Museum of Modern Art, New York

Edgar Degas
Musiciens à l'orchestre 1872
Städelsche Galerie im Städelschen
Kunstinstitut, Frankfurt am Main

8775

Ed Ruscha
*Every building on
the Sunset Strip* (detail) 1966
Collection Siemens Kulturprogramm

8780 8782 8788 Palm 8800 8802 8804 8806

8789

Thomas Struth
Hofgraben, Munich 1981
Thomas Struth, Courtesy Galerie Max Hetzler, Berlin

Thomas Struth
Steet near Charleroi, Charleroi 1980
Thomas Struth, Courtesy Galerie Max Hetzler, Berlin

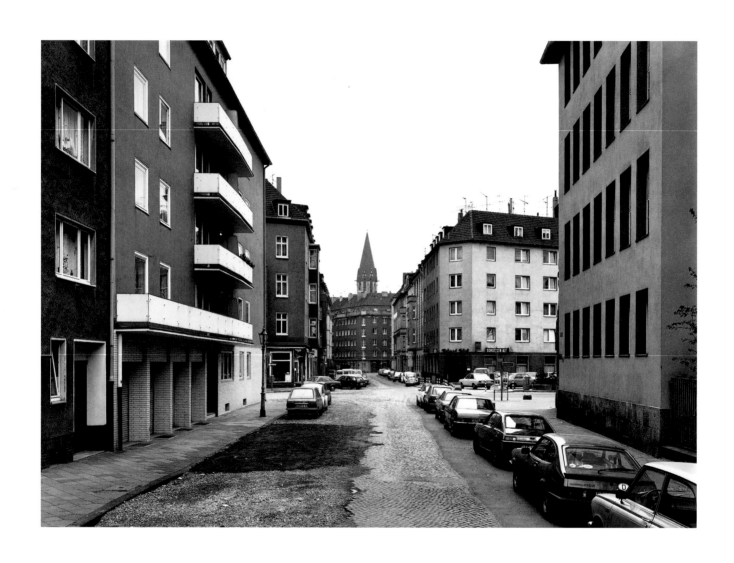

Thomas Struth
Düsselstraße, Düsseldorf 1979
Thomas Struth, Courtesy Galerie Max Hetzler, Berlin

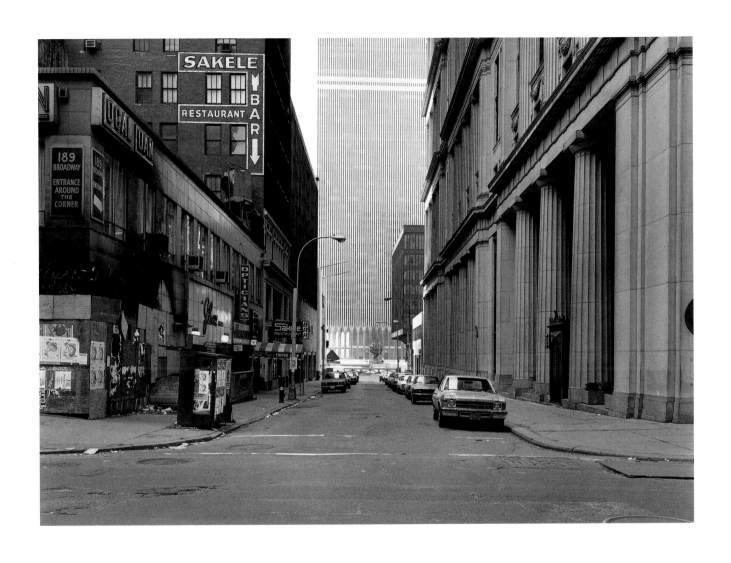

Thomas Struth
Dey Street, New York 1978
Thomas Struth, Courtesy Galerie Max Hetzler, Berlin

Thomas Struth
People on Fuxing Dong Lu, Shanghai 1997
Collection Bernd F. Künne

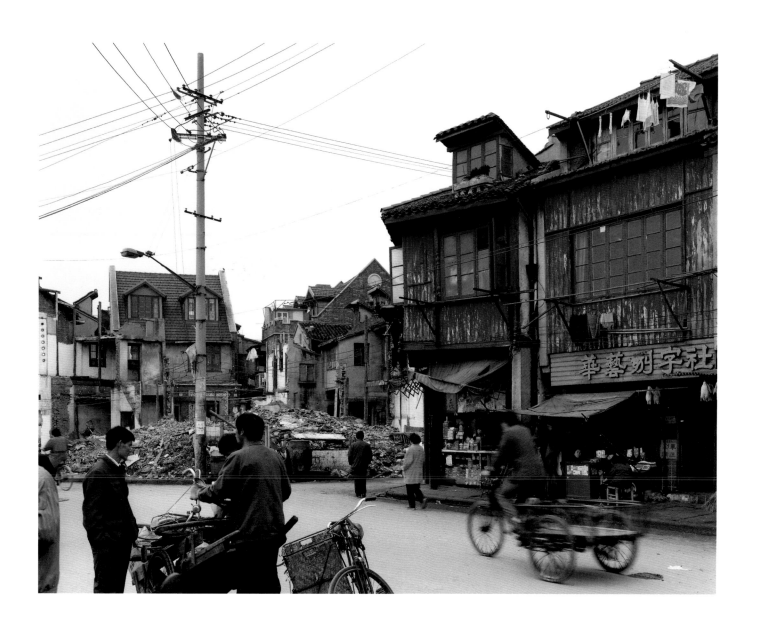

Paul Strand

Charles Sheeler

Albert Marquet

Vilhelm Hammershøi

Max Beckmann

Albert Renger-Patzsch

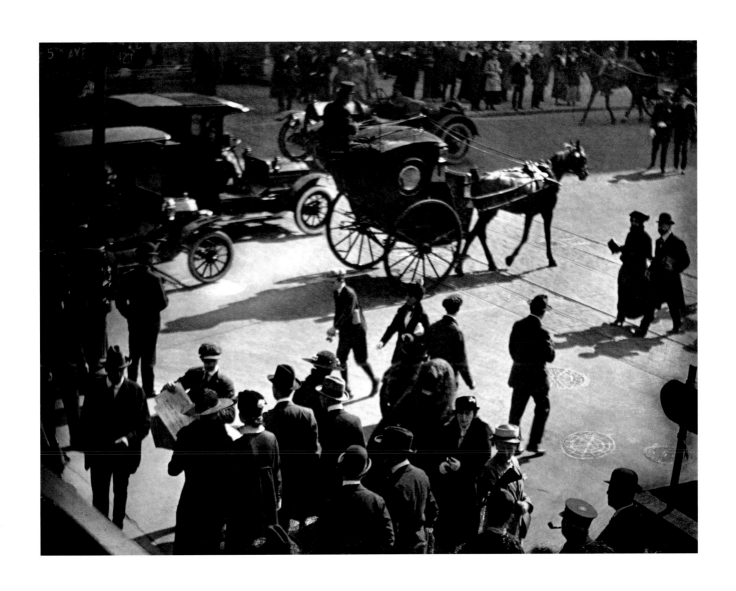

Paul Strand
Fifth Avenue and 42nd Street, New York 1915
© 1971 Aperture Foundation Inc.,
Paul Strand Archive

Paul Strand
Porch Shadows, Twin Lakes, Connecticut 1916
© 1971 Aperture Foundation Inc.,
Paul Strand Archive

Paul Strand
Wall Street, New York 1915
© 1971 Aperture Foundation Inc.,
Paul Strand Archive

Paul Strand
Untitled 1916
© 1981 Aperture Foundation Inc.,
Paul Strand Archive

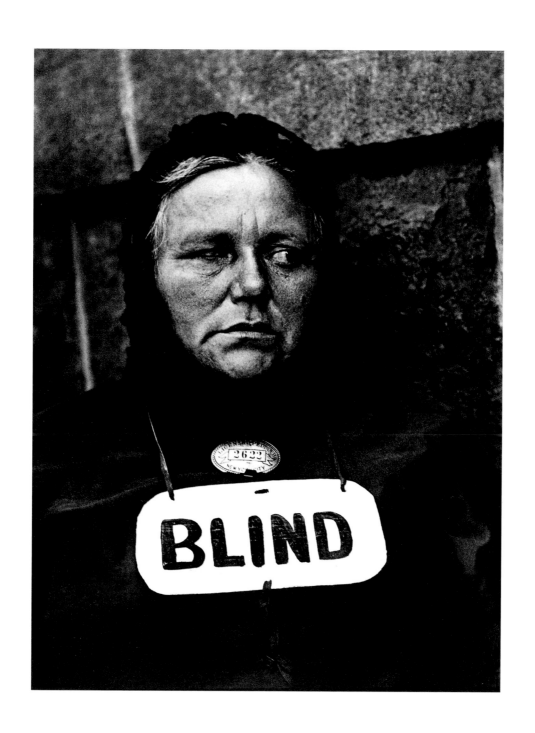

Paul Strand
Blind Woman, New York 1916
© 1971 Aperture Foundation Inc.,
Paul Strand Archive

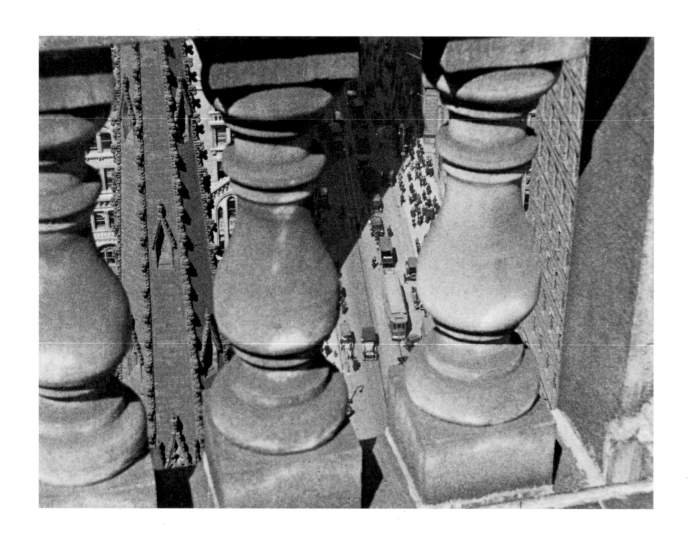

Charles Sheeler
Manhatta-Through a Balustrade 1920
The Lane Collection, Courtesy of Museum of Fine Arts, Boston.
Reproduced with permission
© 1999 Museum of Fine Arts, Boston. All Rights Reserved.

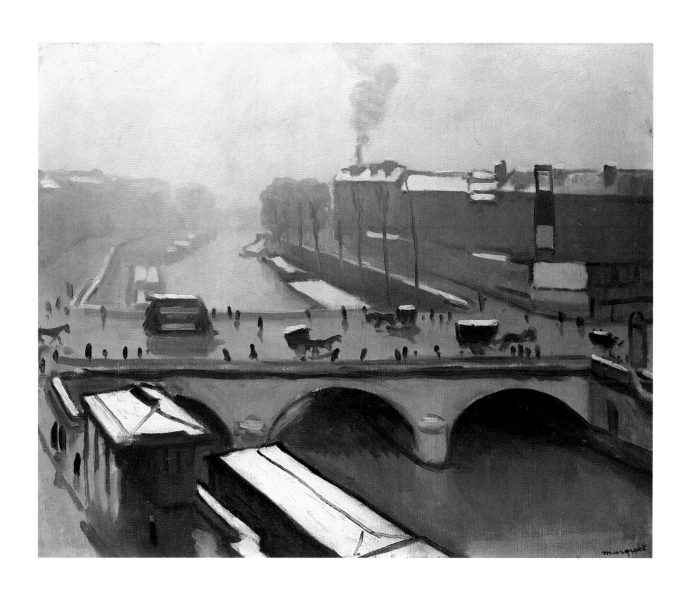

Albert Marquet
View of the Pont Saint Michel in Paris 1912
Staatliche Kunsthalle Karlsruhe

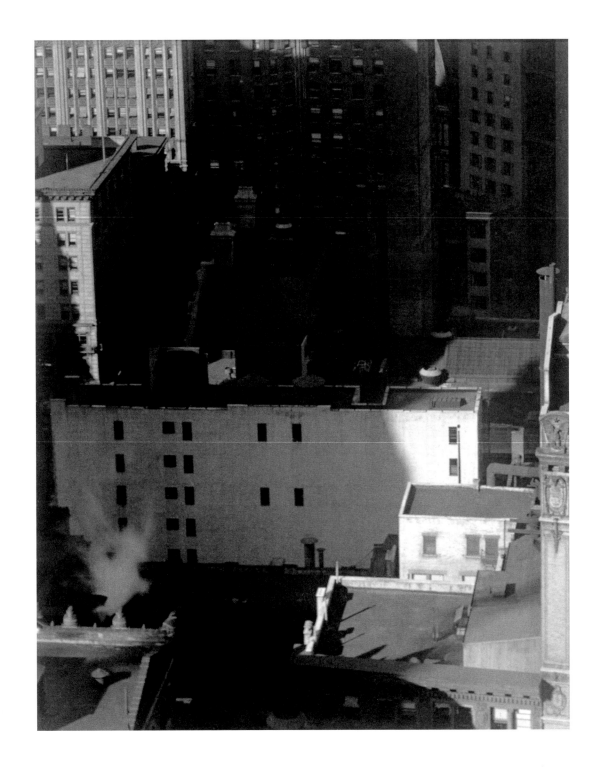

Charles Sheeler
New York, Buildings in the Shadows 1920
The Lane Collection, Courtesy of Museum of Fine Arts, Boston.
Reproduced with permission
© 1999 Museum of Fine Arts, Boston. All Rights Reserved.

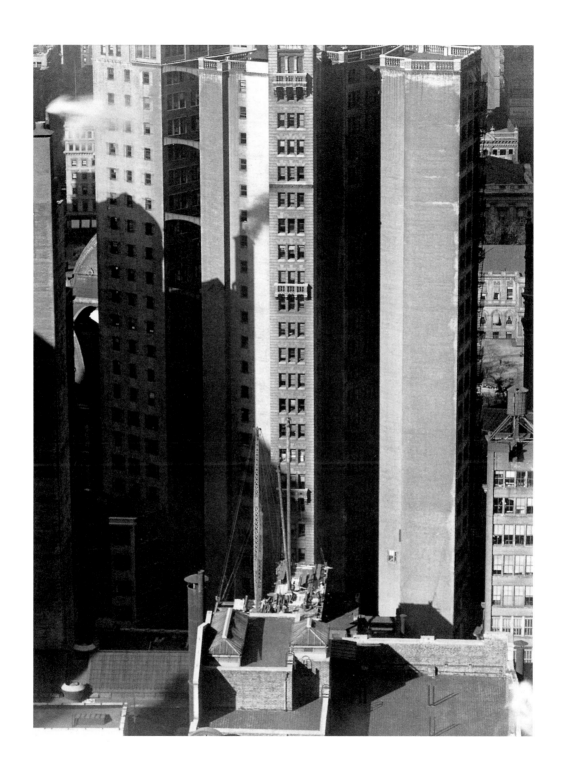

Charles Sheeler
New York, Park Row Building 1920
The Lane Collection, Courtesy of Museum of Fine Arts, Boston.
Reproduced with permission
© 1999 Museum of Fine Arts, Boston. All Rights Reserved.

Vilhelm Hammershøi
Interior (Sunny Room) 1905
Staatliche Museen zu Berlin, Nationalgalerie

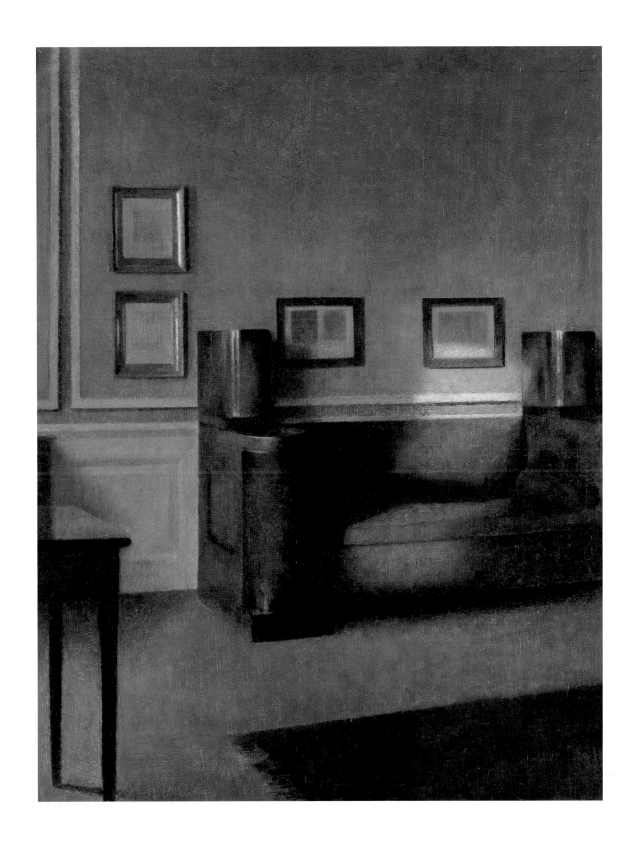

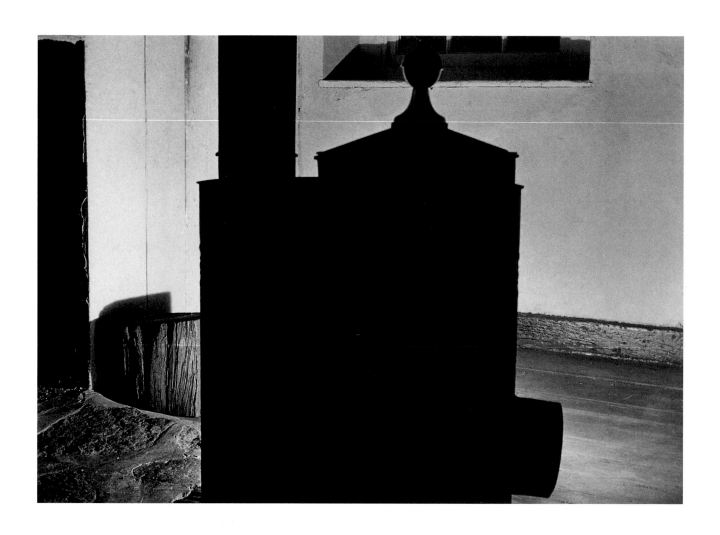

Charles Sheeler
Doylestown House, Stove, Horizontal 1917
The Lane Collection, Courtesy of Museum of Fine Arts, Boston.
Reproduced with permission
© 1999 Museum of Fine Arts, Boston. All Rights Reserved.

Charles Sheeler
Doylestown House, Downstairs Window 1917
The Lane Collection, Courtesy of Museum of Fine Arts, Boston.
Reproduced with permission
© 1999 Museum of Fine Arts, Boston. All Rights Reserved.

150

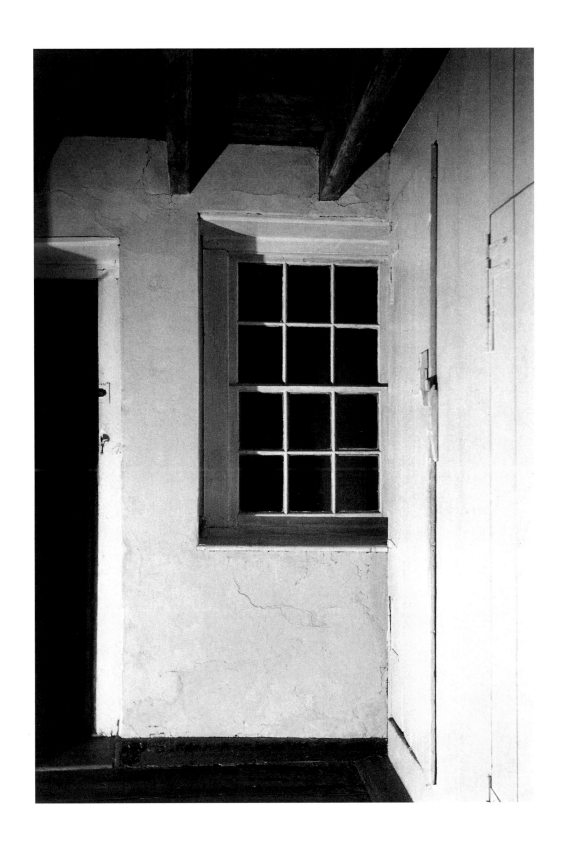

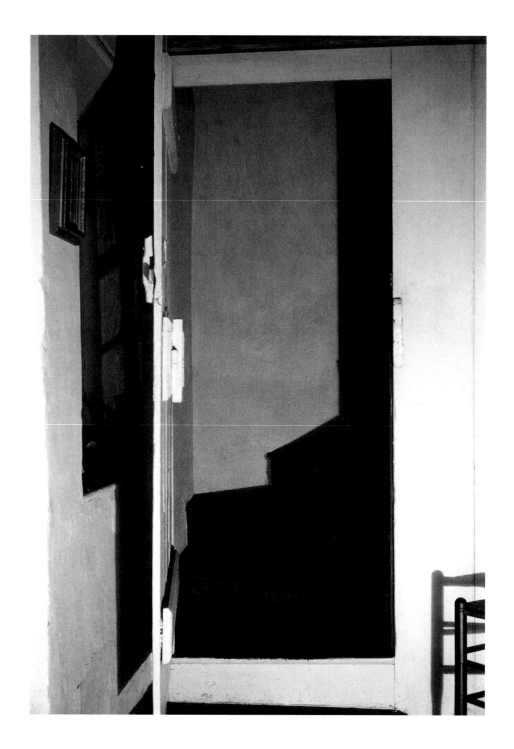

Charles Sheeler
Doylestown House, Stairway with Chair 1917
The Lane Collection, Courtesy of Museum of Fine Arts, Boston.
Reproduced with permission
© 1999 Museum of Fine Arts, Boston. All Rights Reserved.

Charles Sheeler
Doylestown House, Stairs from Below 1917
The Lane Collection, Courtesy of Museum of Fine Arts, Boston.
Reproduced with permission
© 1999 Museum of Fine Arts, Boston. All Rights Reserved.

155

Albert Renger-Patzsch
Essen-Bergeborbeck 1929
All Exhibits: Albert Renger-Patzsch Archiv
Ann und Jürgen Wilde, Zülpich

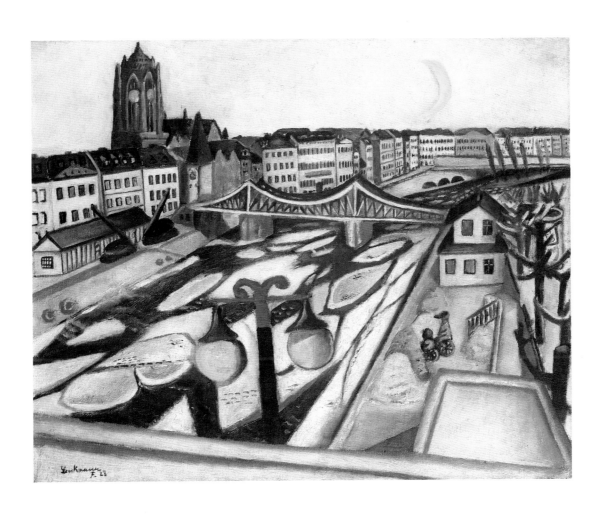

Max Beckmann
Ice Flow 1923
Städelsches Kunstinstitut, Frankfurt am Main
Property of the Städelscher Museumsverein e.V.

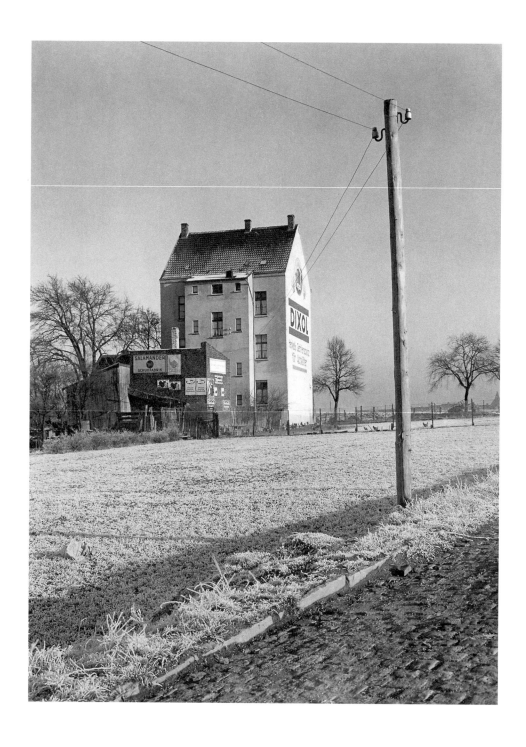

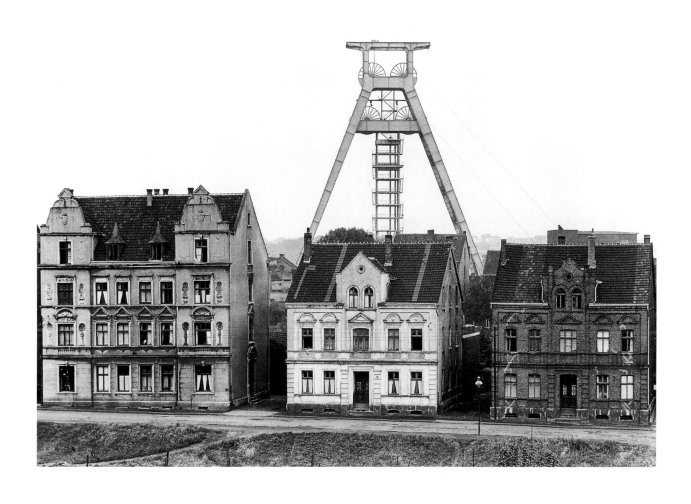

Albert Renger-Patzsch
Outskirts of Essen 1928

Albert Renger-Patzsch
The "Germania" Colliery in Dortmund-Marten 1935

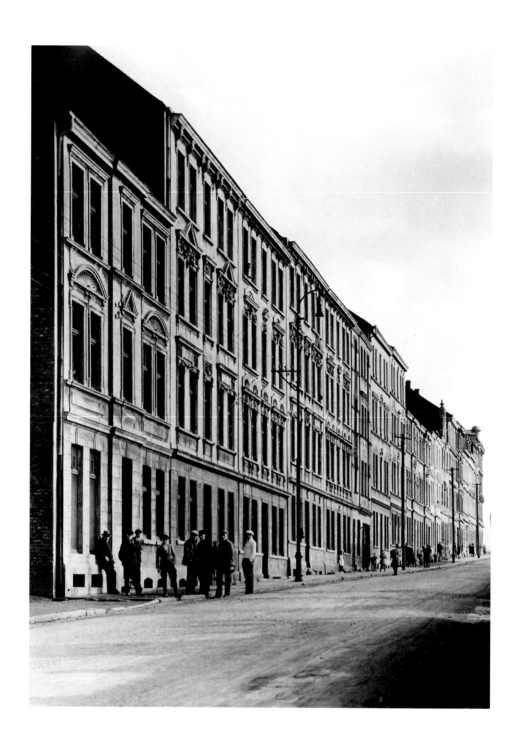

Albert Renger-Patzsch
Houses in Essen-Segeroth 1932

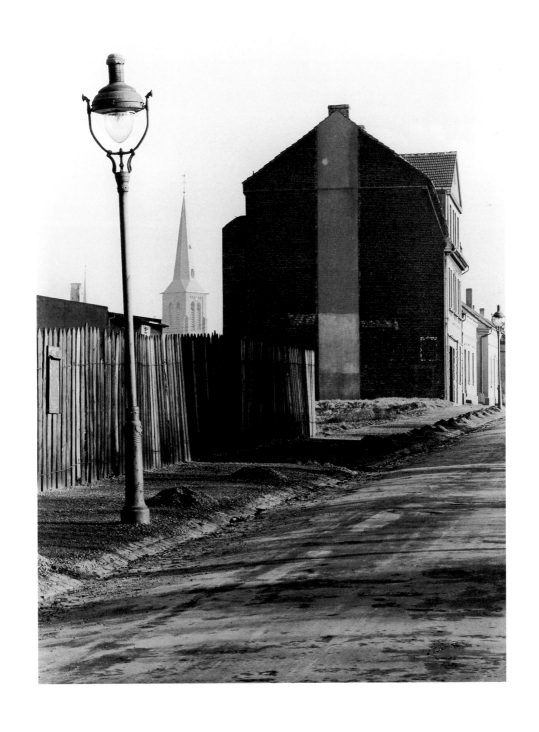

Albert Renger-Patzsch
Oberhauserstraße in Essen-Bedingrade 1932

Albert Renger-Patzsch
"Eiserne Hand" in Essen 1929

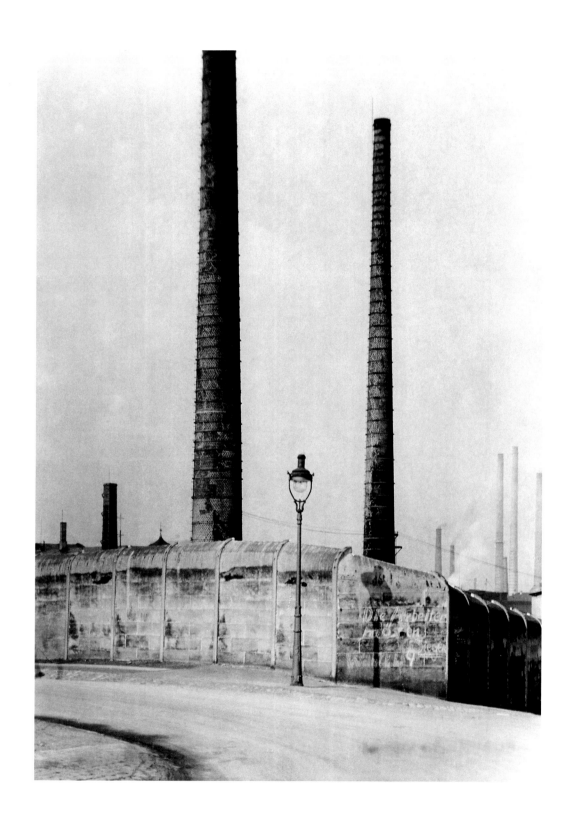

August Sander

Oskar Schlemmer

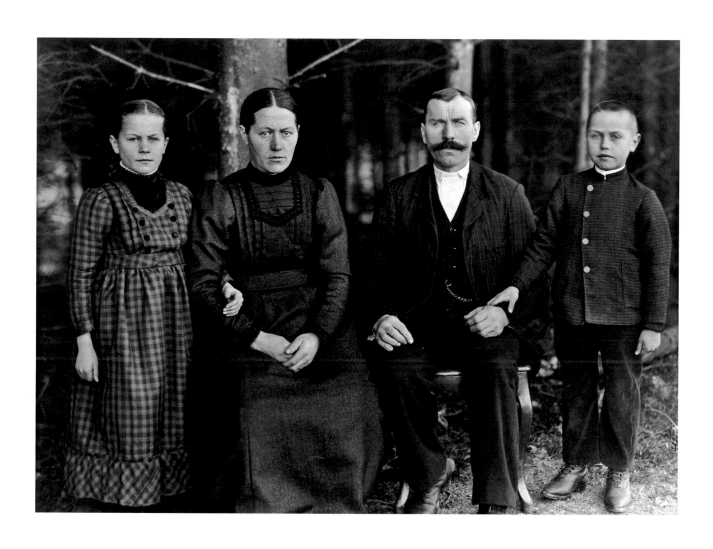

August Sander
Peasant Family 1911/12
Private collection

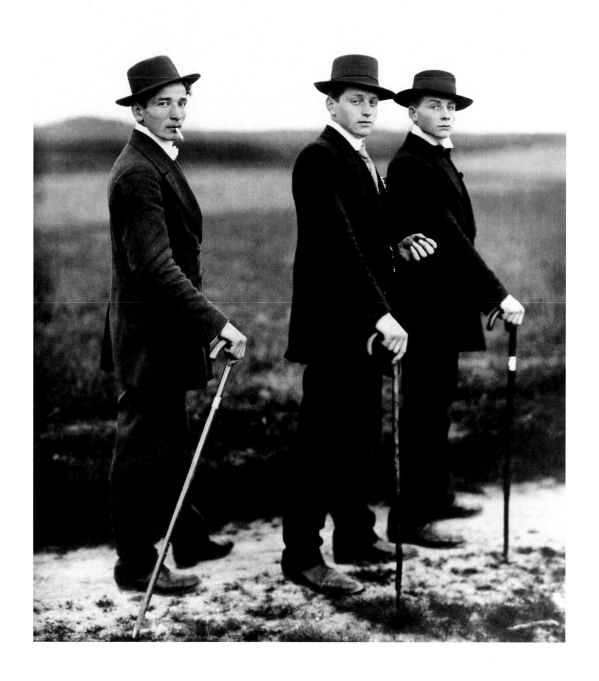

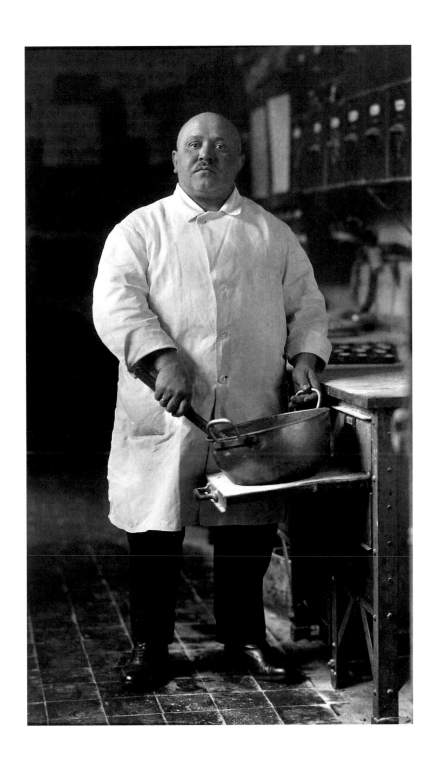

August Sander
Young Farmers, Westerwald 1914
Die Photographische Sammlung/
SK Stiftung Kultur, Cologne

August Sander
Pastry Cook 1928
Die Photographische Sammlung/
SK Stiftung Kultur, Cologne

August Sander
The Gentleman Farmer 1924
Private collection

August Sander
*Mother and Daughter, Farmer's
and Miner's Wives* 1912
Private collection

August Sander
Lawyer 1931
Die Photographische Sammlung/
SK Stiftung Kultur, Cologne

Oskar Schlemmer
Encountering Each Other in an Interior 1928
Sprengel Museum Hannover

August Sander
The Painter (Anton Räderscheidt) ca. 1926
Private collection

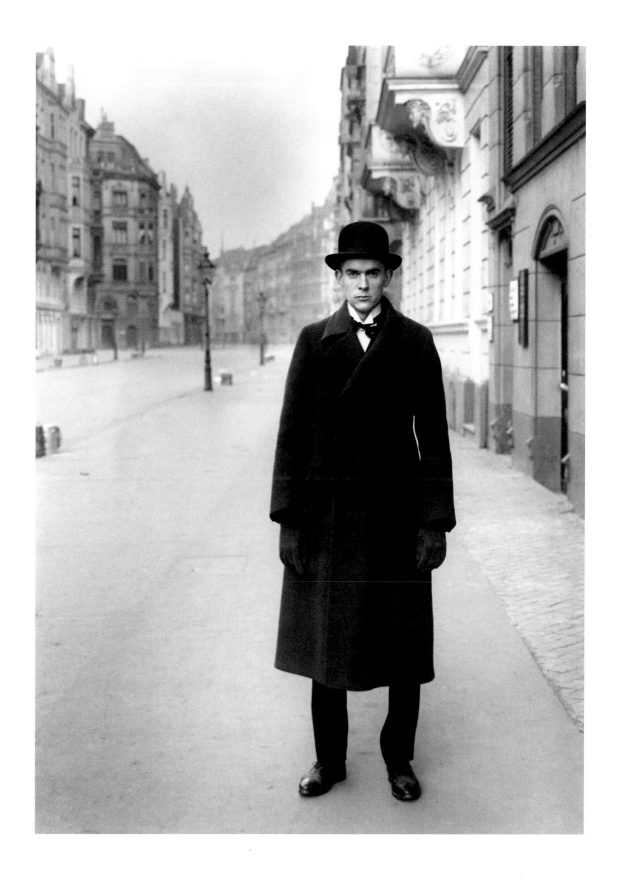

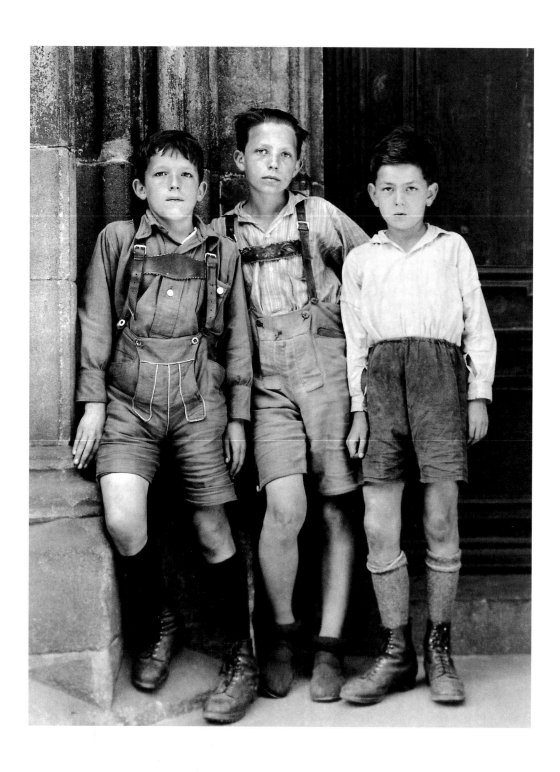

August Sander
City Children, Vienna 1930
Private collection

August Sander
Girl in a Circus Trailer 1932
Private collection

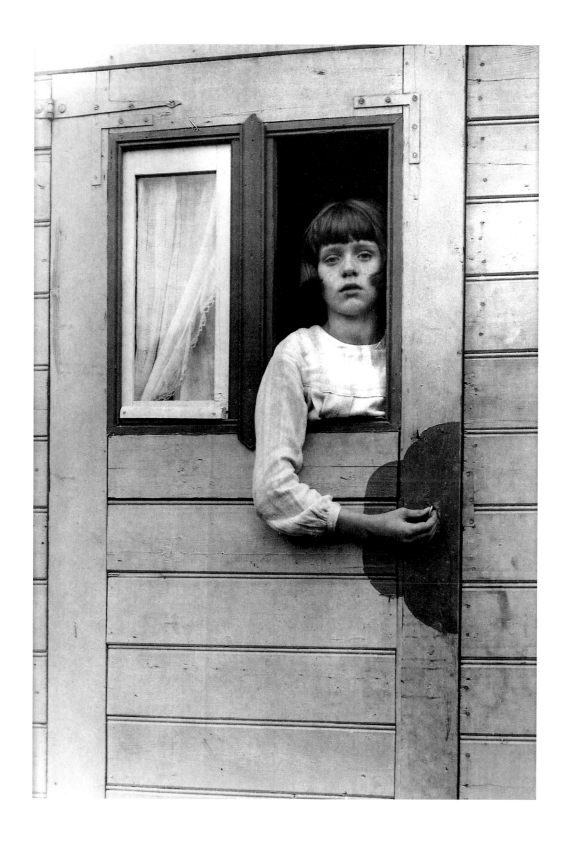

August Sander
Victim of Persecution, Cologne ca. 1938
Die Photographische Sammlung/
SK Stiftung Kultur, Cologne

Walker Evans

Edward Hopper

Andy Warhol

Jasper Johns

Robert Frank

Mark Rothko

Walker Evans
*Penny Picture Display, Savannah / Photographer's
Window Display, Birmingham, Alabama* 1936
The J. Paul Getty Museum, Los Angeles
All Exhibits: © Walker Evans Archive,
The Metropolitan Museum of Art

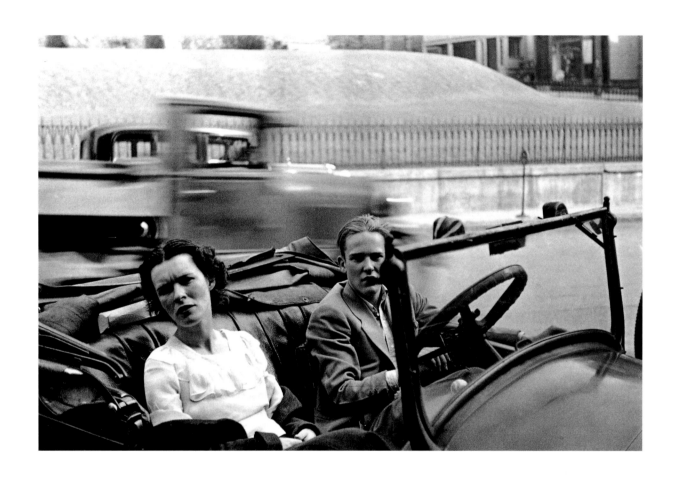

Walker Evans
Parked Car, Small Town, Main Street 1932
Gift of Phyllis Lambert, Montreal, 1982
National Gallery of Canada, Ottawa

Walker Evans
Roadside Gas Sign 1929
Gift of Phyllis Lambert, Montreal, 1982
National Gallery of Canada, Ottawa

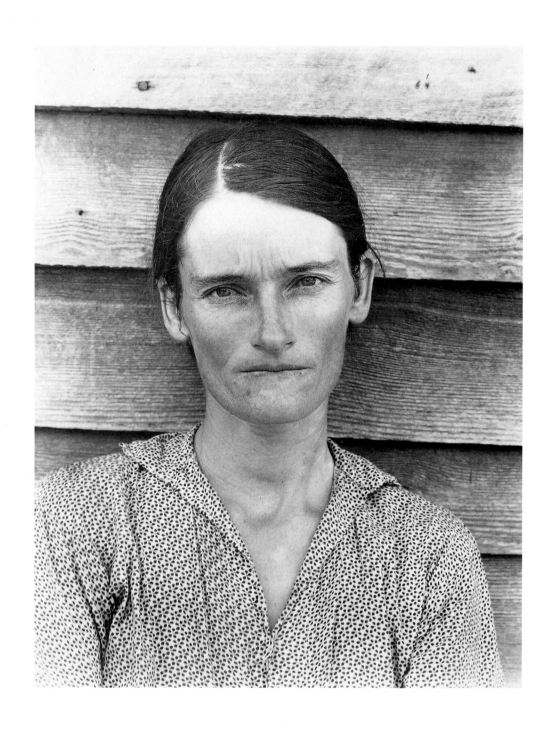

Walker Evans
Allie Mae Burroughs, Wife of a Cotton Sharecropper
Hale County, Alabama 1936
The J. Paul Getty Museum, Los Angeles

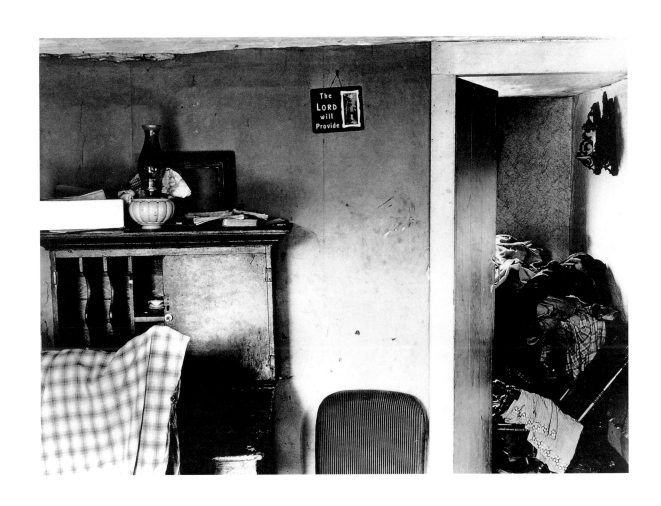

Walker Evans
New York State Farm Interior 1931
Gift of Benjamin Greenberg, Ottawa, 1981
National Gallery of Canada, Ottawa

Edward Hopper
Manhattan Bridge Loop 1928
Addison Gallery of American Art,
Phillips Academy, Andover, Massachusetts.
Gift of Stephen C. Clark, Esq.

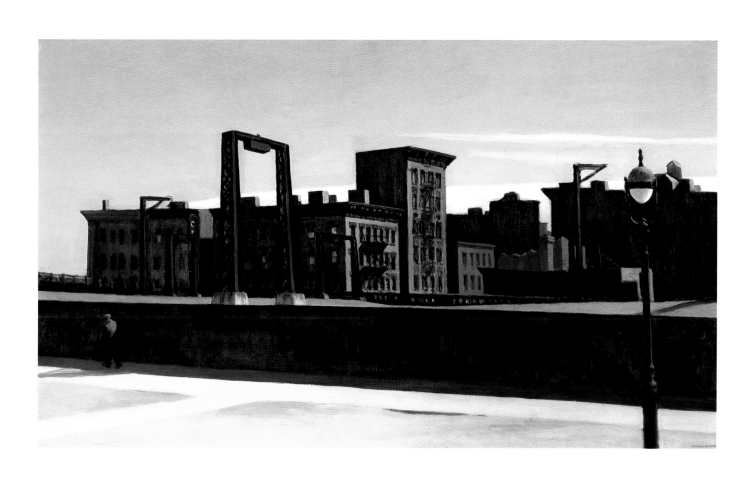

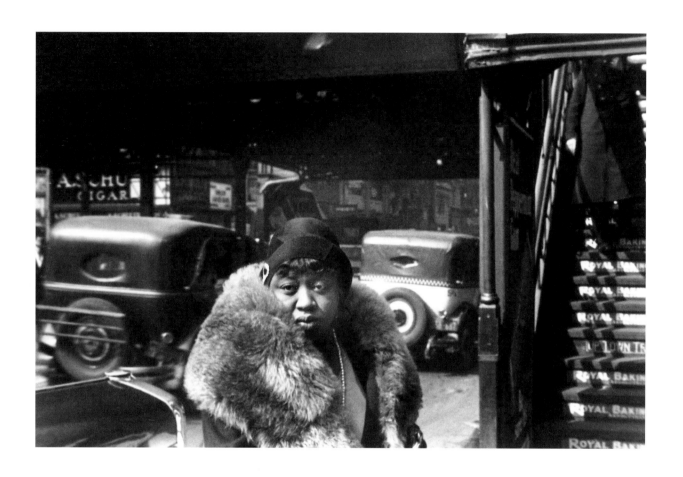

Walker Evans
42nd Street, New York 1929
Gift of Phyllis Lambert, Montreal, 1982
National Gallery of Canada, Ottawa

Walker Evans
Citizen in Downtown Havana 1933
Gift of Benjamin Greenberg, Ottawa, 1981
National Gallery of Canada, Ottawa

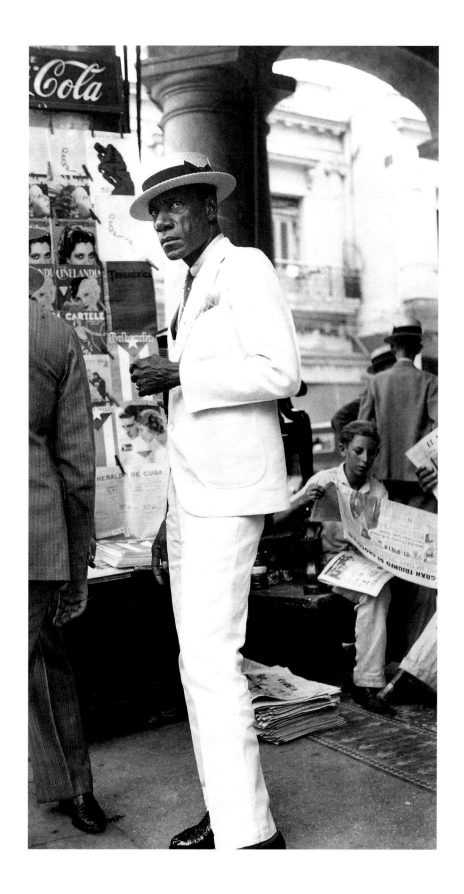

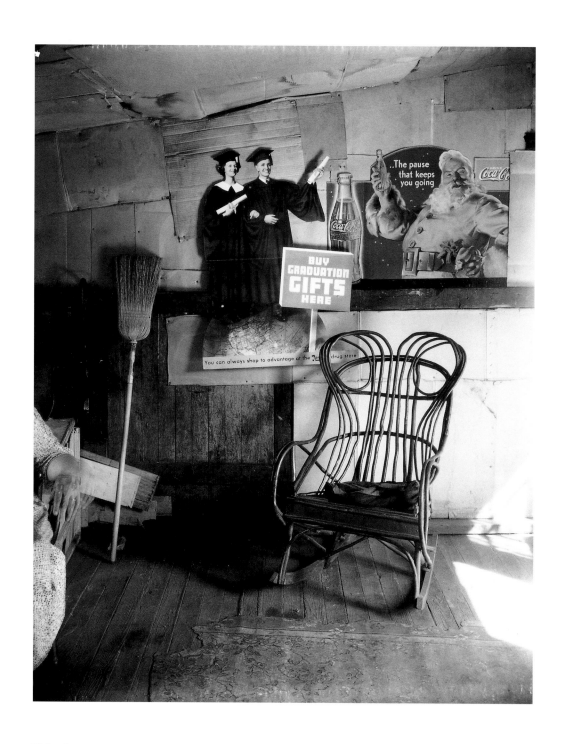

Walker Evans
Interior Detail, West Virginia
Coal Miner's House 1935
Gift of Phyllis Lambert, Montreal, 1982
National Gallery of Canada, Ottawa

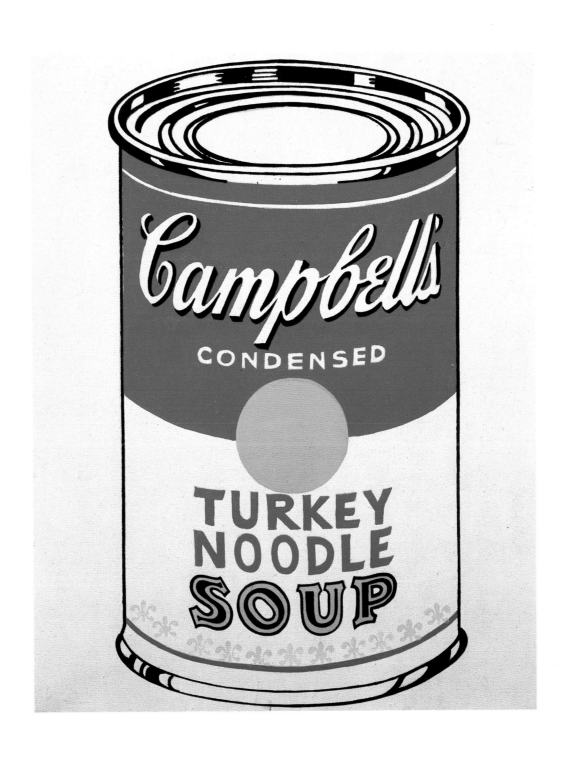

Andy Warhol
Campbell's Soup Can (Turkey Noodle) 1962
Sonnabend Collection

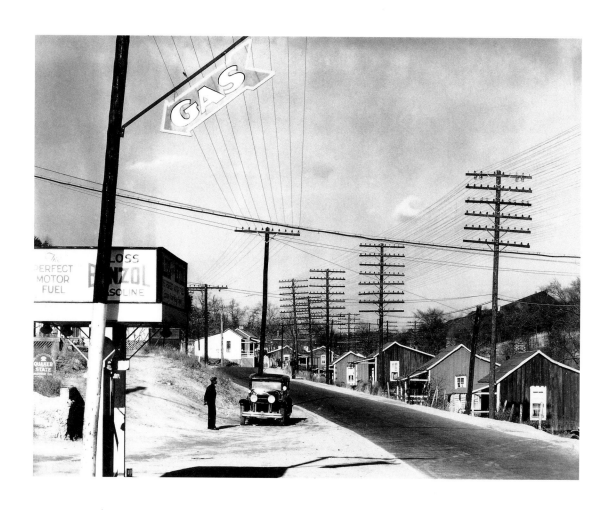

Walker Evans
*Roadside Houses for Miners, Vicinity
of Birmingham, Alabama* 1935
Gift of Phyllis Lambert, Montreal, 1982
National Gallery of Canada, Ottawa

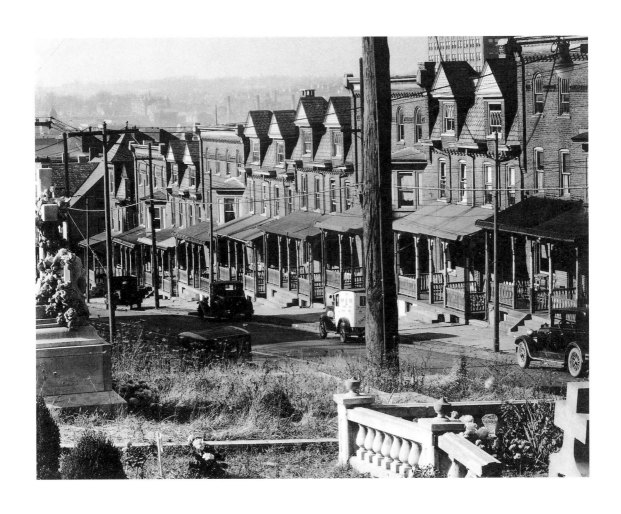

Walker Evans
Street Scene, Bethlehem, Pennsylvania 1935
Gift of Phyllis Lambert, Montreal, 1982
National Gallery of Canada, Ottawa

Jasper Johns
Grey Target 1958
Private collection
Courtesy Sonnabend Gallery

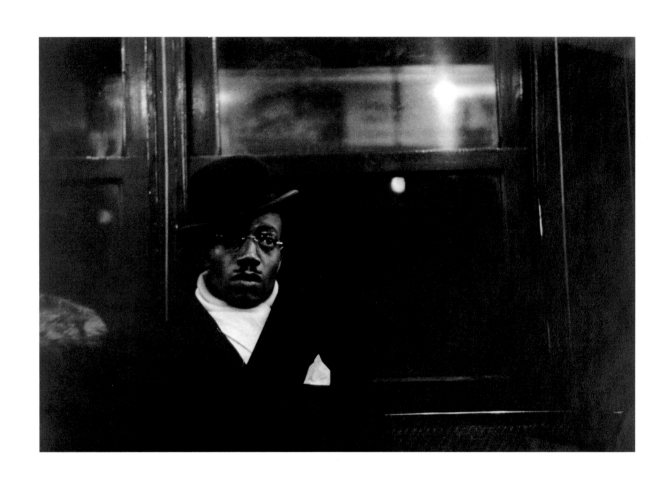

Walker Evans
Subway Portrait 1941
The J. Paul Getty Museum, Los Angeles

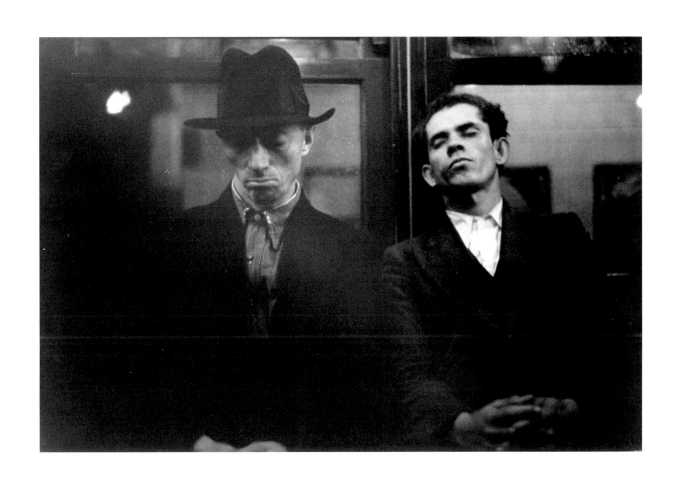

Walker Evans
Subway Portrait 1938–1941
The J. Paul Getty Museum, Los Angeles

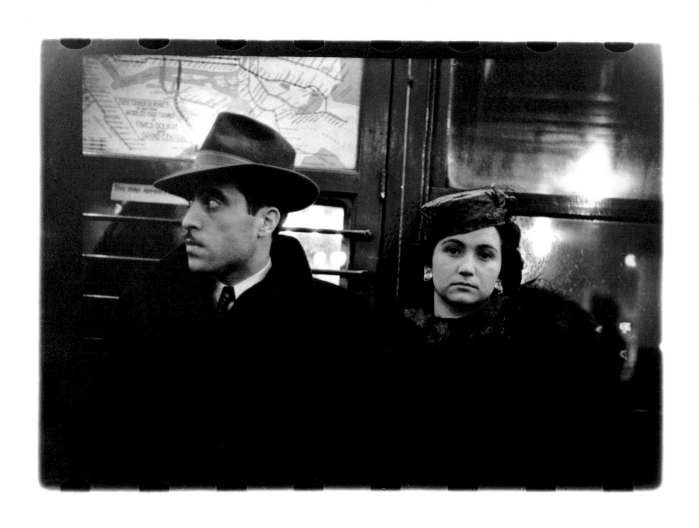

Walker Evans
Subway Portrait 1938–1941
The J. Paul Getty Museum, Los Angeles

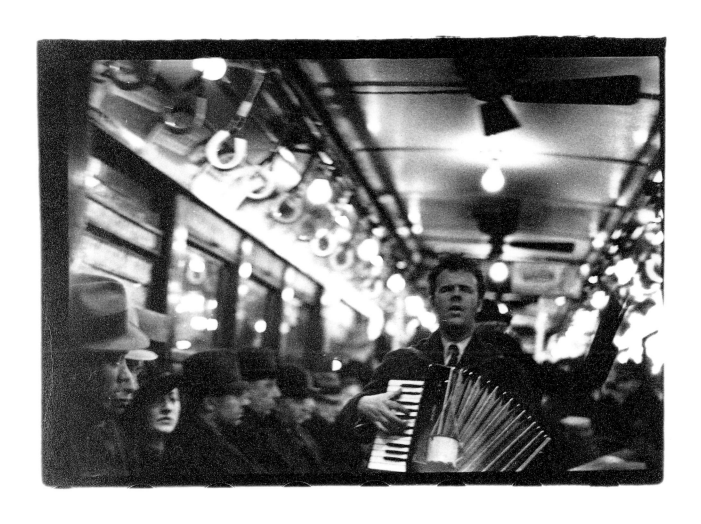

Walker Evans
Subway Portrait 1938–1941
The J. Paul Getty Museum, Los Angeles

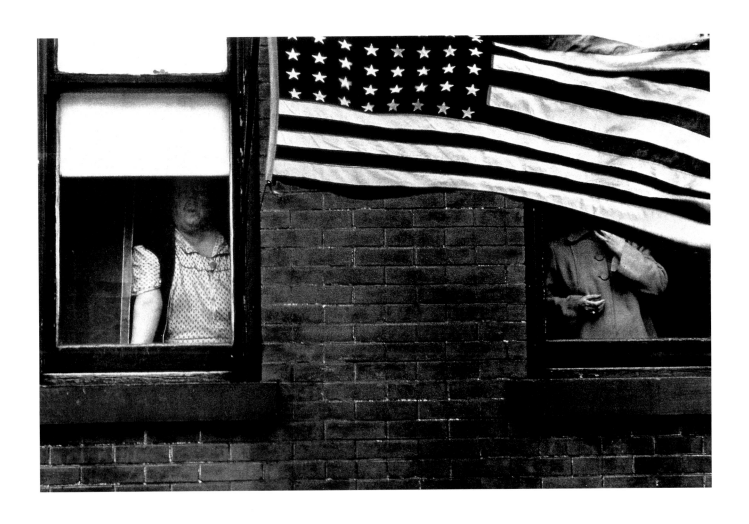

Robert Frank
City fathers, Hoboken, New Jersey
1955/56

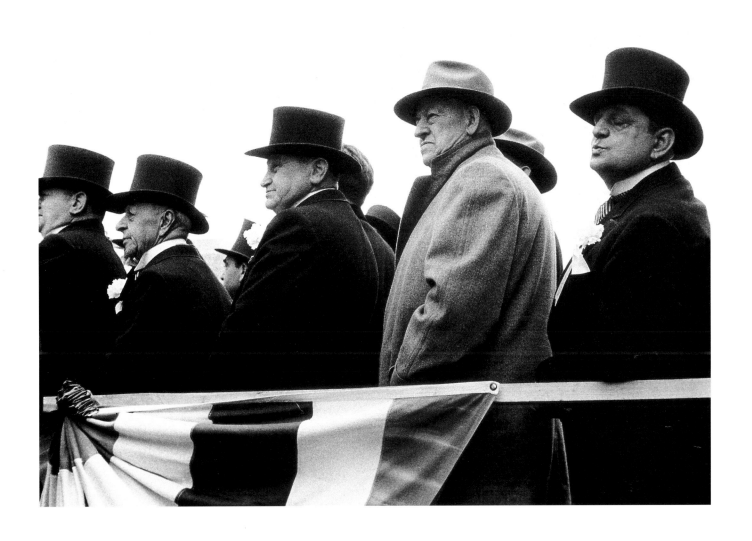

Robert Frank
Funeral, St. Helena, South Carolina
1955/56

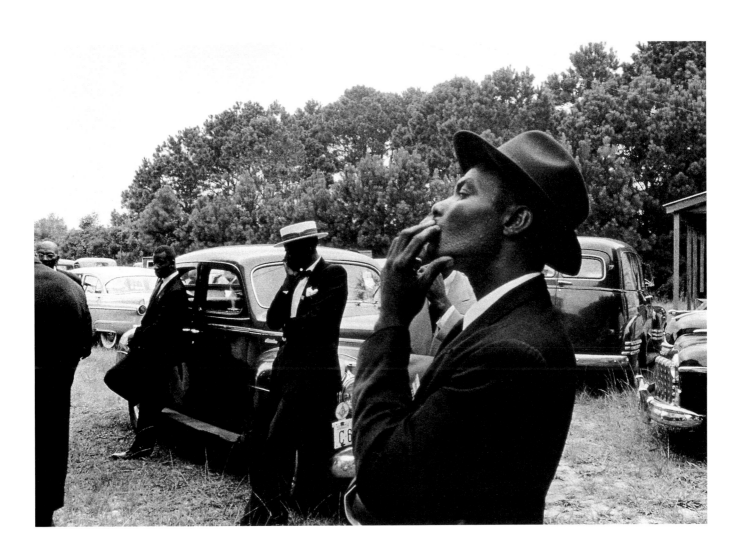

Robert Frank
Trolley, New Orleans
1955/56

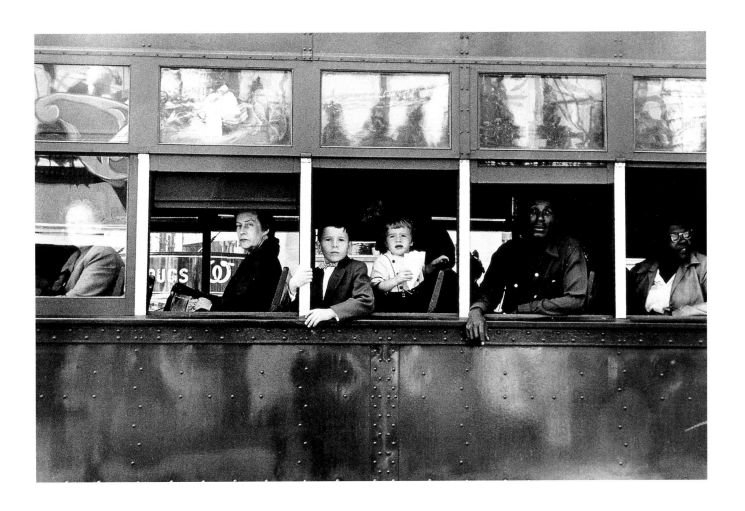

Robert Frank
U.S. 91, leaving Blackfoot, Idaho
1955/56

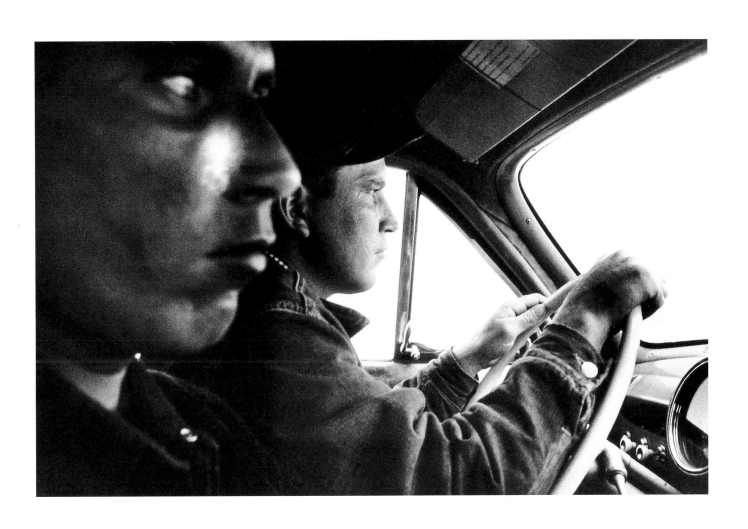

Robert Frank
Bar, New York City
1955/56

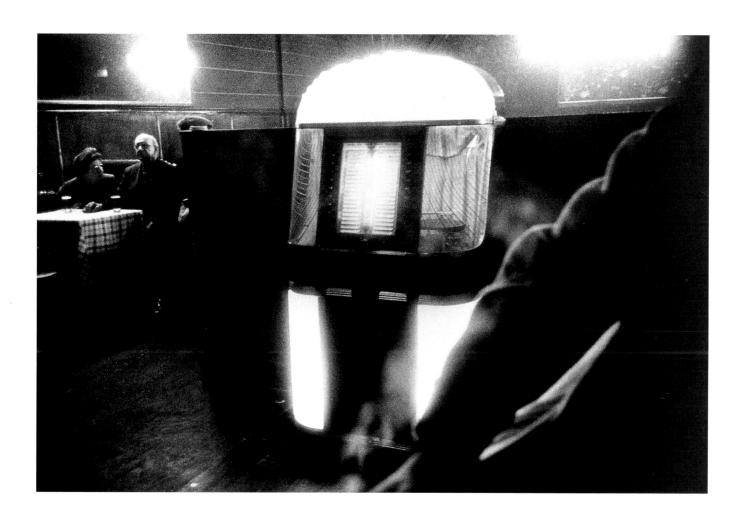

Robert Frank
Elevator, Miami Beach
1955/56

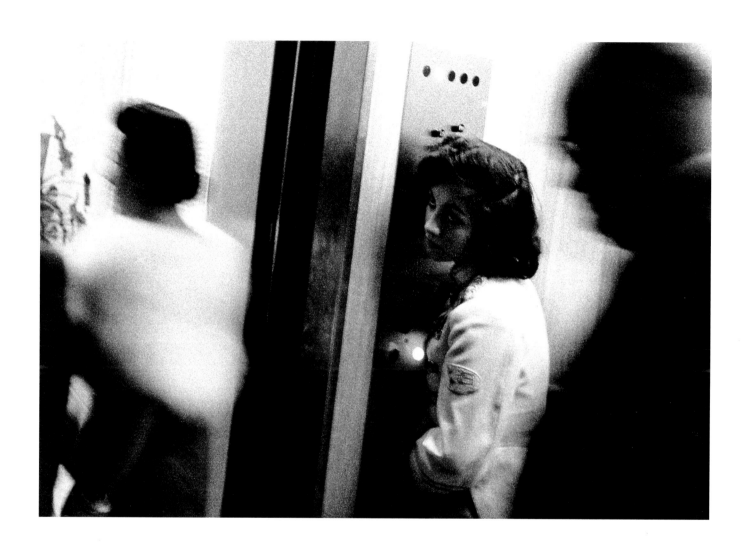

Mark Rothko
Untitled (Light Plum and Black) 1964
Galerie Beyeler

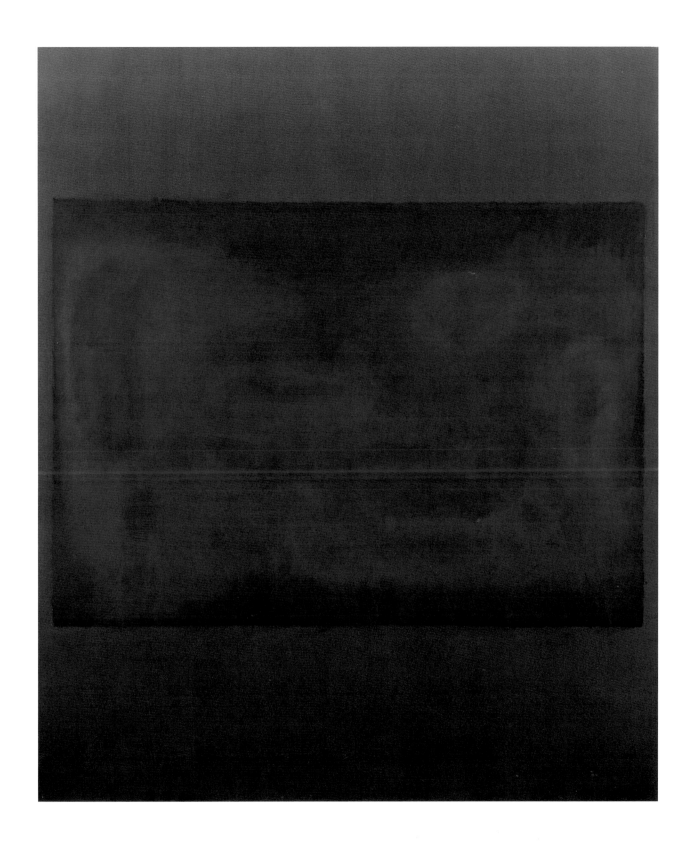

Robert Frank
Los Angeles 1955/56

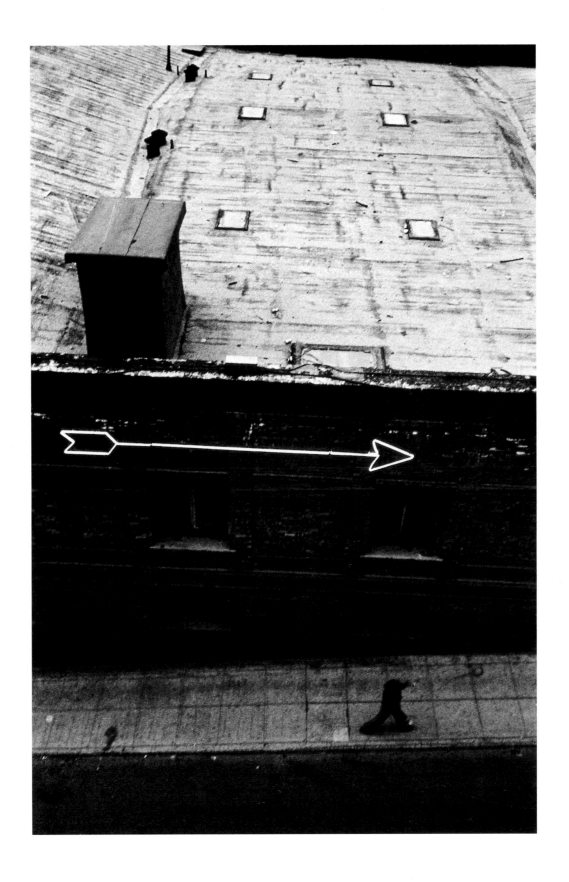

Robert Frank
Movie premiere, Hollywood
1955/56

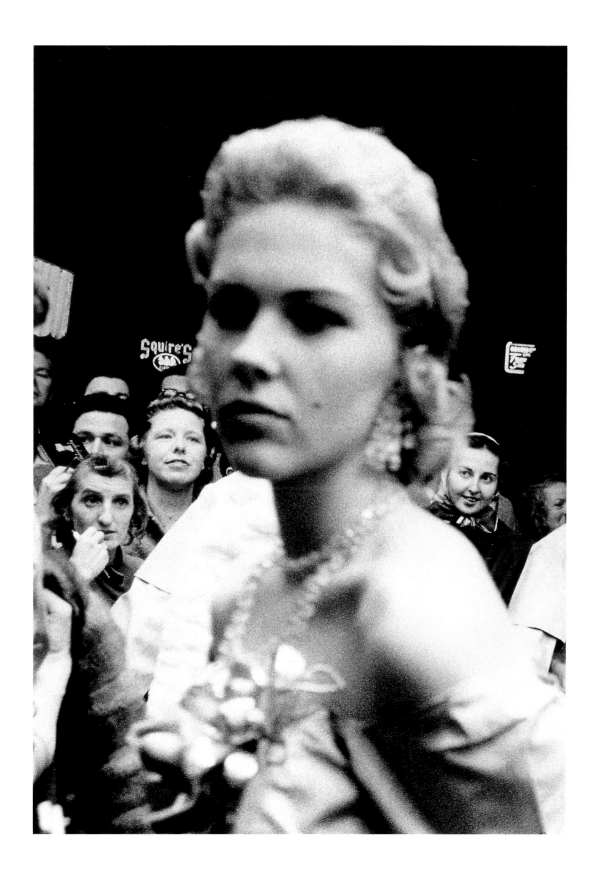

Robert Frank
U.S. 90, en route to Del Rio, Texas 1955/56

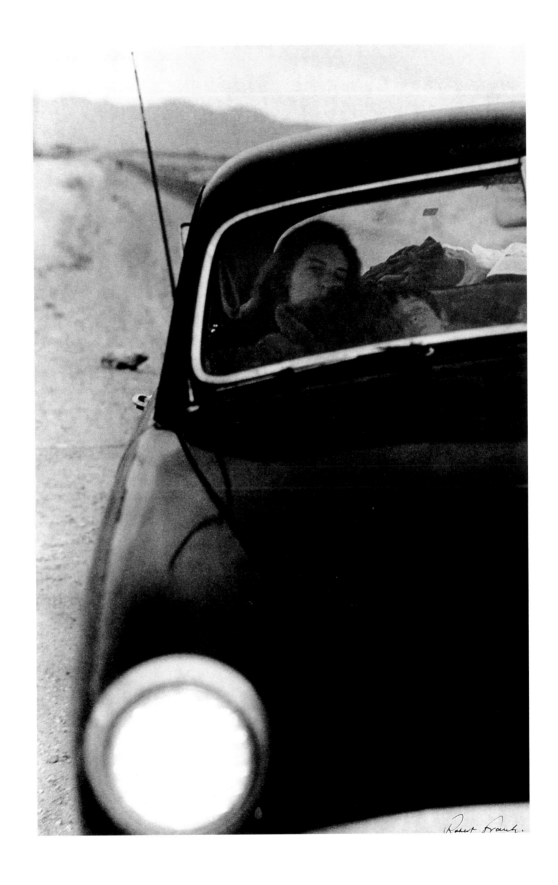

William Eggleston

Bruce Nauman

Sigmar Polke

Roy Lichtenstein

William Eggleston
Sumner, Mississippi undated
Rolf Hengesbach, Räume für neue Kunst

William Eggleston
Tallahatchie County, Mississippi 1969–1970
Rolf Hengesbach, Räume für neue Kunst

William Eggleston
Memphis, Tennessee 1972
Museum Folkwang, Essen

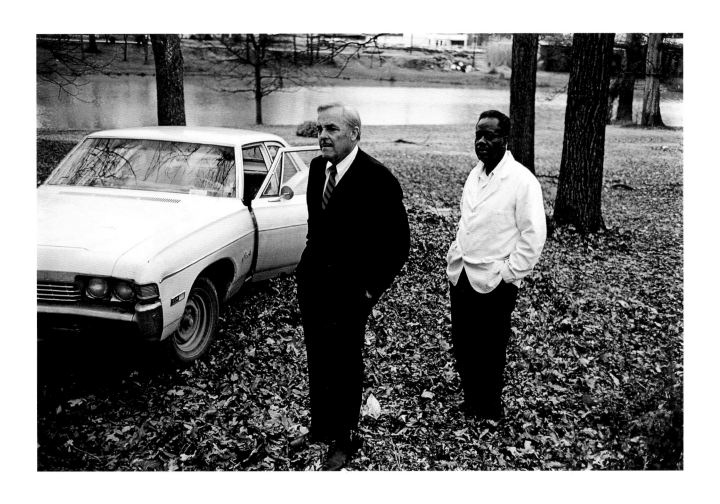

William Eggleston
Memphis, Tennessee 1969–1970
Hasselblad Center

William Eggleston
*Sumner, Mississippi, Cassidy Bayou
in Background* 1969–1970
Hasselblad Center

William Eggleston
Whitehaven, Mississippi undated
Rolf Hengesbach, Räume für neue Kunst

Bruce Nauman
none sing, neon sign 1970
Private collection
Courtesy Sonnabend Gallery

William Eggleston
Greenwood, Mississippi 1973
Collection Wilmar Koenig

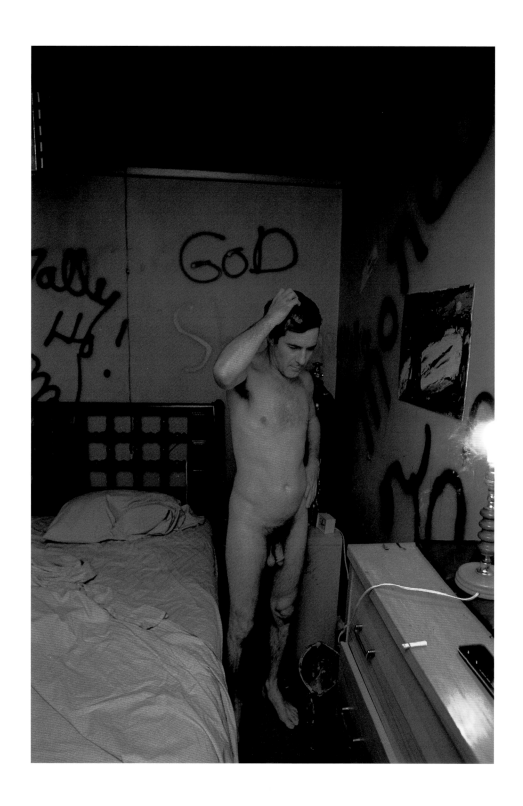

William Eggleston
Greenwood, Mississippi ca. 1972
Hasselblad Center

William Eggleston
Memphis, Brazer BBQpit 1981
Museum Folkwang, Essen

Sigmar Polke
Untitled (Hamburg) 1970
The J. Paul Getty Museum, Los Angeles

Sigmar Polke
Untitled (Düsseldorf) 1970
The J. Paul Getty Museum, Los Angeles

Sigmar Polke
Untitled (Geneva) 1970
The J. Paul Getty Museum, Los Angeles

Roy Lichtenstein
Little Aloha 1962
Sonnabend collection

Sigmar Polke
Untitled (Düsseldorf) 1969
The J. Paul Getty Museum, Los Angeles

Sigmar Polke
Untitled (Düsseldorf) 1969
The J. Paul Getty Museum, Los Angeles

Stephen Shore

David Hockney

Thomas Struth

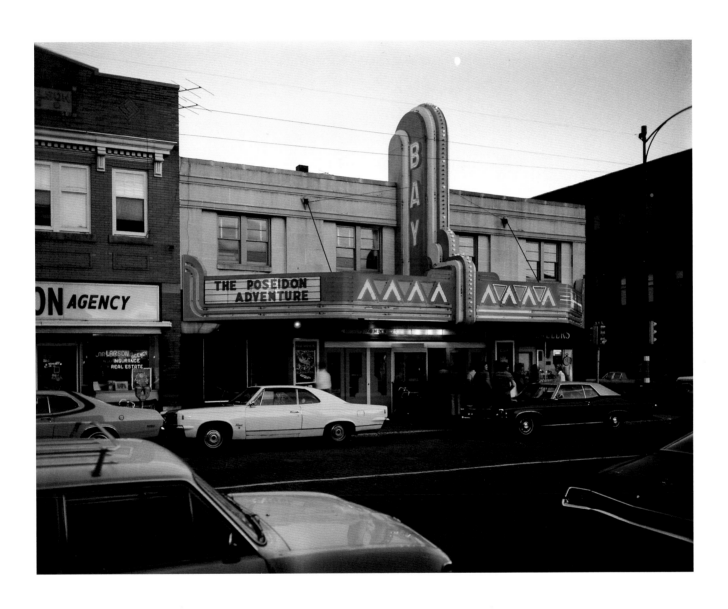

Stephen Shore
from the Series *Uncommon Places*
Second Street, Ashland, Wisconsin, July 9, 1973
All Exhibits: Collection of the Niedersächsische
Sparkassenstiftung, Hanover

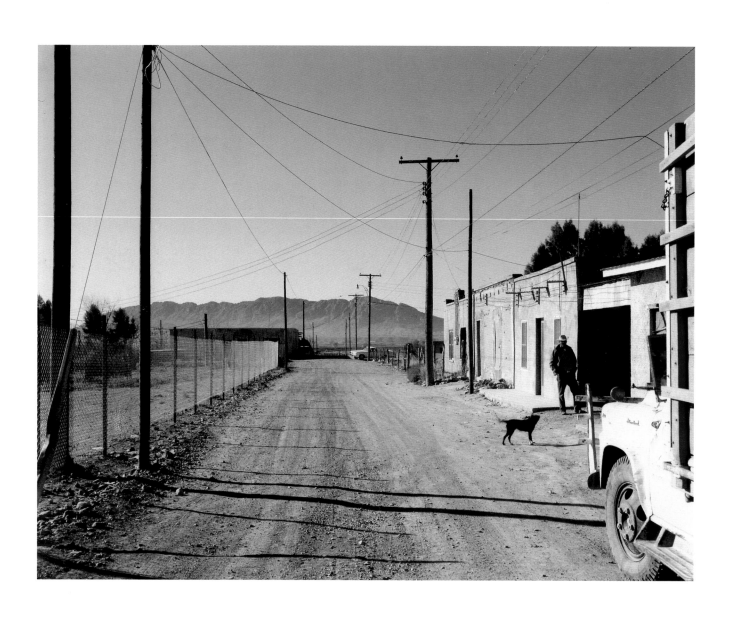

Stephen Shore
Presidio, Texas, February 21, 1975

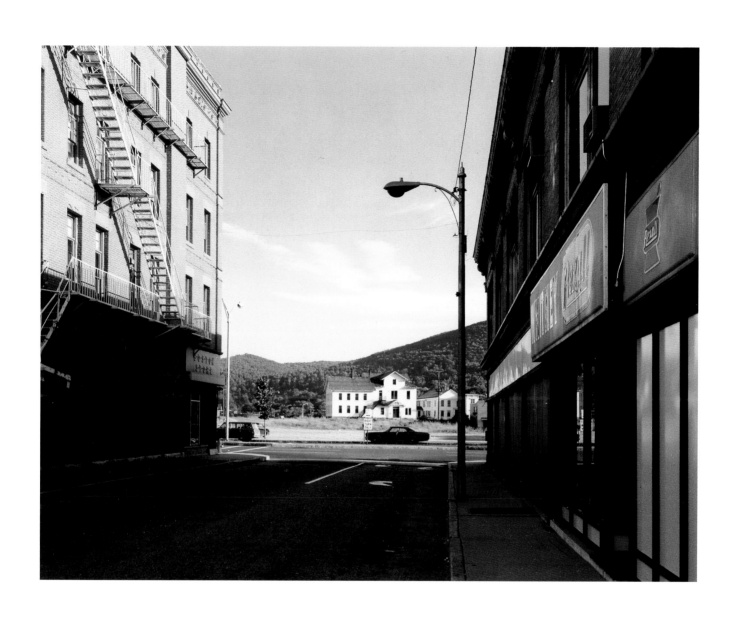

Stephen Shore
Holden Street, North Adams, Massachusetts,
July 13, 1974

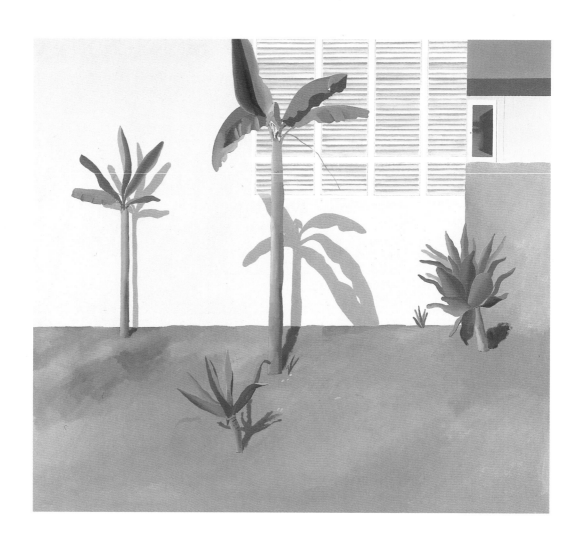

David Hockney
A Hollywood Garden 1966
Hamburger Kunsthalle

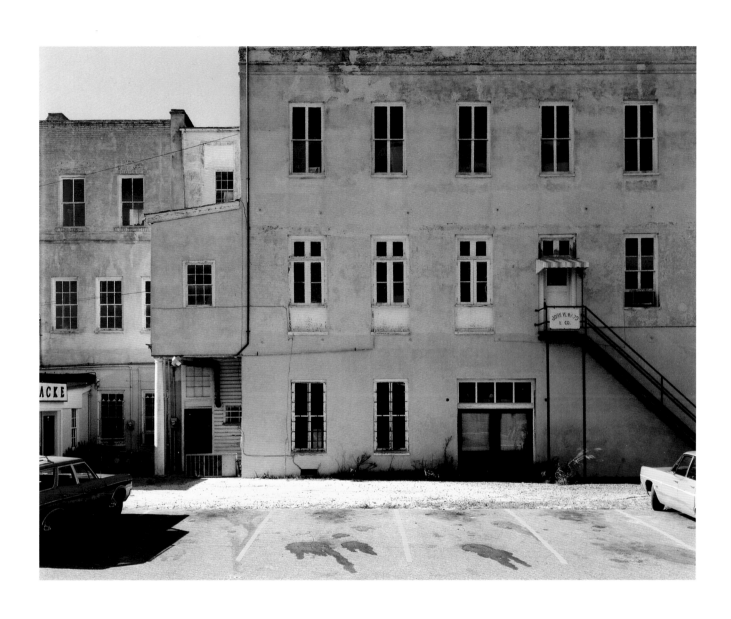

Stephen Shore
Meeting Street, Charleston, South Carolina,
August 3, 1975

Stephen Shore
La Brea Avenue and Beverly Boulevard,
Los Angeles, California, June 21, 1975

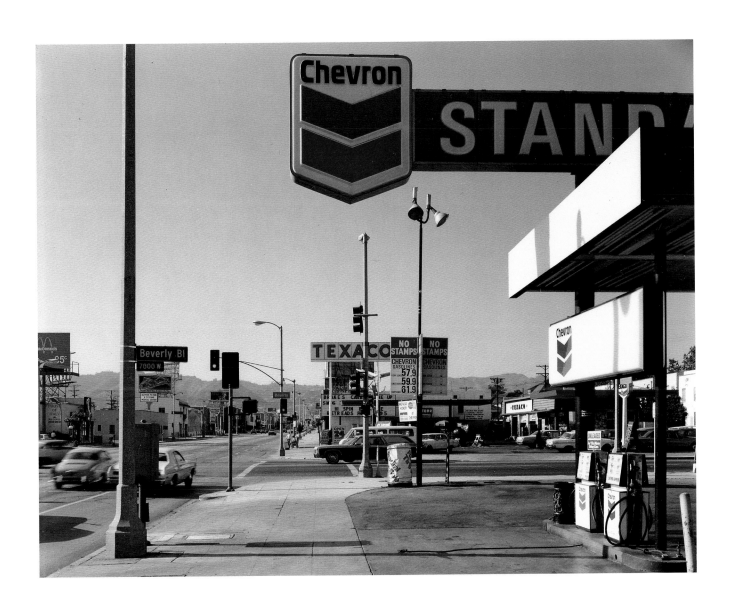

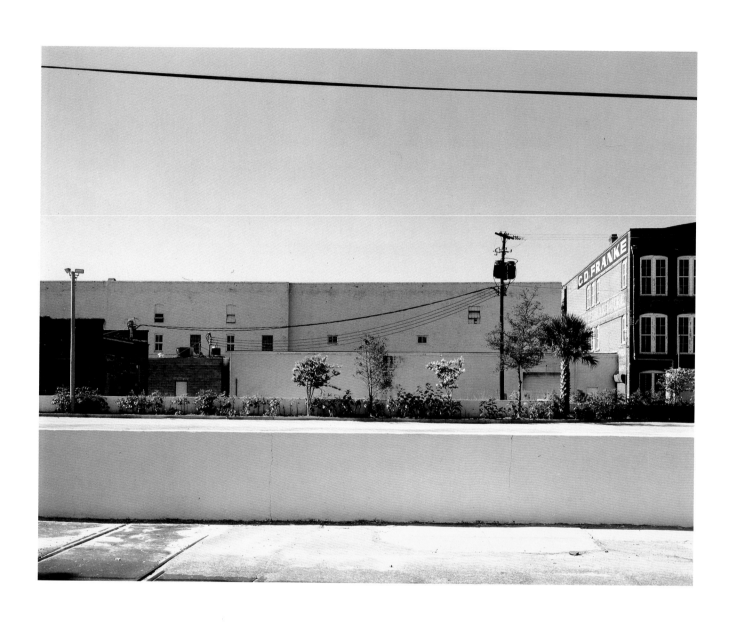

Stephen Shore
*Cumberland Street, Charleston,
South Carolina, August 3, 1975*

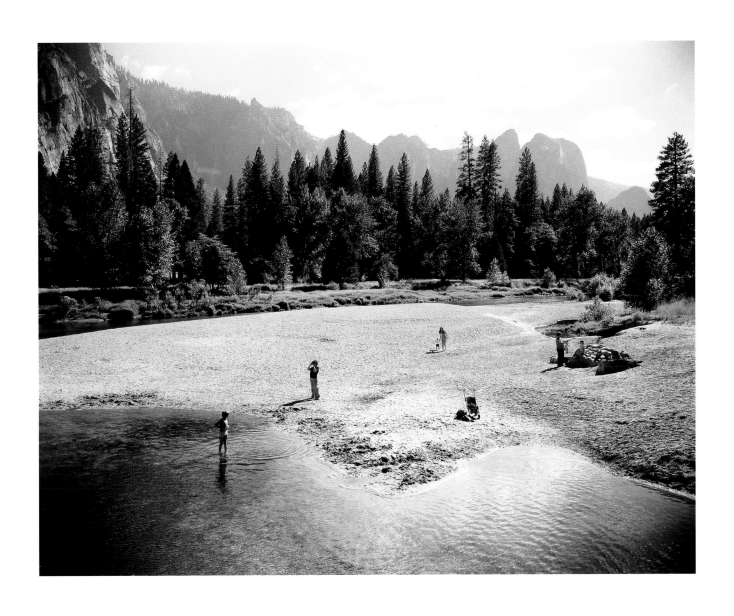

Stephen Shore
Merced River, Yosemite National Park,
California, August 13, 1979

Thomas Struth
Musée du Louvre I, Paris 1989
Private collection

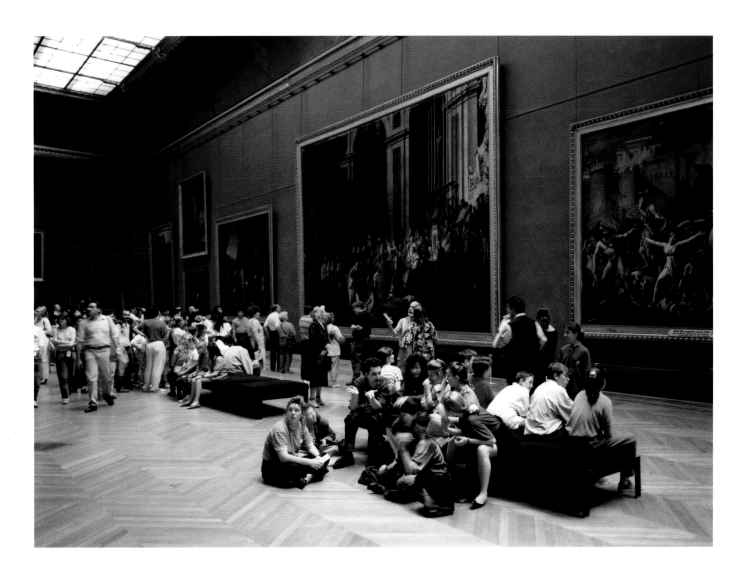

Gerhard Richter

Thomas Ruff

Ludwig Georg Vogel

Rineke Dijkstra

Gerhard Richter
Untitled 1970
Sprengel Museum Hannover

‹ Thomas Ruff
Portrait 1999
Courtesy Mai 36 Galerie
Zurich

‹ Thomas Ruff
Portrait 1998
Courtesy Mai 36 Galerie
Zurich

Thomas Ruff
Portrait, R.M. / B.E. 1991
Portrait, M.B. / B.E. 1991
Portrait, C.K. / B.E. 1991
Portrait, M.V. / B.E. 1991
Collection Bernd F. Künne

Ludwig Georg Vogel
Potrait of a Youth ca. 1810
Kunsthalle Bremen

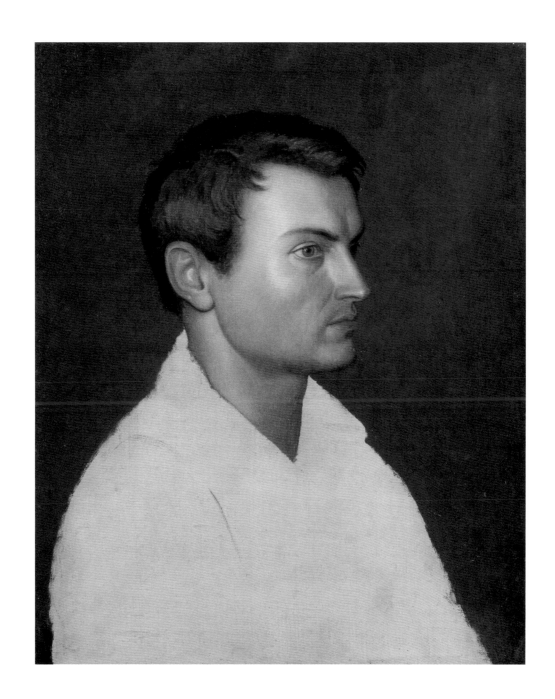

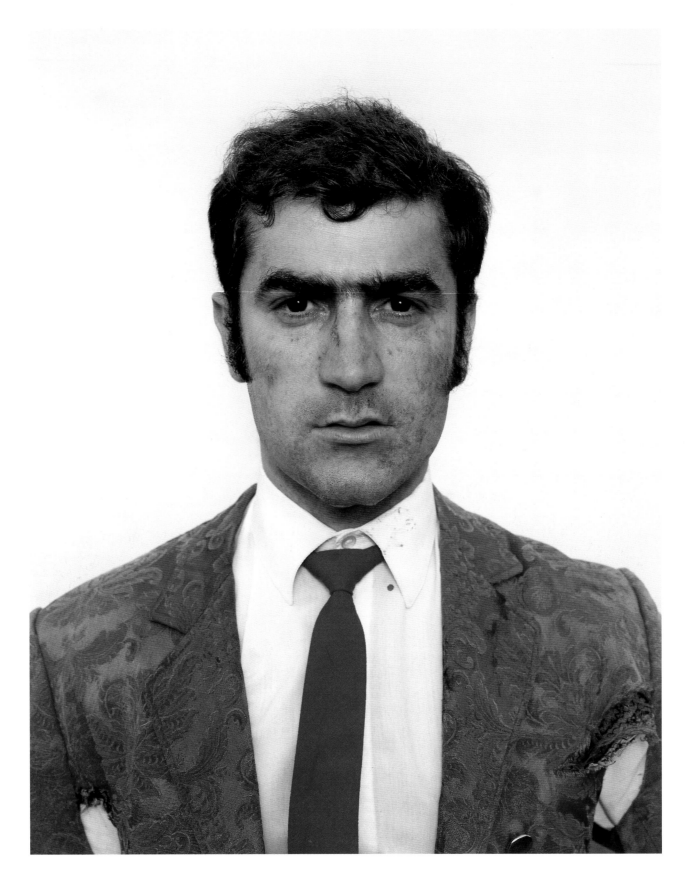

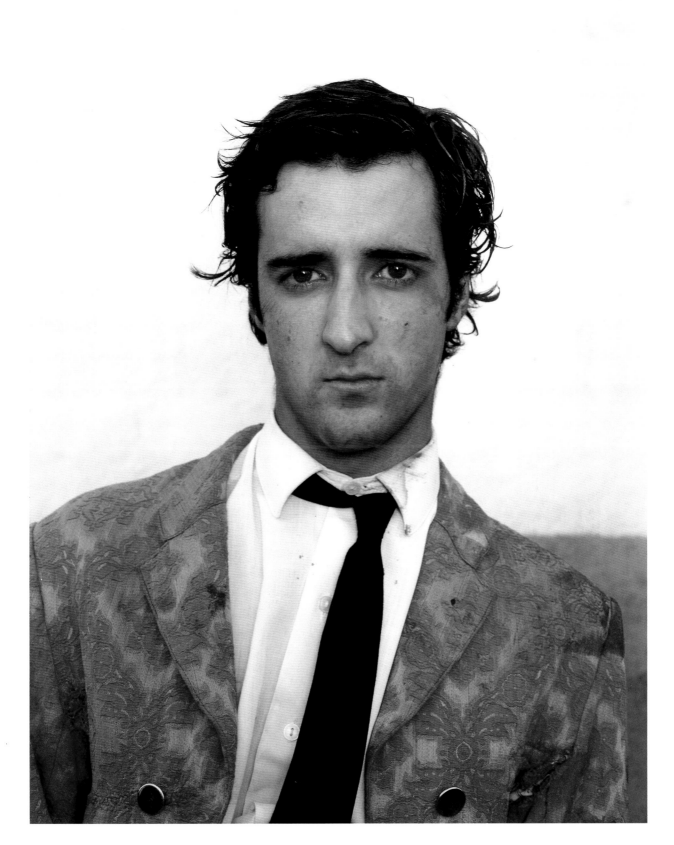

‹ Rineke Dijkstra
Montemor, Portugal, May 1, 1994
Collection Ulla Katzorke

‹ Rineke Dijkstra
Montemor, Portugal, May 1, 1994
Collection Ulla Katzorke

Rineke Dijkstra
Villa Franca, Portugal, May 8, 1994
Collection Ulla Katzorke

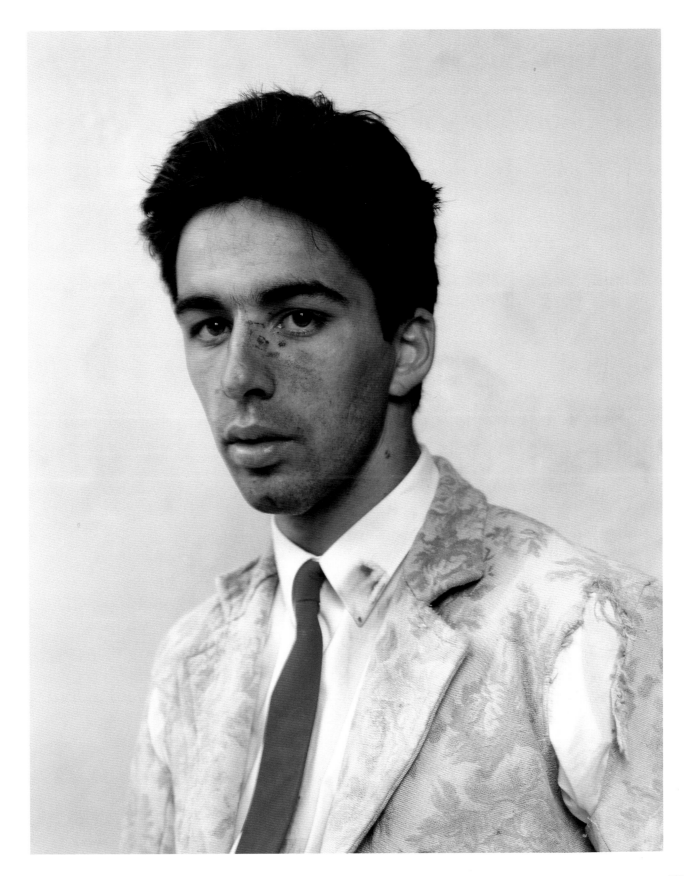

Brassaï

Garry Winogrand

Volker Stelzmann

Boris Michailov

Francis Bacon

Diane Arbus

Brassaï
from the Series *Hidden Paris in the Thirties*
An Urinal on the Boulevard Saint-Jacques ca. 1933
All Exhibits: The Museum of Contemporary Art,
Los Angeles, The Ralph M. Parsons Foundation
Photography collection

Brassaï
Miss Diamonds, Bar de la Lune,
Montmartre ca. 1932

Brassaï
Streetwalker near the Place d'Italie
ca. 1932

Brassaï
Conchitas on display in front
of "Her Majesty, Woman" ca. 1931

Brassaï
*Kiki with her accordion player
at the Cabaret des fleurs,
rue de Montparnasse* ca. 1932

Brassaï
Couple at the Bal des Quatre Saisons,
rue de Lappe ca. 1932

Brassaï
Brothel Suzy, rue Grégoire-de-Tours,
Saint-Germain ca. 1932

Garry Winogrand
from the Series *Public Relations*
Elliot Richardson Press Conference
Austin, TX 1973
Collection Siemens Kulturprogramm /
Sprengel Museum Hannover

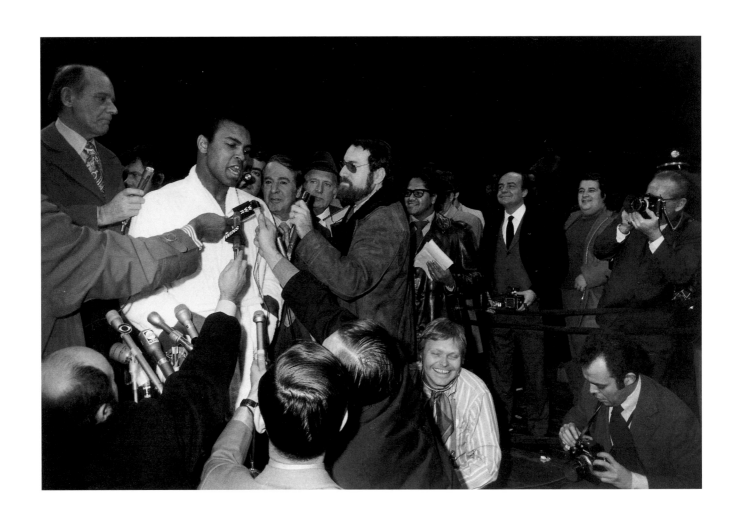

Garry Winogrand
Muhammad Ali–Oscar Bonavena
Press Conference, New York 1970
The Museum of Contemporary Art,
Los Angeles, The Ralph M. Parsons Foundation
Photography collection

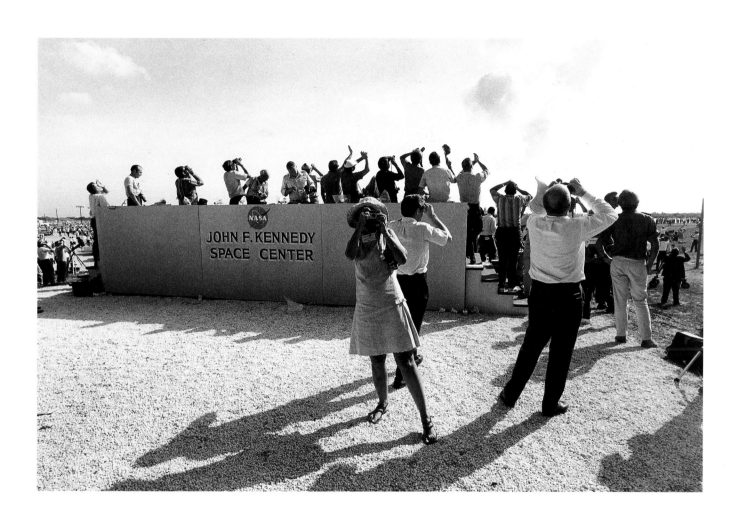

Garry Winogrand
Apollo 11 Moon Shot,
Cape Kennedy, Florida 1969
Fraenkel Gallery, San Francisco

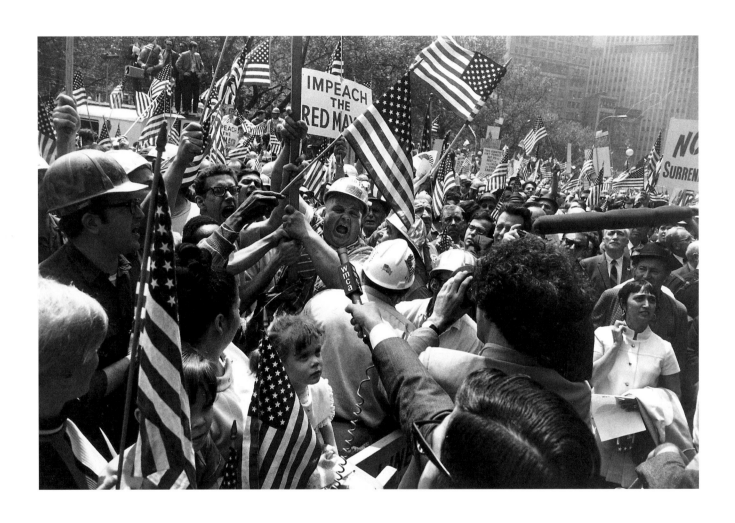

Garry Winogrand
Hard Hat Rally, New York 1969
Fraenkel Gallery, San Francisco

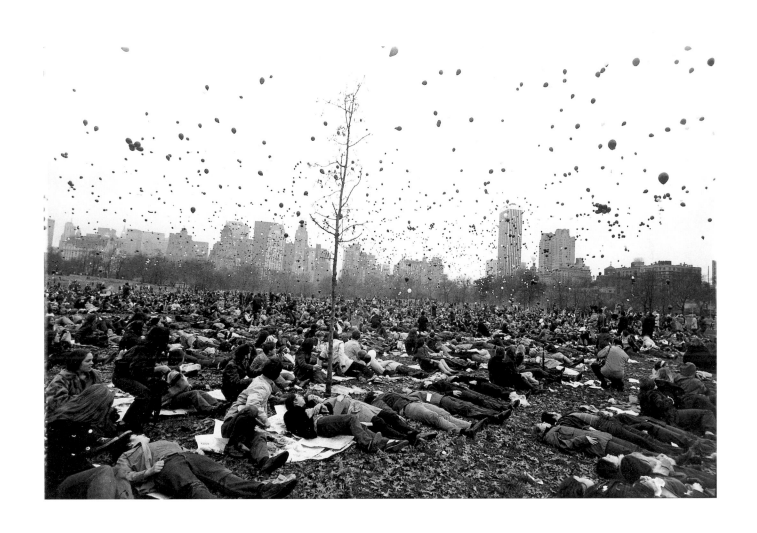

Garry Winogrand
Peace Demonstration, Central Park
New York 1970
Collection Siemens Kulturprogramm /
Sprengel Museum Hannover

Volker Stelzmann
For R. D. (Rudi Dutschke) 1980/81
Private collection

Garry Winogrand
Presidential Candidates' Press Conference,
Providence, RI 1971
Fraenkel Gallery, San Francisco

Garry Winogrand
Opening, Frank Stella Exhibition,
The Museum of Modern Art, New York 1970
The Museum of Contemporary Art,
Los Angeles, The Ralph M. Parsons Foundation
Photography collection

Boris Michailov
from the Series *By the Ground*
Untitled 1991
All Exhibits: Lent by the artist

Boris Michailov
Untitled 1991

Francis Bacon
Study for Portrait of P. L. 1964
Sprengel Museum Hannover

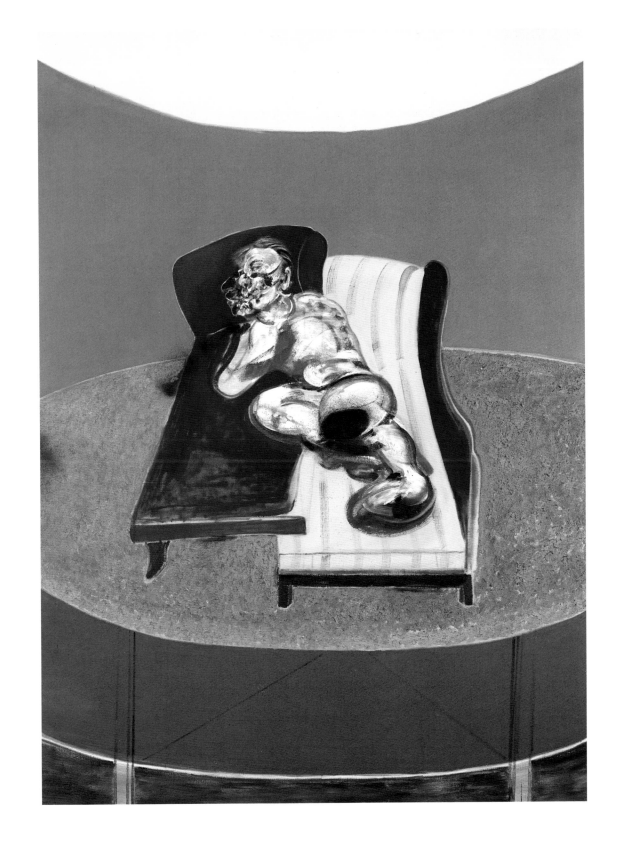

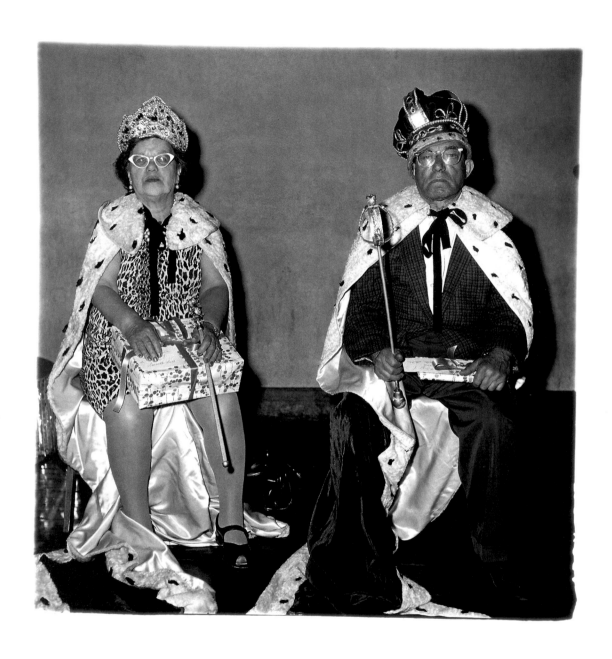

Diane Arbus
The King and Queen
of a Senior Citizens Dance, N.Y.C., 1970
The Museum of Contemporary Art, Los Angeles
The Ralph M. Parsons Foundation, Photography collection
Copyright © 1971 The Estate of Diane Arbus, LLC

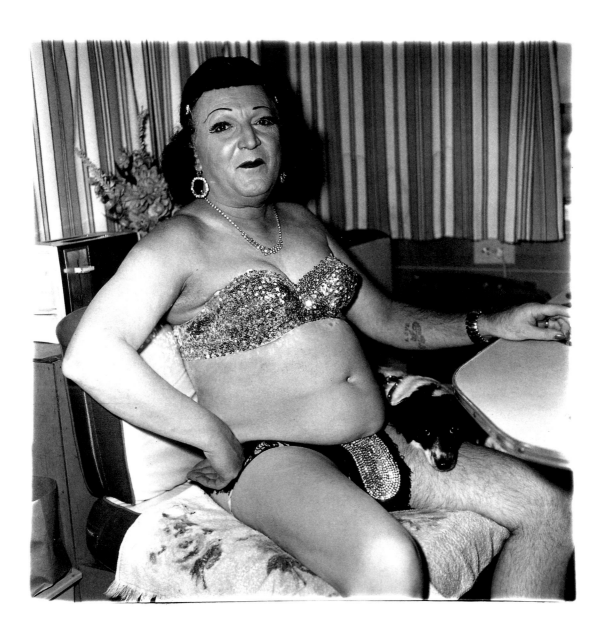

Diane Arbus
Hermaphrodite and a dog
in a carnival trailer, MD., 1970
The Museum of Contemporary Art, Los Angeles
The Ralph M. Parsons Foundation, Photography collection
Copyright © 1971 The Estate of Diane Arbus, LLC

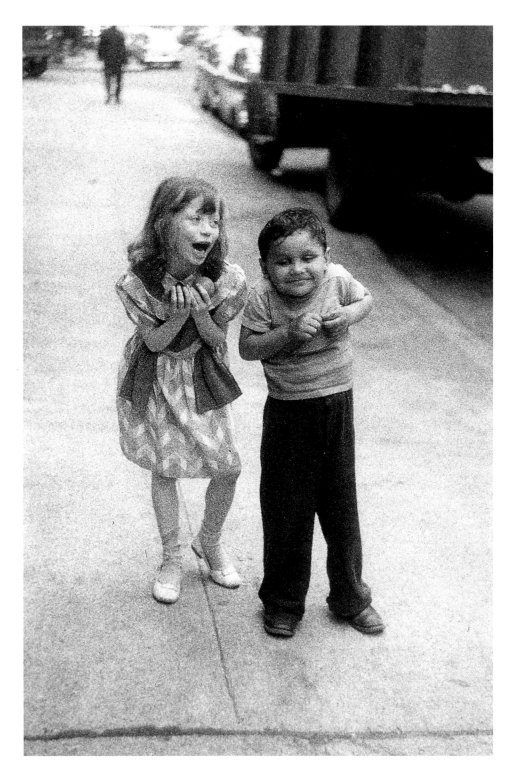

Diane Arbus
Child Teasing Another, N.Y.C., 1960
Collection Goetz, Munich
Copyright © 1960 The Estate of Diane Arbus, LLC

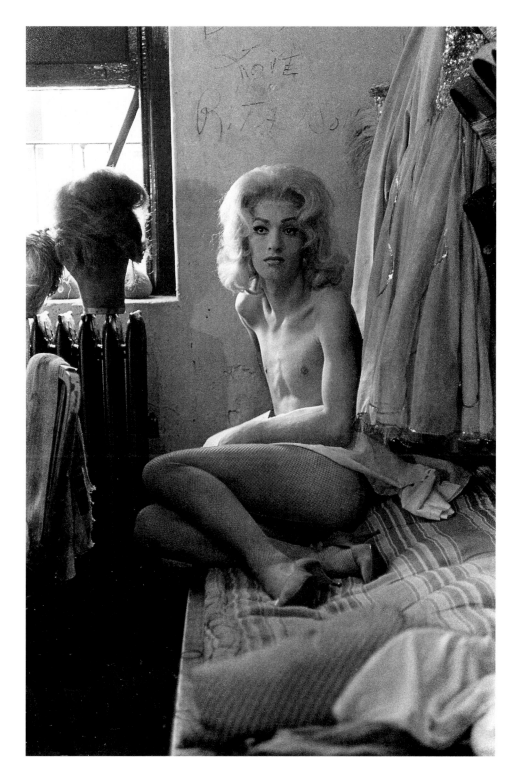

Diane Arbus
Female Impersonator On a Bed, N.Y.C., 1961
Collection Goetz, Munich

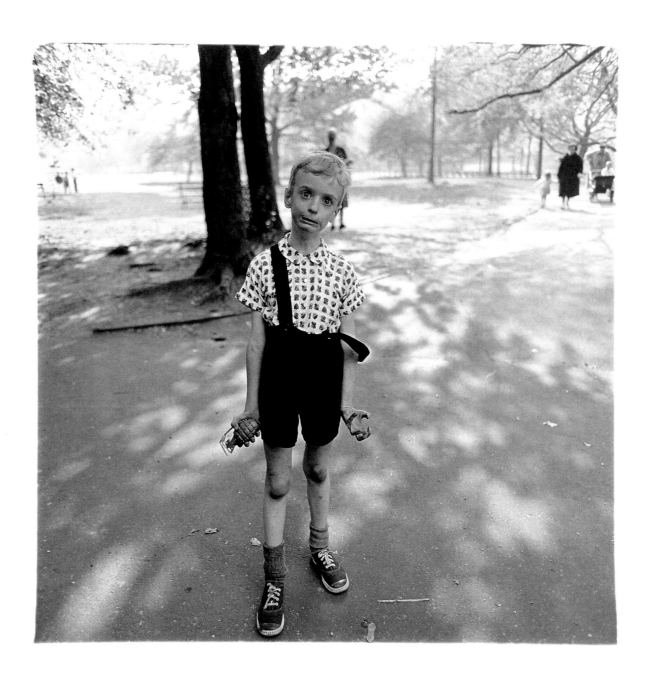

Diane Arbus
Child with a toy hand grenade
in Central Park, N.Y.C., 1962
The Museum of Contemporary Art, Los Angeles
The Ralph M. Parsons Foundation, Photography collection
Copyright © 1970 The Estate of Diane Arbus, LLC

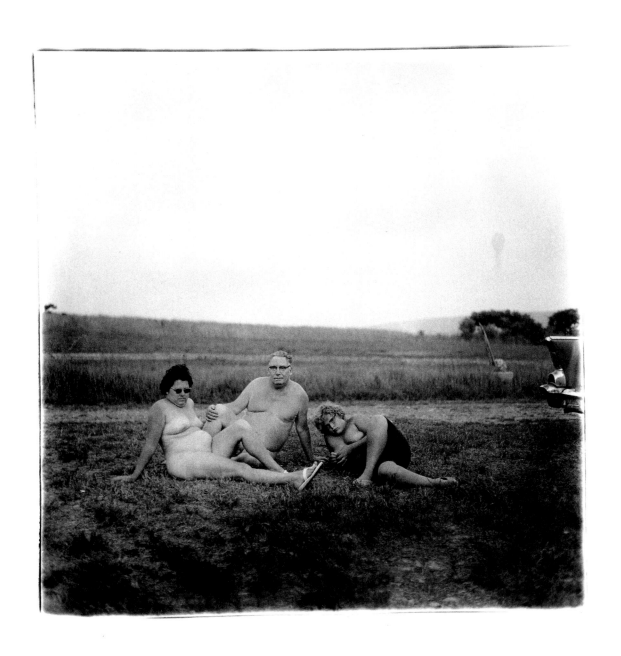

Diane Arbus
A family one evening in a nudist camp, Pa., 1965
The Museum of Contemporary Art, Los Angeles
The Ralph M. Parsons Foundation, Photography collection
Copyright © 1972 The Estate of Diane Arbus, LLC

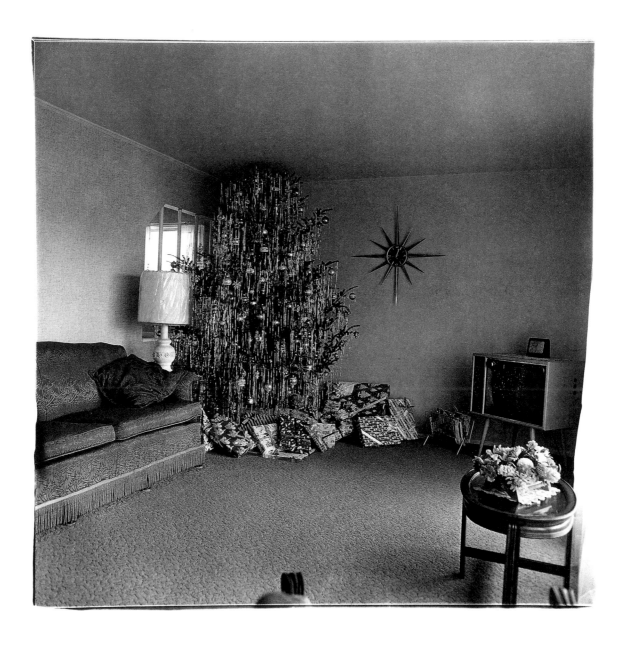

Diane Arbus
Xmas tree in a living room in Levittown, L.I., 1963
The Museum of Contemporary Art, Los Angeles
The Ralph M. Parsons Foundation, Photography collection
Copyright © 1967 The Estate of Diane Arbus, LLC

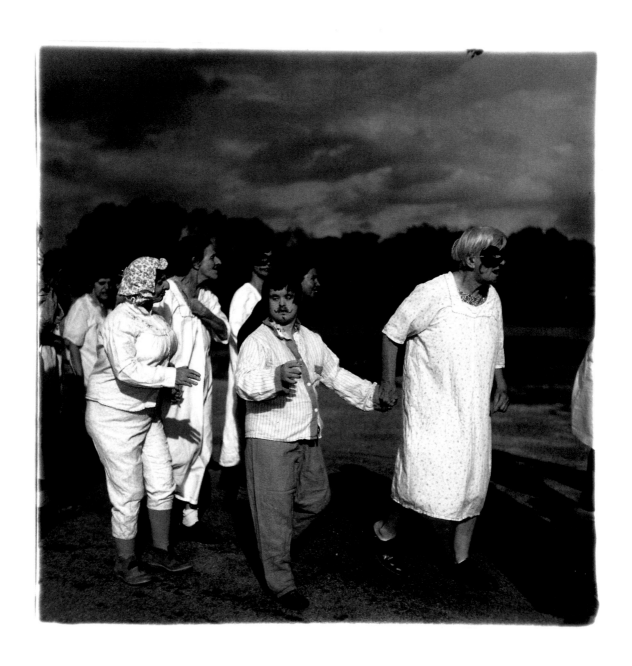

Diane Arbus
Untitled (7), 1970–1971
The Museum of Contemporary Art, Los Angeles
The Ralph M. Parsons Foundation, Photography collection
Copyright © 1972 The Estate of Diane Arbus, LLC

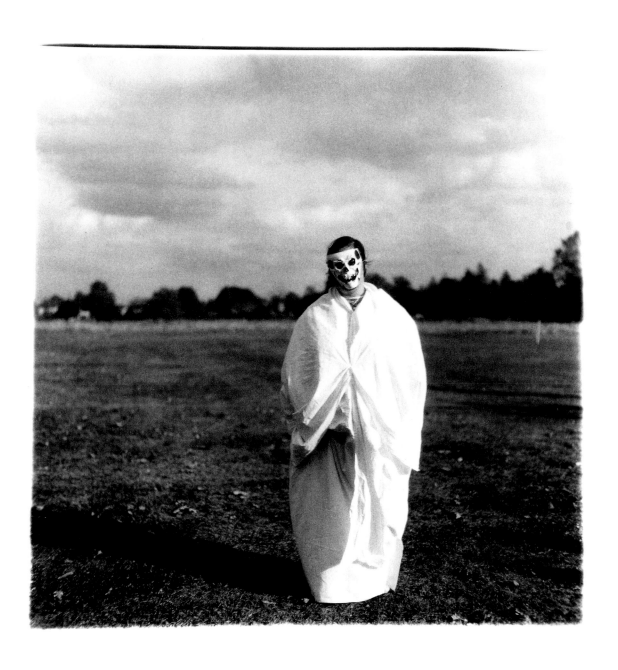

Diane Arbus
Untitled (3), 1970–1971
The Museum of Contemporary Art, Los Angeles
The Ralph M. Parsons Foundation, Photography collection
Copyright © 1972 The Estate of Diane Arbus, LLC

Robert Adams

Edward Hopper

Agnes Martin

Larry Clark

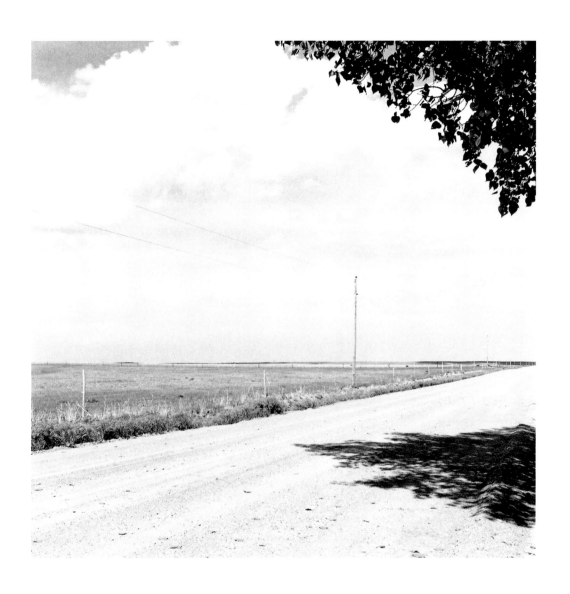

Robert Adams
from the Series *The New West*
Farm road and cottonwood, South of Raymer undated
All Exhibits: Collection of the Niedersächsische
Sparkassenstiftung, Hanover

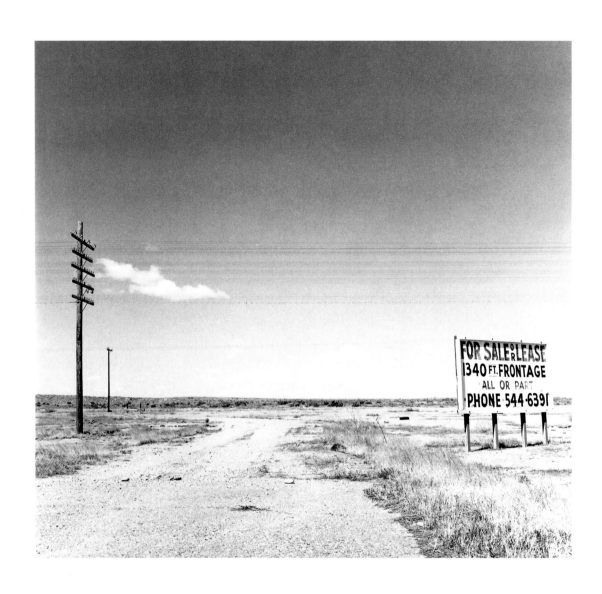

Robert Adams
Along Interstate 25
1968

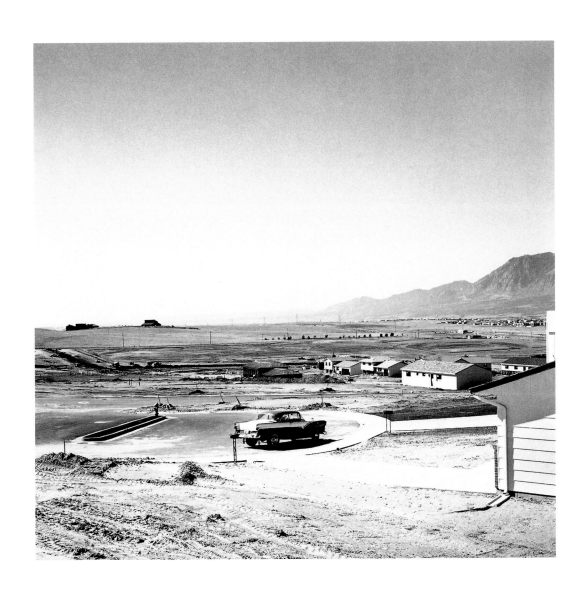

Robert Adams
Newly occupied tract houses,
Colorado Springs undated

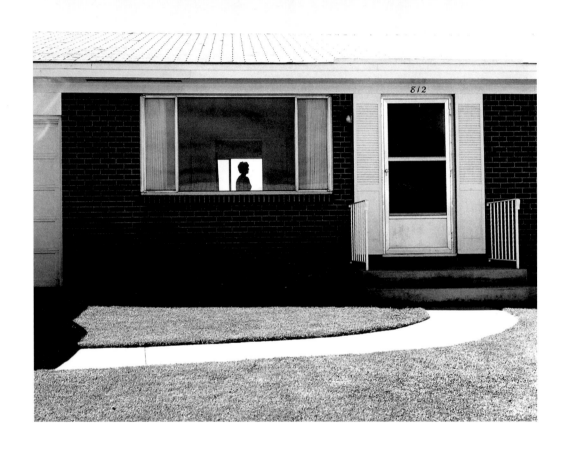

Robert Adams
Colorado Springs
undated

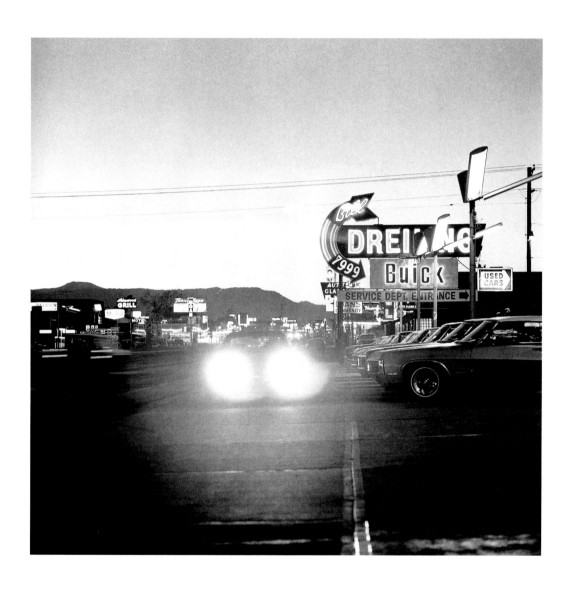

Robert Adams
Colfax Avenue, Lakewood
undated

Edward Hopper
City Sunlight 1954
Hirshhorn Museum and Sculpture Garden,
Smithsonian Institution. Gift of the
Joseph H. Hirshhorn Foundation, 1966

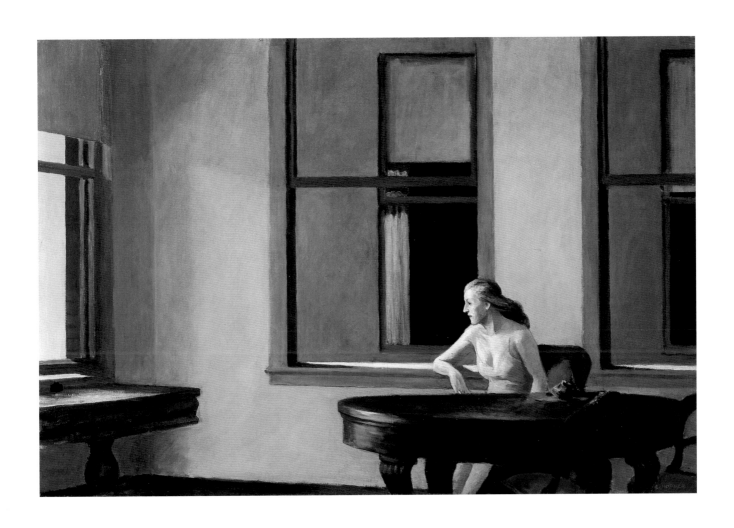

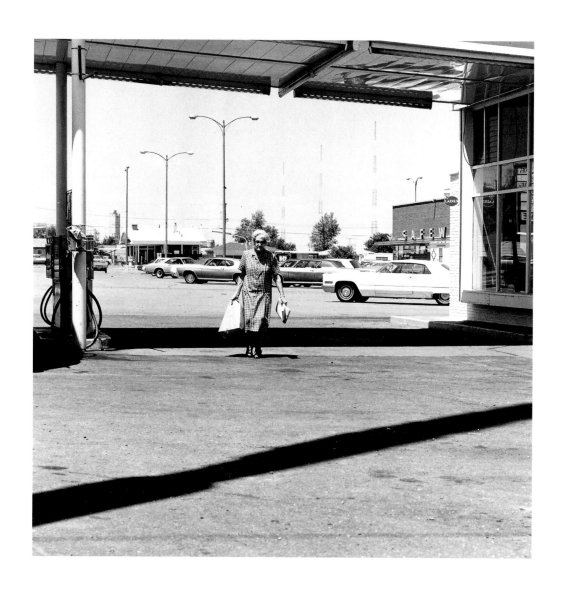

Robert Adams
Federal Boulevard, Denver
undated

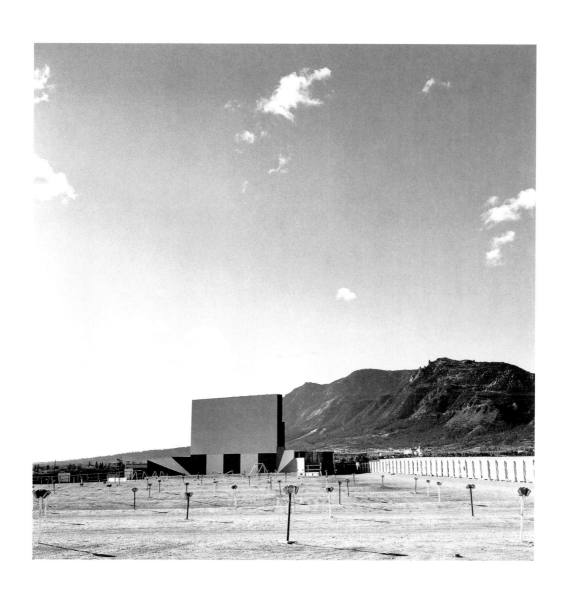

Robert Adams
Outdoor Theater and Cheyenne Mountain
undated

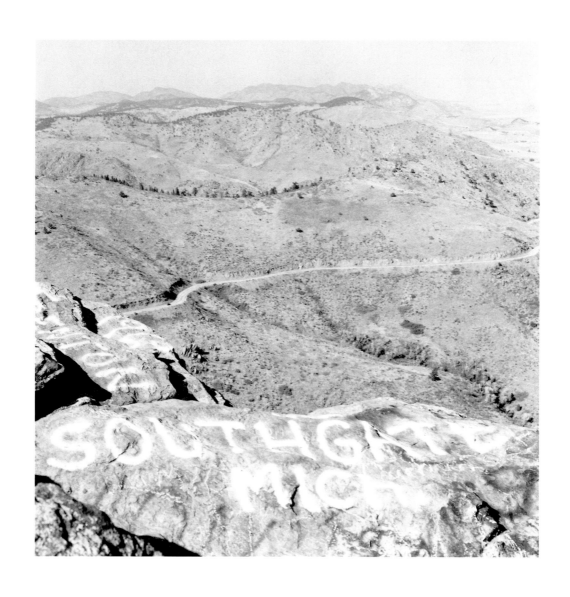

Robert Adams
From Lookout Mountain
undated

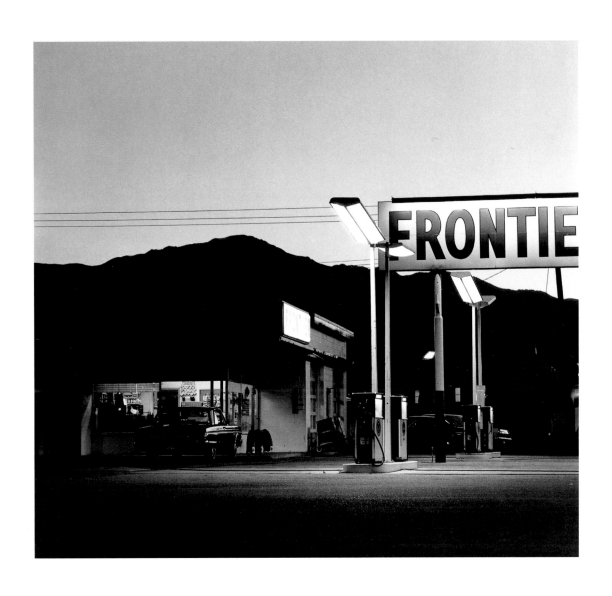

Robert Adams
Pikes Peak
undated

Agnes Martin
Untitled, No. 17 1980
Kunsthalle Bielefeld

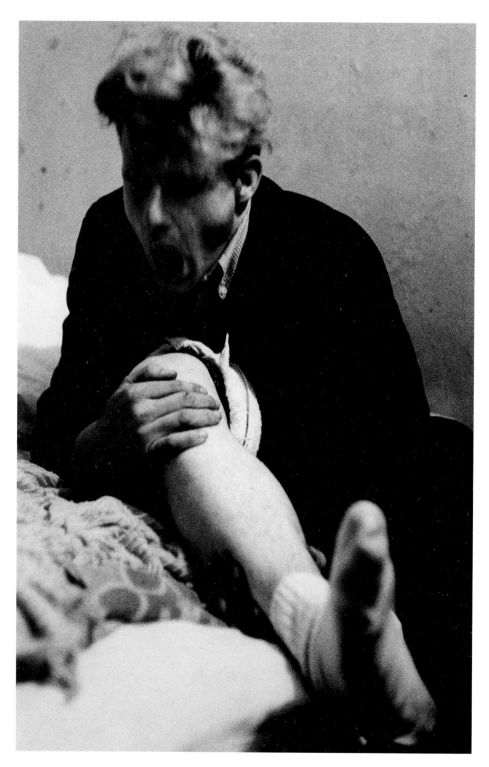

Larry Clark
from the Series *Tulsa*
Untitled 1960s
All Exhibits: Collection F. C. Gundlach

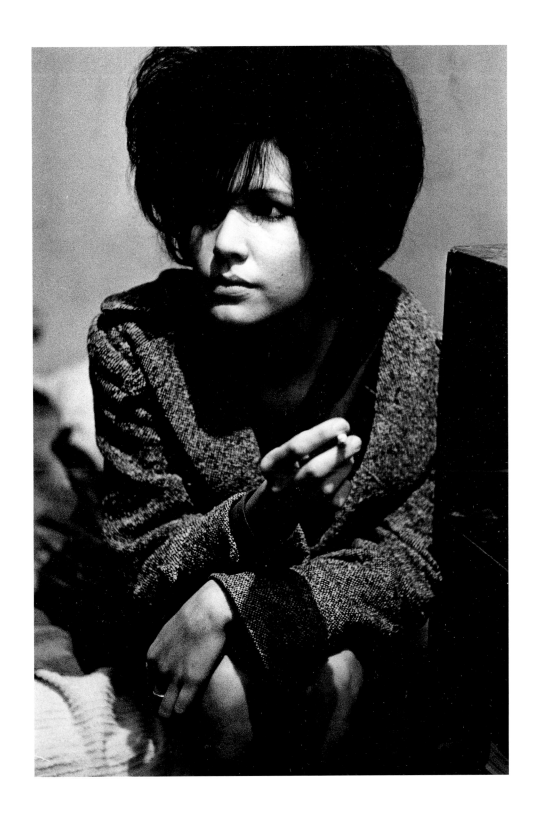

Larry Clark
Untitled 1960s

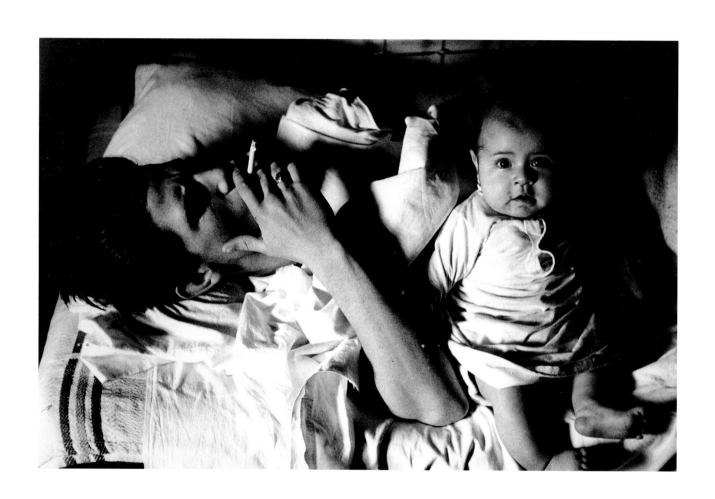

Larry Clark
Untitled 1960s

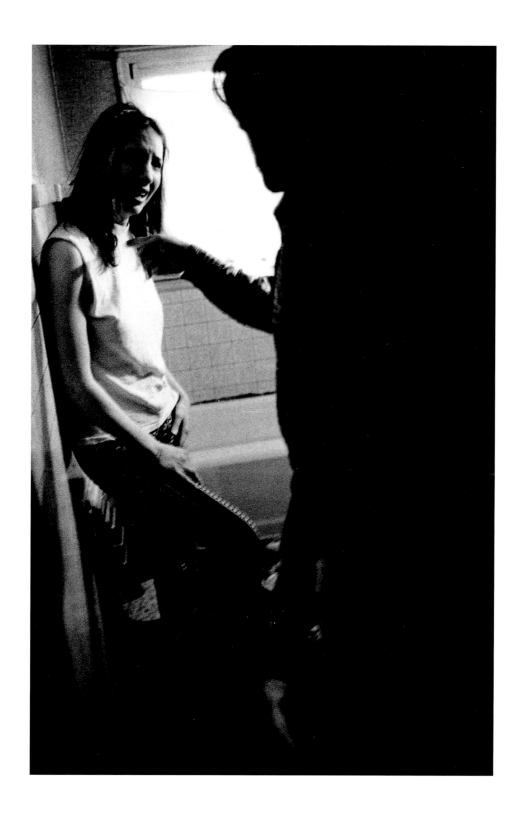

Larry Clark
Untitled 1960s

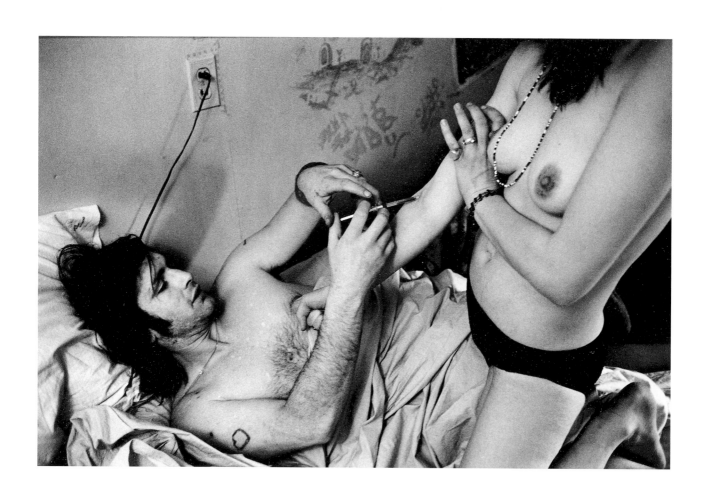

Larry Clark
Untitled 1960s

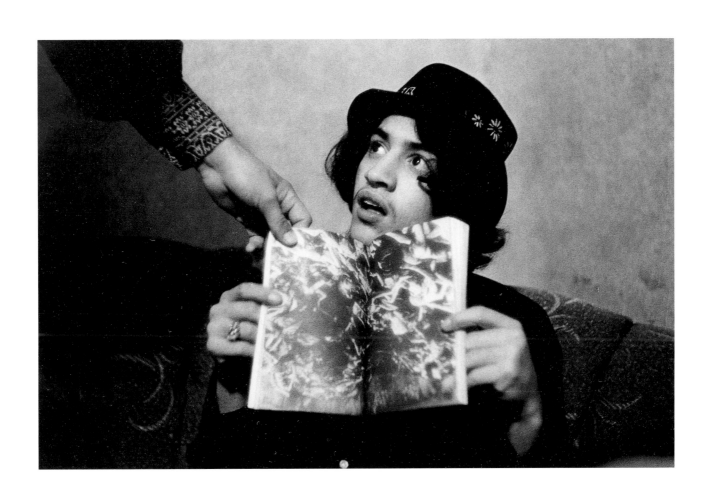

Larry Clark
Untitled 1960s

Charles Sheeler

Franz Kline

Bernd und Hilla Becher

Karl Blossfeldt

Odilon Redon

Ellsworth Kelly

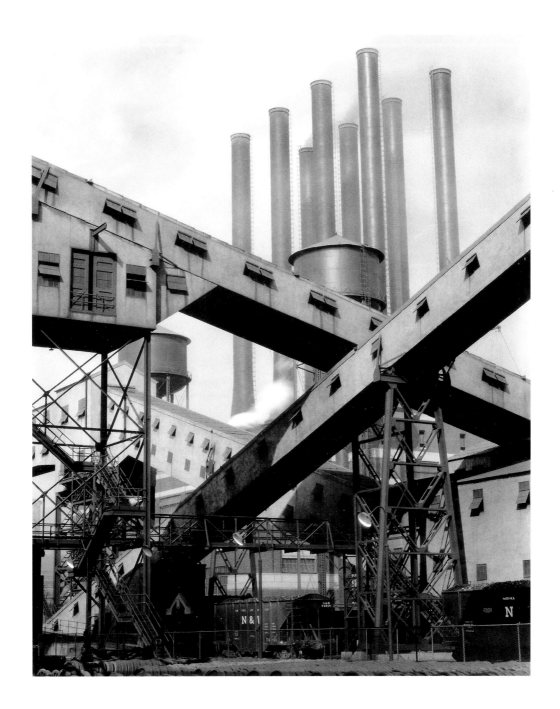

Charles Sheeler
Criss-Crossed Conveyors, Ford Plant 1927
The Lane Collection, Courtesy of Museum
of Fine Arts, Boston.
Reproduced with permission
© 1999 Museum of Fine Arts, Boston.
All Rights Reserved.

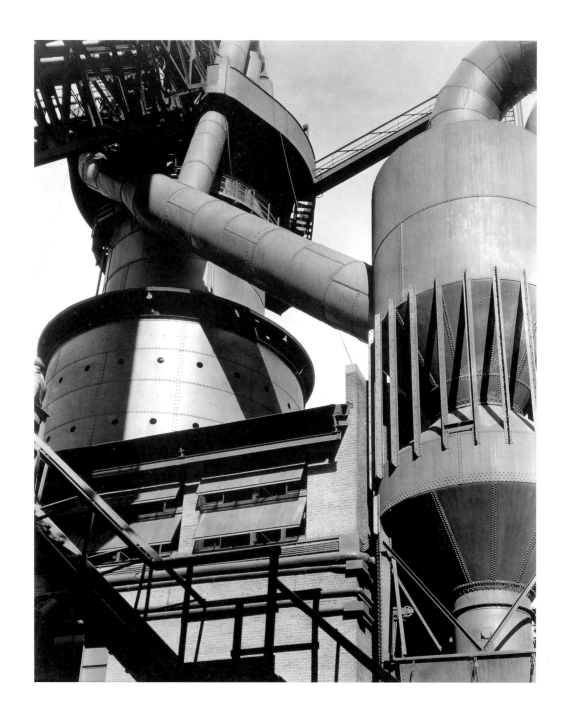

Charles Sheeler
Blast Furnace and Dust Catcher, Ford Plant 1927
The Lane Collection, Courtesy of Museum
of Fine Arts, Boston.
Reproduced with permission
© 1999 Museum of Fine Arts, Boston.
All Rights Reserved.

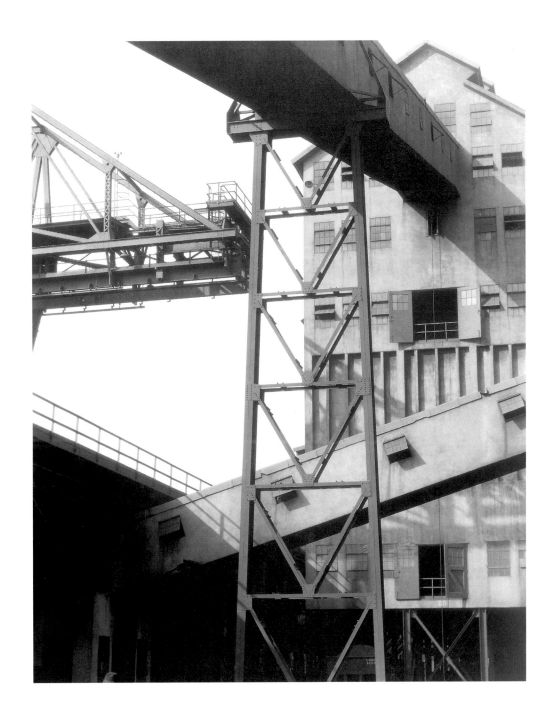

Charles Sheeler
Pulverizer Building, Ford Plant 1927
The Lane Collection, Courtesy of Museum
of Fine Arts, Boston.
Reproduced with permission
© 1999 Museum of Fine Arts, Boston.
All Rights Reserved.

Franz Kline
August Day 1957
Collection Lohmann Hofmann
Courtesy Hachmeister, Münster

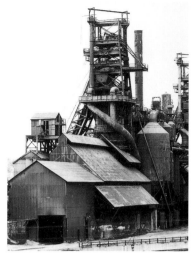
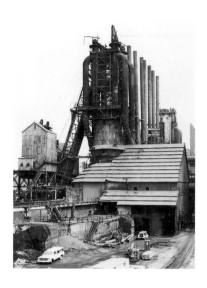

Youngstown Ohio USA 1980

Duquesne Pennsylvania USA 1980

Johnstown Pennsylvania USA 1980

Gadsden Alabama USA 1983

Cleveland Ohio USA 1986

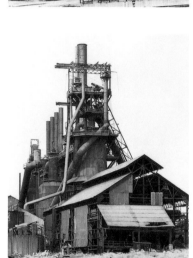
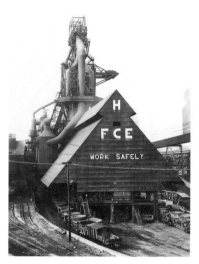

Youngstown Ohio USA 1980

Johnstown Pennsylvania USA 1980

Cleveland Ohio USA 1980

Gadsden Alabama USA 1983

Youngstown Ohio USA 1981

Pittsburgh Pennsylvania USA 1979

Johnstown Pennsylvania USA 1980

Mingo Junction Ohio USA 1986

Cleveland Ohio USA 1986

Steubenville Ohio USA 1986

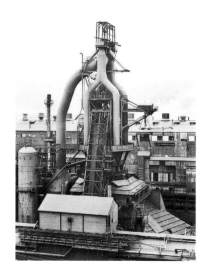
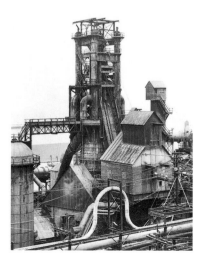

Bernd und Hilla Becher
Blast Furnaces USA
Lent by the artists

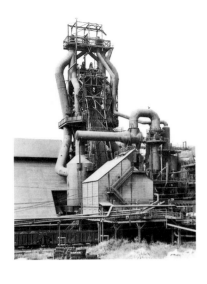 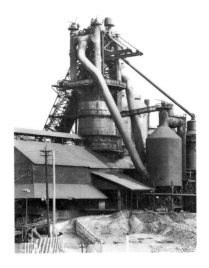 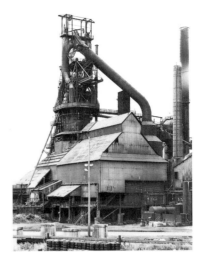

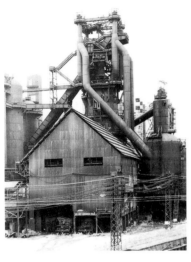 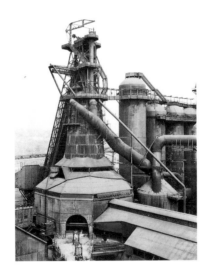 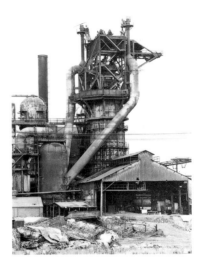

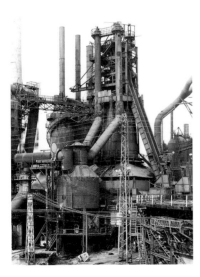 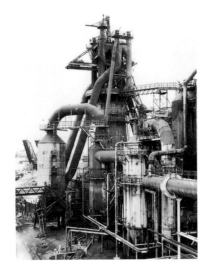 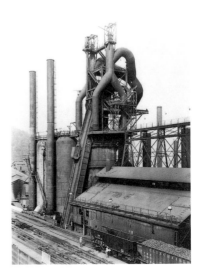

Duisburg Hamborn D 1994

Lübeck Herrenwyk D 1983

Ilsede / Hannover D 1984

Siegen Eiserfeld D 1972

Duisburg Hamborn D 1970

Duisburg Hamborn D 1970

Duisburg Ruhrort D 1970

Charleroi Montignies B 1984

Rombas Lorraine F 1984

Rombas Lorraine F 1984

Esch Alzette L 1979

La Louviere B 1985

Dillingen Saar D 1985

Liège Ougree B 1980

Longwy Senelle F 1986

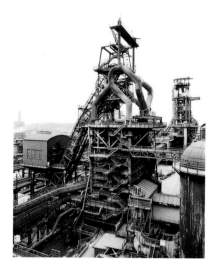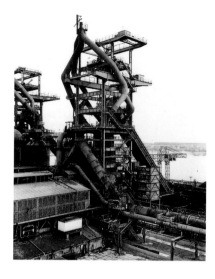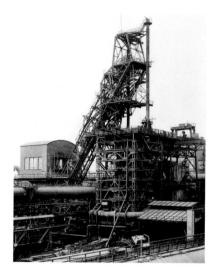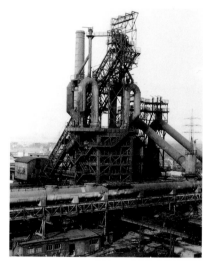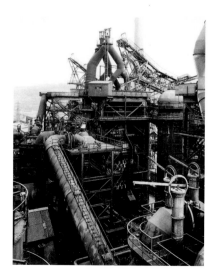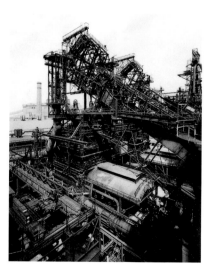

Bernd und Hilla Becher
Blast Furnaces Europe
Lent by the artists

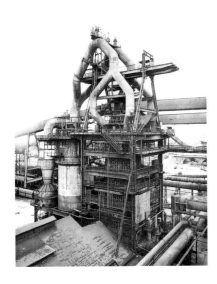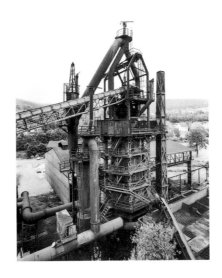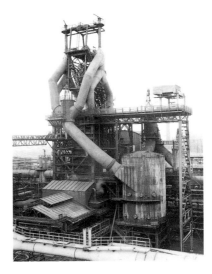
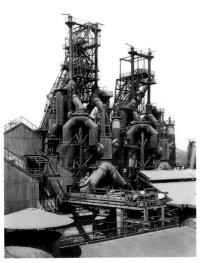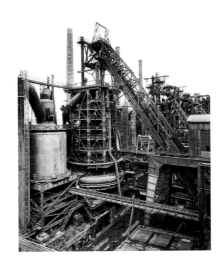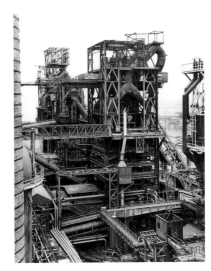
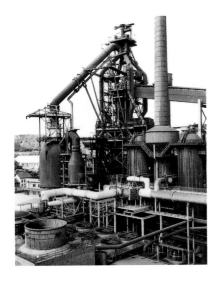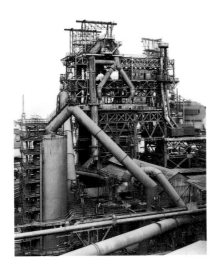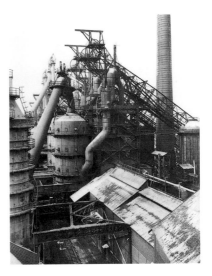

Karl Blossfeldt
Anthriscus silvestris (wild chervil)
enlarged x 18 1900–1926
All Exhibits: Karl Blossfeldt Archiv,
Ann und Jürgen Wilde, Zülpich

Karl Blossfeldt
Silphium perfoliatum (compass plant)
enlarged x 25 1900–1926

Karl Blossfeldt
Equisetum arvense (horsetail)
enlarged x 15 1900–1926

Karl Blossfeldt
Brachypodium distachyum
(two year-old false bromegrass)
enlarged x 12 1900–1926

Odilon Redon
Still Life of Flowers in Green Jug 1866/68
Staatliche Kunsthalle Karlsruhe

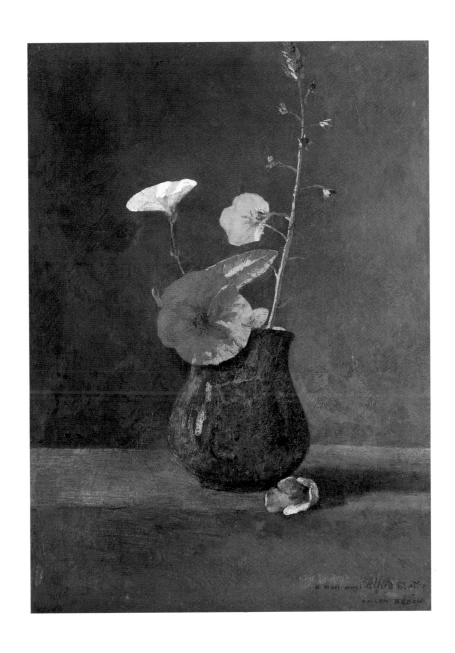

Karl Blossfeldt
Tritonia crocosmiflora (iridaceae)
enlarged x 12 1900–1926

Karl Blossfeldt
Dipsacus laciniatus (fuller's teasel)
enlarged x 12 1900–1926

Karl Blossfeldt
Eryngium bourgatii (eryungo)
enlarged x 12
1900–1926

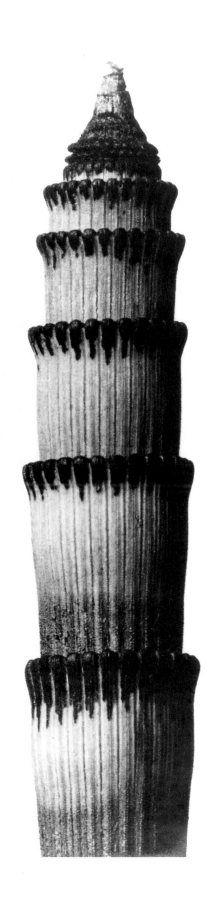

Karl Blossfeldt
*Equisetum hyemale
(pewfer wort)*
enlarged x 30
1900–1926

Elsworth Kelly
Two Panels: Red Yellow 1971
Westfälisches Landesmuseum für Kunst
und Kulturgeschichte, Münster

Dan Graham

Lewis Baltz

Axel Hütte

Bernhard Fuchs

August Sander

Jeff Wall

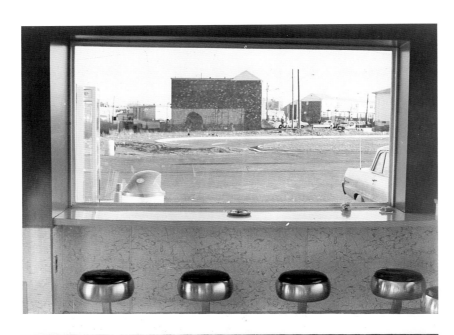

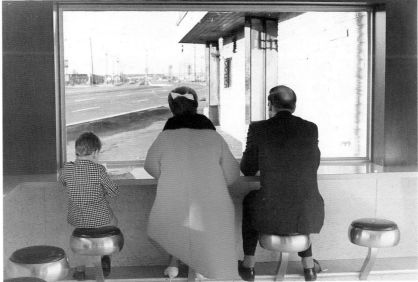

Dan Graham
View Interior, New Highway Restaurant
Jersey City, N.J. 1967
Collection Siemens Kulturprogramm/
Sprengel Museum Hannover

Lewis Baltz
from the Series *Candlestick Point* 1984–1988
Untitled
All Exhibits: Collection Siemens
Kulturprogramm / Sprengel Museum Hannover

Axel Hütte
Furka, Switzerland 1995
Diptych, Private collection

Bernhard Fuchs
Herr Ö., St. Peter 1994
Lent by the artist

Bernhard Fuchs
St. Stephan a.W. 1997
Lent by the artist

Bernhard Fuchs
Traberg, Waldschlag 1997
Lent by the artist

Bernhard Fuchs
Traberg, Waldschlag 1996
Lent by the artist

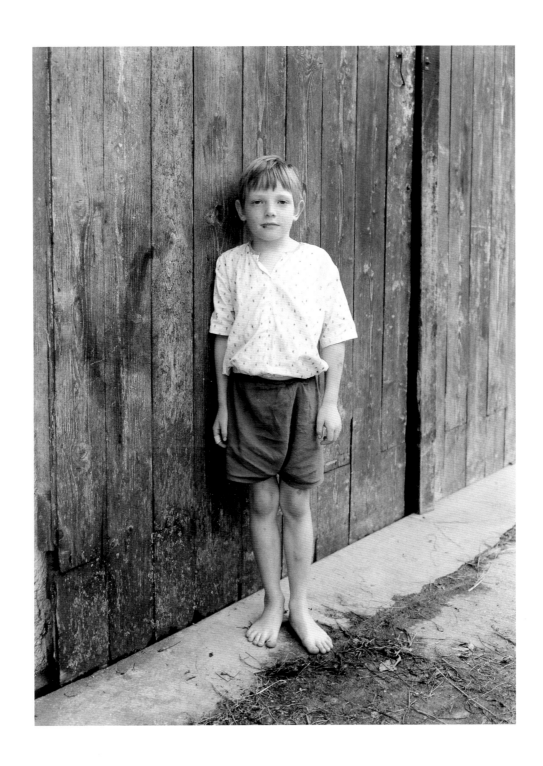

Bernhard Fuchs
Helfenberg 1998
Lent by the artist

August Sander
Forest ca. 1935
Private collection

August Sander
Forest ca. 1935
Private collection

Jeff Wall
The Old Prison 1987
Galerie Johnen & Schöttle,
Cologne

Michael Schmidt

Giorgio Morandi

Judith Joy Ross

Thomas Schütte

Shomei Tomatsu

Patrick Faigenbaum

Carl Schuch

Michael Schmidt
from *Waffenruhe* (Ceasefire) 1985–1987
Installation in the exhibition
Michael Schmidt, Fotografien seit 1965
Berlinische Galerie 1997

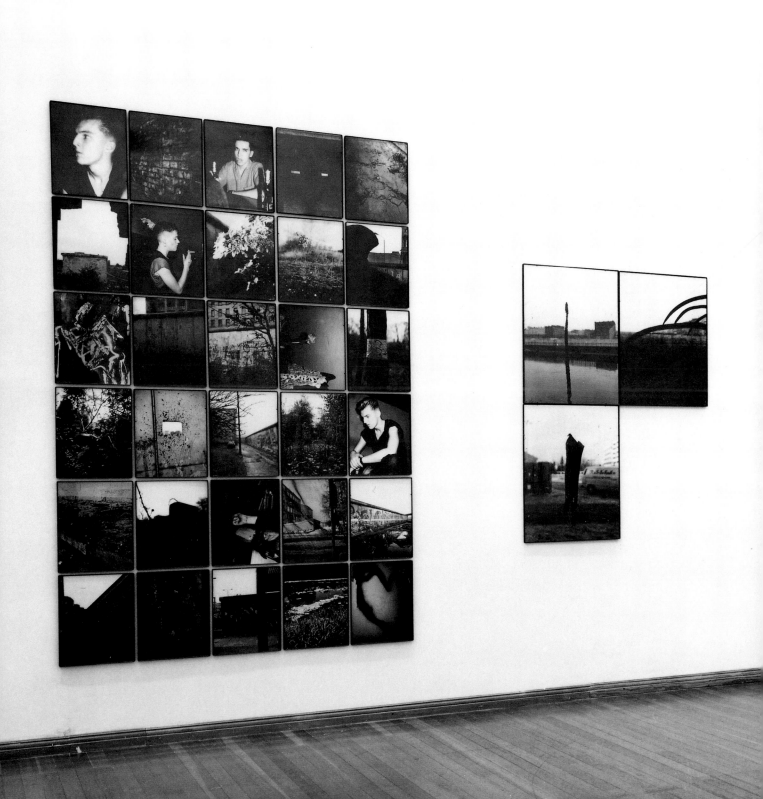

Michael Schmidt
from *Waffenruhe* (Ceasefire)
Untitled 1985–1987
Collection of the Niedersächsische
Sparkassenstiftung, Hanover

Michael Schmidt
from *Waffenruhe* (Ceasefire)
Untitled 1985–1987
Collection of the Niedersächsische
Sparkassenstiftung, Hanover

Giorgio Morandi
Natura morta ca. 1955/56
Sprengel Museum Hannover

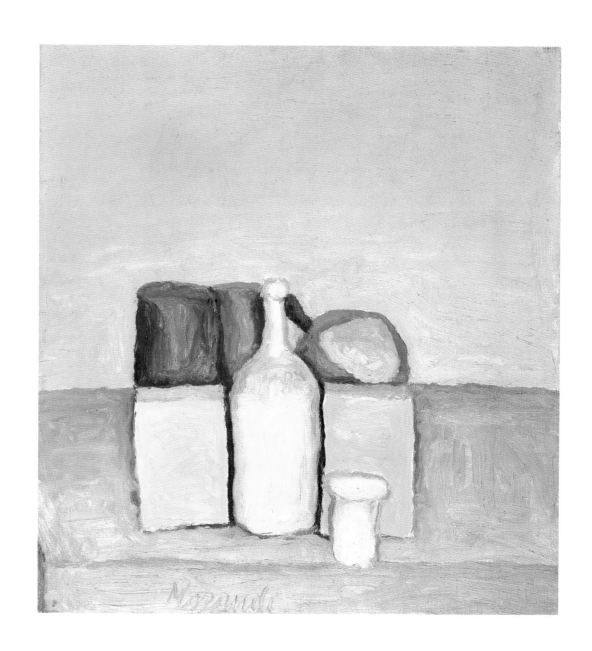

Judith Joy Ross
from the Series *Portraits at the Vietnam Veterans
Memorial, Washington, D.C.*
Untitled 1983–1984
All Exhibits: Collection of the Niedersächsische
Sparkassenstiftung, Hanover

Thomas Schütte
Untitled 1999
Collection of the Niedersächsische
Sparkassenstiftung, Hanover

On 9th August 1945, an American B 29 bomber flew over the northern part of the city of Nagasaki and dropped an atom bomb on the district of Urakami from an altitude of 9,600 metres. The bomb exploded at 11.02 a.m. The weather on that day was pleasantly warm, sunny and very calm.

Shomei Tomatsu

Shomei Tomatsu
from the Series *Nagasaki 11:02, August 9, 1945*
Wristwatch dug up in Uenomachi, 0.7 kilometers
from the hypocenter 1961
All exhibits: Lent by the artist

Shomei Tomatsu
Deformed statues of angels from Urukami
Cathedral, 0.6 kilometers from the hypocenter
1961

Shomei Tomatsu
Ms. Fukuda 1962

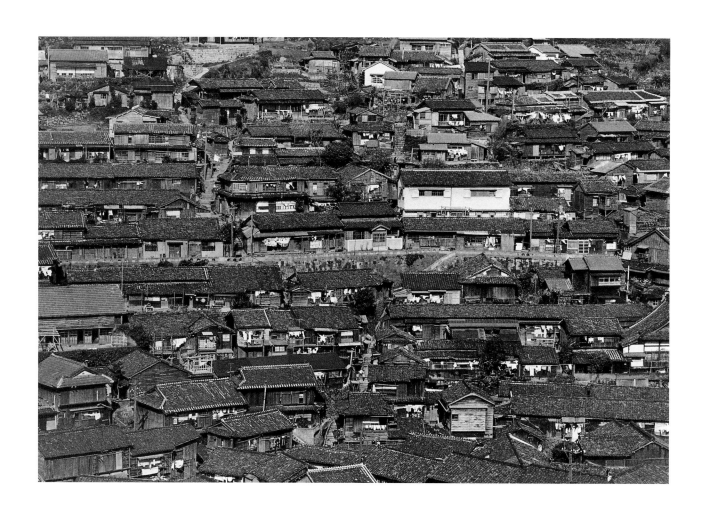

Shomei Tomatsu
Partitioned housing in Oura 1962

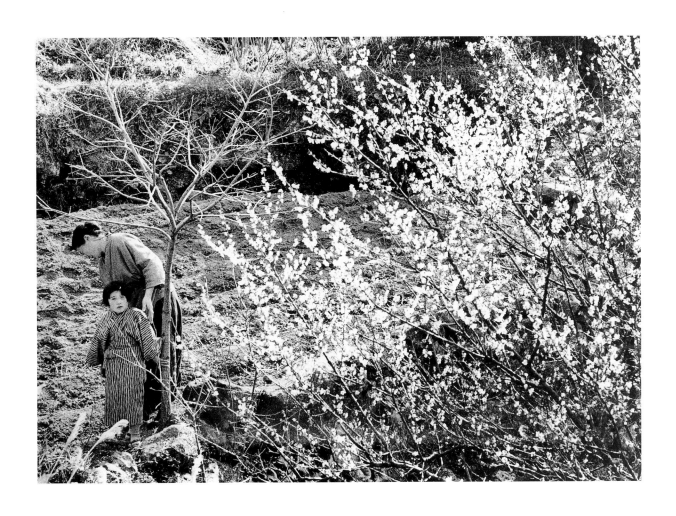

Shomei Tomatsu
Kiyomi and Shizuka Urakawa 1961

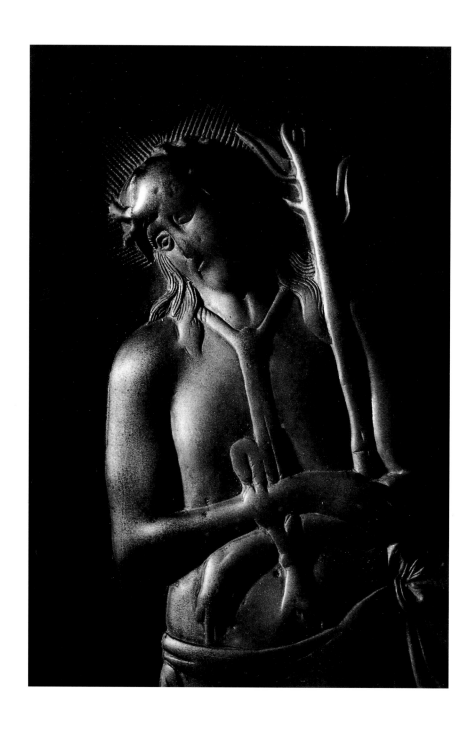

Shomei Tomatsu
*An image of Christ used
as a "fumi-e"* 1963

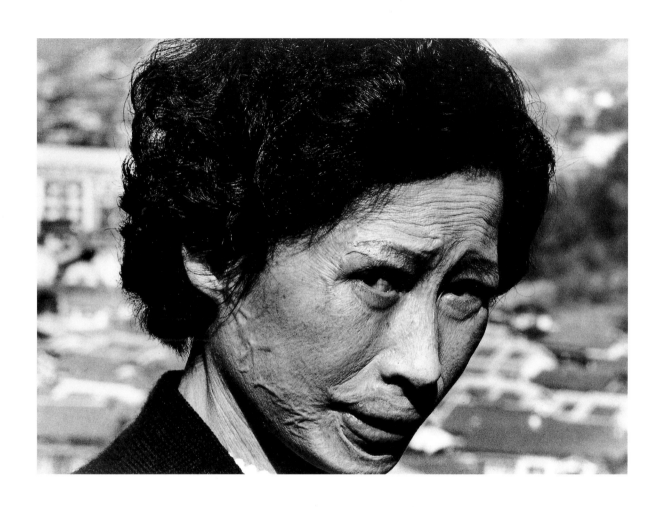

Shomei Tomatsu
Tsuyo Kataoka, of Urakami
1961

Patrick Faigenbaum
from the Series *Parallel Lives*
Gordien III, Rome, August 1987
Lent by the artist

Patrick Faigenbaum
Massimo, Rome, August 1987
Collection d'Œuvres Photographiques
de la Caisse des Depôts, Paris

Patrick Faigenbaum
Massimino, Rome, August 1987
Collection d'Œuvres Photographiques
de la Caisse des Depôts, Paris

Carl Schuch
Two Wild Ducks with Enamel Pot 1880/82
Morat-Institut für Kunst
und Kunstwissenschaft, Freiburg

Hans-Peter Feldmann

Martin Honert

Christian Boltanski

On Kawara

Nicholas Nixon

Hans-Peter Feldmann
*Photos taken from hotel windows
by Feldmann on his travels* 1970s–1990s
Lent by the artist

Burgstall

Vienna

Ottawa

Lipari

Nebraska

Krems

Zurich

Leipzig

Vienna

Paris

Aleppo

New York

392

Gmunden

Stockerau

Freistadt

Eisenstadt

Munich

Lüneburg

Chicago

Chicago

Berlin

Towa

London

Dresden

Görlitz

Vulcano

Augsburg

Hans-Peter Feldmann
Untitled 1972–1973
Private collection

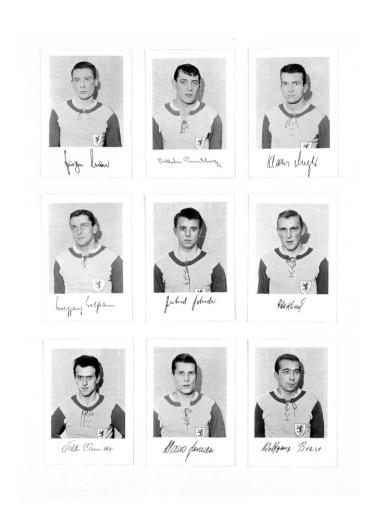

Hans-Peter Feldmann
Untitled 1972–1973
Private collection

Martin Honert
Photo 1993
Collection Landesbank
Baden-Württemberg, Stuttgart

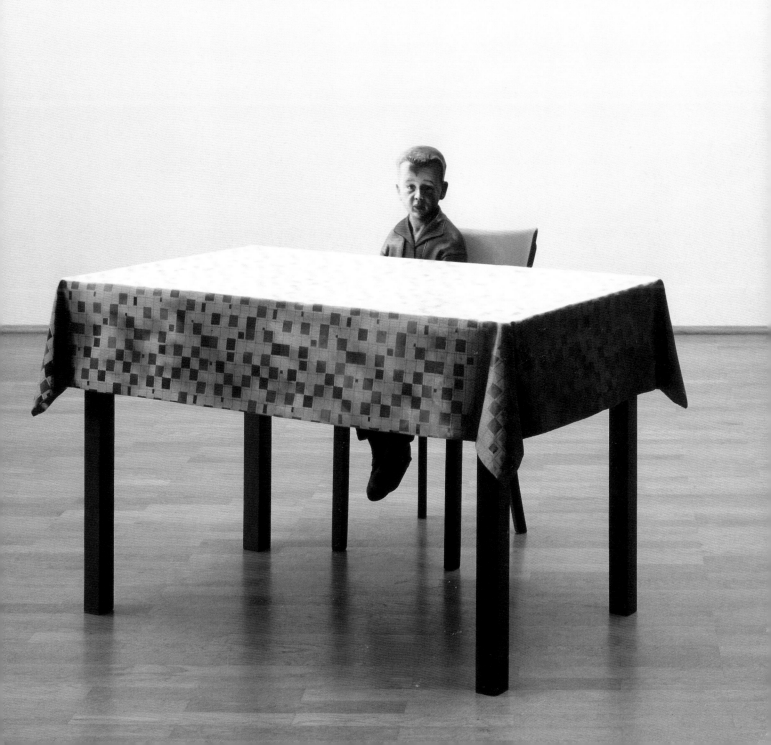

Christian Boltanski
L'album de la famille D., 1939–1964 1971
Collection Liliane & Michel Durand-Dessert,
Paris

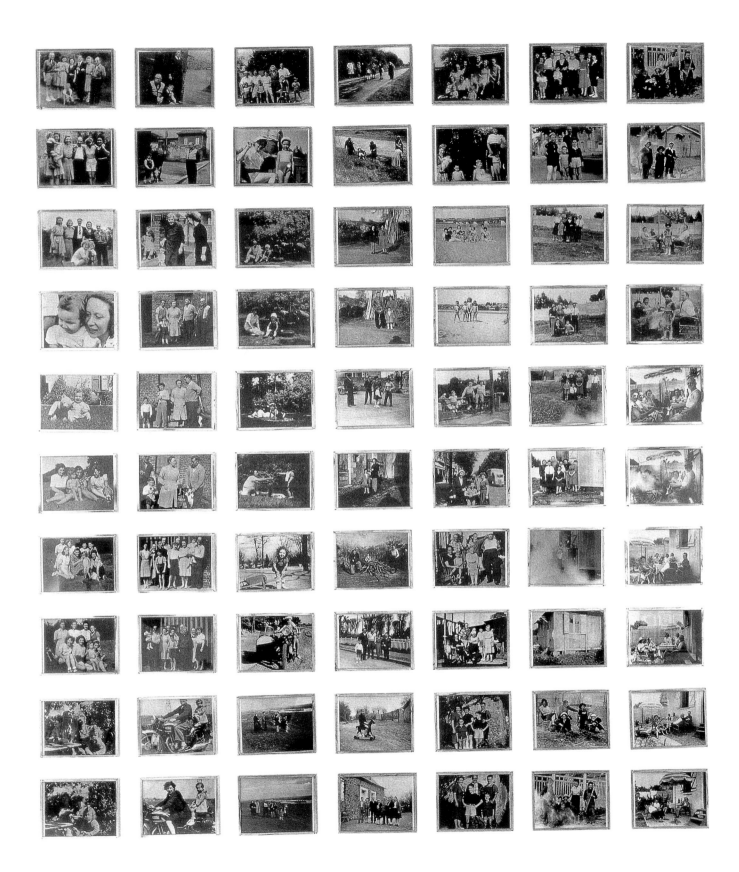

On Kawara
TODAY Series: NOV. 26, 1966
Text verso: "Army won the 20–7 victory over
Navy today before a crowd of 100.000 at
John F. Kennedy Station in Philadelphia, U.S.A.",
Kunstmuseum St. Gallen

On Kawara
TODAY Series: DEC. 28, 1966
Text verso: "Communist China today
exploded its fifth atomic device"
Kunstmuseum St. Gallen

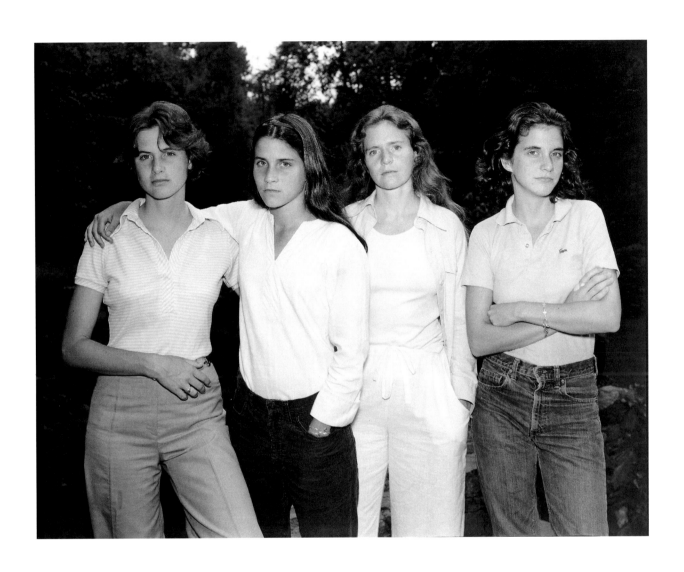

Nicholas Nixon
The Brown Sisters 1975
All Exhibits: Collection of the
Niedersächsische Sparkassenstiftung,
Hanover

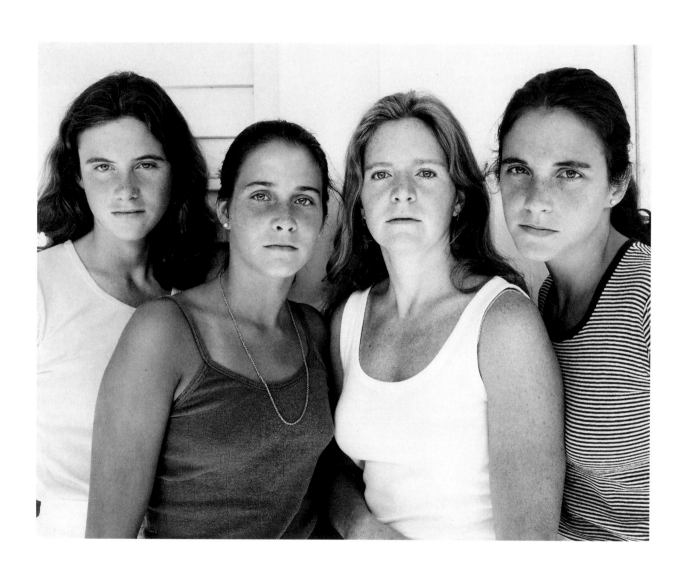

Nicholas Nixon
The Brown Sisters 1978

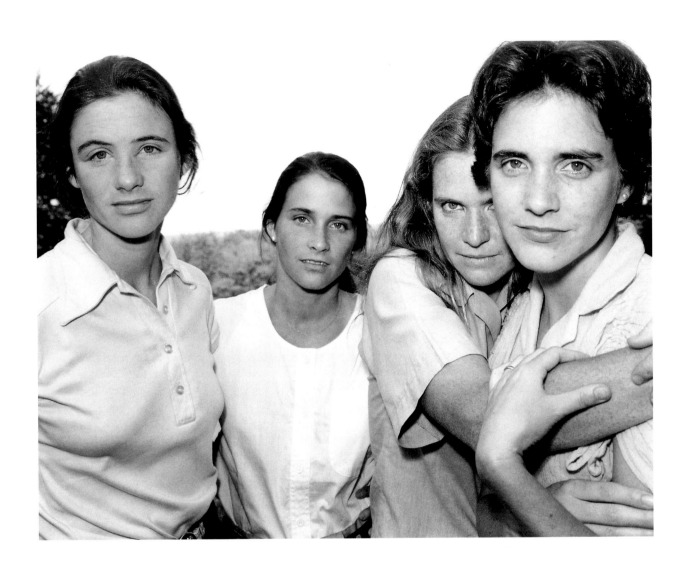

Nicholas Nixon
The Brown Sisters 1980

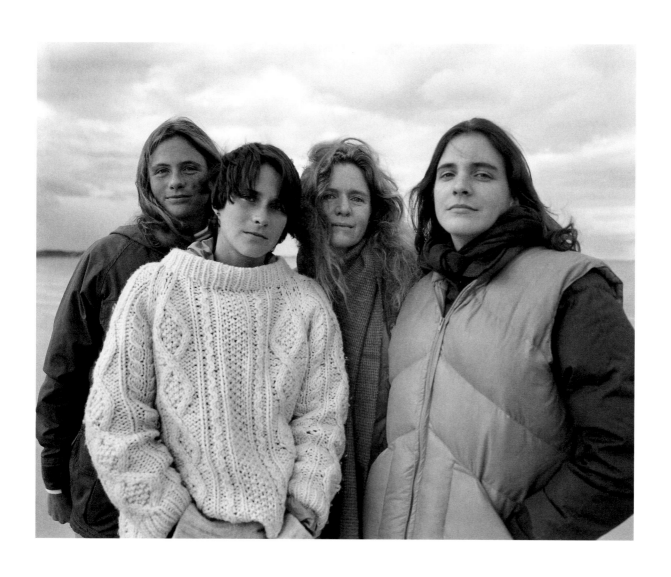

Nicholas Nixon
The Brown Sisters 1982

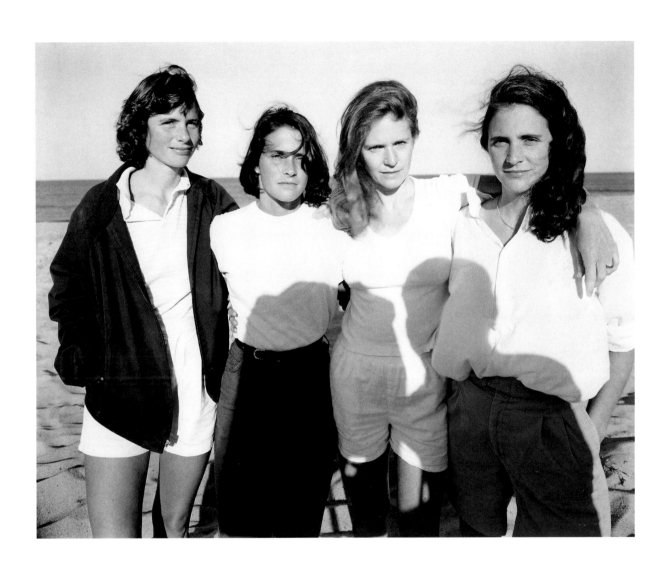

Nicholas Nixon
The Brown Sisters 1984

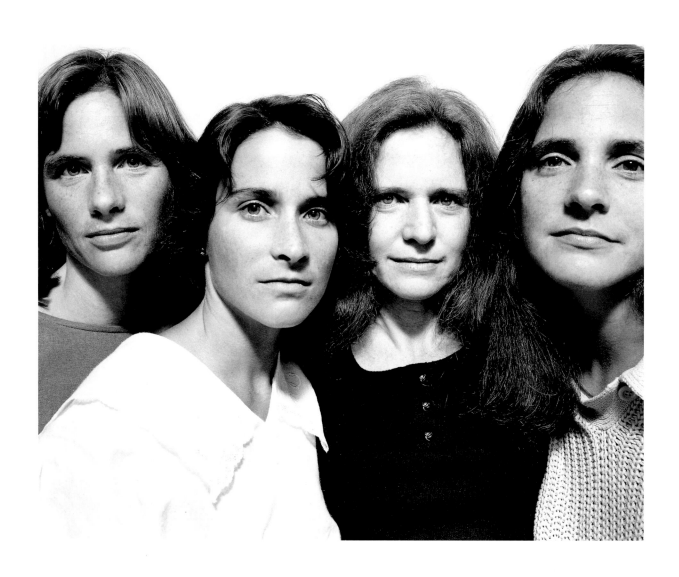

Nicholas Nixon
The Brown Sisters 1986

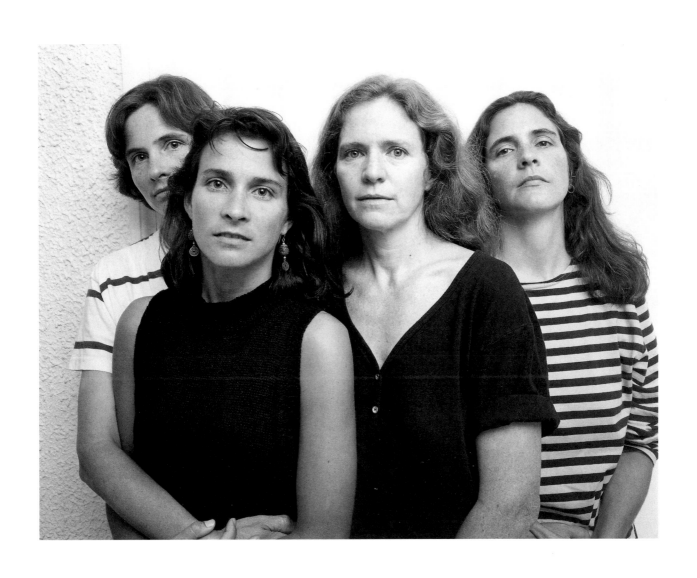

Nicholas Nixon
The Brown Sisters 1989

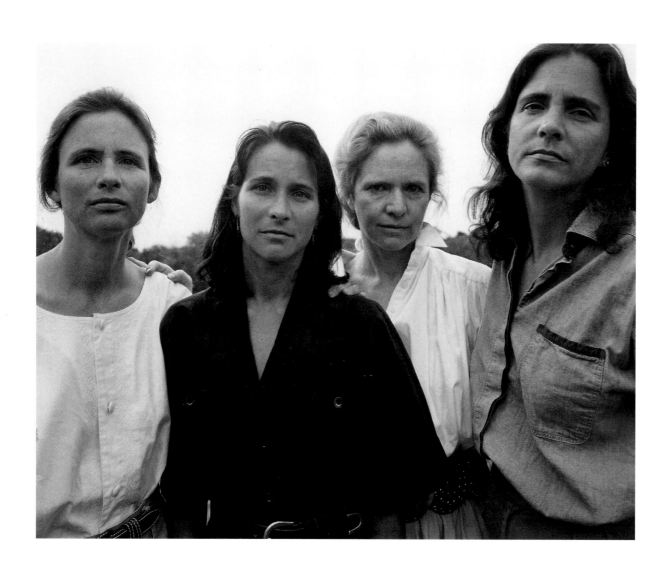

Nicholas Nixon
The Brown Sisters 1991

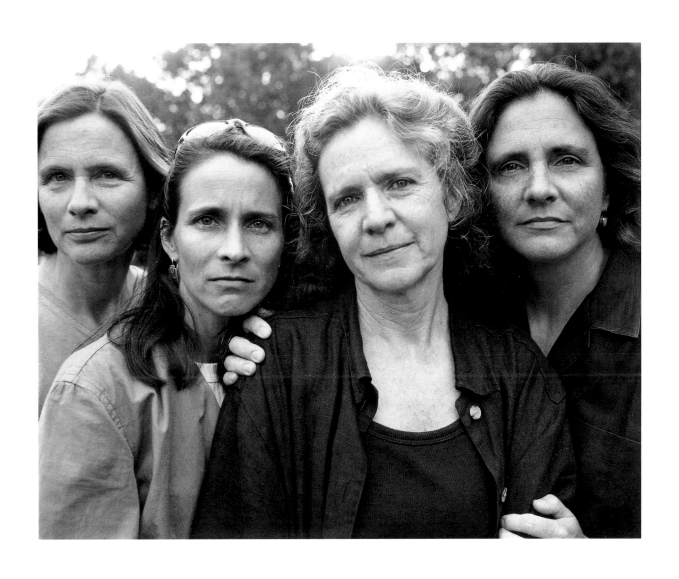

Nicholas Nixon
The Brown Sisters 1999

Nicholas Nixon

Cindy Sherman

David Reed

Lee Friedlander

Max Beckmann

Nicholas Nixon
Bebe and I, Lexington 1998
Lent by the artist

Nicholas Nixon
Bebe and I, Lexington 1998
Lent by the artist

Nicholas Nixon
Sam, Lexington 1998
Lent by the artist

Nicholas Nixon
Bebe and I, Marseille 1998
Lent by the artist

Nicholas Nixon
Clementine, Brookline 1999
Lent by the artist

Cindy Sherman
Untitled # 96 1981
Skarstedt Fine Art, New York
© Courtesy of the artist and Metro Pictures

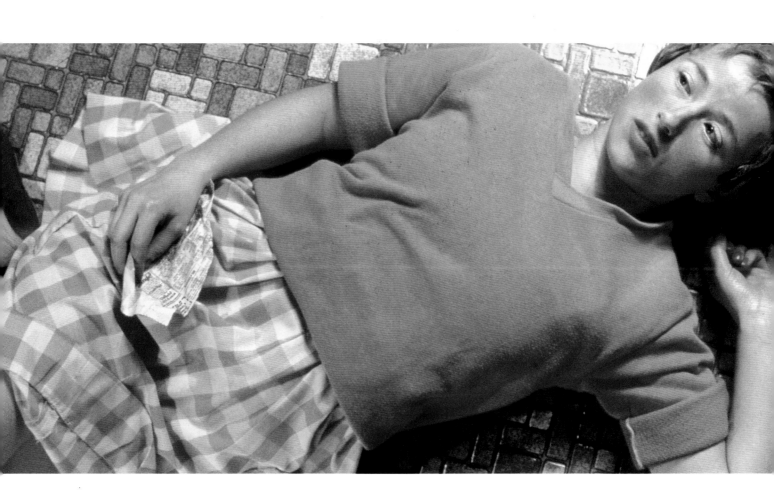

David Reed
276 (for Nicholas Wilder) 1988
Collection Barbara and Howard Morse

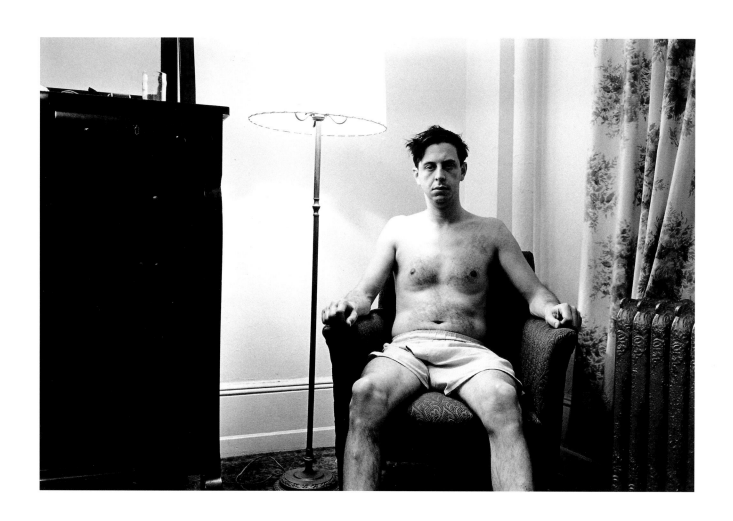

Lee Friedlander
Philadelphia 1965
All Exhibits: Collection of the
Niedersächsische Sparkassenstiftung,
Hanover

Lee Friedlander
NYC 1966

Lee Friedlander
Madison, Wisconsin 1966

Lee Friedlander
New City 1967

Max Beckmann
Self-portrait with Green Curtain 1940
Sprengel Museum Hannover

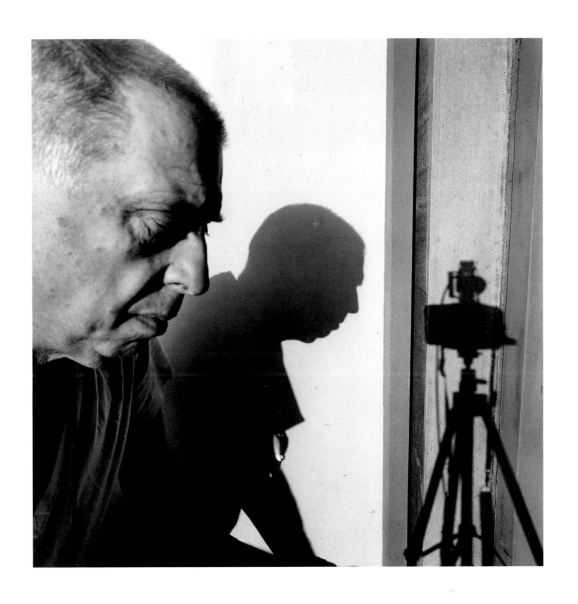

Lee Friedlander
Tokyo 1994

Lee Friedlander
Canyon de Chelly 1983

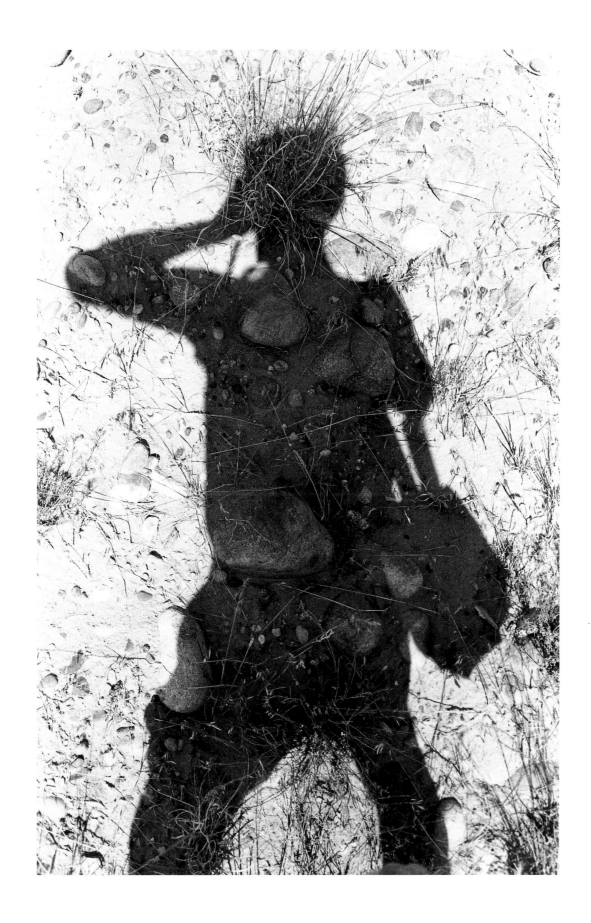

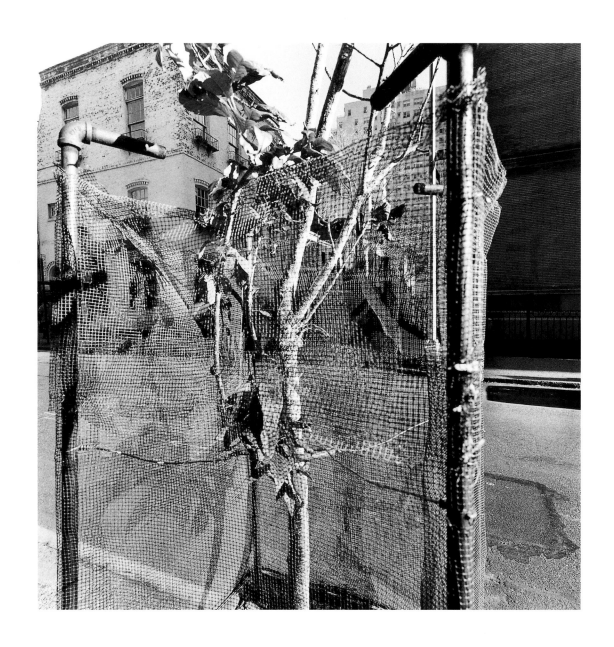

Lee Friedlander
New York City 1994

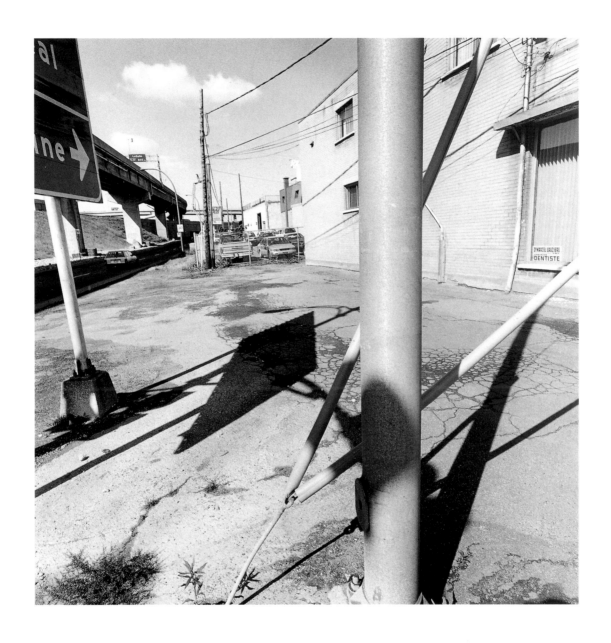

Lee Friedlander
Montreal 1997

Lee Friedlander
New City 1996

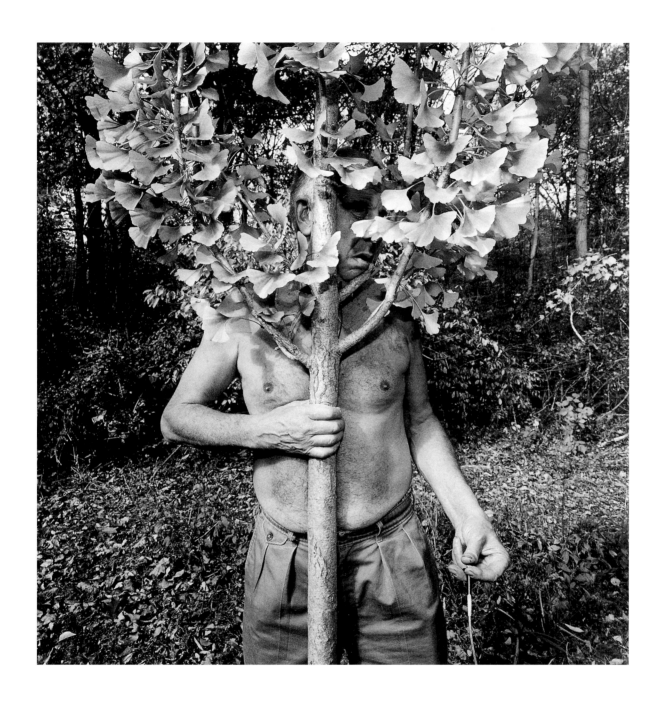

Pablo Picasso

Michael Schmidt

Kurt Kocherscheidt

Andreas Gursky

Pablo Picasso
Inclined Head of a Woman 1906
Staatsgalerie Stuttgart

› Michael Schmidt
from *Women*
Untitled 1997–1999
All Exhibits: Collection of the
Niedersächsische Sparkassenstiftung,
Hanover

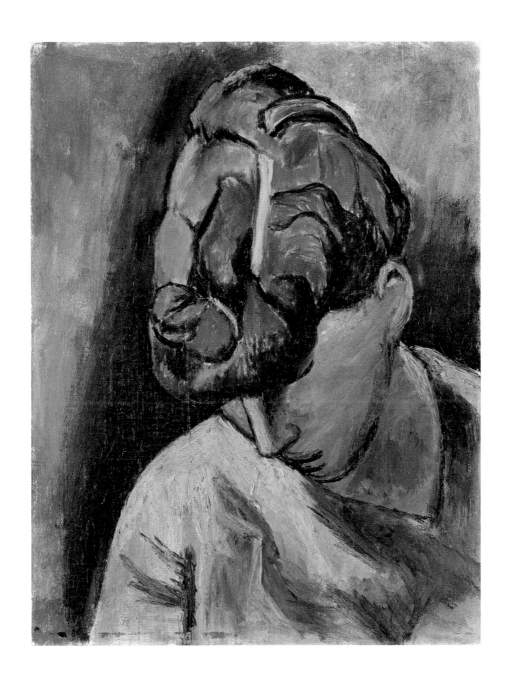

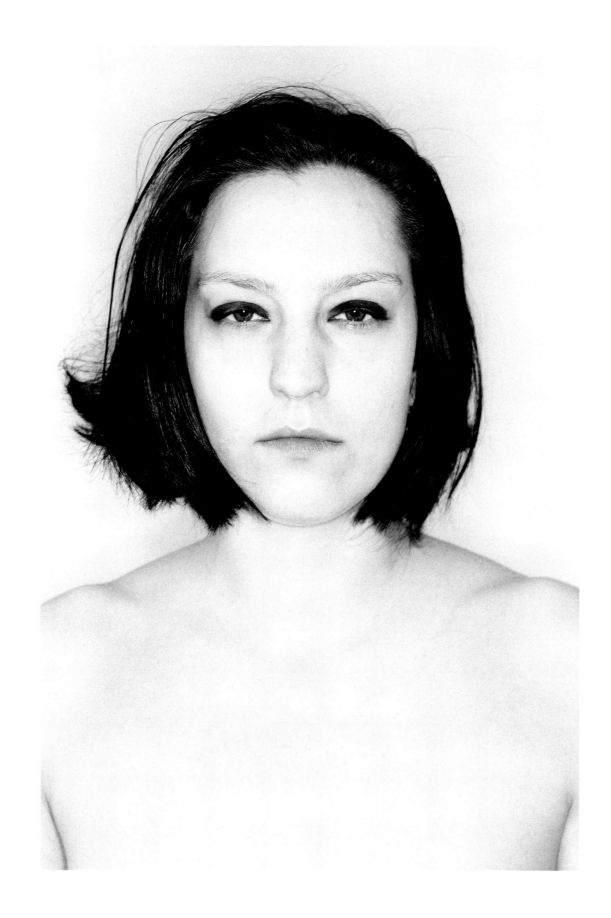

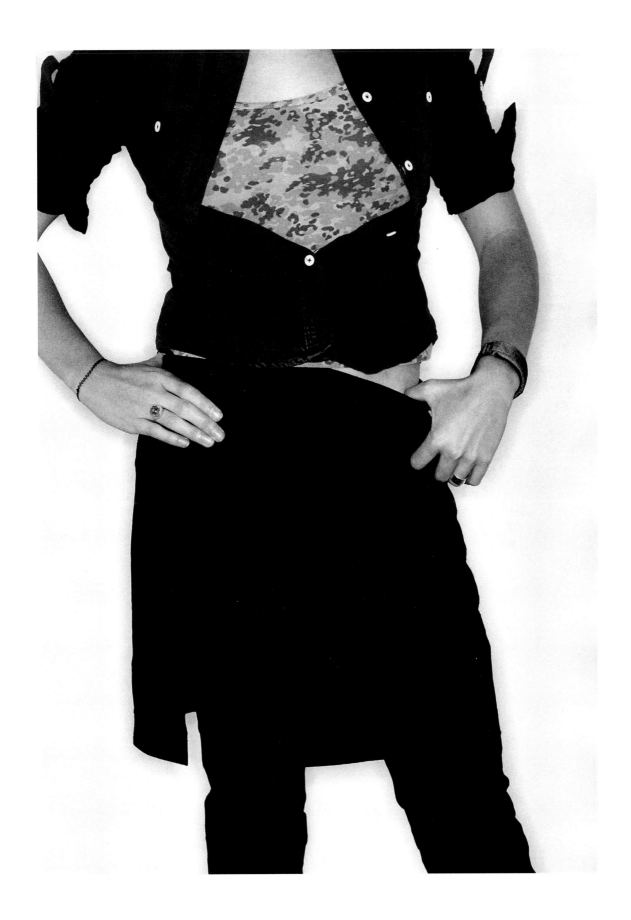

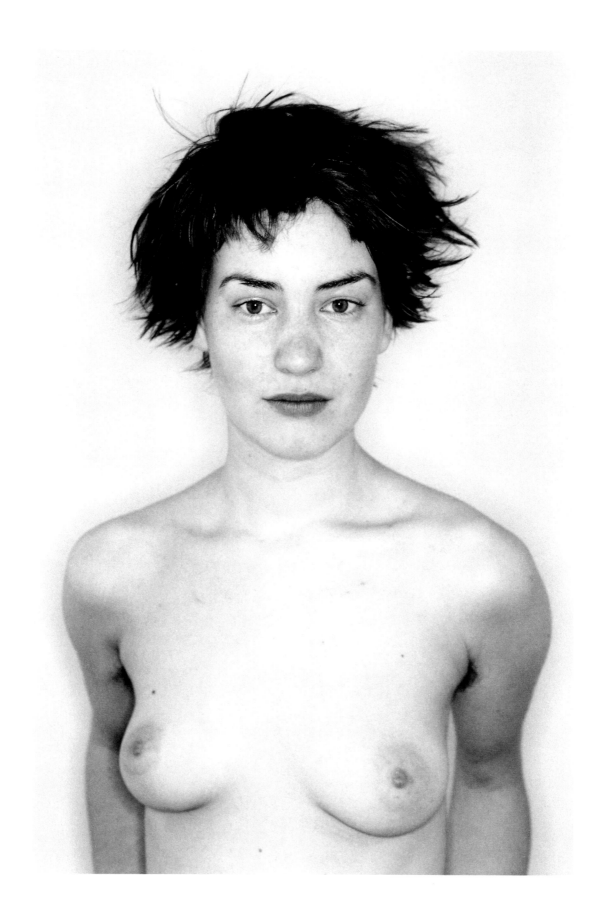

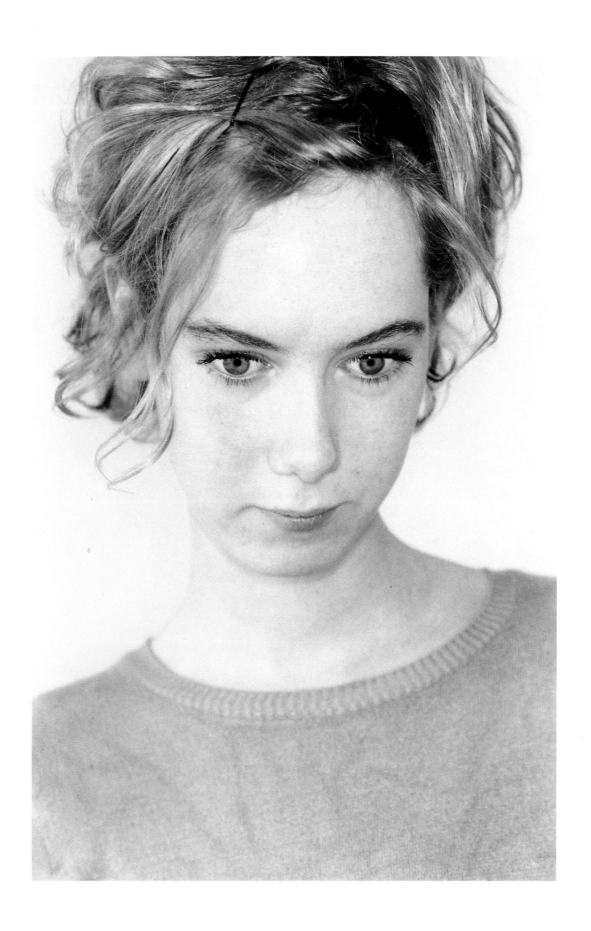

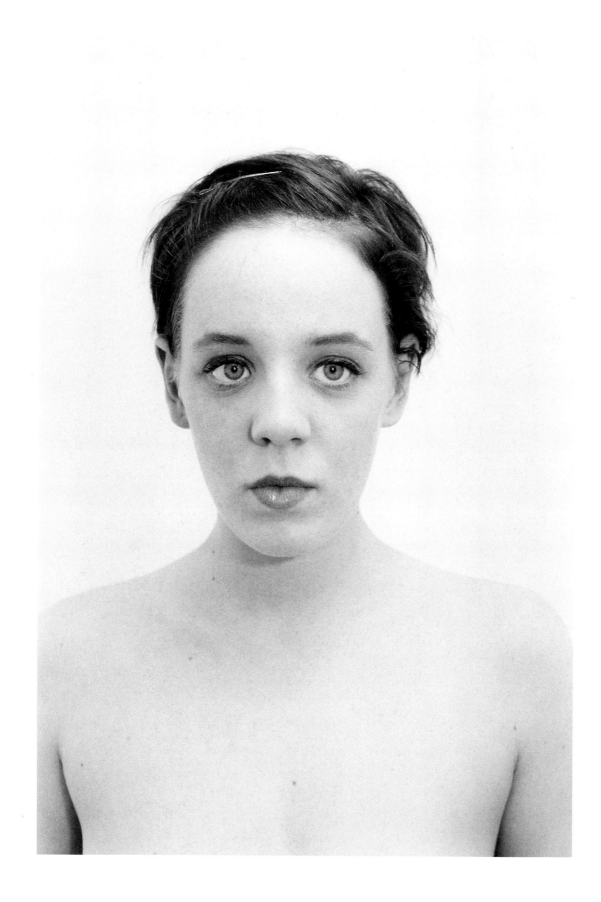

444

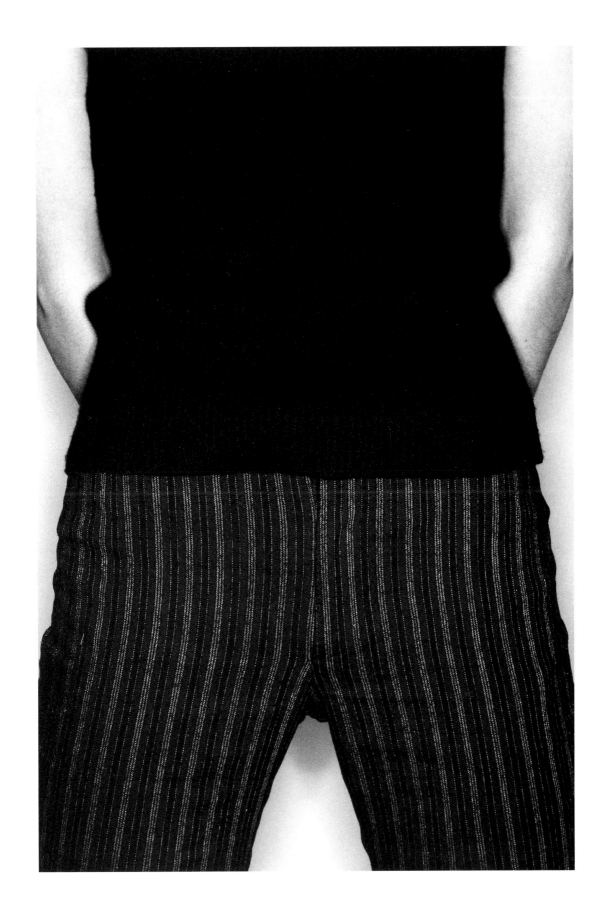

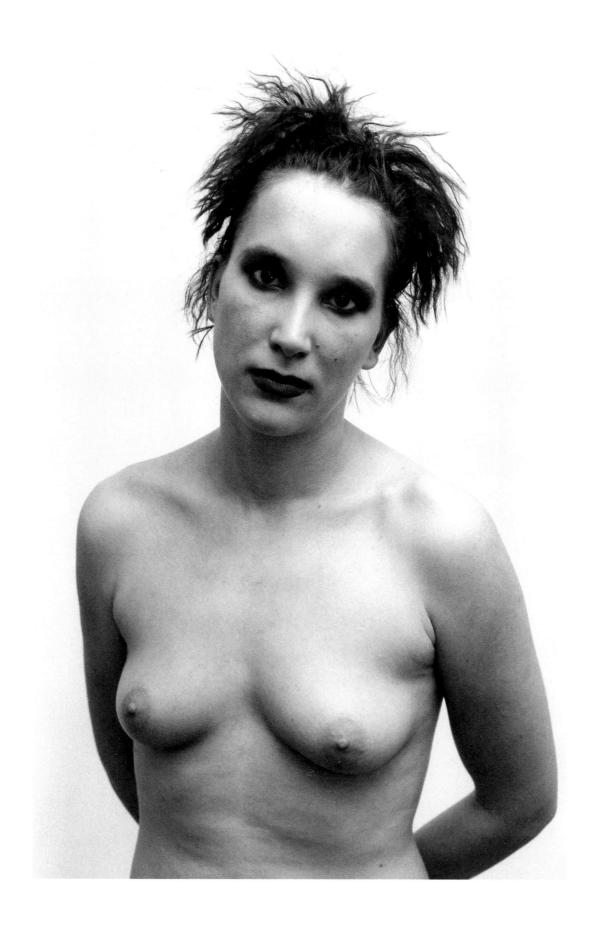

446

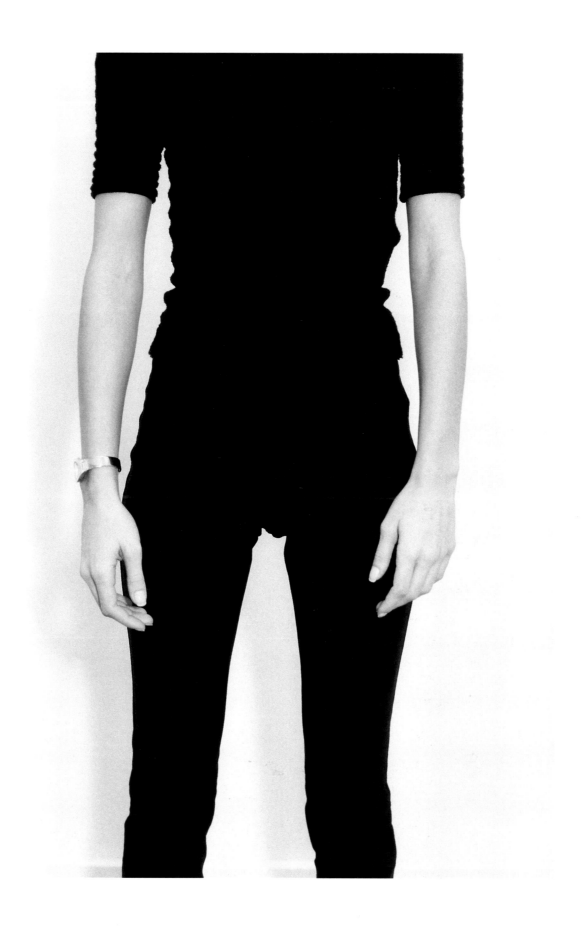

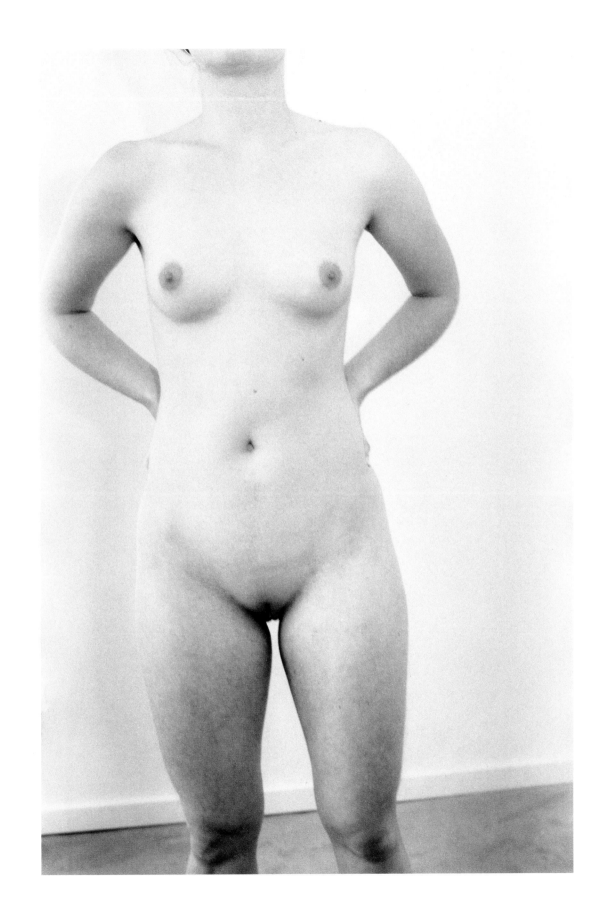

Kurt Kocherscheidt
The Black Sea I 1991
Morat-Institut für Kunst und Kunstwissenschaft,
Freiburg

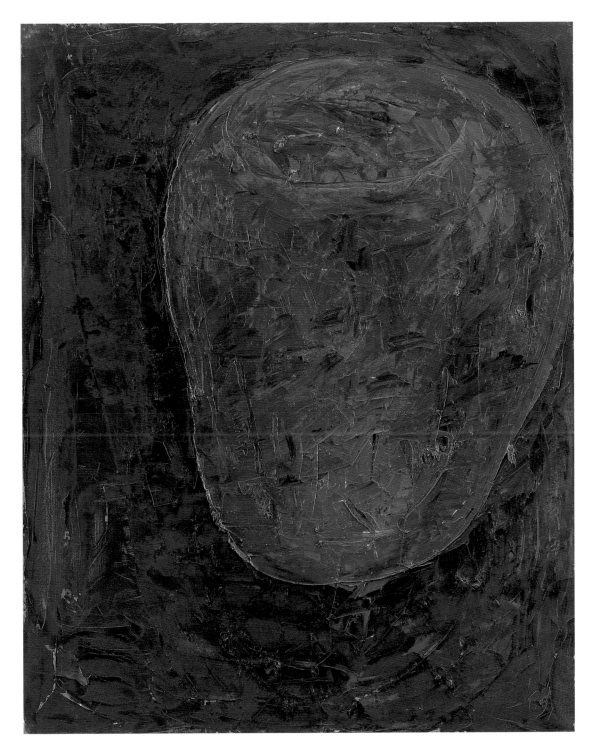

Kurt Kocherscheidt
The Black Sea II 1991
Morat-Institut für Kunst und Kunstwissenschaft,
Freiburg

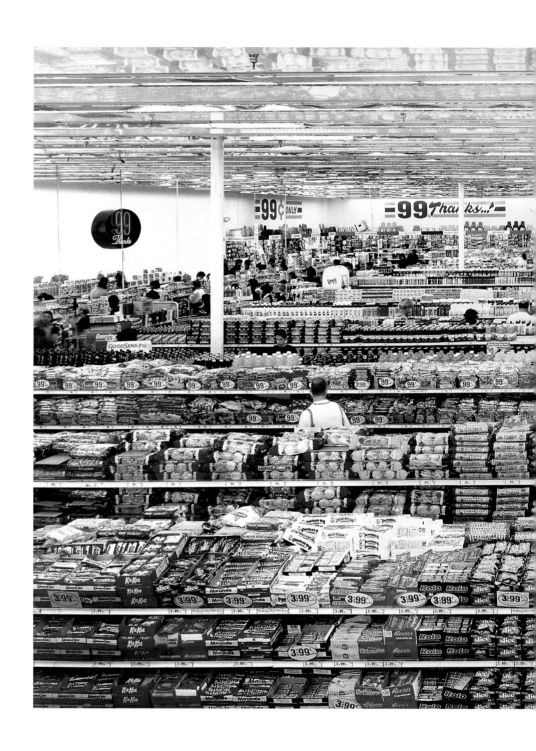

Andreas Gursky
99 Cent 1999
Lent by the artist

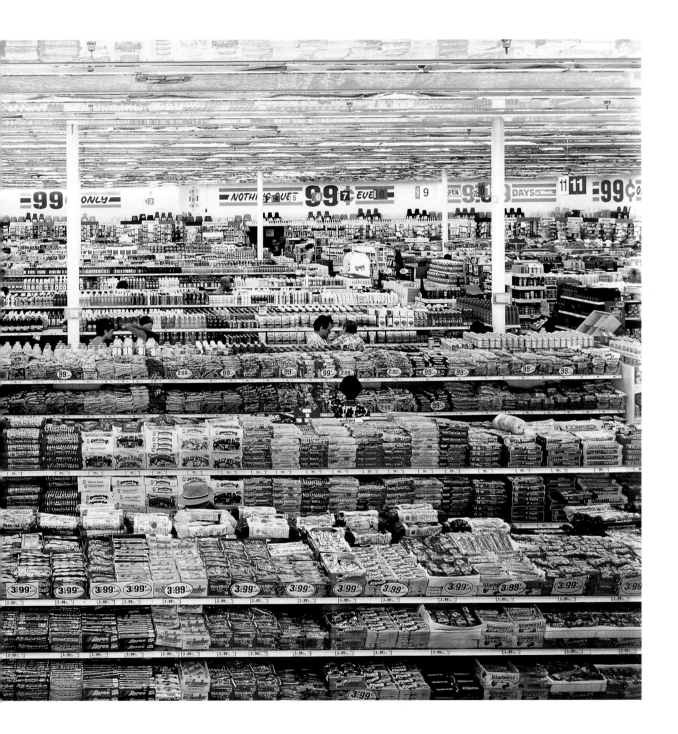

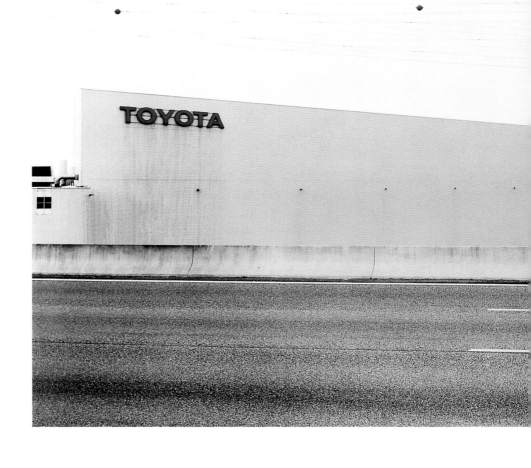

Andreas Gursky
Toys 'R' Us 1999
Lent by the artist

Andreas Gursky
Chicago Board of Trade II 1999
Lent by the artist

Biographies

Exhibitions

Bibliographies

List of Works

Robert Adams

1937 Orange, New Jersey
lives in Astoria, Oregon

For over 35 years Robert Adams has been documenting the effects of human civilization on the landscape of the American Midwest—sober black-and-white photographs which he conceives as lengthy series and has published in numerous volumes.

Robert Adams studied literature at the University of Redlands, California (1956–1959). Having completed his doctorate at UCLA, he then taught English at Colorado College in Colorado Springs from 1962–1970. There, in the early 1960s, he saw that irreversible damage had been done to the landscape where he had first discovered his love of nature on countless hikes and river-trips with his father. In 1963 Adams—a committed environmentalist—turned his attention to mastering the theory and practice of photography in order to photograph the architecture and the landscape in his immediate surroundings. With the precision and rigor of his work and the stylistic restraint of his approach, Adams was in effect taking up the American tradition of topographic photography that was at its height between 1860 and 1880. Above all Robert Adams was deeply influenced by the images that the expedition photographer Timothy O'Sullivan had taken in those days of the still largely unspoiled landscape.

Having reduced his teaching commitment in 1967 in order to concentrate on his work as a photographer, Adams started a year later on a series devoted to the new suburban landscapes along the Colorado Front Range. In 1974 he published 56 of these landscapes in his book *The New West*, which is divided into five sections, each with its own introduction. In the sequencing determined by Adams himself, these unspectacular images describe a journey across the immense, glaringly bright *Prairie*, ending at the anonymous, seemingly desolate *Tracts and Mobile Homes* that had sprung up so rapidly on the outskirts of the *City*. His shots of urban spaces generally show deserted streets, parking lots, filling stations, and cars. These lead on to the last sequence of photographs in the book, which show that civilization has also left its mark on the *Foothills* and on the appearance of the *Mountains*. In a review of the book, the photographer Lewis Baltz points out that Adams's concerns are underlined by his choice of a square picture-format which is relatively rare in landscape photography: "This, together with his tendency toward a centralized image within the frame, results in unusually static pictures, appropriate to an urbanized geography in which little is animate."

In *The New West* Adams succeeded in linking representations of the beauty of a myth-laden American West with his critical—although never moralistic—view of how human beings had treated nature. "My goal, I think, has been twofold: on the one hand, to show what has gone wrong in the contemporary western landscape so we'll want to change it and do better; but I also hope to show what has remained right in that landscape so we will care for it and take guidance from it and take hope in it." (Robert Adams)

This series marked the beginning of Adams's lasting involvement in the evolution of the American landscape and already contained the seeds of many of the themes, motifs, and formal aspects of his subsequent photographic projects. One year after his book appeared, Adams's participation in the ground-breaking exhibition *New Topographics. Photographs of a Man-Altered Landscape* established him as one of the leading exponents of American topographic photography in the 1970s.

In addition to his photographic activities, Adams has written numerous reviews and essays on the history of photography, which have appeared in various publications, including *Beauty in Photography* (1981) and *Why People Photograph* (1994). Since the late 1980s, in photographic series such as *West of the Columbia. Views of the River Mouth*, he has been increasingly occupied with the representation of largely intact landscapes.

ULRIKE SCHNEIDER

Exhibitions (Selected)

1970 *New Acquisitions*, The Museum of Modern Art, New York

1971 Colorado Springs Fine Arts Center (solo exhibition)
 Photographs by Robert Adams and Emmet Gowin, The Museum of Modern Art, New York

1973 *Landscape/Cityscape*, The Metropolitan Museum of Art, New York (cat.)

1975 *New Topographics. Photographs of a Man-Altered Landscape*, George Eastman House, Rochester (cat.)

1978 *Amerikanische Landschaftsphotographie 1860–1978*, Neue Sammlung, Munich (cat.)

1979 *Prairie*, Denver Art Museum (solo exhibition/tour)
 Werkstatt für Photographie, Berlin (solo exhibition)

1981 *The New West. Photographs by Robert Adams*, Philadelphia Museum of Art (solo exhibition)

1986 *Summer Nights*, Denver Art Museum (solo exhibition/tour)

1989 *To Make It Home. Photographs of the American West 1965–1986*, Philadelphia Museum of Art (solo exhibition/tour/cat.)

1994 *Listening to the River. Seasons in the American West*, Sprengel Museum Hannover (solo exhibition/tour)

1995 *What We Bought. The New World. Scenes From the Denver Metropolitan Area 1970–1974*, Sprengel Museum Hannover (solo exhibition/cat.)

1997 *documenta X*, Kassel (cat.)

1999 *The American Century Art and Culture, 1900–2000*, Whitney Museum of American Art, New York (cat.)

Bibliography (Selected)

› *White Churches of the Plains. Examples from Colorado*, Introduction by Thomas Hornsby Ferril, Boulder 1970.

› *The New West. Landscapes Along the Colorado Front Range*, Introduction by John Szarkowski, Boulder 1974.

› *Denver. A Photographic Survey of the Metropolitan Area*, Text by Robert Adams, Boulder 1977.

› *From the Missouri West*, Text by Robert Adams, New York 1980.

› *Beauty in Photography. Essays in Defense of Traditional Values*, Texts by Robert Adams, New York 1981.

› *Our Lives & Our Children. Photographs Taken Near the Rocky Flats Nuclear Weapons Plant*, Text by Robert Adams, New York 1983.

› *To Make It Home. Photographs of the American West*, Text by Robert Adams, exh. cat., Philadelphia Museum of Art, New York 1989.

› *Why People Photograph. Selected Essays and Reviews by Robert Adams*, Texts by Robert Adams, New York 1994.

› *What We Bought: The New World. Scenes From the Denver Metropolitan Area 1970–1974*, Text by Robert Adams, exh. cat., Stiftung Niedersachsen and Sprengel Museum Hannover 1995.

› *West from the Columbia. Views at the River Mouth*, New York 1995.

› *Notes for friends. Along colorado roads*, Text by Robert Adams, Colorado 1999.

Diane Arbus
1923 New York
1971 New York

Powerfully expressive portraits of outsiders, images of apparently alienated members of the upper middle classes—these were the photographs that made Diane Arbus famous in the late 1960s. Not long after this, at the age of 48, she took her own life. Diane Arbus, the daughter of a prosperous Jewish department-store owner, grew up in New York. When she was 18 she married Allan Arbus and until 1956 she worked together with her husband as a fashion photographer for various American magazines. In the late 60s she enrolled at the New School for Social Research in New York to study photography with Lisette Model. Model's notion of the camera as an "instrument of discovery" and her advice only to take a picture if the subject "hit you hard in the solar plexus" had an enduring effect on Diane Arbus's vision and development as a portrait photographer.

In 1960 she started to work as a photo-journalist for magazines such as *Esquire* and *Harper's Bazaar*, publishing portraits of writers, filmstars, and other striking personalities. Fascinated by extreme lifestyles, Diane Arbus also took many photographs purely for her own interest—bizarre individualists, circus performers, nudists, and transvestites in their own surroundings, mentally retarded adults (1969–1971), but also seemingly perfectly normal New Yorkers in the city's parks and streets. In these portraits, many of which were taken with a flash, Diane Arbus manages to make the familiar seem abnormal and the unusual seem normal. Her mercilessly direct portraits were not spontaneous snapshots, but were always taken with the consent of her subjects, who posed before the camera as they themselves wished. Although these frontal portraits are the result of a partnership involving the model and the photographer, many of them still seem particularly revealing because of the way Arbus highlights the discrepancy between the subject's wishful self-image and the effect of that image on the viewer or, as Arbus herself puts it, "the gap between intention and effect." Imitation and simulation are also characteristic of the few photographs by Diane Arbus that do not feature human beings, as in one landscape, for instance, that turns out on closer examination to be a photograph of photo-wallpaper (*A Lobby in a Building*, N.Y.C., 1963).

In 1963 and 1966 Diane Arbus was awarded Guggen-

heim Fellowships to work on her own freelance projects, and in 1967 her portraits were shown in the influential exhibition *New Documents* in the Museum of Modern Art in New York. Her photographs were seen in the company of works by Lee Friedlander and Garry Winogrand. In the view of curator John Szarkowski, these photographers belonged to a new generation which "has redirected the technique and aesthetic of documentary photography to more personal ends."

Following the success of this exhibition, the 1972 retrospective mounted in New York shortly after the death of Diane Arbus became one of the most popular exhibitions of photography to be held in the Museum of Modern Art. In the same year portraits by Diane Arbus were to become the first photographic works shown in the American pavilion at the Biennale in Venice.

Ever since then, her pictures have generated controversy, fueled in the 1970s by various critics, including Susan Sontag, who claimed that Arbus's photographs put across an "anti-humanist message" and reproached her for "cloaking all her subjects in fear, whimsy and mental instability." To this day, Diane Arbus is regarded as "someone already impeccably credentialed as a Great Photographer [...] whom every photographer knows with the passion of fascination, or denunciation, or both at once" (Katherine Lord).

US

Exhibitions (Selected)

1967 *New Documents*, The Museum of Modern Art, New York (tour / cat.)

1972 *Biennale di Venezia*, Venice (cat.)
Retrospective, The Museum of Modern Art, New York (solo exhibition / tour / cat.)

1973 Seibu Museum of Modern Art, Tokyo (solo exhibition / tour)

1974 Hayward Gallery, London (solo exhibition)
Rijksmuseum Vincent van Gogh, Amsterdam (solo exhibition)

1975 Städtische Galerie im Lenbachhaus, Munich
Von der Heydt Museum, Wuppertal (solo exhibition)
Stedelijk Van Abbemuseum, Eindhoven (solo exhibition / cat.)

1976 Frankfurter Kunstverein (solo exhibition)

1977 Helios Gallery, New York (solo exhibition)

1978 *Mirrors and Windows: American Photography since 1960*, The Museum of Modern Art, New York (tour / cat.)

1980 *Unpublished Photographs*, Robert Miller Gallery, New York (solo exhibition)
Unpublished Photographs, Fraenkel Gallery, San Francisco (solo exhibition)
Centre Georges Pompidou, Paris (solo exhibition / tour)

1984 *Magazine Work*, Spenser Museum of Art, The University of Kansas (solo exhibition / tour / cat.)

1985 La Fundacio Caixa de Pensions, Barcelona (tour)
American Center, Paris (solo exhibition)

1987 *Early Works*, Robert Miller Gallery, New York (solo exhibition)

1988 *Untitled*, Fraenkel Gallery, San Francisco (solo exhibition)

1995 *The Movies*, Robert Miller Gallery, New York (solo exhibition)

1996 *Diane Arbus. Photographien ohne Titel*, Kunsthalle Bielefeld (solo exhibition)

1997 *Women*, Robert Miller Gallery, New York (solo exhibition)

1998 *Women*, Photology, Milan and London (solo exhibition)

2000 *Fairy tales for Grown-Ups*, The National Gallery of Canada

Bibliography (Selected)

› *Diane Arbus. An Aperture Monograph*, ed. by Doon Arbus and Marvin Israel, New York 1972.

› *Diane Arbus. Magazine Work*, ed. by Doon Arbus and Marvin Israel, Texts by Diane Arbus, Essay by Thomas Southall, New York 1984.

› *Diane Arbus. Untitled*, conceived and ed. by Doon Arbus and Yolanda Cuomo, New York 1995.

Eugène Atget

1857 Libourne
1927 Paris

Eugène Atget, "the first modern photographer of the 20th century" (Klaus Honnef), systematically photographed the French capital and its environs, yet received little or no recognition during his lifetime.

It was not until shortly before Atget's death that the young American photographer Berenice Abbott realized the significance of his work, which by then comprised around 8,000 semi-documentary photographs. She met him when she was working as an assistant to Man Ray, who had bought a number of photographs

from him in the mid-20s and who had published four of his photographs in the avant-garde journal *La Révolution Surréaliste* in 1926. A year after Atget's death, Berenice Abbott acquired around 5,000 original prints and 1,300 glass negatives from the artist's estate and made his work known through exhibitions and publications.

Eugène Atget was a self-taught photographer. Before taking up photography full-time in 1888, he had already studied at the State Academy of Drama in Paris, had worked for six years as a traveling player, and had also attempted to earn his living as a freelance artist. As a professional photographer he specialized in "Documents for Artists" and produced photographic materials designed to meet the needs of painters, illustrators, set designers, and artist-craftsmen.

Around 1897 he began to build up a "collection of photographic views of old Paris," which was undergoing radical change at the time due to increasing industrialization. On his forays into the oldest parts of the city, he avoided the usual tourist attractions, instead taking pictures of hidden alleys, squares, and backyards, and architectural details such as flights of steps, wrought-iron grills, and shop signs, many of which soon no longer existed. Notable amongst the few photographs specifically focusing on human beings is his 1899 series, *Petits Métiers de Paris*. Most probably a commission, this series consists of 80 photographs of laborers, craftsmen, traders, and other typical representatives of occupations which were also similarly disappearing from the streets of Paris. In 1920, Atget—photographer and passionate collector—could proudly claim: "I can say, I possess all of old Paris."

All of Atget's photographs were made using a heavy, unwieldy 19th century plate camera, which could not take snapshots because of the exposure times required. Atget's precise, classically-composed pictures —which he never retouched—are mostly taken at eye-level and, unlike the work of other artist-photographers around 1900, use purely photographic means.

Atget devoted lengthy series to his different subjects, after 1910 collecting these together in themed albums. Besides artists and private collectors, his customers also included public archives, libraries, and museums such as the Musée Carnavalet in Paris.

Whereas his early works were primarily made with an eye to potential purchasers, the photographs from the last years of his life—including some of his most powerful pieces—are a much clearer reflection of the photog-

rapher's own personal interests. Besides his deserted views of the topography of Paris, it was particularly his late images of window displays and annual fairs that Man Ray, and others regarded as paving the way for surrealist photography, and which, according to Wilfried Wiegand, established Atget "as the first to discover the modern beauty of the banal and the everyday."

US

Exhibitions (Selected)

1928 *Premier Salon des Indépendants de la Photographie*, Comédie des Champs-Elysées, Paris

1929 *Film und Foto*, Städtische Ausstellungshallen, Stuttgart (tour/cat.)

1930 *Atget*, Weyhe Gallery, New York (solo exhibition/cat.)

1939 *Eugène Atget*, Photo-League, New York (solo exhibition)

1941 *Vues de Paris et Petits métiers*, Musée Carnavalet, Paris

1972 The Museum of Modern Art, New York (solo exhibition)

1977 *documenta VI*, Kassel (cat.)

1978 *Eugène Atget. Das Alte Paris*, Rheinisches Landesmuseum, Bonn (solo exhibition/cat.)

1981–84 *The Work of Atget*, The Museum of Modern Art, New York (solo exhibition/cat.)

1982 *Eugène Atget. Intérieurs Parisiens artistiques, pittoresques et bourgeois, début du XXe siècle*, Musée Carnavalet, Paris (solo exhibition/tour/cat.)

1991 *Eugène Atget. El París de 1900*, IVAM, Centro Julio González, València (solo exhibition/tour/cat.)

1998 *Eugène Atget 1857–1927. Frühe Fotografien*, Kunstbibliothek Berlin (solo exhibition/tour/cat.)
Eugène Atget. A retrospective, Tokyo Metropolitan Museum of Photography (solo exhibition/cat.)

Bibliography (Selected)

› *Eugène Atget. Photographe de Paris*, Introduction by Pierre Mac Orlan, Paris 1930.

› *The World of Atget,* ed. by Berenice Abbott, New York 1964.

› *Atget, magicien du vieux Paris et son époque*, ed. by Jean Leroy, Paris 1975.

› *Eugène Atget. Das alte Paris*, Texts by Klaus Honnef, Gisèle Freund et al., exh. cat., Rheinisches Landesmuseum Bonn, Cologne 1978.

› *Eugène Atget. Voyages en ville*, Texts by Romeo Martinez, Pierre Gassmann et al., Paris 1979.

› *Eugène Atget 1857–1927*, ed. by James Borcoman, National Gallery of Canada, Ottawa 1984.

› *The Work of Atget*, ed. by John Szarkowski and Maria Morris Hambourg, 4 vols, The Museum of Modern Art, New York 1981-1985. (vol. 1: *Old France*; vol. 2: *Old Paris*; vol. 3: *The Ancient Regime*; vol. 4: *Modern Times.*)
› *Atget's Seven Albums*, ed. by Molly Nesbit, New Haven 1992.
› *Atget, Paris pittoresque*, ed. by Guillaume Le Gall, Paris 1998.
› *Eugène Atget. Paris*, Text by Wilfried Wiegand, Munich 1998.

Lewis Baltz

1945 Newport Beach, California
lives in Paris

Lewis Baltz is regarded as one of the most important so-called "New Topographers," who owe this designation to the group show on *New Topographics*, which took place in Rochester in 1975. His photographic output blazed the trail for this particular grouping of younger landscape photographers, operating in those transitional regions where nature and human occupation come into contact with each other.

Baltz, who enrolled in the San Francisco Arts Institute in 1969 and continued his studies at the Claremont Graduate School in California in 1971, already dealt with the margins of urban development in his first major series *The New Industrial Parks Near Irvine, California* (1975), which mainly showed purpose-built constructions in an industrial park. This was followed by *Nevada* (1978), the portrait of a faceless suburban housing development as seen by day and by night, and most notably *Park City* (1980): 102 shots taken throughout an area near Salt Lake City while a winter-sports center was under construction. This work is essentially a systematic and painstaking record of the transformation of a landscape into profitable units, simply by taking pictures of countless skeleton structures and piles of earth, unfinished rooms, and scattered rubbish. "In these images the photographer describes in functional terms, almost without any emotion, how monstrosities come into being or rather, how monstrous something like normality can be" (Urs Stahel).

Lewis Baltz's work has been significantly influenced by that of Frederick Sommer. In the 1940s Sommer combined elements of European surrealism with the technical perfection of Edward Weston and his landscape photographs were among the first to draw attention to the detritus of human habitation. Additional points of reference for Baltz have been the typologically ordered sequences of industrial buildings by Bernd and Hilla Becher, and the analytical land art of Robert Smithson. Doubting the expressive power of the single picture, Baltz exclusively produced relatively lengthy series up until the late 1980s, often arranging his pictures on the wall as tableaux. Thus things are never viewed in isolation but, in the author's eyes, always constitute a part of socio-economic structures although he does not directly criticize these as such. "When you talk about critique, it sounds as though you know what the problem is and what the solution is…, the place is its own critique" (Baltz). His most important projects of this kind were *San Quentin Point* (1986), a work rich in close-ups, about a bleak site near a luxury development, and *Candlestick Point* (1989) showing mounds of debris and the sparse vegetation on another wasteland near San Francisco, where there is now a neighborhood recreation park.

In the early 1990s, Baltz's work took a surprising turn: "In 1988 I stopped photographing the territory because I thought that everyone already knew too much about the appearance of the world… I became fascinated with the twin phenomena of technology and nomadism. They seemed to be related to each other and to the disappearance of the world." Baltz began taking part in public philosophical debates on simulation and post-industrial reality: At the same time, he started to combine individual large-format, color images of European cities and research laboratories to create wall-sized installations, such as the twelve-meter-long *Ronde de nuit* (1992). Today Baltz is preoccupied with the new soft technologies, which in his view constitute "the ultimate subversion of the idea of visual information." Thus the structures of urban life and technology—the focus of Baltz's interest from the outset—now appear in entirely new forms, partly abstracted by means of powerful close-ups or taken directly from images captured on surveillance cameras, and presented, amongst other things, as light-boxes. What Baltz perceives as the virtualization of the world is, for him, also the source of a new artistic challenge.

MARKUS FREHRKING

Exhibitions (Selected)

1971 Castelli Graphics, New York (solo exhibition)
1972 George Eastman House, Rochester (solo exhibition)
1974 Corcoran Gallery of Art, Washington (solo exhibition)
1975 *New Topographics. Photographs of a Man-Altered Landscape*, George Eastman House, Rochester (tour/cat.)
1977 *Biennial Exhibition*, Whitney Museum of American Art, New York (cat.)
1978 *Mirrors and Windows: American Photography since 1960*, The Museum of Modern Art, New York (tour/cat.)
1980 Werkstatt für Photographie, Berlin (solo exhibition)
1981 San Francisco Museum of Modern Art (solo exhibition)
1985 Victoria and Albert Museum, London (solo exhibition)
1987 *Vom Landschaftsbild zur Spurensicherung*, Museum Ludwig, Cologne (cat.)
1990 *Rule without Exception*, New York Institute for Contemporary Art, Museum at P.S.1 (solo exhibition/tour/cat.)
1992 *Ronde de Nuit*, Musée National d'Art Moderne, Centre Georges Pompidou, Paris (solo exhibition/cat.)
1993 *Regel ohne Ausnahme*, Fotomuseum Winterthur (solo exhibition/tour/cat.)
1995 Lousiana Museum of Modern Art, Humlebæk (solo exhibition/cat.)
Geschichten von Verlangen und Macht, Museum für Photographie Braunschweig (exhibition with Slavica Perkovic/tour/cat.)
1998 The Museum of Contemporary Art, Los Angeles (solo exhibition/cat.)

Bibliography (Selected)
› *The New Industrial Parks Near Irvine, California*, ed. by Castelli Graphics, New York 1975.
› *Park City*, with Gus Blaisdell, ed. by Castelli Graphics and Artspace, New York/Albuquerque 1981.
› *San Quentin Point*, Text by Mark Haworth-Booth, Berlin/Paris/New York 1986.
› *Candlestick Point*, Text by Gus Blaisdell, Tokyo 1989.
› *Lewis Baltz. Five Projects 1983–1988*, Text by Hripsimé Visser, exh. cat., Stedelijk Museum Amsterdam 1992.
› *Regel ohne Ausnahme*, Texts by Marvin Heiferman, Paolo Costantini et al., exh. cat., Fotomuseum Winterthur, Zurich/Berlin/New York 1993.
› *Classiques du XXI Siècle*, ed. by Bernard Lamarche-Vadel, Paris 1993.
› *Die Toten von Newport Beach*, ed. by Museum für Photographie Braunschweig, Text by Lewis Baltz, Zurich/Berlin/New York 1995.
› *The Politics of Bacteria, Docile Bodies, Ronde de Nuit*, Text by Cornelia H. Butler, exh. cat., The Museum of Contemporary Art, Los Angeles 1998.

Bernd and Hilla Becher

Bernd Becher: 1931 Siegen
Hilla Becher (née Wobeser): 1934 Potsdam
based in Düsseldorf

The work of the husband-and-wife team, Bernd and Hilla Becher, is not only of artistic significance, it also constitutes an exceptional visual record of industrial history. Since 1959, with acuity and consistency, they have photographed engineered structures: water-towers, gasholders, and mines.

Bernd Becher grew up in a landscape filled with industrial structures. From 1953 to 1956 he studied at the Kunstakademie in Stuttgart, and from 1957 to 1961 at the Kunstakademie Düsseldorf, where he himself was to become a leading professor of photography fifteen years later. Hilla Wobeser started out as a commercial photographer in Hamburg before moving to Düsseldorf in 1957. Upon meeting Bernd Becher at the Kunstakademie, the two started to collaborate in 1959 and married in 1961.

Their work has taken them to numerous locations, criss-crossing the Ruhr valley, then further afield in Europe, and to the USA in 1968 for the first time. Using a system drawing on a high level of technical expertise, they spent these meticulously planned trips taking precise black-and-white shots of a range of industrial structures. Little by little the Bechers built up extensive sequences of large-format images of cement works, half-timbered houses, derricks, and blast furnaces. Their work almost always concentrates exclusively on the object itself, ignoring its surroundings or function. The buildings and structures are always photographed in the same shadowless light, head on, often from different sides: a matter-of-fact, almost scientific method that maximizes the objectivity of the images. Only certain archetypal motifs are analyzed by means of a "process" of additional close-ups and distance shots. Finally the material is ordered into groups according to form, function, and date of making, to be presented as comparable tableaux and sequences.

At the Kunsthalle Düsseldorf in 1969, Bernd and Hilla Becher already had an exhibition of their photographs, titled *Anonymous Sculptures*. Their methodical approach was more readily appreciated in fields of minimal and conceptual art than in photography and, through their cooperation with Galerie Fischer in Düsseldorf, they soon established contact with artists like Carl Andre, Richard Long, and Sol LeWitt. Nevertheless, the Bechers are neither interested in bowing to any canons in photography nor in swimming with the tide of younger photographers and their artistic practices. Unmoved by the subjectivity and originality that are so highly valued in photography today, they have continued undaunted with their absorbing documentary and archive work over the last four decades, continually exploring new structures (factory interiors, grain silos) as well as adding to existing groups.

Many buildings and structures spawned by industrialization, with functional, idiosyncratic forms, are already obsolete, if not destroyed, due to changing economic structures. A lively awareness of these processes is the basis of the Bechers' work. However their output is received in art circles, their work as photographers—respectful and consistent—constitutes an invaluable record of cultural history: "Just as it is impossible to reverse the demolition of individual buildings or the disappearance of whole areas of industry, so, too, is it impossible to re-produce the Bechers' compendium of images which, with its encyclopedic dimensions, could be described as a visual memorial" (Susanne Lange).

Bernd and Hilla Becher, following in the footsteps of August Sander and Eugène Atget, are impressive in their unsentimental dedication to industrial architecture, which has resulted in a unique picture archive of our industrial heritage.

MF

Exhibitions (Selected)

1965 Galerie Pro, Bad Godesberg (solo exhibition)
1967 *Industriebauten 1830–1930*, Neue Sammlung, Munich (solo exhibition/cat.)
1969 *Anonyme Skulpturen*, Kunsthalle Düsseldorf (solo exhibition/cat.)
1970 Moderna Museet, Stockholm (solo exhibition)
1972 *documenta V*, Kassel (cat.)
 Gallery Sonnabend New York (solo exhibition)
1975 *New Topographics. Photographs of a Man-Altered Landscape*, George Eastman House, Rochester (cat.)

Fotografien 1957–1975, Rheinisches Landesmuseum, Bonn (solo exhibition/tour/cat.)
1977 *documenta VI*, Kassel (cat.)
1981 Stedelijk Van Abbemuseum, Eindhoven (solo exhibition/cat.)
 Absage an das Einzelbild, Museum Folkwang, Essen (cat.)
1982 *documenta VII*, Kassel (cat.)
1985 *Fördertürme*, Museum Folkwang, Essen (solo exhibition/cat.)
1989 Palais des Beaux Arts, Brussel (solo exhibition)
 Dia Art Foundation, New York (solo exhibition)
1990 *XLIV Biennale di Venezia. Deutscher Pavillon*, Venice (solo exhibition/cat.)
1991 *Aus der Distanz*, Kunstsammlung Nordrhein-Westfalen, Düsseldorf (cat.)
1992 *Photographie in der deutschen Gegenwartskunst*, Walker Art Center, Minneapolis (tour/cat.)
1997 *Vergleichende Konzeptionen*, Die Photographische Sammlung/SK Stiftung Kultur, Cologne (tour/cat.)
1999 *Bergwerke*, Die Photographische Sammlung/SK Stiftung Kultur, Cologne (solo exhibition/tour/cat.)

Bibliography (Selected)
› *Industriebauten 1830–1930. Eine photographische Dokumentation von Bernd und Hilla Becher*, exh. cat., Neue Sammlung, Munich 1967.
› *Anonyme Skulpturen. Eine Typologie technischer Bauten*, exh. cat., Galerie Konrad Fischer, Düsseldorf 1970.
› *Wassertürme*, Text by Reyner Bauham, Munich 1988.
› *Tipologie, Typologien, Typologies*, ed. by Klaus Bußmann, exh. cat., Biennale di Venezia, Munich 1990.
› *Hochöfen*, Munich 1990.
› *Pennsylvania Coal Mine Tipples*, Foreword by Charles B. Wright, Munich 1991.
› *Häuser und Hallen*, ed. by Museum für Moderne Kunst Frankfurt, Text by Susanne Lange, Frankfurt 1992.
› *Fabrikhallen*, Text by Susanne Lange, Munich 1994.
› *Industriephotographie*, ed. by Monika Steinhauser together with Kai-Uwe Hemken, Düsseldorf 1994.
› *Bergwerke*, Text by Susanne Lange, exh. cat., Die Photographische Sammlung/SK Stiftung Kultur Cologne, Munich 1999.

Karl Blossfeldt

1865 Schielo/Harz
1932 Berlin

In 1928 Karl Blossfeldt published *Urformen der Kunst (Art Forms in Nature)*, a collection of 120 photographs of plants, and within a very short space of time this self-taught photographer became internationally known as one of the most important exponents of Neue Sachlichkeit.

Having completed an apprenticeship as a decorative metal worker at a foundry in the Harz mountains, he enrolled in the teaching institute of the Königliches Kunstgewerbe Museum in Berlin. From that point onward his professional development was largely guided by his teacher Moritz Meurer. As an art educator, Meurer campaigned to introduce the study of natural forms into the curriculum for the visual arts and architecture, and worked out a corresponding syllabus to reform the training of artist-craftsmen and architects. In 1889 Meurer was commissioned to collect teaching materials to use in conjunction with the theories he had developed, and so it was that Blossfeldt accompanied his teacher on a seven-year study trip through the lands of Classical Antiquity, not only making drawings, casts, and models of plants, but also taking photographs for their collection.

After his return, Blossfeldt took up a position in 1899 at the same teaching institute in Berlin to teach the newly-introduced subject, Live Plant Modeling, thus keeping alive Meurer's concept of studying natural forms until his own retirement in 1930. In order to build up a collection of visual materials to use in drawing classes, Blossfeldt began systematically to photograph plants, using the simplest of means. He worked with a home-made plate camera, using negatives of up to 5 x 7 inches, in order to achieve the highest possible quality of image. For his strictly functional black-and-white prints he would remove the plant from its natural habitat and photograph it in his studio, generally head on, as symmetrical as possible, and against a neutral background. Blossfeldt barely, if ever, altered his technique, using it to produce around 6,000 photographs over a period of over 30 years.

Since the interest in his motifs was not that of a botanist, but of an art educator and artist, he frequently trimmed and manipulated the plants in order to demonstrate—in the spirit of Professor Meurer—visual parallels between forms and structures in the plant world and those in art and architecture.

This was also the main consideration in many of the reviews of Blossfeldt's publication, *Art Forms in Nature*, where critics were quick to point out that his enlargements of plant details (from 3 to 45 times the original size) open up new perspectives for human perception. "Thus Blossfeldt with his astonishing photographs of plants reveals the forms of ancient columns in horse willow, a bishop's crosier in the ostrich fern, totem poles in tenfold enlargements of chestnut and maple shoots" (Walter Benjamin).

While Blossfeldt's own skills as a craftsman and his conviction that nature is the "best teacher" for art are largely indebted to 19th century attitudes, his photographs actually turned him into a member of the avant-garde. The extent of his influence on the 20th century may be seen, for instance, in the work of Bernd and Hilla Becher, whose typologies of "anonymous" industrial architecture—demonstrating similarly cool precision and standardized working methods—are also produced as series and result from long-term, intensive concentration on one central theme.

US

Exhibitions (Selected)

1926	Galerie Neumann-Nierendorf, Berlin (solo exhibition)
1929	*Film und Foto*, Städtische Ausstellungshallen, Stuttgart (tour/cat.)
1929	*Karl Blossfeldt. Urformen der Kunst*, Staatliches Bauhaus, Dessau (solo exhibition)
1974	*Karl Blossfeldt, Foto's*, Rotterdam Arts Foundation (solo exhibition)
1976	*Karl Blossfeldt. Unbekannte Fotografien*, Galerie Wilde, Cologne (solo exhibition)
	Karl Blossfeldt. Fotografien 1900–1932, Rheinisches Landesmuseum Bonn (solo exhibition/cat.)
1977	*Karl Blossfeldt. Photographs taken between 1900 and 1928*, Sander Gallery, Washington (solo exhibition)
	documenta VI, Kassel (cat.)
1978	*Karl Blossfeldt. Photographs*, Museum of Modern Art, Oxford (solo exhibition/cat.)
1980	Sonnabend Gallery, New York (solo exhibition)
1987	*Botanica*, Palais de Tokyo, Paris (cat.)
1994	*Karl Blossfeldt. Fotografie*, Kunstmuseum Bonn (solo exhibition/tour/cat.)
1999	*Karl Blossfeldt*, Akademie der Künste, Berlin (solo exhibition/cat.)

Bibliography (Selected)
› *Urformen der Kunst. Photographische Pflanzenbilder von Professor Karl Blossfeldt*, Introduction by Karl Nierendorf, Berlin 1928. (New edition with an afterword by Ann and Jürgen Wilde, Dortmund 1982.)
› *Wundergarten der Natur. Neue Folge. Urformen der Kunst. Neue Bilddokumente schöner Pflanzenformen von Karl Blossfeldt*, Foreword by Karl Blossfeldt, Berlin 1932.
› *Wunder in der Natur. Bild-Dokumente schöner Pflanzenformen von Karl Blossfeldt*, Introduction by Otto Dannenberg, Leipzig 1942.
› *Karl Blossfeldt. Fotografien 1900–1932*, ed. by Klaus Honnef, exh. cat., Rheinisches Landesmuseum Bonn, Cologne 1976.
› *Karl Blossfeldt 1865–1932. Das fotografische Werk*, Text by Gert Mattenklott, Munich 1981.
› *Karl Blossfeldt*, ed. by Michael Brix, Fachhochschule Munich 1992.
› *Karl Blossfeldt. Photographien 1865–1932*, Text by Rolf Sachse, Cologne 1993.
› *Karl Blossfeldt. Fotografie*, Texts by Jürgen Wilde and Christoph Schreier, exh. cat., Kunstmuseum Bonn, Ostfildern 1994.
› *Karl Blossfeldt. Urformen der Kunst. Wundergarten der Natur. Das fotografische Werk in einem Band*, Text by Gert Mattenklott, Munich 1994.
› *Karl Blossfeldt 1865–1932*, ed. by Hans Christian Adam, Cologne 1999.

Christian Boltanski

1944 Paris

lives in Malakoff

Collecting, archiving, and documenting memories is a central theme in the work of Christian Boltanski, one of the best known French artists of his generation. Since 1974 when he participated in the exhibition *Spurensicherung (Forensic Evidence)* in the Kunstverein Hamburg, he has been regarded as a pioneer in the movement of the same name.

Boltanski regards himself as a painter although he gave up painting as long ago as 1967 and has since been working mainly with found photographic materials and everyday objects, which he presents in showcases, artist's books, and installations.

In the early 1970s Boltanski particularly used the medium of photography in his artistic work in order to come to terms with his own childhood. For the first time in 1969, in his first artist's book, *Recherche et présentation de tout ce qui reste de mon enfance, 1944–1950 (Research and presentation of everything that remains of my childhood, 1944–1950)*, he mixed authentic materials, such as his own class-photo, with later shots of his nephew which the captions claim are relics of his own childhood. Ever since then Boltanski has been exploiting the supposed objectivity of photographs plus captions to give credence to inventions of his own making. Instead of reconstructing his own childhood, he creates a childhood which reveals itself as a fiction only on second sight. In this connection Uwe Schneede has rightly pointed out that these invented memories serve the artist as a means "of exploring collective memory." Since the early 1970s Boltanski has increasingly been addressing the childhoods and lives of other people, and his *Album de Photo de la Famille D., 1939–1964* of 1971 is his first project that works exclusively with family photographs of people unrelated to himself.

The artist himself has described the genesis of this work, which was shown in 1972 at *documenta V* in Kassel. It began in July 1971 when he asked his friend Michel D. to lend him his parents' amateur family photographs: "Je voulais, moi qui ne savais rien d'eux, tenter de reconstituer leur vie en me servant de ces images, qui, prises à tous les moments importants, resteraient après leur mort comme la pièce à conviction de leur existence." (Never having known them, I wanted to try to reconstruct their life by means of those images which had been taken at all the important moments in their lives and would still remain after their death like proof of their existence.) Having had copies made of 150 of these landscape-format, black-and-white photographs, Boltanski spent several months trying to order the pictures chronologically in an attempt to trace the life lived by this affluent Parisian family. But soon he had to admit that his experiment was doomed to failure: "Ces photographies ne m'apprenaient rien sur ce qu'avait été réellement la vie de la famille D…, elles me renvoyaient à mes propres souvenirs." (I realized that these images didn't teach me anything about the Family D… but only sent me back to my own past.) This in turn led him to hope that the sight of these photographs of journeys, celebrations, and other events in the life of the family would remind viewers of their own memories,

and that they would recognize themselves in his art as if they were looking into what he himself describes as a "mirror." While he was working on this piece, he came to the conclusion that photography does not "say anything about reality, but does say something about our cultural codes." He may have been influenced in this by his brother who participated in the 1960s in Pierre Bourdieu's renowned sociological study of amateur photography *Un art moyen: Essai sur les usages sociaux de la photographie.*

The *Album de Photo de la Famille D., 1939–1964* is one of an edition of three. The edition on view in our exhibition is on loan from Parisian gallerist Michel Durand, who originally allowed the artist access to his own family album in 1971 for this very work and who then bought the pictures back from the artist as a work of art in 1987.

After producing his own large-format color photographs for the series *Compositions* (1978–1983), since the early 1980s Christian Boltanski has again been working with photographs made by others, usually much-enlarged portrait photos. For Boltanski, each of these photographic images is "an object remembering a subject" and he combines them with large numbers of identical, three-dimensional objects like tin cans, cardboard boxes, table lamps, etc. The results are often sparsely lit, quasi-religious or theatrical spatial installations, which are also presented outside of traditional exhibition spaces, as in churches or factories.

Since 1985, in a number of works collectively entitled *Leçons de ténèbres (Lessons of Darkness)*, death has become an increasingly important central theme. Although many of his installations since the 1980s bring to mind thoughts of the holocaust, Christian Boltanski, who is himself of Russian-Jewish origin, has repeatedly referred in interviews to the universal character of his work: "My work is really not about the holocaust, but about death in general, about all our deaths."

US

Exhibitions (Selected)

1965 *IVe Biennale de Paris*, Musée d'Art Moderne de la Ville de Paris (cat.)

1968 *La Vie impossible de Christian Boltanski*, Cinéma Le Ranelagh, Paris (solo exhibition)

1970 Musée d'Art Moderne de la Ville de Paris (exhibition with Sarkis/cat.)

1972 *documenta V*, Kassel (cat.)

Ben Vautier, Christian Boltanski, Jean Le Gac, John C. Fernie, Kunstmuseum Luzern (cat.)
XXVI Biennale di Venezia, Venice (cat.)

1973 *Les Inventaires*, Staatliche Kunsthalle, Baden-Baden (solo exhibition/tour)
Sonnabend Gallery, New York (solo exhibition)

1974 *Spurensicherung, Archäologie und Erinnerung*, Kunstverein Hamburg (tour/cat.)
Affiches–Accéssoires–Décors, documents photographiques, Westfälischer Kunstverein, Münster (solo exhibition/tour/cat.)

1976 *Modellbilder*, Rheinisches Landesmuseum Bonn (exhibition with Annette Messager/cat.)
Photographies couleurs–Images modèles, Musée National d'Art Moderne, Centre Georges Pompidou, Paris (solo exhibition)

1977 *documenta VI*, Kassel (cat.)
Bookworks, The Museum of Modern Art, New York

1978 *Arbeiten 1968–1978*, Badischer Kunstverein, Karlsruhe (solo exhibition/cat.)

1979 *The Third Biennial of Sydney*, Art Gallery of New South Wales, Sydney (cat.)

1984 Musée National d'Art Moderne, Centre Georges Pompidou, Paris (solo exhibition/tour/cat.)

1986 *Leçons de Ténèbres*, Kunstverein München (solo exhibition/cat.)
XLII Biennale di Venezia, Venice (cat.)

1987 *documenta VIII*, Kassel (cat.)

1988 *Lessons of Darkness*, Museum of Contemporary Art, Chicago (solo exhibition/tour/cat.)
El Caso, Centro de Arte Reina Sofia, Madrid (solo exhibition)

1989 *La fête du Pourim*, Museum für Gegenwartskunst Basel, (solo exhibition/cat.)

1990 *Reconstitution*, The Whitechapel Art Gallery, London (solo exhibition/tour/cat.)

1991 *Inventar*, Hamburger Kunsthalle (solo exhibition/cat.)
Les Suisses morts, Museum für Moderne Kunst, Frankfurt (solo exhibition/cat.)

1992 *The Missing House*, DAAD Berlin Artists' Program (solo exhibition/cat.)

1993 *XLV Biennale di Venezia*, Venice (cat.)

1995 *XLVI Biennale di Venezia*, Venice (cat.)

1996 *Sterblich*, Hessisches Landesmuseum, Darmstadt (solo exhibition/cat.)
Advent and other Times, Centro Galego de Arte Contemporánea, Santiago de Compostela (solo exhibition/cat.)

1998 *Dernières années*, Musée d'Art Moderne de la Ville de Paris (solo exhibition / cat.)

1999 *Reichstag-Archive*, Berliner Reichstag (permanent exhibition)

Bibliography (Selected)

› *Reconstitution*, Text by Lynn Gumpert et al. Box also includes numerous artist's books and projects by Boltanski, exh. cat., The Whitechapel Art Gallery, London 1990.
› *Inventar*, Texts by Uwe Schneede, Günter Metken et al., exh. cat., Hamburger Kunsthalle 1991.
› *Christian Boltanski*, ed. by Centre National des Arts Plastiques, Text by Lynn Gumpert, Paris 1992.
› *Catalogue. Books, Printed Matter, Ephemera 1966–1991*, ed. by Jennifer Flay, Commentaries by Günter Metken, Cologne 1992.
› *Christian Boltanski*, Texts by Didier Semin, Tannar Garb et al., London 1997.
› *Lessons of Darkness*, Texts by Lynn Gumpert, Mary Jane Jacob and Christian Boltanski, exh. cat., Museum of Contemporary Art, Chicago 1988.
› *Kaddish*, exh. cat., Musée d'Art Moderne de la Ville de Paris 1998.

Brassaï (Gyula Halasz)

1899 Brasso, Hungary (now Brasov, Romania)
1984 Beaulieu-sur-Mer, France

Brassaï's early photographic work was almost entirely taken up with images of Paris in the 1930s. Having studied art in Budapest and Berlin, Brassaï moved to the French capital at the age of 25, where he devoted his energies to painting, sculpture, and literature, while also working as a journalist for various German and Hungarian newspapers. Besides coming into contact with numerous representatives of the artistic and literary avant-garde, he also met the photographers Eugène Atget and André Kertész, whose work he later took as the yardstick for his own photographic output.

In early 1930, in order to capture his many different impressions of Paris at night, Brassaï started to take photographs: "During my first year in Paris […] I led the life of a night owl, as the sun rose I went to bed, when the sun set I would get up and walk through the town from Montmartre to Montparnasse. I became a photographer in order to make lasting images of all that fascinated and entranced me about Paris at night […]."

In December 1932 a selection of these photographs appeared in the book *Paris de nuit (Paris by Night)*, published under the name of Brassaï, which the artist had recently adopted from his home town of Brasso in Hungary. This volume contains 62 black-and-white images of sparingly lit, often deserted streets—rainy or shrouded in fog—and became one of the most popular photography books of the day.

While Brassaï's *Paris de nuit* concentrates mainly on scenes out of doors, his 1976 book, *Le Paris secret des années 30 (The secret Paris of the 30's)*, also gives an insight into the everyday life of the town's inhabitants and into the "world of pleasure, love, vice, crime, drugs…" (Brassaï). His photographs of prostitutes, cleaners in public conveniences, vagrants, and Parisian "characters" in their own milieu were almost always taken with the agreement of the individuals concerned, who are often seen confidently facing the camera head-on, which in turn bears witness to Brassaï's respect for his subjects and his fascination with the Parisian underworld—an interest shared by others like the writer Henry Miller, who accompanied the photographer on many of his nocturnal walks and later called him "the eye of Paris."

Despite the fact that after 1933 Brassaï published many of his often poetic and seemingly mysterious photographs in the surrealist journal *Minotaure* and worked for a time with Salvador Dalí, while André Breton used Brassaï's photographs to illustrate his own literary texts, Brassaï never regarded himself as a disciple of surrealism. In his eyes the "surrealism" of his images was "nothing other than reality seen in a fantastic light. I only wanted to portray reality, for there is nothing more surreal."

In the 1930s Brassaï became known not only for his images of Paris by night but also for his photographs of graffiti and portraits of writers and artists in his circle of friends, including Samuel Beckett, Alberto Giacometti, and Pablo Picasso. The latter featured in various works by Brassaï including his book *Conversations avec Picasso* (1964).

In 1962 Brassaï ended his long career as a freelance photographer for *Harper's Bazaar* and soon stopped taking photographs altogether. From now on he turned his attention to publishing his photographs in book

form and once again returned to his work as a painter, sculptor, and writer.

US

Exhibitions (Selected)

1933 *Paris de nuit*, Galerie Arts et Métiers Graphiques, Paris (solo exhibition / tour)

1937 *Photography 1839–1937*, The Museum of Modern Art, New York (cat.)

1951 *100 photographies de Brassaï*, Musée des Beaux-Arts, Nancy (solo exhibition)
 Subjektive Fotografie, Staatliche Schule für Kunst und Handwerk, Saarbrücken (cat.)

1954 *Brassaï*, The Art Institute of Chicago (solo exhibition / tour / cat.)

1955 *Brassaï*, George Eastman House, Rochester (solo exhibition / tour)
 The Family of Man, The Museum of Modern Art, New York (tour / cat.)

1956 *Language of the wall: Parisian graffiti photographed by Brassaï*, The Museum of Modern Art, New York (solo exhibition / tour / cat.)

1963 *Brassaï*, Bibliothèque Nationale, Paris (solo exhibition / tour / cat.)

1968 *Brassaï*, The Museum of Modern Art, New York (solo exhibition / tour / cat.)

1977 *documenta VI*, Kassel (cat.)

1979 *Brassaï*, The Photographers' Gallery, London (solo exhibition / tour / cat.)

1987 *Picasso vu par Brassaï*, Musée Picasso, Paris (solo exhibition / cat.)

1988 *Brassaï. Paris le jour, Paris la nuit*, Musée Carnavalet, Paris (solo exhibition / cat.)

1993 *Brassaï. Vom Surrealismus zum Informel*, Fundació Antoni Tàpies, Barcelona (solo exhibition / tour / cat.)

1999 *The Eye of Paris*, The Museum of Fine Arts, Houston (solo exhibition / cat.)

2000 Musée National d'Art Moderne, Centre Georges Pompidou, Paris (solo exhibition / cat.)

Bibliography (Selected)

› *Paris de nuit. 60 Photos de Brassaï*, Text by Paul Morand, Paris 1932.
› *Les sculptures de Picasso*, Text by Daniel-Henry Kahnweiler, Paris 1949.
› *Brassaï*, Introduction by Henry Miller, Text by Brassaï, Paris 1952.
› *Graffiti*, Text by Brassaï, Stuttgart 1960.
› *Conversations avec Picasso*, Paris 1964.
› *Brassaï*, Foreword by John Szarkowski, Text by Lawrence Durell, exh. cat., The Museum of Modern Art, New York 1968.
› *Le Paris secret des années 30*, Text by Brassaï, Paris 1976.
› *The artists of my life*, New York 1982.
› *Brassaï. Vom Surrealismus zum Informel*, Texts by Manuel J. Borja-Villel et al., exh. cat., Fundació Antoni Tàpies, Barcelona 1994.
› *Brassaï. The Eye of Paris*, ed. by Anne Wilkes Tucker, exh. cat., The Museum of Fine Arts Houston, New York 1999.

Larry Clark
1943 Tulsa, Oklahoma
lives in New York

The central theme of Larry Clark's photography since the early 1970s has been the experience of adolescence. In a variety of ever-changing forms he has focused primarily on the situation of young outsiders on the brink of violence and drug abuse.

Larry Clark grew up in the late 1950s in a small-town atmosphere in Oklahoma and first came into contact with photography at the age of 15 when he helped his mother take portrait-photographs of small children in the neighborhood. He describes his youth as unremittingly difficult: a father who despised him and the delayed onset of puberty led him to his first heroine experiments with his friends. In the end he himself became part of the drug scene in his home town of Tulsa and was regularly seen there, camera in hand. In 1971, after his return from Vietnam, he published the now legendary *Tulsa* with the help of Robert Frank. The book's intimate, intense black-and-white reportage shows the stark reality of his friends' lives: their desperate attempts to break out of what was for them an oppressively narrow-minded society. *Tulsa* not only became a cult hit in Clark's world, but was also acclaimed by others with an interest in photography. Today it is a sought-after collector's piece and has, not least, inspired such films as *Taxi Driver* and *Drugstore Cowboy*.

In *Teenage Lust* (1983), published over ten years later, besides images from *Tulsa*, there are also pictures of

streetwalkers in New York, where Clark was now living. The book takes the form of a wide-ranging essay on teenage sex as a basic factor in the adolescent search for freedom and is combined with a long autobiographical text by Clark. As a 40-year-old he views the young generation from a certain distance, yet with as much energy and curiosity as ever. To this day, his work still focuses on the problems of growing-up that face (mainly male) adolescents. He presents this phase in life with all its euphoria, despair, and the danger courted by rebellious young people seeking escape, "always at the point where unbelievable fun turns into some kind of (life-)threatening shit" (Jutta Koether).

In the late 1980s Clark's approach changed: he abandoned "authentic" observation and turned instead to the mass media. This led to collages which contained, along with his own pictures, sections torn out of newspapers, images from pop culture, and objects such as skateboards or T-shirts. Clark also had young people pose for photographs. His book, *The Perfect Childhood* (1993), still addresses his old theme but in more general, structured terms, a development that not least has its roots in the increasing age difference between the artist and his protagonists. This new publication (along with the immense popularity of the unmediated, real-life photography of Nan Goldin, Nobuyoshi Araki, and others) generated considerable art-market interest in his early pictures as well.

Recently Clark has chosen to express himself in video installations and feature films (*Kids*, 1995; *Another Day in Paradise*, 1999). Here, too, he has endeavored to open up new perspectives on his theme. Particularly *Kids* caused considerable controversy because of its drastic subject matter. But all the debate on the glorification of violence or the uncritical attitude of the artist simply serve to prove that it was never Clark's intention to hold society to account, but rather that he tries—at times with obsessive devotion—to explore not only the dangers but also the beauty and power of youth by portraying his subjects as openly as he knows how: "I love everyone I photograph."

<div align="right">MF</div>

Exhibitions (Selected)
1971 San Francisco Art Institute (solo exhibition)
1975 George Eastman House, Rochester (solo exhibition/tour)
1976 New School of Photography, New York (solo exhibition)
1981 Werkstatt für Photographie, Berlin (solo exhibition)

Biennial Exhibition, Whitney Museum of American Art, New York (cat.)
1982 Museum of Art, Rhode Island School of Design, Providence (solo exhibition)
1986 Barbican Art Gallery, London (solo exhibition)
Fotografiska Museet i Moderna Museet, Stockholm (solo exhibition)
1991 Grazer Kunstverein, Graz (solo exhibition)
1992 *American Documents: On the Fringe*, Tokyo Metropolitan Museum of Photography (cat.)
The Young Rebel in American Photography, 1950–1970, The Museum of Modern Art, New York
Kunsthalle Luzern (solo exhibition)
1993 Fraenkel Gallery, San Francisco
1994 Taka Ishii Gallery, Tokyo (solo exhibition)
L'hiver de l'amour, Musée d'Art Moderne de la Ville de Paris (cat.)
1996 Wiener Secession (solo exhibition)
Milwaukee Art Museum (solo exhibition)
Sex and Crime, Sprengel Museum Hannover (cat.)
The Photographers' Gallery, London (solo exhibition)
1999 Groninger Museum (solo exhibition/cat.)
Portfolios, Galerie Max Hetzler, Berlin (solo exhibition)

Bibliography (Selected)
› *Tulsa*, New York 1971.
› *Teenage Lust*, New York 1983.
› *Larry Clark 1992*, ed. by Thea Westreich and Gisela Capitain, New York/Cologne 1992.
› *Die perfekte Kindheit*, Zurich/Berlin/New York 1993.
› *Kids*, with Harminy Korine, New York 1995.
› *1 Hour Photo Service*, exh. cat., Groninger Museum 1999.
› *Heroin*, with Tony Morgan, New York 2000.

Rineke Dijkstra
1959 Sittard
lives in Amsterdam
The Dutch photographer Rineke Dijkstra came to public attention in the mid-90s with her portraits of children and young people, in which—as she herself has said—her aim was to portray "an authentic moment of intensity and […] a concentration of power and vulnerability."

Having completed her studies at the Gerrit Rietveld Academie in Amsterdam (1981–86), Rineke Dijkstra became a freelance photographer, working in advertising as well as for a number of journals and for various grant-awarding bodies in the arts, photographing scholarship holders and prize-winners.

In 1991 she started to concentrate on color photography, using a large-format camera (4 x 5 inches). That same year she made a portrait of herself in a pensive pose in the shower room of an Amsterdam swimming pool, which may be regarded as the "proto-model" (to quote Ulf Erdmann Ziegler) for her subsequent series of portraits. This is particularly true of her first independent series, her well-known *Beach Portraits* (1992–1996). This extensive series consists of full-length shots of children and young people in their swimsuits or bathing trunks on various beaches in England, Belgium, Poland, the Ukraine, and the USA, photographed against the sea as a plain, yet richly symbolic background.

Her subjects gaze directly into the camera; the pictures are taken in daylight, frontally and from slightly below. The additional use of flash means that the figures are portrayed in merciless detail, sharply outlined against the sea; this in turn heightens the tension between physical presence and distance which is the hallmark of Dijkstra's portraits. The shots home in on the way that the subjects present themselves to the camera, the individual gestures of the vulnerable-looking children and adolescents, and their at times gauche body-language.

By virtue of her strict, conceptual approach and her respectful, distanced attitude, Dijkstra's photographs have frequently been compared to the work of Thomas Ruff. But this comparison only applies to formal concerns. For while Ruff maintains that a portrait photograph "can only portray the surface of things," Dijkstra —as she herself has said—has set herself the goal of showing "people in all their complexity and in their ultimately undefinable identity." This interest in the processes involved as human beings grow up and find themselves links Dijkstra with the photographer Diane Arbus, although the latter frequently portrayed society's outsiders.

During a visit to Portugal in 1994, Dijkstra made four large-format portraits of bullfighters, photographed against a neutral background immediately after they had left the arena. The men are evidently still swept up in the intense experience of the fight that they have just endured, and seem alert and withdrawn at once.

Soon afterwards, her interest in experiences on the margins of existence led to a series of portraits of three women. Dijkstra photographed them naked in the hallways of their apartments, shortly after they had given birth, with their new-born babies in their arms. As before, in the pictures of the Portuguese bullfighters and in the *Beach Portraits*, Dijkstra's aim is to show a moment when the subject is exposed to a process of change, either induced by the particular stage of development or by extreme physical or mental experiences. In 1994, Hripsimé Visser was one of the first to point out that in her photographic works Dijkstra frequently seeks out the moment when "a pose is either forming or disintegrating, the moment when hesitancy and uncertainty in the subject's attitude and gaze become visible." Against this background it seems logical that since the mid-90s Dijkstra, in her interest in young disco-goers, has for the first time started to use video rather than photography. The resulting video-works, *The Buzzclub, Liverpool, UK/Mysteryworld, Zaandam, NL* (1996-1997), and *Annemiek* (1999), focus on the media and the drug-induced behavior and poses of the young people there. Dijkstra's videos portray not only the discrepancy between the role models purveyed by the media and the reality of the young people, but also their reaction to the photographer and her camera.

Both in her video works and in her concurrent photographic portrait-series, Dijkstra lives up to her own declared intention "to capture something universal, but something personal at the same time."

US

Exhibitions (Selected)

1984 *Paradiso Portretten*, de Moor, Amsterdam (solo exhibition)

1988 *Het Ontstaan van Vorm*, de Moor, Amsterdam (solo exhibition)

1993 *Foto Festival Naarden*, Naarden (cat.)

1994 *Kunstaanmoedigingsprijs Amstelveen*, Aemstelle (solo exhibition)

 De ander, der Andere, l'autre. Werner Mantz Prize, Het Domein, Sittard und Ludwig Forum für Internationale Kunst, Aachen (cat.)

1995 Stedelijk Museum Bureau Amsterdam (exhibition with Tom Claassen)

The European Face, Talbot Rice Gallery, Edinburgh (tour / cat.)

1996 Galerie Sabine Schmidt, Cologne (solo exhibition)
Galerie Bob van Orsouw, Zurich (solo exhibition / cat.)
Prospect '96, Schirn Kunsthalle, Frankfurt am Main (cat.)
Le printemps de Cahors (tour / cat.)
100 foto's uit de collectie, Stedelijk Museum Amsterdam (cat.)
Zeitgenössische Fotokunst aus den Niederlanden, NBK, Berlin (tour / cat.)

1997 *Location*, The Photographers' Gallery, London (solo exhibition / cat.)
XLVII Biennale di Venezia, Venice (cat.)
Photowork(s) in Progress / Constructing Identity: Rineke Dijkstra, Wendy Ewald, Paul Seawright, Nederlands Foto Instituut, Rotterdam (cat.)
New Photography 13, The Museum of Modern Art, New York

1998 *Menschenbilder*, Museum Folkwang, Essen (solo exhibition / tour / cat.)
The Buzzclub, Liverpool, UK / Mysteryworld, Zaandam, NL, 1996/97 (About the World), Sprengel Museum Hannover (solo exhibition / cat.)
Rineke Dijkstra, Museum Boymans-van Beuningen, Rotterdam (solo exhibition)
XXIV Biennal Internacional, São Paulo

1999 *Annemiek*, Anthony d'Offay Gallery, London (solo exhibition)
Rineke Dijkstra, Herzliya Museum of Art (solo exhibition)
The Citibank Private Bank Photography Prize, The Photographers' Gallery, London
Portraits. Rineke Dijkstra, Bart Domburg, daadgalerie, Berlin (cat.)
Ich und die Anderen, Ursula Blickle Stiftung, Kraichtal (tour / cat.)

Bibliography (Selected)
› *Beaches,* Text by Birgid Uccia, exh. cat., Galerie Bob van Orsouw, Zurich 1996.
› *Location*, Texts by Michael Bracewell and Joanna Lowry, Interview with Mariska van den Berg, exh. cat., The Photographer's Gallery, London 1997.
› *Menschenbilder*, Foreword by Ute Eskildsen, Text by Ulf Erdmann Ziegler, exh. cat., Museum Folkwang, Essen, Bottrop 1998.
› *The Buzzclub, Liverpool, GB / Mysteryworld, Zaandam, NL, 1996/97*, Text by Thomas Weski, exh. cat., Sprengel Museum Hannover 1998.
› *Die Berliner Zeit. Rineke Dijkstra, Bart Domburg*, Text by Friedrich Meschede, exh. cat., daadgalerie, Berlin / Amsterdam 2000.

William Eggleston
1937 Memphis, Tennessee
lives in Memphis, Tennessee

In the mid-70s, when most artist-photographers were still working with black-and-white photography, partly in order to make a distinction between their work and the color photography predominantly used in advertising and fashion, William Eggleston's first exhibition in the Museum of Modern Art in New York consisted entirely of color photographs. The accompanying book, *William Eggleston's Guide*, has since become a classic. Although Eggleston's work—with its supposedly trivial motifs—initially met with incomprehension and generated widespread criticism, soon others were imitating his style. Nowadays he is regarded as a pioneer of color in art-photography.

With an old Leica that he has used since 1958, Eggleston generally works with small format, dye transfer prints. This is a relatively expensive printing process which produces intense colors and allows partial correction to individual colors. Eggleston studied photography at Vanderbilt University in Mississippi, but the photography department was understrength at the time, and Eggleston partly had to teach himself. A freelance photographer since 1962, he spent a short period in New York in 1967. There he met Garry Winogrand, Lee Friedlander, and Diane Arbus, all three of whom were shown at the Museum of Modern Art by curator John Szarkowski and were known for the radical, personal and uncontrived realism of their photography. Eggleston started out as a photographer in his own home territory, the American South, photographing more or less everything in sight, often from unusual angles: an open fridge, a backyard, undergrowth, a tricycle. In the early 1980s, Eggleston also worked in Europe and Africa, and further developed his wide-ranging yet precise vision. He himself has described

473

this non-hierarchical method as "democratic." In 1989, by way of an interim report, he produced *The Democratic Forest*, in which it is clear that Eggleston is not merely the photographer of the American South, as critics claim. More to the point, his work displays a much broader, more widely relevant vision of how a photographer may deal with reality. This goes back in part to his declared model Cartier-Bresson, but above all to the magic realism of literary figures, much admired by Eggleston, such as William Faulkner and Eudora Welty. "I see my pictures as parts of a novel I'm writing."

During the 1980s Eggleston traveled widely, taking photographs in Egypt, South Africa, Europe, the Persian Gulf, and elsewhere—confirming that his work is not dependent on any particular location. In 1992 he published *Ancient and Modern* in conjunction with his major retrospective in London. Another diverse accumulation of glimpses of the author's surroundings, as provokingly unspectacular as they are poetic, these pictures are virtually bereft of people and yet close to people, for they constantly record traces of human activity: "What is there, however strange, can be accepted without question; familiarity will be what overwhelms us" (Eudora Welty).

So far William Eggleston has produced ten Dye Transfer Portfolios, including one from 1984 on Elvis Presley's residence, Graceland, and its deterioration into a kitsch Mecca. In late 1999 Eggleston published *2 1/4*, with square, medium-sized, previously unpublished pictures from the 1960s. Although relatively classical in their composition these already record the dawning astonishment of a young photographer at the sight of everyday things. Things that are so obvious that they needed the eyes of a stranger in order to be seen at all. Eggleston's ability to see as a stranger has stayed with him ever since: "I've often asked myself how other creatures see—whether they see like we do. And I've tried to take all sorts of shots that look as if they weren't made by human hand."

MF

Exhibitions (Selected)

1974 Jefferson Place Gallery, Washington (solo exhibition)
1975 *14 American Photographers*, The Baltimore Museum of Art (cat.)
1976 *Color photographs*, The Museum of Modern Art, New York (solo exhibition / tour)
1977 *Color Photographs 1966–1977*, Castelli Graphics, New York (solo exhibition)
1978 *Amerikanische Landschaftsphotographie 1860–1978*, Neue Sammlung, Munich (cat.)
 Mirrors and Windows: American Photography since 1960, The Museum of Modern Art, New York (tour / cat.)
1979 Werkstatt für Photographie, Berlin (solo exhibition)
1981 *Photographs 1967–1978*, Light Gallery, New York (solo exhibition)
1983 *Colour Photographs from the American South*, Victoria and Albert Museum, London (solo exhibition / tour)
1984 *Elvis at Brooks: The Graceland. Photographs of William Eggleston*, Memphis Brooks Museum of Art (solo exhibition)
1989 New Orleans Museum of Art (solo exhibition)
 Spectrum Photogalerie, Sprengel Museum Hannover (solo exhibition)
1990 *The Democratic Forest*, Corcoran Gallery of Art, Washington (solo exhibition / cat.)
1992 *Ancient and Modern*, Barbican Art Gallery, London (solo exhibition / tour / cat.)
1994 *William Eggleston*, Sprengel Museum Hannover (solo exhibition)
1998 *Morals of Vision*, Westfälischer Kunstverein, Münster (solo exhibition)
1999 *William Eggleston. Hasselblad Award Winner 1998*, Göteborg Museum of Art (solo exhibition / cat.)
 William Eggleston and the Color Tradition, The J. Paul Getty Museum, Los Angeles

Bibliography (Selected)

› *William Eggleston's Guide*, Text by John Szarkowski, exh. cat., The Museum of Modern Art, New York 1976.
› *The Democratic Forest*, Text by Eudora Welty, London 1989.
› *Faulkner's Mississippi*, Text by Willie Morris, Birmingham 1990.
› *Ancient and Modern*, Text by Mark Holborn, exh. cat., The Barbican Art Center, London 1992.
› *Horses and Dogs. Photographs by William Eggleston*, ed. by Constance Sullivan, Washington / London 1994.
› *The Hasselblad Award 1998. William Eggleston*, Texts by Thomas Weski and Walter Hopps, Interview with Ute Eskildsen, Zurich / Berlin / New York 1999.
› *Photographs 1966–1971*, Nachwort by Bruce Wagner, Santa Fé 1999.

Walker Evans

1903 St. Louis, Missouri
1975 New Haven, Connecticut

After studying at the Phillips Academy in Andover and Williams College in Williamstown, both in Massachusetts, Walker Evans worked in a bookshop in New York that specialized in French literature. In 1926 Evans, whose ambition was to be a writer, enrolled in a literature course at the Sorbonne in Paris. While he was there he translated texts by Charles Baudelaire, André Gide, and others. At the same time he also took his first photographs. On his return to New York in 1927, he started to devote much more attention to photography as a means of artistic expression. Although at first he described his photography as no more than a "lefthand hobby," his photographs of the Brooklyn Bridge were published in Hart Crane's book *The Bridge* (1930). Shortly after the opening of the Museum of Modern Art in New York, Evans was engaged to photograph sculptures. In 1933 he traveled to Cuba and took photographs there for Carleton Beals's book *Crimes of Cuba.* From 1936-1938 he worked for the federal Farm Security Administration (FSA), documenting the situation of the population in the southern United States afflicted by drought and poverty. He worked closely on this with the writer James Agee, and although their report was not printed as such, it did appear as a book in 1941, titled *Let Us Now Praise Famous Men.* The Department of Photography at the Museum of Modern Art bought a number of pictures that Evans had made in connection with these projects and decided to put on an exhibition of his work in 1938. This was the first solo exhibition of a photographer's work in this institution. Evans took the exhibition as an opportunity to advance his project "to compose a critical portrait of America's historical present, at once resolutely unspectacular and shockingly real." The exhibition was marked by the publication of *American Photographs*, a classic in the history of photography which has been in print ever since. It is presented as a pictorial essay and has an essay by Lincoln Kirstein.

Between 1938 and 1941 Evans took photographs with a concealed camera in the New York subways. These covert photographs show Evans's fellow passengers as "ladies and gentleman of the jury"—as he himself called them—in almost existential portraits. Titled *Many Are Called*, the series and accompanying essay by James Agee was not published until 1966. During the last two years of the war Evans worked for *TIME*, and in 1945 he became Special Photographic Editor at *Fortune Magazine*. For the next twenty years he regularly supplied *Fortune* with themed photo essays, for which he also wrote accompanying texts. In 1964 Evans became Professor of Photography at the School of Art and Architecture at Yale University, where he taught for ten years until he became professor emeritus. In 1971 John Szarkowski mounted a major retrospective of his work at the Museum of Modern Art, and in 1975 Walker Evans died in New Haven, Connecticut. His archive, which was transferred to the Metropolitan Museum of Art in New York in 1994, also contains his extensive collections of American popular culture including advertising signs and postcards.

Today Walker Evans is regarded as possibly the most important photographer of the 20th century. Influenced by the "authorless" art of Flaubert, the minute descriptions in Baudelaire's writing, and the more than documentary photography of Eugène Atget, Evans has remained a role model for subsequent generations of photographers, who still look up to him for the conceptual approach that he took to photography—which can be read both as a sign of the time and as aesthetic expression—and for his work as the author of photographs in the "documentary style."

THOMAS WESKI

Exhibitions (Selected)

1930 *International Photography*, Harvard Society for Contemporary Art, Cambridge

1932 *Modern Photographs by Walker Evans and George Platt Lynes*, Julien Levy Gallery, New York

1933 *Walker Evans. Photographs of Nineteenth-Century Houses*, The Museum of Modern Art, New York (solo exhibition)

1938 *Walker Evans. American Photographs*, The Museum of Modern Art, New York (solo exhibition / cat.)

1947 *Walker Evans Retrospective*, Art Institute of Chicago (solo exhibition)

1964 *The Photographer's Eye*, The Museum of Modern Art, New York

1966 *Walker Evans' Subway*, The Museum of Modern Art, New York (solo exhibition)

1971 *Walker Evans*, The Museum of Modern Art, New York (solo exhibition / tour / cat.)
Looking at Photographs, The Museum of Modern Art, New York (cat.)

1977 *Walker Evans. A Retrospective Exhibition from the collection of Arnold Crane*, Museum of Contemporary Art, Chicago (solo exhibition/tour)

1978 *Walker Evans*, Bahnhof Rolandseck (solo exhibition/cat.)

1989 *The Art of Photography. 1839-1989*, Museum of Fine Arts, Houston (tour)

1990 *Walker Evans' Amerika. Bilder aus den Jahren der Depression*, Städtische Galerie im Lenbachhaus, Munich (solo exhibition/cat.)

1992 *Edward Hopper und die Fotografie*, Museum Folkwang, Essen (cat.)

1997 *documenta X*, Kassel (cat.)

2000 *Walker Evans*, The Metropolitan Museum of Art, New York (solo exhibition/cat.)

Walker Evans & Company, The Museum of Modern Art, New York (cat.)

Bibliography (Selected)

› *The Bridge*, Text by Hart Crane, New York 1930.
› *The Crime of Cuba*, Text by Carleton Beals, Philadelphia/London 1933.
› *American Photographs*, Text by Lincoln Kirstein, exh. cat., The Museum of Modern Art, New York 1938.
› *Let Us Now Praise Famous Men: Three Tenant Families*, Walker Evans and James Agee, Boston 1941.
› *Many Are Called*, Text by James Agee, Boston 1966.
› *Message from the Interior*, Text by John Szarkowski, New York 1966.
› *Walker Evans. Photographs for the Farm Security Administration. 1935-1938*, Text by Jerald C. Maddox, New York 1973.
› *Walker Evans. First and Last*, New York 1978.
› *Walker Evans at Work. 745 Photographs Together with Documents Selected from Letters, Memoranda, Interviews, Notes*, Text by Jerry L. Thompson, New York 1982.
› *Walker Evans. Subways and Streets*, ed. by Sarah Greenough, exh. cat., National Gallery of Art Washington 1991.
› *Walker Evans and Dan Graham*, Texts by Jean-François Chevrier, Allan Sekula, Benjamin H. D. Buchloh, exh. cat., Witte de With Center for Contemporary Art, Rotterdam 1992.
› *Walker Evans. The Hungry Eye*, Texts by Gilles Mora and John T. Hill, New York 1993.
› *Walker Evans. The Getty Museum Collection*, Text by Judith Keller, Malibu 1995.
› *Walker Evans. A Biography*, Text by Belinda Rathborn, New York 1995.
› *The Last Years of Walker Evans. A First-Hand Account*, Text by Jerry L. Thompson, New York 1997.
› *Walker Evans*, Text by James R. Mellow, New York 1999.
› *A Walker Evans Anthology*, Texts by Jeff L. Rosenheim and Douglas Eklund, New York/Zurich 2000.

Patrick Faigenbaum
1954 Paris
lives in Paris

Born in 1954, Patrick Faigenbaum—a French artist with East European roots—has spent almost two decades exploring the identity of various social groups. His chosen form is subjective portraiture, and his method involves working on the black-and-white images in his darkroom until they take on the desired "inner reality" (Heinz Liesbrock). For this reason, many of his pictures are one-offs or only exist in small editions.

Having originally trained as a painter from 1968-1973, Faigenbaum then turned to photography. This medium provided him with the ideal means to translate his physiognomic observations of people into artistic images. The photographic process begins at an authentic starting point and it is only after the necessary work has been completed in the darkroom that the print is able to make its own, subjective statement. As Faigenbaum himself has said: "The negative is like a musical score. [...] There are thousands of ways of interpreting a score." His most comprehensive work, which also established his international reputation, comprises a series of portraits of aristocratic Italian families. In order to carry out this project, which lasted several years, Faigenbaum moved to Italy and took photographs in Florence (1983/84), Rome (1985-87), and Naples (1990/91). He was fascinated by what Heinz Liesbrock has called the "puzzle of history" that strikes one at the sight of Italy's ancient, virtually uninhabited palazzos. Who lives behind those old walls, and how does the present generation manifest the cultural inheritance of families that are often hundreds of years old? Faigenbaum's photographs thus inextricably combine two different levels of time: the present in the figures, and the past in the historic interiors.

A similar story lies behind the *Roman Portraits* (1987) that he shot while he was staying on a scholarship at the Villa Medici in Rome. In these portraits, Faigenbaum photographed existing sculptural busts of famous rulers as though they were real people. He points to the interdisciplinarity of portraiture by allowing his historical subjects to melt into contemporary black-and-white prints.

In the early 1980s, Patrick Faigenbaum traveled to Prague for the first time. Once again he was fascinated by the historical dimension of the city, which he saw through the eyes of Franz Kafka and his writings. It was not until ten years later that he felt he knew this foreign place, which he had explored step by step, and in 1994 started to take photographs there. While it would seem that the pictorial worlds in *Praha* (1995) extend from closed interiors out into the streets, in the faces of the people there is an oppressive sense of introspective melancholy which seems to be at odds with the outward appearance of the images.

In 1996 Patrick Faigenbaum was invited by the town of Bremen to become artist-in-residence for one year. Without any concrete notion of how he should proceed, he began exploring the city, which was smaller than usual. Besides making portraits and taking group shots, he also photographed residential buildings and business premises, wharves, roads, etc. The closer he comes to the present moment in time, the more obviously and readily does Faigenbaum integrate signs of the present into his pictures. His confident admixture of colored shots with black-and-white images and genre portraits, townscapes, and interiors resulted in an invitation to participate in *documenta X* (1998) curated by Catherine David.

THOMAS SEELIG

Exhibitions (Selected)

1980 *La Photographie française de 1945 à 1980*, Galerie Zabriskie, Paris

1983 *Le portrait photographique contemporain*, University of Tuscon

1984 Musée National d'Art Moderne, Paris (solo exhibition)
Musée National d'Art Moderne, Centre Georges Pompidou, Paris (solo exhibition)

1986 Institut Français, Prague (solo exhibition/tour/cat.)
Fratelli Alinari – Patrick Faigenbaum 1885–1985, Institut Français, Florence (solo exhibition/cat.)

1987 *Vies Parallèles*, Villa Medici, Rome (solo exhibition/cat.)
Contemporary Photography from France, Photographers' Gallery, London (cat.)

1988 *Roman Portraits,* Art Institute of Chicago (solo exhibition/cat.)
New Photography 4, The Museum of Modern Art, New York
Tenir l'image à distance, Musée d'Art Contemporain, Montréal (cat.)

1989 *Das Portrait in der zeitgenössischen Fotografie*, Kunstverein Frankfurt (cat.)
Tableaux romains, Musée d'Art Contemporain, Nîmes (solo exhibition/cat.)

1991 *Patrick Faigenbaum 1989–1991*, Musée d'Art Moderne de la Ville de Paris (solo exhibition/cat.)
Barbara Gladstone Gallery, New York (solo exhibition)

1992 *Eliat–Jérusalem. Déplacement 1990–1992*, Galerie Crousel-Robelin Bama, Paris (solo exhibition)
Family Album. Changing Perspectives of Family Portrait, Metropolitan Museum of Photography, Tokyo (cat.)

1995 *Traces, fragments, ellipses*, Galerie d'Art Moderne, New Delhi (cat.)
Beyond National Recognition, Gallery of Australia, Canberra (cat.)

1997 *documenta X*, Kassel (cat.)

1998 *Prague*, Westfälischer Kunstverein, Münster (cat.)

1999 *Patrick Faigenbaum, Fotografien. Florence, Rome, Naples, Bremen*, Neues Museum Weserburg, Bremen (solo exhibition/cat.)
Barbara Gladstone Gallery, New York (solo exhibition)

Bibliography (Selected)

› *Fratelli Alinari – Patrick Faigenbaum 1885–1985*, Texts by Jean François Chevrier et al., exh. cat., Institut Français, Florence 1986.

› *Vies Parallèles*, exh. cat., Villa Medici, Rome 1987.

› *Roman Portraits*, Texts by Jean François Chevrier et al., exh. cat., Art Institute of Chicago 1988.

› *Patrick Faigenbaum 1989–1991*, Texts by Jean-François Chevrier, E. Chiosi, M. Visceglia, exh. cat., Musée d'Art Moderne de la Ville de Paris 1991.

› *Patrick Faigenbaum. Prague*, Texts by Jean-François Chevrier and Heinz Liesbrock, exh. cat., Westfälischer Kunstverein, Münster 1998.

› *Patrick Faigenbaum. Fotografien*, Texts by Jean François Chevrier, Thomas Deecke and Hanne Zech, exh. cat., Neues Museum Weserburg, Bremen 1999.

Hans-Peter Feldmann

1941 Düsseldorf

lives in Düsseldorf

Hans-Peter Feldmann, who does not describe himself as an artist, produces work that is as many-sided as it is apparently simple: he collects objects and pictures, exhibits them and publishes them. He operates on the periphery of the art business as we know it and avoids producing collectable one-offs, by restricting himself to industrially-made objects or anonymous illustrations. His interest is in the everyday and in everyday reproductions.

Feldmann, who started in the 1960s with large-format oil paintings of drawers and pencils, soon came to the conclusion that reproductions could convey his message just as effectively as the originals. In 1967 he started to paste pictures from newspapers onto the backs of paintings. Shortly after this he made his *Aufklapp-Bilderbuch (Fold-up Picture Book)*: a copy of a Knaur's dictionary for young people with cut-out pictures pasted into it throughout. In 1975 an exhibition in the Galerie Maenz in Cologne presented Feldmann's collection of toys, some still with their original packaging. In the late 1960s he started printing gray-bound notebooks in unspecified print runs (1968–1975) which show different pictures of the same subject, such as shoes, filmstars, or airplanes, and which were named according to the number of illustrations, for instance, *7 Bilder (7 Pictures)*.

Feldmann takes the images for his works from private collections or from newspapers; sometimes he also makes his own photographs, but without making any distinction between his own and other people's pictures. His book output is diverse. It includes *Eine Stadt: Essen* (1977, *A City: Essen*), laconic photo-reportage of banal locations in the city, views that strike a familiar chord, though not necessarily as pictures. Whatever the theme, Feldmann's method does not change: photographs are extracted from their original context and arranged without commentary. In *Der Überfall* (1975, *The Hijack*) he collected all the newspaper pictures of a hijacking drama. *Alle Kleider einer Frau* (1974, *A Woman's Entire Wardrobe*) consists of 70 Polaroid shots, each with a single item of clothing against a white wall. In addition, Feldmann is renowned for his collection of thimbles, has produced garishly painted plaster casts of Classical sculptures, colors black-and-white pictures, and has also made postcards and posters. Thus he has managed to avoid any hint of predictability in his output and to sidestep the unmistakable identity that the art market insists on. He is sparing when it comes to giving his works titles, rarely appears in public, and virtually never comments on his works: in 1972 he answered an interviewer's questions with found pictures. In 1980 Hans-Peter Feldmann ceased all artistic activity and destroyed all the works in his possession. It was only eight years later that he was prepared to exhibit in galleries again. Since 1995 he has been involved in the artists' journal *Ohio*, which—in keeping with his own ideas—regularly publishes his pictures with no context and arranged by subject. He has also produced new books according to the old pattern, such as *Voyeur* or *Portrait*.

Hans-Peter Feldmann's work may be seen as a stand against the aura of the one-off in art; he explores the "life cycle" of a reproduction. In whatever form his (of course, always unsigned) photographic works reach the public, Feldmann heightens the appearance of banality by reducing it to a single image and thus revealing its intrinsic fascination. It is as though the motif were presented for renewed appraisal.

In one of his rare public appearances (at the *Symposion über Fotografie XV*, in Graz in 1994), Feldmann spoke, among other things, about the cave paintings at Lascaux and the way people painted animals on the walls of the caves in order to understand them, thereby working up the courage to go hunting and attack the animals—a useful, almost therapeutic activity. He went on to say that he, too, pins things down on paper, hence making it easier for himself to deal with them.

MF

[Hans-Peter Feldmann does not publish any lists of exhibitions or publications.]

Robert Frank

1924 Zurich

lives in New York and Mabou, Canada

No book had such a powerful effect on American photography in the 1960s as *The Americans* by Robert Frank, whose radically subjective pictorial language revolutionized American "straight photography," and played a large part in making the photo book into an independent art form.

After training as a photographer, Frank gained experience shooting statues, then further extended his skills by completing an apprenticeship in commercial photography and photo-journalism (1942–1944) before working as a photographer in Geneva and Basel. At the age of 22 he left the "narrow confines" of Switzerland and went to New York, where the well-known art director Alexey Brodovitch engaged him to work on the journal *Harper's Bazaar*.

Despite marking up his first commercial successes, Frank abandoned fashion photography after only one year and in 1948 traveled to Peru to work on his own photographic projects. His subsequent journeys through South America and Europe generated numerous melancholy black-and-white pictures which Frank, looking back, has described as "lyrical."

In 1953 he returned to the United States where he then worked as a freelance photo-journalist. Shortly before this he had started taking photographs with a 35mm camera, which allowed him to react faster, more directly and intuitively to his surroundings, which was crucial in the development of his free, spontaneous style. As the first European recipient of a Guggenheim Fellowship, he traveled through his adopted homeland in 1955/56, in order to realize "a wide-ranging, comprehensive pictorial representation of American life." In his application for the fellowship, Frank wrote: "What I intend to do, is to observe and record what I will see, as a 'new' American! A civilization, born & made in the USA."

In a lengthy selection process at the end of his journey, out of 30,000 shots, Frank chose 83 for his book *The Americans*. This was published in Paris in 1958 and reissued the following year in New York with a text by Jack Kerouac.

Inspired by the photo book *American Photographs* (1938) by Walker Evans, Frank evolved a new system of formal and thematic interconnections between individual pictures, by which he then succeeded in conveying his ambivalent relationship with American society. In his many-layered black-and-white photographs, Frank confronts various issues, including racism in everyday life and American ideals such as freedom or mobility. His images often center on visual icons such as the American flag, cars, televisions, juke boxes, etc., which he sees as symbols of the transitional quality of American life in the 1950s.

Since Frank's cheerless portrait of contemporary society is distinctly at odds with the self-image of many Americans, his book, when it came out in the USA, was widely interpreted as an "attack on the United States." Criticism was also raised against Frank's unconventional, cursory pictorial language of coarse-grained photographs, often without a central motif and characterized by unusual angles and views, collapsing perspectives and blurred images.

In the 1960s there was a reappraisal of the book, for its critical attitudes and subjective pictorial language struck a chord with many young photographers and became an ideal to live up to for Lee Friedlander, Garry Winogrand, and others.

Frank's *Ten Bus Photographs*, made in New York in 1958, were to be his last photographic project as such, and their serial character already pointed ahead to film, which then became the main focus of his creative work.

In 1970 Frank moved from New York to Mabou, an isolated spot in Nova Scotia, where he once again turned to the medium of photography in addition to making films. Since then he has rarely worked with individual pictures, preferring complex sequences or collages of black-and-white prints or Polaroids, often adding handwritten notes. Frank's most recent photographs generally emerge from his own private surroundings and serve as a way of dealing with a lifetime of memories.

US

Exhibitions (Selected)

1950 *51 American Photographers*, The Museum of Modern Art, New York

1953 *Post-War European Photography*, The Museum of Modern Art, New York

1955 *The Family of Man*, The Museum of Modern Art, New York (tour/cat.)

Photographie als Ausdruck, Helmhaus Zürich

1961 *Robert Frank, Photographer*, The Art Institute of Chicago (solo exhibition)

1962 *Photographs by Harry Callahan and Robert Frank*, The Museum of Modern Art, New York

1969 *Robert Frank*, Philadelphia Museum of Art (solo exhibition)

1976 *Robert Frank*, Photo-Galerie, Kunsthaus Zürich (solo exhibition)

1978 *Robert Frank: Photography and Films, 1945–1977*, Mary Porter Sesnon Art Gallery, University of California, Santa Cruz (solo exhibition/cat.)

1979 *Robert Frank: Photographer/Filmmaker, Works from 1945–1979*, Long Beach Museum of Art, California (solo exhibition/cat.)

Robert Frank (Venezia '79—La Fotografia), Padiglione Centrale, Venice (solo exhibition/cat.)

1986 *Robert Frank. New York to Nova Scotia*, The Museum of Fine Arts Houston 1986 (solo exhibition/tour/cat.)

Robert Frank. États d'urgence, Centre National de la Photographie, Palais de Tokyo, Paris (solo exhibition)

1988 *The Lines of My Hand*, Museum für Gestaltung, Zurich (solo exhibition/cat.)

1994 *Robert Frank. Moving Out*, National Gallery of Art Washington (solo exhibition/tour/cat.)

1996 *Robert Frank. Les Américains*, Maison Européene de la Photographie, Paris (solo exhibition)

1997 *Robert Frank. Hasselblad Award Winner 1996*, Göteborg Museum of Art (solo exhibition/cat.)

2000 *Gotthard Schuh und Robert Frank*, Kunsthaus Zürich

Bibliography (Selected)

› *Indiens pas morts*, photographs by Werner Bischof, Robert Frank and Pierre Verger, Text by Georges Arnaud, Paris 1956.

› *Les Américains*, Text by Alain Bosquet, Paris 1958 (*The Americans*, Text by Jack Kerouac, New York 1959).

› *The Lines of My Hand*, New York 1972.

› *Tod Papageorge, Walker Evans and Robert Frank. An Essay on Influence*, Yale University Art Gallery, New Haven 1981.

› *Robert Frank. New York to Nova Scotia*, Texts by Sarah Greenough, Philip Brookman et al., The Museum of Fine Arts, Houston 1986.

› *Robert Frank. Moving Out*, Texts by Sarah Greenough, Philip Brookman et al., exh. cat., National Gallery of Art, Washington 1994.

› *Robert Frank. Black White and Things*, exh. cat., National Gallery of Art, Washington 1994.

› *Robert Frank. Flamingo. The Hasselblad Award 1996*, Text by Mikael van Reis, exh. cat., Hasselblad Center, Göteborg 1997.

Lee Friedlander
1934 Aberdeen, Washington
lives in New City, New York

Since the 1960s Lee Friedlander, together with Walker Evans and Robert Frank, has been regarded as one of the leading American exponents of an approach to photography that aims at the direct, unmanipulated representation of reality, but which is at the same time recognizable for the individuality of its vision.

Friedlander started taking photographs when he was 14 years old, and in the early 1950s studied photography for a short time at the Art Center School in Los Angeles. In 1956, on the advice of his teacher Edward Kaminski, he moved to New York where he met some of the most influential photographers of his time, such as Walker Evans, Robert Frank, Garry Winogrand, and Diane Arbus.

In 1958 he rediscovered the work of the American photographer E. J. Bellocq, whose 1912 photographs of prostitutes in New Orleans he later published in collaboration with John Szarkowski in the book *Storyville Portraits* (1970).

As an enthusiastic jazz fan he took shots of musicians for record companies, and in 1960 received an award for these photographs from the Simon Guggenheim Memorial Foundation. This award and others allowed Friedlander to concentrate increasingly on non-commercial projects.

In the years to come, he made a name for himself as an exponent of "street photography." He shot his black-and-white photographs of everyday urban situations with a handy small-format camera in New York and on various trips through the USA.

In carefully composed pictures, that at times seem like montages, Friedlander worked with extreme cuts, confusing perspectives, reflections, and "picture-within-a-picture" motifs, thereby radically breaking with aesthetic convention.

Many of these shots are self-portraits, which he commented on in 1970 in the foreword to his book *Self Portrait*: "I suspect it is for one's self-interest that one looks at one's surroundings and one's self. This search is personally borne and is indeed my reason and motive for making photographs. The camera is not merely a reflecting pool and the photographs are not exactly the mirror, mirror on the wall that speaks with a twisted tongue. Witness is borne and puzzles come together at the photographic moment which is very simple and

complete. The mind-finger presses the release on the silly machine and it stops time and holds what its jaws can encompass and what the light will stain. That moment when the landscape speaks to the observer."

Friedlander's photographs not only bear witness to his preference for complex pictorial constructions but also reflect social developments, and may be read as symbols of the disturbing multiplicity of everyday life in the USA in the 1960s and 1970s. The New York photo-historian Peter Galassi has written in connection with his photograph *Man in Window, New York City*, 1964—which like many of Friedlander's works deals with isolation in the midst of urban life—that his "strangely still cityscapes seem like images from an abandoned land." Since the 1970s Lee Friedlander has constantly addressed new subjects such as landscape, factory work, portraiture, or nudes. These themes, together with the revival of his interest in self-portraits in the early 1980s, demonstrate his criticism of conditioned and habitual ways of seeing. They also bear the fruits of his exploration of the media-specific qualities of photography and his endeavor to extend the pictorial language of photography. "Positioning himself a half-step to one side of where we ordinarily stand, Friedlander imparts a characteristic spin to the objects of his attention; given the option, he goes for the bank shot rather than rifling the ball straight into the pocket." (Frank Gohlke)

US

Exhibitions (Selected)

1963 International Museum of Photography, George Eastman House, Rochester (solo exhibition)
The Photographer's Eye, The Museum of Modern Art, New York (cat.)

1966 *Towards a Social Landscape*, George Eastman House, Rochester

1967 *New Documents*, The Museum of Modern Art, New York (tour/cat.)

1972 *Gatherings*, The Museum of Modern Art, New York (solo exhibition)

1974 The Museum of Modern Art, New York (solo exhibition)
Lee Friedlander, 15 Photographs, Galerie Wilde, Cologne (solo exhibition)

1976 The Photographers' Gallery, London (solo exhibition)
Kunsthaus Zurich (solo exhibition)

1978 Museum of Fine Arts, Boston (solo exhibition)
Mirrors and Windows. American Photography since 1960, The Museum of Modern Art, New York (tour/cat.)

1979 Center for Creative Photography, Tucson (solo exhibition)

1981 California Museum of Photography, Riverside (solo exhibition)

1983 San Francisco Museum of Modern Art (solo exhibition)

1986 Museum Folkwang, Essen (solo exhibition)

1987 Seibu Museum of Art, Tokyo (solo exhibition)

1989 Seattle Art Museum (solo exhibition/tour/cat.)

1991 *Nudes*, The Museum of Modern Art, New York (solo exhibition/cat.)
San Francisco Museum of Modern Art (solo exhibition)

1993 *Cray at Chippewa Falls*, Sprengel Museum Hannover (solo exhibition)
Walker Art Center, Minneapolis (solo exhibition)

1994 *Letters from the People*, The Museum of Modern Art, New York (solo exhibition)

1997 *Self-Composed*, Janet Borden, New York (solo exhibition/cat.)
Viewing Olmstedt: Photographs by Robert Burley, Lee Friedlander and Geoffrey James, CCA, Montreal (tour/cat.)

1998 The Cleveland Museum of Art (solo exhibition)

1999 *Vive les modernités. Rencontres International de la Photographie*, Arles (cat.)

2000 *Stamps*, Janet Borden, New York (solo exhibition)

Bibliography (Selected)
› *Work from the Same House. Lee Friedlander and Jim Dine*, London/New York 1969.
› *E.H. Bellocq. Storyville Portraits. Photographs from the New Orleans Red-Light District ca. 1912*, ed. by John Szarkowski and Lee Friedlander, New York 1970.
› *Self Portrait*, Afterword by John Szarkowski, New York 1970.
› *The American Monument*, Text by Leslie George Katz, New York 1976.
› *Lee Friedlander. Photographs*, New York 1978.
› *Factory Valleys*. Afterword by Leslie George Katz, New York 1982.
› *Like a One-Eyed Cat. Photographs 1956–1987*, Text by Rod Slemmons, New York 1989.
› *Nudes*, ed. by Mark Holborn, Afterword by Ingrid Sischy, London 1991.
› *The Desert Seen*, Text by Lee Friedlander, New York 1996.
› *American Musicians*, Introduction by Joel Dorn, New York 1998.

Bernhard Fuchs

1971 Haslach a.d. Mühl, Upper Austria
lives in Düsseldorf

In 1994, a year after enrolling to study under Bernd Becher at the Kunstakademie Düsseldorf, photographer Bernhard Fuchs, who grew up in rural Austria, embarked on his most important work to date: a series of portraits predominantly of the people from his native region, the Mühlviertel in Upper Austria.

These works by Bernhard Fuchs are the outcome of his enduring engagement with a rural landscape that as yet still shows few signs of the rapid changes in social and economic structures found elsewhere. His interest is in the people who live and work there in traditional village communities; and he approaches his subjects with both respect and familiarity. The resulting portraits mainly depict full-length figures—either posing or at work—embedded in the landscape around them. The pictures not only exude calm and composure, but also reveal the different characters of the sitters and, above all, their unbroken sense of identification with their surroundings. Fuchs approaches his subjects with an accordingly classical, uncontrived notion of picture-making, which produces—not least by means of the calculated use of color and shadowless light—compositions that are both psychological and formally compelling. He never sets out to criticize or expose his subjects. As Heinz Liesbrock has said, "Fuchs leaves the people in his pictures behind the veil of their own particular lives; he does not attempt to draw it aside because this obscuring intimacy is essential to everyone's life."

These pictures, with their heavy weighting towards local color, clearly stand opposed to the current preference for images of highly individualized, cosmopolitan figures, completely detached from their own surroundings. In Bernhard Fuchs's photographs the significance of the landscape as an element that both protects and leaves its mark on human beings is symbolized in the edges of woods denoting the borderline between lack of protection and refuge: a motif that also plays a part in other works made concurrently with these portraits, such as his landscapes and his more recent images of cars parked by areas of woodland.

With his work Bernhard Fuchs positions himself in a tradition of documentary photography that examines the world with photographic restraint, yet without denying the author's own biography. Anchoring subjects in their own surroundings had already been of central importance to photographers such as August Sander, as also to painters—particularly in the 19th century—for instance, Jean François Millet and Giovanni Segantini. Bernhard Fuchs cites all three as a source of inspiration. Like Fuchs, these artists worked to achieve that balance of psychology and formal composition which is so crucial to any portrait.

MF

Exhibitions (Selected)
1991 Galerie Waxenberg, Upper Austria (solo exhibition)
1995 Galerie Lukas & Hoffmann, Cologne (solo exhibition)
1996 Westfälischer Kunstverein, Münster (exhibition with Simone Nieweg / cat.)
 Manifesta I, Chabot Museum Rotterdam (cat.)
 Habitus, Galerie Fotohof, Salzburg (cat.)
1997 *una vision real*, Centro de la Imagen, Mexico City (cat.)
 Eine reale Vision, Künstlerhaus Wien (cat.)
 Ich ist ein anderer, Kulturhaus der Stadt Graz
1998 Galerie Konrad Fischer, Düsseldorf (solo exhibition)
 Ehemalige Reichsabtei Aachen-Kornelimünster (cat.)
1999 *Ort—Raum—Identität*, Preussag, Hannover (cat.)
2000 Galerie Fotohof, Salzburg (solo exhibition)

Bibliography (Selected)
› "Bernhard Fuchs. Den Augenblick fokussieren", Text by Johanna Hofleitner, in: *EIKON*, no. 16/17, pp. 35ff, Vienna 1995.
› *Portraits*, Text by Heinz Liesbrock, exh. cat., Westfälischer Kunstverein, Münster 1996.

Dan Graham

1942 Urbana, Illinois
lives in New York

Since the mid-60s the complex, multi-faceted work of the American Dan Graham has been closely intertwined with the current theoretical, aesthetic, and critical debate, and as such has been described by Rainer Metzger as "exemplifying the art of post-modernity." Dan Graham grew up in New York, studied philosophy at Columbia University for a time and first came into contact with the art world in 1964 as a gallerist. When financial difficulties forced the John Daniels Gallery to close after only a year—where Graham had been pre-

senting early manifestations of Minimal Art—he started for the first time to engage in artistic activity himself. His earliest works from between 1965 and 1969 include work for magazines, which can be categorized as Conceptual Art. In these he takes a critical approach towards the traditional art business and Pop and Minimal Art.

Graham's first editorial contribution to a magazine appeared, heavily cut, in *Arts Magazine* in December 1966 with the title "Homes for America," and again in 1971 in the journal *Interfunktionen* as a double-spread using his originally planned layout. Described by Graham as a "photo-journalistic think piece," this work looks like a conventional feature article, with several photographs, tables, and a text in which the 24 year-old compares different designs and possible combinations of serial housing and "in an obviously ironic, ambiguous manner, reflects the formal and stylistic principles of Minimal Art." (Benjamin Buchloh) The starting point for this work—consciously distinct from what Dan Graham himself called "fine photography"—was a series of color photographs made with a cheap small-format camera, showing newly built, stereotypical one-family homes and their social contexts in American suburbs.

The two-part work *View Interior, New Highway Restaurant, New Jersey, New York* was made in 1967 in the interior of a recently-opened fast food restaurant. It shows a similar view of two different window seats: on the lower of the two images there is a seated family, while the upper image is deserted. The suburban surroundings visible through the window look bleak, anonymous, and interchangeable. The three figures in the photograph seem isolated and out of place; they are seen only from behind and thus equally interchangeable. The socio-critical note which sounds through all the photographs in the series *Homes for America* may be read as criticism of the monotony and inhumanity of American suburban town planning, which was the subject of much sociological research in the mid-60s.

Hans Dieter Huber has rightly pointed out that this piece, which is typical of Graham's early output prefigures many themes that are still characteristic of his work today: the social interaction of people and the architecture of their surroundings, the phenomenon of social alienation, the relationship between the world inside and outside, the private and the public, and the artistic principle of seriality.

Graham's films, videos, and performances of the 1970s predominantly addressed processes of perception, but since 1989 he has been increasingly occupied with the social implications of architecture, and in this connection has devised video installations, architectural models, and glass pavilions, which are amongst his best-known works today.

These walk-in pavilions are based on simple geometric forms and, alluding to functional designs for offices and banks, are often built by Graham out of steel and reflective glass, which—depending on the lighting—either seems transparent or reflective, i.e., serving either as a window or as a reflective surface. In his own words, these pavilions "show the viewer his own body and himself as a perceiving subject, but also give him the chance to observe other people, who in turn perceive themselves."

Since the mid-60s Graham has also published theoretical writings in which he reflects on his own work, analyzes the works of other artists, and critically addresses the phenomenon of popular culture, as in the mass media or punk music. With his texts, which are in themselves an integral part of his oeuvre, Graham has made an important contribution over the last three decades to the cutting edge of art discourse.

US

Exhibitions (Selected)

1966 *Projected Art*, Contemporary Wing of Finch College Museum of Art, New York

1969 John Daniels Gallery, New York (solo exhibition)
Konzeption—Conception, Städtisches Museum Leverkusen (cat.)

1970 *Information*, The Museum of Modern Art, New York (cat.)

1972 *Selected Works 65–72*, Lisson Gallery, London (solo exhibition / cat.)
documenta V, Kassel (cat.)

1976 *Biennale di Venezia*, Venice (cat.)
Kunsthalle Basel (exhibition with Lawrence Weiner / cat.)

1977 *documenta VI*, Kassel (cat.)
Stedelijk Van Abbemuseum, Eindhoven (solo exhibition / cat.)

1980 The Museum of Modern Art, New York (solo exhibition)

1982 *documenta VII*, Kassel (cat.)

1983 *Pavillons*, Kunsthalle Bern (solo exhibition / cat.)

1985 The Art Gallery of Western Australia, Perth (solo exhibition / cat.)

1987 Musée d'Art Moderne de la Ville de Paris (solo exhibition / cat.)
Biennial Exhibition, Whitney Museum of American Art, New York (cat.)
Skulptur. Projekte, Münster (cat.)

1988 *Pavillons,* Kunstverein Munich (solo exhibition / cat.)

1989 *Children's Pavilion*, Galerie Pailhas, Marseilles (exhibition with Jeff Wall / tour / cat.)

1991 *New Work. Roof Project*, DIA Center for the Arts, New York (solo exhibition / cat.)

1992 *documenta IX*, Kassel (cat.)

1994 *Dan Graham. New American Film and Video Series*, Whitney Museum of American Art, New York (solo exhibition)

1996 *The Suburban City*, Museum für Gegenwartskunst, Basel (solo exhibition / cat.)

1997 *documenta X*, Kassel (cat.)
Skulptur. Projekte, Münster (cat.)
Centro Galego de Arte Contemporánea, Santiago de Compostela (solo exhibition / cat.)

1998 P.S.1 Contemporary Art Center, Long Island City (solo exhibition)

1999 *Fotografische Recherchen in der Stadt*, Österreichische Galerie Belvedere, Vienna (cat.)

Bibliography (Selected)
› *Video—Architecture—Television*, ed. by Benjamin H.D. Buchloh, Texts by Dan Graham, Michael Asher et al., Halifax / New York 1979.
› Jeff Wall, *Dan Graham's Kammerspiel,* Toronto 1991.
› *Walker Evans and Dan Graham*, Texts by Jean-François Chevrier, Allan Sekula, Benjamin H. D. Buchloh, exh. cat., Witte de With Center for Contemporary Art, Rotterdam 1992.
› *Dan Graham. Rock my Religion. Writings and Art Projects 1965–1990*, ed. by Brian Wallis, Cambridge 1993.
› *Dan Graham. Ausgewählte Schriften*, ed. by Ulrich Wilmes, Stuttgart 1994.
› Rainer Metzger, *Kunst in der Postmoderne. Dan Graham*, Cologne 1996.
› *Two-way Mirror Pavilions / Einwegspiegel-Pavillons 1989–1996*, ed. by Martin Köttering and Roland Nachtigäller, exh. cat., Städtische Galerie Nordhorn 1996.
› Hans Dieter Huber, "In every Dream Home a Heartache (Roxy Music). Zu den Fotoarbeiten von Dan Graham", in: *4 x 1 im Albertinum*, exh. cat., Gemäldegalerie Neue Meister, Staatliche Kunstsammlung Dresden 1997.

Andreas Gursky

1955 Leipzig
lives in Düsseldorf

Born into the third generation of a family of photographers, Andreas Gursky started his studies in photography at the Gesamthochschule Essen where Michael Schmidt was on the faculty. As a result of meeting Thomas Struth, Gursky transferred to the Kunstakademie Düsseldorf in the late 1970s, there studying under Bernd Becher and graduating as a Master Pupil in 1987. His first published color photographs were taken between 1984 and 1989 in the Alps and in the immediate surroundings of Düsseldorf. Unlike his fellow students, Gursky was producing pictures with a limited narrative content. The epic breadth and monumentality of his, as yet, small-format landscapes was alleviated by modest spots of color that turn out, on closer examination, to be groups of people. In these works Gursky's intention—then as now—was to create visual equivalents for intellectual concepts. As a photographer Gursky readily draws on the history of painting, which he views as a "widely applicable treasure trove of forms that we (as contemporary artists) turn to again and again."

In the early 1990s Andreas Gursky started to divide up the pictorial space into different areas. Taking advantage of a number of travel and study grants he familiarized himself with the world of international trade and production. He photographed over 70 factory interiors, where architectural structures are designed to meet the demands of the production process. Gursky then introduced the notion of a "higher order" into his own photographic output, no longer primarily seeking to illustrate reality as he found it, but accentuating the compositional structure of the pictorial space. By 1995 he had made a range of comparative images of stock exchanges, car shows and horse races, where individual figures at times merge completely into the areas of color in the print.

At about the same time, Gursky also started digitally post-editing individual shots. Rather like Jeff Wall, whose work he cites as a source of inspiration, Gursky uses a computer to maintain or, ideally, to enhance the credibility of his images. Without inside knowledge, it is impossible to tell from looking at his pictures where a horizon may have been straightened or individual sections darkened for dramaturgical purposes.

Andreas Gursky's approach to any subject matter involves an extremely prolonged decision-making pro-

cess. For instance, he spent years on the theory of how to portray the "department store," without taking a single shot of one. It is only in his more recent works that he has found a way to photograph objects in department store displays and to convey the ethos that applies in different stores. Recently he has also been looking at other phenomena such as youth culture and consumerism, working together with artist-friends Stefan Hoderlein and Nina Pohl. Andreas Gursky is currently investigating the challenge of representing "mass in ornament" (Annelie Lütgens).

TS

Exhibitions (Selected)

1985 Künstlerwerkstatt Lothringer Straße, Munich
1987 Flughafen Düsseldorf (solo exhibition)
1988 Galerie Johnen & Schöttle, Cologne (solo exhibition/cat.)
1989 P.S.1, The Clocktower Gallery, New York (exhibition with Thomas Struth/cat.)
 303 Gallery, New York (solo exhibition)
 Museum Haus Lange, Krefeld (cat.)
 Photokunst, Staatsgalerie Stuttgart (cat.)
1990 *LIV Biennale di Venezia*, Venice (cat.)
 De Afstand, Witte De With, Rotterdam (cat.)
1992 Kunsthalle Zürich (solo exhibition/cat.)
1993 Monika Sprüth Galerie, Cologne (solo exhibition)
 Doubletake. Collective Memory & Current Art, Kunsthalle Wien (cat.)
 Siemens Fotoprojekte 1987–1992, Neue Pinakothek, Munich (tour)
1994 *Fotografien 1984–1993*, Deichtorhallen, Hamburg (solo exhibition/tour/cat.)
 The Epic and the Everyday, Hayward Gallery, London (cat.)
1995 *Images*, Tate Gallery, Liverpool (solo exhibition/cat.)
 Portikus, Frankfurt (solo exhibition/cat.)
1996 *10th Biennial of Sydney*, Art Gallery of New South Wales, Sydney (cat.)
1997 *Positionen künstlerischer Photographie in Deutschland seit 1945*, Berlinische Galerie, Martin-Gropius-Bau, Berlin (cat.)
1998 Columbus Museum of Art (solo exhibition)
 Kunstmuseum Wolfsburg (solo exhibition/tour/cat.)
 Contemporary Arts Museum, Houston (solo exhibition)
 Kunsthalle Düsseldorf (solo exhibition/cat.)
1999 *Tomorrow for Ever. Photographie als Ruine*, Kunsthalle Krems (tour/cat.)

Grosse Illusionen. Demand, Gursky, Ruscha, Kunstmuseum Bonn (tour/cat.)
Matthew Marks Gallery, New York

Bibliography (Selected)
› *Andreas Gursky*, ed. by Norbert Messler, exh. cat., Galerie Johnen & Schöttle, Cologne 1988.
› *Andreas Gursky*, Text by Bernhard Bürgi, exh. cat., Kunsthalle Zürich, Cologne 1992.
› *Doubletake: Collective Memory & Current Art*, Texts by Lynne Cook, Bice Curiger et al., exh. cat., Hayward Gallery, London 1992.
› *Distanz und Nähe*, ed. by Wulf Herzogenrath, exh. cat., Institut für Auslandsbeziehungen, Berlin 1993.
› *The Epic and the Everyday. Contemporary Photographic Art*, Text by James Lingwood, exh. cat., Hayward Gallery and the South Bank Centre, London 1994.
› *Andreas Gursky. Fotografien 1984–1993*, Text by Rudolf Schmitz, exh. cat., Deichtorhallen Hamburg, Munich 1994.
› *Montparnasse*, Text by Hans Irrek, exh. cat., Portikus, Frankfurt am Main, Stuttgart 1995.
› *Fotografien 1994–1998*, Texts by Veit Görner and Annelie Lütgens, exh. cat., Kunstmuseum Wolfsburg, Ostfildern 1998.
› *Fotografien 1994 bis heute*, Texts by Lynne Cooke, Rupert Pfab et al., exh. cat., Kunsthalle Düsseldorf, München 1998.

Axel Hütte
1951 Essen
lives in Düsseldorf

Axel Hütte's interest is in urban and rural subjects that bespeak human existence, yet in his entire body of work, commencing in 1982, people are rarely to be seen. In an emotionless, neutral style of photography Hütte creates images where the motifs—pointing to past, present, and future—function like vehicles of history open to interpretation.

Axel Hütte enrolled at the Kunstakademie Düsseldorf in 1973 and was part of the first intake of the newly-established photography class under Professor Bernd Becher in 1976. He graduated in 1981 and the following year traveled to London where he spent several months

photographing the town. He found himself drawn to its unprepossessing underpasses, high-rise buildings, and post-war public housing. Hütte's field of vision in these photographs is always restricted—views without horizons that evoke a sense of claustrophobia. During the same period Hütte also took similar photographs of West Berlin, analyzing the modern urban environment in what Gerda Bauer has described as "silent sociology."

In 1985 Hütte started to work with landscape photography. On trips to northern Italy he found himself face to face with a cultural landscape that has been depicted in various media for hundreds of years, whose beauty has repeatedly been the subject of copper engravings, drawings, and photographs. Hütte's aim was to create photographs that would defy cliché and convention, that would make sense to the viewer as compositions, but that would not convey a legible insight. The photographer's intention was to lead viewers away from the overt content of the image to the point where they would reflect on the image itself. Kirby Gookin, pointing out this particular feature of Hütte's work, has commented that "these photographs are made by an eye that not only sees but also thinks."

In many of Axel Hütte's photographs, large areas are dominated by a pale, whitish-gray background. This serves both as a neutral projection surface, so to speak, and as a contrast to buildings and vegetation, which are generally located to the far right or left of center and cut off at the edge of the picture. In this configuration the architecture represents the present, whereas other elements, such as remnants of landscape, point back into the past. Meanwhile the pale areas leave room for the imagination.

Hütte prepares his pictures down to the last detail, so that when he finally shoots the actual motif he is implementing a clearly predefined ideal. In 1995 Hütte abandoned his customary long shot. Now the camera points sharply upwards, mountainous masses virtually fill the entire picture plane and at times extend across two pictures to form a diptych. Colors are denser and also make a greater impact in the exhibition space.

TS

Exhibitions (Selected)
1979 *In Deutschland*, Rheinisches Landesmuseum Bonn (cat.)
1984 Galerie Konrad Fischer, Düsseldorf (solo exhibition)

1987 Galerie Max Hetzler, Cologne (solo exhibition)
1988 Regionalmuseum, Xanten (solo exhibition/cat.)
Exchange. Germany–Ireland, Dublin (tour/cat.)
BiNationale, Kunsthalle Düsseldorf (tour/cat.)
1989 Massimo Audiello Gallery, New York (cat.)
1990 *Der klare Blick*, Kunstverein München (cat.)
Glenn & Dash Gallery, Los Angeles (solo exhibition)
Galerie Modulo, Lisbon (solo exhibition/cat.)
1991 Museum of Contemporary Photography, Chicago (exhibition with Thomas Ruff)
Galerie Bruges la Morte, Bruges (solo exhibition/cat.)
Aus der Distanz, Kunstsammlung Nordrhein-Westfalen, Düsseldorf (cat.)
1992 FRAC, Marseilles (solo exhibition/cat.)
1993 Hamburger Kunsthalle (solo exhibition/tour/cat.)
Mathildenhöhe, Darmstadt (solo exhibition/cat.)
1994 *Deutsche Kunst mit Fotografie,* Rheinisches Landesmuseum Bonn (tour/cat.)
La Ville, Musée National D'Art Moderne, Centre Georges Pompidou, Paris (cat.)
Junge deutsche Kunst der 90er Jahre, Songe Museum of Contemporary Art, Kyongju, Korea (tour/cat.)
1995 *Landschaft*, Rheinisches Landesmuseum Bonn (solo exhibition/cat.)
1996 Kunstverein Wolfsburg (solo exhibition)
1997 Fotomuseum Winterthur (solo exhibition/tour/cat.)
1998 Stephen Wirtz Gallery, San Francisco (solo exhibition)
Landschaft. Die Spur des Sublimen, Kunsthalle zu Kiel (cat.)
Landschaften, Kunstverein für die Rheinlande und Westfalen, Düsseldorf (cat.)
At the End of the Century. 100 Years of Architecture, Museum of Contemporary Art, Tokyo (tour/cat.)
1999 Galerie Wilma Tolksdorf, Frankfurt (solo exhibition)
2000 *Ansicht Aussicht Einsicht. Architekturphotographie*, Museum Bochum

Bibliography (Selected)
› *Italien*, Text by Uwe Schneede, exh. cat., Hamburger Kunsthalle, Munich 1993.
› *London. Photographien 1982–1984*, Text by Gerda Bauer, exh. cat., Mathildenhöhe Darmstadt, Munich 1993.
› *Landschaft*, Texts by Klaus Honnef and Veit Loers, exh. cat., Rheinisches Landesmuseum Bonn, Munich 1995.
› *Theorea*, Texts by Hans Irrek and Urs Stahel, exh. cat., Fotomuseum Winterthur, Munich 1996.
› *Kontinente*, Text by Cees Nooteboom, Munich 2000.

Boris Michailov

1938 Kharkov, Ukraine

lives in Kharkov

The life of Ukrainian photographer Boris Michailov has been shaped by the never-ending changes affecting politics and society in his home region. Although he shows his work predominantly in Europe and North America, he still prefers to live in his native town, Kharkov. There he finds the motifs for his photo series, reflecting social change all the more clearly against the background of a constant location.

Michailov started life as an engineer and came to photography in the late 1960s when he was asked to make a documentary record of the factory where he worked. Shortly after this, Michailov and the photographers Pavlov, Suprun, and Mal'ovanij founded the artists' cooperative Vremja. Their exhibition program concentrated above all on young, unknown photographers, who often shocked the public with their abrasive style. In order to make a living, Michailov worked as a photo journalist until the 1970s.

As a result of his personal experience of censorship in journalism, he planted covert criticism in his art photography. He made everyday pictures, but embedded them firmly in a political context by means of aesthetic interventions, such as his use of color and comments in the margins. Seemingly harmless images laid bare the propagandist subtext of official photography. In marked contrast to the pop artists in the USA who were primarily interested in aesthetics, Michailov took a distinctly historical and sociological view of life.

In spring 1991, after the collapse of the Soviet Union, Michailov reacted to the general worsening of living standards with the 100-part series *U Zemli* (*Rock Bottom*): an epic array of sepia panoramas showing a pessimistically distorted view of urban life, in which there is no hint of the author apportioning blame. Instead his aim is to present poverty as a social problem, in oppressively long sequences of images linking individual pictures made in Kiev and Kharkov.

For *U Zemli* and the blue-toned series *Sumerkj* (*Twilight*), from 1994, Michailov used a panorama camera made in Kharkov; the camera itself scans the individual elements of the scene from left to right, creating images that have no real center. Michailov further pursues his "democratic" style of photography by shooting people and street scenes from hip-level. In exhibitions he reflects this method of working by hanging the pictures at the level from which they were taken in honor of the stooped figures they depict.

It was not until the late 1990s that Michailov first used color photography, which he regards as symbolic of trivial, westernized consumerism. His *Case History* (1999) is a striking, eccentric volume of pictures, which makes use of the latest technology and a direct style of photography to present, yet again, a society caught in the depths of disillusion. Michailov's shots of the homeless—some intentionally posed—may at first glance seem amateurish, but perhaps this is precisely what makes their relentless imagery hit home all the harder. It is in moments such as this that Boris Michailov's work seems at its most "apocalyptic" (Andreas Krase).

TS

Exhibitions (Selected)

1982 Bratislava

1986 *Another Russia*, Museum of Modern Art, Oxford (cat.)

1988 *Contemporary Photography from the Soviet Union*, Musée de l'Elysée, Lausanne

1989 Museum of Contemporary Art, Tampere (solo exhibition)
 150 Years of Photography, Manezh, Moscow (tour)
 Op-positions. Photography Biennial, Rotterdam (cat.)

1990 Museum of Contemporary Art, Tel Aviv (solo exhibition/cat.)
 The Missing Picture, Visual Arts Center, Cambridge (solo exhibition/cat.)

1991 The Hasselblad Center, Göteborg (solo exhibition)
 Carnegie International, Pittsburgh

1992 *Boris Michailov. Works from 1970–1991*, Forum Stadtpark, Graz (solo exhibition)
 Herbarium, Kunsthalle Wien

1993 *I am not I*, Photo-Postscriptum Gallery, St. Petersburg (solo exhibition)
 New Photography 9, The Museum of Modern Art, New York

1994 *Europa, Europa*, Kunst- und Ausstellungshalle der Bundesrepublik Deutschland, Bonn (cat.)

1995 The Institute of Contemporary Art, Philadelphia (solo exhibition/cat.)
 Portikus, Frankfurt (solo exhibition/tour/cat.)
 If I Were German..., Galerie in der Brotfabrik, Berlin (cat.)

1996 Kunsthalle Zürich (solo exhibition/cat.)

1998 *Boris Michailov. Les Misérables (About the World)*, Sprengel Museum Hannover (solo exhibition/cat.)

1999 Centre National de la Photographie, Paris (solo exhibition/cat.)
2000 The Photographers' Gallery, London (solo exhibition)

Bibliography (Selected)
› *Another Russia*, Texts by Daniela Mrázková and Vladimir Remes, exh. cat., Museum of Modern Art Oxford, London 1986.
› *Zeitgenössische Fotografie in der Sowjetunion*, ed. by Viktor Misiano, Schaffhausen 1988.
› *Photostroika. Aperture,* No. 116, New York 1989.
› *Boris Michailov*, ed. by Brigitte Kölle, exh. cat., Portikus Frankfurt, Stuttgart 1995.
› *Boris Michailov. Am Boden*, ed. by Brigitte Kölle, Cologne 1996.
› *Boris Michailov. Die Dämmerung*, ed. by Brigitte Kölle, Cologne 1996.
› *Unvollendete Dissertation*, Text by Margarita Tupitsyn, Zurich 1998.
› *Boris Michailov. Les Misérables*, Text by Victor Tupitsyn, exh. cat., Sprengel Museum Hannover 1998.
› *Case History*, Zurich 1999.

Nicholas Nixon

1947 Detroit, Michigan
lives in Lexington, Massachusetts

Since the 1980s, the American Nicholas Nixon has been pursuing long-term photographic projects looking at the basic values of human existence and, in the process, combining artistic issues with social commitment. Having studied American Literature at the University of Michigan (1965–1969), Nixon transferred to the University of New Mexico and completed his studies in 1974 with a Master of Fine Arts in Photography. In the same year Nixon moved to Lexington near Boston where he still teaches photography at the Massachusetts College of Art. Shortly after this move, he produced his 40-part series *Boston Views*: precise black-and-white images of the architectural fabric of the city taken from high vantage points. This series was shown in 1975 in the ground-breaking exhibition *New Topographics* and again the following year in Nixon's first solo exhibition

at the Museum of Modern Art, sealing his reputation as a photographer.

Having concentrated for a time on landscape photography, Nixon began increasingly to include people in his pictures from 1977 and in doing so discovered the motif that to this day is at the heart of his "humanist" photographic work.

The series *People* (1977–1982) consists of crowded shots of socially-disadvantaged people, whom Nixon photographed in the suburbs of American cities, on their verandahs, at the beach, or in the street. Although he works with a relatively awkward large-format camera—the size of a portable television—his black-and-white shots often seem as lively and spontaneous as if they had been taken with a small hand-held camera. As Peter Galassi has pointed out, Nixon "helped to lead a revival of the large-format camera and the formal craft favored by Edward Weston and Walker Evans, which had been out of fashion for over a generation." Since the early 1970s Nicholas Nixon has preferred this comparatively old-fashioned technique because he does not have to enlarge the 8 x 10 inch negatives but can simply make full-scale contact prints. By virtue of their unusual level of detail and the finely differentiated gray tones, his photographs create "the illusion of being able to see more than the eye could see if you were there. It's basically the clearest picture one can make in photography" (Nicholas Nixon).

In the early 1980s, Nixon started to take an ever greater interest as a photographer in his immediate surroundings. In 1983 he began taking individual pictures and also making series of shots of the residents in a home for the elderly, where he was working as a volunteer. Having initially concentrated in his group shots on the placement of people in space, in the series *Old People* he then consistently decreased the distance to his subjects and for the first time worked with extreme close-ups. His keen interest in gestures, moments of contact, and the sensual quality of the skin of his subjects is found again not long afterwards in the intimate portraits and nude studies that he started making in the mid-80s of his wife and of his children as they grew up. In 1987, having come up against AIDS close to home, Nixon started to photograph a number of AIDS victims over an extended period of time, documenting the process of physical decay with great candor and sensitivity. The book, *People with AIDS* (1991), contains fifteen in-depth portrait series—as always made in close coop-

eration with the subjects—accompanied by interviews that his wife conducted with the HIV patients and their families and friends.

Time, aging, and change are also the central focus of Nixon's well-known series, *The Brown Sisters*. He took his first picture of his wife Bebe Brown and her three sisters in 1975. Since then he has photographed the four women in the same grouping once every year in "a tradition, an annual rite of passage," as he calls it. On the basis that "the world is infinitely more interesting than any of my opinions about it," Nixon never thrusts himself into the foreground as the author of his work, but instead retreats behind his motif. The photographs in this series are not a means of self-expression but rather a way of documenting the imperceptible passing of time as seen in the processes of bodily change.

US

Exhibitions (Selected)

1975 *New Topographics. Photographs of a Man-Altered Landscape*, George Eastman House, Rochester (cat.)

1976 The Museum of Modern Art, New York (solo exhibition)

1977 *Contemporary American Photographic Works*, Museum of Fine Arts, Houston (cat.)

1978 Light Gallery, New York (solo exhibition)
Mirrors and Windows. American Photography since 1960, The Museum of Modern Art, New York (tour / cat.)

1982 *Photographs from One Year*, The Institute of Contemporary Art, Boston (solo exhibition / tour / cat.)
20th Century Photographs from The Museum of Modern Art, The Seibu Museum of Art, Tokyo (cat.)

1984 California Museum of Photography, Riverside (solo exhibition)
Pace/MacGill Gallery, New York (solo exhibition)

1985 Art Institute of Chicago (solo exhibition)

1986 Cleveland Museum of Art (solo exhibition)

1987 *Twelve Photographers Look at US*, Philadelphia Museum of Art (cat.)

1988 *Pictures of People*, The Museum of Modern Art, New York (solo exhibition / cat.)

1989 *Photography Until Now*, The Museum of Modern Art, New York (tour / cat.)

1994 *Familienbilder*, Sprengel Museum Hannover (solo exhibition / cat.)
Room 306: A Year in Public School and Visiting Nurses (Work in Progress), Zabriskie Gallery, New York (solo exhibition)

1995 *People with Aids*, Kunsthalle Bielefeld (solo exhibition)

1997 *Bebe & Me*, Fraenkel Gallery, San Francisco (solo exhibition)

1998 *Family Pictures: Now and Then*, Zabriskie Gallery, New York (solo exhibition)

1999 *25 Years of the Brown Sisters and New Work*, Zabriskie Gallery, New York (solo exhibition)
Modern Starts: People, The Museum of Modern Art, New York (cat.)

Bibliography (Selected)

› *Photographs from One Year*, Introduction by Robert Adams, exh. cat., The Friends of Photography and The Institute of Contemporary Art, Boston / Carmel 1983.

› *Pictures of People*, Introduction by Peter Galassi, exh. cat., The Museum of Modern Art, New York 1988.

› *People with AIDS*, Text by Bebe Nixon, Boston 1991.

› *Family Pictures (= Photographers at Work)*, Washington / London 1991.

› *Nicholas Nixon. Familienbilder*, Text by Thomas Weski, exh. cat., Sprengel Museum Hannover 1994.

› *School. Photographs from three Schools by Nicholas Nixon*, Text by Robert Coles, Boston 1998.

› *The Brown Sisters*, Text by Peter Galassi, The Museum of Modern Art, New York 1999.

Sigmar Polke

1941 Oels, Lower Silesia
lives in Cologne

Throughout his career Sigmar Polke has engaged in tireless experimentation with materials and the limits of figurative representation. For over three decades he has concerned himself principally with painting and photography, constantly re-combining and playfully undermining their traditional use. According to *Capital-Kunst-Kompass* he is presently the most successful contemporary artist worldwide.

Sigmar Polke arrived in West Germany at the age of twelve and from 1961 to 1967 studied at the Staatliche Kunstakademie Düsseldorf under Karl Otto Götz and Gerhard Hoehme. Polke, Gerhard Richter, and Konrad Lueg—co-founders of "capitalist realism"—in effect made a stand against the socialist realism of the GDR as well as the pop art dominating Western art at the

time. Right from the outset Polke used his art to comment on politics, consumerism, and everyday life in Germany, favoring a bold mixture of realistic representation, collage, and manipulated materials. In the mid-60s he first started to produce paintings that consisted partly of painted, much enlarged dot-screen grids, which became ever less representational. Polke not only experimented by appropriating materials from other sources, such as newspapers, he also varied his picture supports, which now ranged from patterned fabrics to long-pile carpets. In the 1980s he started to work with minerals and chemicals, almost like an alchemist; by initiating processes that cannot entirely be controlled, he allowed chance to enter his work. For the Venice Biennale in 1986 he created a wall painting that reacted to the changing humidity levels in the pavilion. At this time there was also a greater concentration of political references in his work, for instance, East-West relations or the threat of nuclear war.

Photography has always been a factor in Sigmar Polke's work, not only as a visual notebook but also as a source for his own work. In the 1970s he produced a particularly large number of photographic works. Once again he was experimenting with a medium and ignoring convention: negatives and prints are treated with chemicals, partly destroyed, or overpainted; spontaneity and chance prevail. His *Paris* series (1971) emerged entirely under the influence of LSD. He worked with the camera especially when traveling and produced sequences depicting the homeless in New York (1973), a bear fight in Afghanistan (1974), an opium den in Pakistan (1974/75), and everyday life in the Hochschule für Bildende Kunst in Hamburg (1975/76), where he himself was a professor from 1977 to 1991.

In the 1960s Polke was in close contact with Joseph Beuys. Although not agreeing with the latter's provocative prohibition of painting, in his own way he did dispense with painting's traditional values: "It is this internal contradiction—his refusal to either give it [painting] up or to exculpate it, his obstinate insistence on forcing it into new corners, from which new escapes must be found—which is his Work and his Madness at once" (Thomas McEvilley). The same may be said of his photography. In step with the rise of flower power, Polke's work constituted a critique of two ossified systems: society and art. His open confrontation with German history, his interest in drugs and Eastern cultures are all part of his constantly expanding artistic consciousness.

To this day, Sigmar Polke prefers experiment—the hallmark of freedom—to rigidified value systems.

MF

Exhibitions (Selected)

1966 *Hommage à Schmela*, Galerie Schmela, Düsseldorf (solo exhibition)
 Junge Generation: Maler und Bildhauer in Deutschland, Akademie der Künste, Berlin (cat.)

1967 *Neuer Realismus*, Haus am Waldsee, Berlin (cat.)

1970 *Malerei nach Fotografie*, Münchner Stadtmuseum (cat.)

1972 *documenta V*, Kassel (cat.)

1974 *Original und Fälschung*, Kunstmuseum Bonn (exhibition with Achim Duchow/cat.)

1976 *Bilder, Tücher, Objekte: Werkauswahl 1962–1971*, Kunsthalle Tübingen (solo exhibition/tour/cat.)

1978 Halle für internationale neue Kunst, Zürich (solo exhibition/cat.)

1981 *Westkunst*, Fair Cologne (cat.)

1982 *Zeitgeist*, Martin-Gropius-Bau, Berlin (cat.)
 Works 1972–1981, Holly Solomon Gallery, New York (solo exhibition)

1983 Museum Boymans-van Beuningen, Rotterdam (solo exhibition/tour/cat.)

1988 Musée d'Art Moderne de la Ville de Paris (solo exhibition/cat.)

1990 *Fotografien*, Staatliche Kunsthalle Baden-Baden (solo exhibition/cat.)
 San Francisco Museum of Modern Art (solo exhibition/tour/cat.)

1993 *Photography in Contemporary German Art: 1960 to the Present*, Walker Art Center, Minneapolis (cat.)

1995 *Photoworks: When Pictures Vanish*, The Museum of Contemporary Art, Los Angeles (solo exhibition/tour/cat.)

1997 *Die drei Lügen der Malerei*, Kunst- und Ausstellungshalle der Bundesrepublik Deutschland, Bonn (solo exhibition/tour/cat.)

1999 *Works on Paper 1963–1974*, The Museum of Modern Art, New York (solo exhibition/cat.)

Bibliographie (Selected)
› *Höhere Wesen befehlen*, Berlin 1968.
› *Bundestagswahl 1972: Bizarre Fotos aufgenommen in Düsseldorf und Köln*, Heidelberg 1972.
› *Franz Liszt kommt gern zu mir zum Fernsehen*, with Achim Duchow, Münster 1973.

› *Day by Day… They Take Some Brain Away*, São Paoulo 1975.
› *Sketch Pad (Stenoblock)*, Bonn 1990.
› *Sigmar Polke*, Texts by Harald Szeemann, Dietrich Helms et al., exh. cat., Josef-Haubrich-Kunsthalle, Cologne, Zurich 1984.
› *Sigmar Polke. Zeichnungen, Aquarelle, Skizzenbücher 1962–1988*, Texts by Katharina Schmidt and Gunter Schweikhart, exh. cat., Kunstmuseum Bonn, Cologne 1988.
› *Sigmar Polke. Zeichnungen 1963–1969*, ed. by Johannes Gachnang, Bern / Berlin 1987.
› *Sigmar Polke. Fotografien*, Texts by Jochen Poetter and Bice Curiger, exh. cat., Staatliche Kunsthalle Baden-Baden 1990.
› *Photoworks: When Pictures Vanish*, Text by Maria Morris Hambourg, exh. cat., The Museum of Contemporary Art, Los Angeles 1996.

Albert Renger-Patzsch

1897 Würzburg
1966 Wamel im Möhnesee

As a declared opponent of turn-of-the-century "art photography," Albert Renger-Patzsch evolved a direct, noncommittal style in the 1920s, which established him alongside August Sander and Karl Blossfeldt as one of the outstanding exponents of the New Objectivity in photography.

Guided by his father, who was himself a keen amateur photographer, Albert Renger-Patzsch took his first pictures at the age of 12. Having broken off his chemistry studies at the Technische Hochschule in Dresden, he was appointed Head of the Picture Archive at the Folkwang-Verlag in Hagen in 1920 and started to photograph museum exhibits in ethnographic collections for the archives. In 1922, in his work for the book series *Die Welt der Pflanze (The World of Plants)*, edited by Ernst Fuhrmann, Renger-Patzsch began systematically photographing plants. His work on these early, scientific photographs led him to his own distinctly neutral, documentary style, which was to characterize his entire photographic output.

At the age of 28, Renger-Patzsch set himself up as a freelance photographer in Bad Harzburg, mainly earn-ing his living from commissions for industry and advertising. Not long afterwards he published his first book of photographs, *Das Chorgestühl von Kappenberg* (1925, *The Choir Stalls of Kappenberg*), which was followed by numerous volumes of photographs of towns and cities such as *Die Halligen* (1927), *Lübeck* (1928) and *Hamburg* (1930).

As a protagonist of Neue Sachlichkeit, Renger-Patzsch made a name for himself in 1928 with his book, *Die Welt ist schön (The World is Beautiful)*, which he originally wanted simply to call *Die Dinge (Things)*. This volume shows a representative selection of shots from 1922 to 1928, drawn from different areas of his photographic output. By means of close-ups, striking angles, extreme perspectives, and diagonal structures, Renger-Patzsch developed a new mode of photographic vision and directed the viewer's gaze to the surface, structure, and shape of "things." Looking back, Renger-Patzsch described *Die Welt ist schön*—his most influential and most controversial publication—as a "pattern book of objects," as a "primer to show how pictorial solutions may be found by purely photographic means."

Shortly before Albert Renger-Patzsch moved to Essen in 1929 to take up a post as a photographer at the Museum Folkwang, he started on his extensive photographic series on the Ruhr. Between 1927 and 1935 he produced over 150 largely deserted, static images of mines, workers' housing, backyards, railroad embankments, and allotments: neutral black-and-white shots of typical cultivation and housing in the urban margins of this supposedly graceless industrial region, dominated by coal and steel. It was only some time later that other photographers such as Chargesheimer (1924–1972) were to discover the region as a motif. In this series, which was first published in its entirety in 1982 by Ann and Jürgen Wilde, the founders of the Albert Renger-Patzsch Archive, "Renger-Patzsch's concept of *objectivity* broadens out into a historical inventory of a region; an inventory that is without illusion but not without feeling" (Thomas Janzen).

After his archives were largely destroyed during an air raid on Essen in 1944, Renger-Patzsch moved to Wamel am Möhnesee. Here, besides his work as an architectural and industrial photographer, he became increasingly interested in photographing landscapes and nature and published, amongst other things, the lavish, privately printed large-format picture books, *Bäume* (1962, *Trees*) and *Gestein* (1966, *Stone*).

When Albert Renger-Patzsch died at the age of 69, he left behind a large body of work which impressively documents how consistently he remained true to the principle he first developed in the 1920s, according to which the task of photography is "to do justice to the subject matter rather than expressing one's own artistic individuality."

US

Exhibitions (Selected)

1925 Atelier Albert Renger-Patzsch, Bad Harzburg (solo exhibition)
1927 Behnhaus, Lübeck (solo exhibition)
Kestner-Gesellschaft, Hanover
Exposition International de la Photographie, Société Française de Photographie, Paris
1928 Kunstgewerbemuseum, Zurich (solo exhibition)
Kunst und Technik, Museum Folkwang, Essen
1929 *Film und Foto*, Städtische Ausstellungshallen, Stuttgart (tour / cat.)
1930 Bloomsbury Galleries, London (solo exhibition)
Das Lichtbild, Munich (tour)
1935 The Royal Photographic Society of Great Britain, London
1953 Museum am Ostwall, Dortmund
1960 *photokina*, Cologne
1966 *Albert Renger-Patzsch. Der Fotograf der Dinge*, Ruhrland- und Heimatmuseum, Essen (solo exhibition / cat.)
1977 *Fotografien 1925–1960. Industrielandschaft, Industriearchitektur, Industrieprodukt*, Rheinisches Landesmuseum Bonn (solo exhibition / cat.)
Albert Renger-Patzsch. 1897–1966, The Friends of Photography Gallery, Carmel (solo exhibition / cat.)
1984 *Portraits. Albert Renger-Patzsch (1897–1966)*, Museum Folkwang, Essen (solo exhibition)
1993 *Albert Renger-Patzsch. Späte Industriephotographie*, Museum Ludwig, Cologne (solo exhibition / tour / cat.)
Albert Renger-Patzsch. Joy before the Object, Philadelphia Museum of Art (solo exhibition / tour / cat.)
1996 *Albert Renger-Patzsch. Das Spätwerk. Bäume, Landschaften, Gestein*, Kunstmuseum Bonn (solo exhibition / cat.)
1997 *Albert Renger-Patzsch, Meisterwerke*, Sprengel Museum Hannover (solo exhibition / tour / cat.)

Bibliography (Selected)

› *Das Chorgestühl von Kappenberg*, Berlin 1925.
› *Die Welt ist schön*, Introduction by Carl Georg Heise, Munich 1928 (reprinted: Dortmund 1992).
› *Albert Renger-Patzsch. Ruhrgebiet-Landschaften 1927–1935*, ed. by Ann and Jürgen Wilde, Text by Dieter Thoma, Cologne 1982.
› *Albert Renger-Patzsch—Photographien des Ruhrgebiets. Zwischen der Stadt* (= KunstOrt Ruhrgebiet, vol. 7), Text by Thomas Janzen, Ostfildern 1996.
› *Albert Renger-Patzsch. Meisterwerke*, ed. by Ann and Jürgen Wilde, and Thomas Weski, Text by Thomas Janzen, exh. cat., Sprengel Museum Hannover, Munich 1997.
› *Albert Renger-Patzsch. Bilder aus der Fotografischen Sammlung und dem Girardet-Foto-Archiv*, Texts by Ute Eskildsen and Virginia Heckert, exh. cat., Museum Folkwang, Essen 1997.

Judith Joy Ross

1946 Hazleton, Pennsylvania
lives in Bethlehem, Pennsylvania

Whether Judith Joy Ross is portraying visitors at the Vietnam Memorial in Washington, delegates in the American Congress, or pupils in Pennsylvania—all her series since the early 1980s are marked by her capacity "to capture people at particularly revealing moments" (Sandra S. Phillips).

While she was training to be an art teacher at Moore College of Art in Philadelphia (1964–1968), Judith Joy Ross turned to photography, which she feels "can show better than any other medium how astonishing reality is." Having completed her studies in photography at the Institute of Design in Chicago, Ross taught for 14 years at a college in Pennsylvania until she was awarded a Guggenheim Fellowship in 1986 which allowed her to pursue her own projects and to give up her teaching post.

At the center of the first series of portraits, which made Judith Joy Ross's reputation in the USA, are portraits of children which she took in 1982 in Eurana Park in Weatherly, Pennsylvania. These direct, frontal portraits of individuals and groups are taken from the perspective of the children, demonstrating the photographer's ability to empathize with her subjects and her fascination with the innocence, vulnerability, and strength

of these children poised on the threshold to adulthood. In 1983 Judith Joy Ross started work on her second major portrait series shortly after the opening of the Vietnam Veterans Memorial in Washington. She photographed visitors from different American states at the memorial which had quickly become a focus for the collective grief of the nation. Since the subjects remain anonymous and there are only isolated glimpses of the memorial itself, this series, originally conceived as a project about America and the war, may also be seen as a "work on the human capacity to mourn, which has a relevance beyond that of its original, concrete subject matter" (Thomas Weski).

The figures in the portraits appear moved, pensive, and entirely wrapped up in their own thoughts, scarcely aware of the photographer. Nevertheless, none of these pictures is made without the knowledge of the subject because, since 1981, Judith Joy Ross has been working with a large-format camera which can only be used with a tripod: its bulk and awkwardness by definition require close co-operation between photographer and subject.

In order to achieve the best possible quality of image, Ross makes contacts from the 8 x 10 inch negatives by printing them directly in sunlight and then tones them with gold to produce reddish-lavender print colors.

Ross's early output, her *Portraits of the United States Congress* (1986/87), and the portraits she has been making of children in public schools since 1992 have repeatedly been compared to the work of the German photographer August Sander. Although Ross herself cites Sander as a role model, her own work is much more open, both in form and content. While Sander photographed his subjects as representatives of a particular profession or social class, Ross is interested in her subjects in their own right and endeavors to do justice to their individuality by coming up with a unique photographic solution for each one.

US

Exhibitions (Selected)
1984 *Eurana Park, Weatherly, PA*, Allentown Art Museum (solo exhibition)
1985 *New Photography*, The Museum of Modern Art, New York
1987 *Portraits of the United States Congress*, Pennsylvania Academy of the Fine Arts, Philadelphia (solo exhibition)
1988 *Real Faces*, Whitney Museum of American Art, New York (cat.)

1990 *Photography Until Now*, The Museum of Modern Art, New York (tour/cat.)
1993 *New Work. Photographs by Judith Joy Ross*, San Francisco Museum of Modern Art (solo exhibition/cat.)
1995 *Warworks. Women, Photography and The Art of War*, Victoria and Albert Museum, London (tour/cat.)
1996 *Judith Joy Ross. Portraits*, Sprengel Museum Hannover (solo exhibition/cat.)
1997 *Judith Joy Ross. Retrospective*, Allentown Art Museum (solo exhibition)
1998 *Judith Joy Ross*, Pace Wildenstein MacGill, New York (solo exhibition)

Bibliography (Selected)
› *Judith Joy Ross*, Text by Vicki Goldberg, exh. cat., James Danziger Gallery, New York 1991.
› *New Work. Photographs by Judith Joy Ross,* Text by Sandra S. Phillips, exh. cat., San Francisco Museum of Modern Art 1993.
› Robert Adams, *Judith Joy Ross*, in: *Photographs from the Real World*, ed. by Dag Alveng, exh. cat., Lillehamer Art Museum 1993, S. 52.
› *Judith Joy Ross*, Text by Susan Kismaric, exh. cat., The Museum of Modern Art, New York 1995.
› *Judith Joy Ross. Portraits*, Text by Thomas Weski, exh. cat., Sprengel Museum Hannover 1996.

Thomas Ruff
1958 Zell am Hamersbach, Black Forest
lives in Düsseldorf

Portraiture is the red thread that runs through Thomas Ruff's photographic output. Since the early 1980s, starting in his student days at the Kunstakademie Düsseldorf (1977-1985) in the class of Professor Bernd Becher, Ruff has produced a variety of series exploring and experimenting with contemporary representations of individuals and their circumstances.

The representation of the people in his first portraits up until 1985 is not yet rigorouslyvdefined. Set against differently colored backgrounds, the subjects—mostly friends and acquaintances around the age of thirty from the art academy—are photographed in a mixture of profiles, three-quarters and front views.

In 1986 Ruff adopted a neutral, gray-white picture ground and started to enlarge his head-and-shoulders portraits on a precise scale of 3:1. At the same time he also laid down other lasting ground rules: a camera positioned at eye-level, a softly-lit subject, and a direct, emotionless gaze into the camera. Seen as a sequence, these shots with their neutral, objective style come together as a typology of anonymous faces that reveal nothing more than their physiognomies. In view of the ubiquity of photography in the media today, Ruff is realistic about the photographic act itself, contrasting the present with the past: "August Sander was optimistic in his estimation of the reality content of his photographs." Ruff himself sees his photographs "as the reality of an order that exists in its own right—at the same time pointing clearly to the fiction of objectivity in documentary photography" (Annelie Pohlen).

From 1988 onwards, while continuing to make portraits, Ruff also turned his attention to radically different pictorial subjects. With different origins and motivations, these images both unsettle their viewers and lay bare the artist's own questioning attitude to the medium of photography. For instance, he bought negatives of the night-sky from scientific research institutes and enlarged these (1989); over a period of years he reproduced pictures from a particular daily newspaper (1990); using a night-vision camera he photographed potential scenes-of-crime (1992), or, with equipment borrowed from the police, he constructed depersonalized composite portraits (1995).

For over a decade Ruff has pinned down his wide-ranging gaze in self-contained series. Far from indulging in narrative polemics, he simply draws attention to different things and lays them out before the viewer. His practice of grouping together the same or similar motifs supports his apparently nonjudgmental style of presentation. By this means he reduces subjective detail in individual pictures and at the same time legitimizes the series as such. "With calm matter-of-factness these portraits maintain their individuality—even within a series—just as unmistakably as do Josef Albers' squares" (Peter Sager).

As late as 1997, Ruff began citing elements from John Heartfield's propaganda collages in his ironic references to current affairs, but by 1999 he was resorting to a very different source for his *Nudes* series. The *Nudes* are taken from the small images found in pornographic web-sites. Ruff enlarges these using computer technol-

ogy until they are the size he normally exhibits, and accordingly unspecific. Bearing in mind the variety of subjects and themes the artist has addressed in recent years, it is perhaps surprising that in the late 1990s Ruff once again created a series of portraits of thirty year-olds, thereby returning to a subject that he had already dealt with ten years before.

TS

Exhibitions (Selected)
1981 Galerie Rüdiger Schöttle, Munich (solo exhibition)
1986 *Reste des Autenthischen*, Museum Folkwang, Essen (cat.)
1988 Portikus, Frankfurt (solo exhibition / cat.)
XLIII Biennale di Venezia, Venice (cat.)
1989 303 Gallery, New York (solo exhibition)
Portraits Häuser Sterne, Stedelijk Museum, Amsterdam (solo exhibition / tour / cat.)
1991 Bonner Kunstverein (solo exhibition / tour / cat.)
Metropolis, Martin-Gropius-Bau, Berlin (cat.)
Aus der Distanz, Kunstsammlung Nordrhein-Westfalen, Düsseldorf (cat.)
1992 *documenta IX*, Kassel (cat.)
Photography in contemporary german art. 1960 to the present, Walker Art Center, Minneapolis (tour / cat.)
1993 *Distanz und Nähe*, Neue Nationalgalerie, Berlin (tour / cat.)
Konstruktion Zitat. Kollektive Bilder in der Fotografie, Sprengel Museum Hannover (cat.)
1995 *XLVI Biennale di Venezia. Deutscher Pavillon*, Venice (solo exhibition / cat.)
1996 Rooseum—Center for Contemporary Art, Malmö (solo exhibition / cat.)
Silent & Violent, MAK Center for Art and Architecture, Los Angeles (cat.)
1997 *Thomas Ruff*, Centre Nationale de la Photographie, Paris (solo exhibition)
Young German Artists 2, Saatchi Gallery, London
1998 Gallery Koyanagi, Tokyo (solo exhibition)
1999 *Das Versprechen der Fotografie, Die Sammlung der DG Bank*, Kestner-Gesellschaft, Hanover (tour / cat.)
Galerie Johnen & Schöttle, Cologne (solo exhibition)

Bibliography (Selected)
› *Porträts*, exh. cat., Portikus, Frankfurt am Main 1988.
› *1. Deutscher Photopreis '89*, ed. by Landesgirokasse Stuttgart 1989.

› *Porträts Häuser Sterne*, exh. cat., Stedelijk Museum Amsterdam 1990.
› *Thomas Ruff*, ed. by Museum für Moderne Kunst Frankfurt, Text by Boris von Brauchitsch, Frankfurt 1992.
› *Andere Porträts + 3D*, Foreword by Jean-Christoph Ammann, exh. cat., Biennale Venedig, Ostfildern 1995.
› *Thomas Ruff*, exh. cat., Rooseum—Center for Contemporary Art, Malmö 1996.
› *Sterne & Häuser*, exh. cat., Museum Kurhaus, Kleve 1997.
› *Thomas Ruff*, Text by Regis Durand, exh. cat., Centre National de la Photographie Paris, Arles 1997.

Ed Ruscha

1937 Omaha, Nebraska
lives in Los Angeles, California

Ed Ruscha's work—witty and relaxed, playfully affirming the artificial, delighting in things as they are—strikes many as a reflection of the reality of Los Angeles which has been Ruscha's adopted home for the last 44 years. Ruscha grew up in Oklahoma City, a town with no artistic traditions. As a result the first visual influences on him as a young boy were home-made comics, his stamp collection, and the cinema, which still has a powerful fascination for him. At the age of 19, he moved to Los Angeles and enrolled at the Chouinard Art Institute, a well-known training ground for Disney animators. Impressed by painters like Robert Rauschenberg and Jasper Johns, his style of painting quickly changed from abstract expressionism to a matter-of-fact planarity, with signs, objects, and words as his subject matter. Working on canvas, he painted words like *Noise, Smash* and *Damage*, or a gas station with the word *Standard* emblazoned on it. He drew faceless bungalows and photographed the stuff of everyday life. He never had any interest in obvious meanings or ironic hyperbole; he was simply using visual found objects, including words, to explore the potential of optical effects, at the same time playing with the public's eagerness to interpret things: "For me, words were like flowers in a vase. I just happened to be painting words like other people painted flowers."

Besides making paintings and drawings, Ruscha's interest in things already reproduced and in isolated everyday objects has led him to produce many artist's books and editions in his private press. His first book, *Twentysix Gasoline Stations* (1962), illustrates nothing more and nothing less than the 26 gas stations along the road to his home town. Similarly, *Every Building on Sunset Strip* (1966)—which has since become a classic—consists of an eight-meter, concertina fold-out with the two sides of the famous Sunset Strip running along the top and bottom of the paper. It is made up of hundreds of individual shots pasted next to each other, identified only by house numbers and the names of the streets crossing the Strip. Every last garage, every last drive-in restaurant is there, every single one of the other buildings on the street, with no hierarchical variation. The same spirit inhabits other, similar artist's books such as *Thirtyfour Parking Lots in Los Angeles* (1967) and *A Few Palmtrees and Records* (both 1971).

Ed Ruscha, who quickly made a name for himself in the Los Angeles art scene, has continued to this day with diverse experiments involving words and trivial motifs. In the late 1960s he made his so-called *Liquid Paintings*, in which he used a variety of liquids instead of paint. As well as producing animal pictures or attempting to paint rays of light, Ruscha was constantly coming up with new ways of presenting words, word combinations or whole sentences, experimenting with different letter-sizes and backgrounds, and hinting at pictorial references.

An obvious source of inspiration for his work are the billboards found all over Los Angeles. Other important influences include his Catholic background with its many icons, and not least artists such as Kurt Schwitters, Marcel Duchamp, and René Magritte. Ruscha's work, considered typical of its Californian surroundings and diametrically opposed to the aggressive, ironic and, at times, loud pop art of Andy Warhol, has often been described as humorous and smart but also as provokingly passive for it rarely makes any kind of a statement. The critic Harold Rosenberg once called Ruscha's paintings "advertising art advertising itself as art that hates advertising." And one might say there is a similar contradiction in the curiously naked appearance of his work with its unabashed emptiness and lack of content, which has one overriding feature: it does not allow the viewer to remain passive.

MF

Exhibitions (Selected)

1960 *Four Oklahoma Artists*, Oklahoma City Art Center

1963 Ferus Gallery, Los Angeles (solo exhibition)
Pop Art USA, Oakland Art Museum (cat.)

1968 Galerie Rudolf Zwirner, Cologne (solo exhibition)

1970 *Information*, The Museum of Modern Art, New York (cat.)

1972 *Drawings*, Leo Castelli Gallery, New York (solo exhibition)
USA West Coast, Hamburger Kunstverein (tour / cat.)

1974 *American Pop Art*, Whitney Museum of American Art, New York (cat.)

1975 *Prints and Publications 1962–1974*, Art Council of Great Britain, London (solo exhibition / tour / cat.)

1976 Institute of Contemporary Arts, London (solo exhibition)

1979 Halle für internationale Kunst, Zurich (solo exhibition / cat.)

1982 *The Works of Edward Ruscha*, San Francisco Museum of Modern Art (solo exhibition / tour / cat.)

1986 *4 x 6. Zeichnungen von Edward Ruscha*, Westfälischer Kunstverein Münster (solo exhibition / cat.)

1987 *Whitney Biennial*, Whitney Museum of American Art, New York (cat.)

1989 *Paintings*, Musée National d'Art Moderne, Centre Georges Pompidou, Paris (solo exhibition / tour / cat.)

1990 *Los Angeles Apartments 1965*, Whitney Museum of American Art, New York (solo exhibition / cat.)

1993 *Romance with Liquids*, Gagosian Gallery, New York (solo exhibition / cat.)

1999 *The Complete Editions*, Walker Art Center, Minneapolis (solo exhibition / cat.)
Grosse Illusionen. Demand, Gursky, Ruscha, Kunstmuseum Bonn (tour / cat.)

Bibliography (Selected)

› *Twentysix Gasoline Stations*, 1963.
› *Every Building on the Sunset Strip*, 1966.
› *Thirtyfour Parking Lots in Los Angeles*, 1967.
› *Nine Swimming Pools and a Broken Glass*, 1968.
› *A Few Palm Trees*, 1971.
› *The Works of Edward Ruscha*, ed. by Dave Hickey, New York / San Francisco 1982.
› *Paintings*, Texts by Dan Cameron, Pontus Hulten et al., exh. cat., Museum Boymans-van Beuningen, Rotterdam 1990.
› *Romance with Liquids*, exh. cat., Gagosian Gallery, New York 1993.
› *Editions 1959–1999*, Texts by Siri Engberg and Clive Phillpot, exh. cat., Walker Art Center, Chicago 1999.
› *Grosse Illusionen. Thomas Demand, Andreas Gursky, Edward Ruscha*, Texts by Stefan Gronert, Diedrich Diederichsen et al., exh. cat., Kunstmuseum Bonn, Cologne 1999.

August Sander

1876 Herdorf
1964 Cologne

Having moved from Linz an der Donau to Cologne in 1910, August Sander had to acquire another source of income besides his commercial photography studio. At the weekends he therefore traveled with his heavy plate camera out into the Westerwald in order to make portraits of the people living in his own home territory. Up until 1914 Sander participated successfully in a number of photography competitions, generally submitting "art photography" using a variety of special print processes. From the early 1920s, through his close contacts with the artists of the "Kölner Progressiven" group, he reassessed his photography so far. Encouraged by the painter Franz W. Seiwert, August Sander now enlarged his prints on photo paper that produced relatively strong contrasts, and devised a complex structure for his ultimately unfinished social portrait, *Menschen des 20. Jahrhunderts (Man in the 20th Century)*. This "cultural work in photographs" (Sander), divided into seven sections and arranged according to class, was to comprise 45 folios. The starting point is the so-called "root folio" consisting of 12 images of rural "archetypes." With one exception, it contains portraits taken between 1910 and 1914. The project spans an arc from *Peasants* and *Craftsmen* to *Woman, Classes, Artists*, the *City*, and finally the *Last People*. Through the interplay of the individual pictures, the people portrayed in them stand as representatives of different trades and professions and hierarchies, providing the material for a detailed analysis of society during the Weimar Republic. Sander's immense undertaking was helped by the fact that right from the outset he had an understanding of life both rural and urban, and was all the while striving to achieve a symbiosis between his business and artistic activities.

Two years after a major solo exhibition of portraits in the Kölnischer Kunstverein in 1927, almost as a preview of his vast cultural history project, he published his first book, *Antlitz der Zeit (Face of Our Time)*, with 60 representative photographs and an introduction by Alfred Döblin. The printing plates were destroyed in 1934 by the Nazis, who took umbrage at his formulaic image of society. To this day *Antlitz der Zeit* joins *Die Welt ist schön (The World is Beautiful)* by Albert Renger-Patzsch and *Art Forms in Nature* by Karl Blossfeldt in being regarded as crucial to the development of the New Objectivity as a photographic style.

With the outbreak of the Second World War, August Sander set about saving his negative plates from anticipated air raids. In 1939 he moved ever further away from Cologne until he was in the heart of the Westerwald and able to safely store 10,000 of his most valuable negatives. Another 30,000 were destroyed in a fire in his city apartment in 1946. In 1953, the City of Cologne bought his sequence of 16 folios, *Köln wie es war (Cologne as it was)*, containing over 400 of Sander's original pre-war photographs.

It was not until after his death in 1964 that his oeuvre came to the notice of a wider public. Publications appeared which presented the full thematic spectrum of Sander's work, such as the largely unknown *Rheinlandschaften* (1975, *Rhine Landscapes*); there was also a first attempt to reconstruct *Menschen des 20. Jahrhunderts* (1980), and in 1988 the volume *Köln wie es war* was published. Today the August Sander Archive in Cologne, under the auspices of the SK Stiftung Kultur, is working on the photographer's estate.

TS

Exhibitions (Selected)

1927 Kölnischer Kunstverein

1951 *photokina*, Cologne

1956 *August Sander, Alvarez Bravo, Walker Evans und Paul Strand,* The Museum of Modern Art, New York

1959 *Gestalten seiner Zeit*, Deutsche Gesellschaft für Photographie, Cologne (solo exhibition)

1973 Sonnabend Gallery, New York (solo exhibition)

1976 The Art Institute of Chicago, Illinois (solo exhibition)
Menschen des 20. Jahrhunderts, Kölnischer Kunstverein (solo exhibition)

1977 *Menschen ohne Maske*, Kunstgewerbemuseum, Zurich

1980 *August Sander. Bernd und Hilla Becher*, Permanent Mission of the Federal Republic of Germany, Berlin/East

Photographs of an Epoch 1904–1959, Philadelphia Museum of Art (solo exhibition)

1981 *Menschen des 20. Jahrhunderts*, Hochschule für Graphik und Buchkunst, Leipzig (solo exhibition)

1994 *In der Photographie gibt es keine ungeklärten Schatten*, Pushkin Museum, Moscow (solo exhibition/tour/cat.)

1995 *Köln wie es war*, Kölnisches Stadtmuseum (solo exhibition/cat.)

1997 *Vergleichende Konzeptionen*, Die Photographische Sammlung/SK Stiftung Kultur, Cologne (tour/cat.)

1999 *Landschaften,* Die Photographische Sammlung/SK Stiftung Kultur, Cologne (solo exhibition/tour/cat.)

2000 *Zeitgenossen. August Sander und die Kunstszene der zwanziger Jahre im Rheinland*, Josef-Haubrich-Kunsthalle, Cologne (tour)

Bibliography (Selected)

› *Antlitz der Zeit*, Introduction by Alfred Döblin, Munich 1929.

› *Deutschenspiegel. Menschen des 20. Jahrhunderts*, Introduction by Heinrich Lützelar, Gütersloh 1962.

› *Rheinlandschaften. Photographien 1929–1946*, Text by Wolfgang Kemp, Munich 1975.

› *Menschen des 20. Jahrhunderts. Portraitphotographien 1892–1952*, Text by Ulrich Keller, Munich 1980.

› *Cologne wie es war. August Sander Werkausgabe*, ed. by Kölnisches Stadtmuseum, August Sander Archiv and Kulturstiftung Stadtsparkasse Köln, Texts by Susanne Lange and Christoph Kim, Amsterdam 1995.

› *Eine Reise nach Sardinien. Fotografien 1927*, ed. by Ann and Jürgen Wilde, and Thomas Weski, Text by Susanne Lange, exh. cat., Sprengel Museum Hannover 1995.

› *August Sander. 1876–1964*, ed. by Manfred Heiting, Text by Susanne Lange, Cologne 1999.

› *Zeitgenossen. August Sander und die Kunstszene der zwanziger Jahre im Rheinland*, Texts by Anne Gantefübrer, exh. cat., Die Photographische Sammlung/SK Stiftung Kultur, Cologne 2000.

Michael Schmidt

1945 Berlin

lives in Berlin

Michael Schmidt's artistic position has regional, national and international dimensions. The visual impulses for his early photographic ventures and for his exhibition and book, *Waffenruhe* (1985–1987, *Ceasefire*), all came to the artist in his native Berlin. After re-unification in 1989, he produced large-scale works such as *Ein-heit* (1991–1994, *U-ni-ty*) and *Frauen* (1997–1999, *Women*), drawing on places both within and beyond his own home territory.

In 1973, Schmidt—a self-taught photographer—made an important decision, namely to resign from the police force in order to concentrate on his artistic activities. Deeply affected by his parents' moving in the 1950s from West to East Berlin and back again, his early projects already show his sensitivity to history as it impinges on individual lives. In his books *Berlin Kreuzberg* (1973), *Berlin Wedding* (1978), and *Berlin. Stadtlandschaften* (1978, *Berlin. Cityscapes*) he presented a broad spectrum of unprettified portraits and unspectacular architectural views. Taken as a whole, these photographic sequences comprise a self-contained picture of West Berlin that communicates what it was like to live in that divided city.

While working on his photographic projects, Michael Schmidt became the co-founder and director of the Werkstatt für Fotografie in the Volkshochschule Kreuzberg in 1976. His instruction there included (advanced) training in photography, which, far from having anything to do with academic qualifications, was open to all comers. Keen to exchange views and experiences with colleagues who—like Walker Evans and Eugène Atget before them—were pursuing the path of purely illustrative photography, he invited photographers such as Robert Adams, Lewis Baltz, and William Eggleston to participate in exhibitions and workshop discussions. Schmidt thereby acted as a transatlantic link, generating and fostering mutual exchange both in Germany and abroad.

In 1987, the exhibition *Waffenruhe*, conceived together with the Berlinische Galerie, exploded hitherto accepted notions of photography, for in it viewers were confronted with a new, unsettling style of pictorial focus. Powerfully subjective views of concrete and undergrowth, raw flashlight portraits of punks and nationalist graffiti combine to create a traumatic sequence of images. The demarcation line of the Berlin Wall was the grim photographic stimulus, with its individual elements coming under the photographer's scrutiny. "Gray is my color" was Schmidt's own comment on himself and the direction of his pictures. According to his concept of photography, the people and places he portrays come second to his "search for his own position" (Ulf Erdmann Ziegler).

In the project *Ein-heit* Schmidt further intensified the way he combines historical props. Created between 1991–94, it was first seen the following year in an exhibition at the Museum of Modern Art in New York, the first solo exhibition by a German artist in this museum for many decades. In a sequence of over 160 prints, Michael Schmidt combined portraits and landscapes of his own with photographic items from our collective memory. Newspaper photos, pictures from private albums, business publications, and company reports are integrated in *Ein-heit* in a manner that is as complex as it is restrained. This leads the viewer to make visual associations which can only be worked through by means of a process of individual sorting and evaluating. In the series, *Frauen*, specially created for the present exhibition, *How you look at it*, Schmidt focuses on women from the age of 18 to their late twenties. Portraits, views of unclothed bodies, and glimpses of items of clothing are the raw material for the analysis of a phase in life when women are still in search of themselves. Thus the pictures point far beyond the individuals portrayed in them and, as is always the case in Schmidt's work, may be understood as an image (plus commentary) of their own time.

TS

Exhibitions (Selected)

1973 *Kreuzberger Motive*, Berlin Museum (solo exhibition)

1975 Galerie Springer, Berlin (solo exhibition)

1978 *Berlin Wedding*, Rathaus Wedding (solo exhibition)

1979 *In Deutschland*, Rheinisches Landesmuseum Bonn (cat.)

1980 *Absage an das Einzelbild*, Museum Folkwang, Essen (cat.)

1981 *Stadtlandschaften*, Museum Folkwang, Essen (solo exhibition)

1982 *Berlin fotografisch*, Berlinische Galerie

1986 *Reste des Authentischen*, Museum Folkwang, Essen (cat.)

1987	*Bilder 1979–1986,* Spectrum Photogalerie, Sprengel Museum Hannover (solo exhibition / cat.)
	Waffenruhe, Berlinische Galerie (solo exhibition / tour / cat.)
1989	*Photography Until Now*, The Museum of Modern Art, New York (tour / cat.)
1992	*Mehr als ein Bild*, Sprengel Museum Hannover
1994	*Industriefotografie heute*, Neue Pinakothek, Munich (cat.)
1995	*Fotografien seit 1965*, Museum Folkwang, Essen (solo exhibition / tour / cat.)
	U-ni-ty, The Museum of Modern Art, New York (solo exhibition / tour / cat.)
1997	*Positionen künstlerischer Fotografie in Deutschland seit 1945*, Berlinische Galerie (cat.)
1998	*Landschaft –Waffenruhe –Selbst –Menschenbilder (Ausschnitte)*, Westfälischer Kunstverein, Münster (solo exhibition / cat.)
1999	*Michael Schmidt. Fotoarbeiten aus der Sammlung Bernd F. Künne*, Kunsthalle Bremen (solo exhibition / cat.)

Bibliography (Selected)
› *Berlin Kreuzberg*, Foreword by Friedrich Voss, Berlin 1973.
› *Stadtlandschaften und Menschen. Berlin-Wedding*, Foreword by Horst Bowitz, Introduction by Heinz Ohff, Berlin 1978.
› *Stadtlandschaften 1981*, Essen 1981.
› *Berlin–Kreuzberg. Stadtbilder*, Berlin 1984.
› *Bilder 1979–1986*, Text by Dieter Hacker, exh. cat., Spectrum Photogalerie, Sprengel Museum Hannover 1987.
› *Waffenruhe*, Text by Einar Schleef, Berlin 1987.
› *Fotoprojekt 9*, ed. by Siemens AG, Text by Thomas Weski, Essen 1990.
› *Fotografien seit 1965*, ed. by Ute Eskildsen, exh. cat., Museum Folkwang, Essen 1995.
› *Ein-heit*, ed. by Thomas Weski, Zurich 1996.
› *Landschaft –Waffenruhe –Selbst –Menschenbilder (Ausschnitte)*, Texts by Heinz Liesbrock and Susanne Meyer-Büser, exh. cat., Westfälischer Kunstverein, Münster 1999.

Charles Sheeler

1883 Philadelphia, Pennsylvania
1965 Dobbs Ferry, New York

Charles Sheeler is regarded as one of the few North American artists who were equally influential in painting and photography. While Sheeler's cool, seemingly stylized paintings of industrial sites, architectural views, and machines may be classified as American Precisionism, his exact, unmanipulated photographs of similar motifs established his reputation around 1917 as one of the first exponents of "straight photography." Sheeler exploited photography for its commercial potential, as an artistic means in its own right, and as a basis for his own drawings and paintings.

After three years at the School of Industrial Art in Philadelphia, Sheeler studied painting from 1903 to 1906 under William Merritt Chase at the Pennsylvania Academy of the Fine Arts. In 1909, on his third trip to Europe, he was confronted with works by Cézanne, Picasso, and Braque, and for the first time engaged with the formal language of the French Cubists, which was to have a decisive effect on his artistic development. Around 1910 Sheeler started to work as an architectural photographer in Philadelphia in order to earn a living. In addition he also made a name for himself with his sensitive, coolly accurate photographs of artworks, and from 1916 he worked as a photographer for leading museums, galleries, artists, and collectors.

In early 1917 the New York Modern Gallery showed an exhibition of *Photographs by Sheeler, Strand, and Schamberg*, and a few months later put on Sheeler's first solo exhibition, which established the 34 year-old painter's reputation as a photographer as well. At the heart of this presentation was the series *Doylestown House*. It was made in 1917 in Pennsylvania in a plain country house from the 18th century, which Sheeler had been using as a studio and weekend house since 1910. The rigorously formal yet intimate interior shots of the house are notable for their carefully calculated treatment of light and line. These images draw not only on Sheeler's experience as an architectural photographer but also on his intense study of the formal principles of Cubist painting.

At around the same time, in the rural surroundings of Doylestown, Sheeler made individual shots of the simple barns that were typical of that area, as in *Side of White Barn* (1917), which is regarded as an early exam-

ple of straight photography and has become one of his best known works.

Between 1915 and 1922, Sheeler's approach to photography was much affected by the influential American photographer Alfred Stieglitz. A few months after moving from Philadelphia to New York, Sheeler and Paul Strand—who also admired Stieglitz's work—made the six-and-a-half minute silent film *Manhatta* (1920). This was an avant-garde film showing the dynamism of city life in the financial quarters of Lower Manhattan, shot from the same extreme angles that are characteristic of the photographs of New York that Sheeler was making at the time.

Between 1926 and 1929 Sheeler worked as a fashion photographer and portraitist for the journals *Vogue* and *Vanity Fair* and for various advertising agencies. It was in this connection that he made a 32-photograph documentation of the newly built River Rouge Plant near Detroit in late 1927, in response to a commission from its owners, the Ford Motor Company. At the time this was the biggest industrial complex in the world. As in the *Doylestown House* series, Sheeler first shows the factory in its entirety before approaching the different groups of buildings more closely and photographing details of the inside of the factory. The resulting photographs demonstrate Sheeler's interest in using photographic means to reduce complex structures to clear, geometric forms, and—as he himself said—"to capture the immediate facts as accurately as possible." These purist advertising shots for the automobile maker were soon being published in numerous international art journals and have become some of the most widely published industrial photographs of the 20th century.

Although Charles Sheeler worked for three years as a photographer at the Metropolitan Museum of Art in New York during the Second World War and continued to take photographs until 1959, from the early 1930s onwards his creative work centered mainly on painting rather than photography—just as it had done at the outset of his career.

US

Exhibitions (Selected)

1908 McClees Gallery, Philadelphia (solo exhibition)
William Macbeth Gallery, New York
1913 Armory Show, New York
1916 *Forum Exhibition of Modern American Painters*, New York (cat.)
1917 *Photographs by Sheeler, Strand and Schamberg*, Modern Gallery, New York
Modern Gallery, New York (solo exhibition)
1922 Daniel Gallery, New York (solo exhibition)
1929 *Film und Foto*, Städtische Ausstellungshallen, Stuttgart (cat.)
1931 Edith Halpert's Downtown Gallery, New York (solo exhibition)
Julien Levy Gallery, New York (solo exhibition)
1932 *Murals by American Painters and Photographers*, The Museum of Modern Art, New York
1939 *Charles Sheeler: Paintings, Drawings, Photographs*, The Museum of Modern Art, New York (solo exhibition/cat.)
1954 *Charles Sheeler. A Retrospective Exhibition*, Art Galleries, University of California, Los Angeles (solo exhibition/cat.)
1961 Allentown Art Museum, Pennsylvania (solo exhibition)
1977 *documenta VI*, Kassel (cat.)
1982 *Fotografie 1922–1982. Dialog der jungen Generation. photokina*, Cologne (cat.)
1987 *Charles Sheeler: Paintings, Drawings, Photographs*, Museum of Fine Arts, Boston (solo exhibition/tour/cat.)
1997 *Charles Sheeler in Doylestown: American Modernism and the Pennsylvania Tradition*, Allentown Art Museum (solo exhibition/cat.)
1999 *Native Modern: Charles Sheeler and Precisionism*, San Francisco Museum of Modern Art (solo exhibition)

Bibliography (Selected)
› Constance Rourke, *Charles Sheeler. Artist in the American Tradition*, New York 1938.
› *Charles Sheeler. Paintings, Drawings, Photographs*, exh. cat., The Museum of Modern Art, New York 1939.
› *Charles Sheeler. A Retrospective Exhibition*, Texts by Frederick S. Wight et al., exh. cat., Art Galleries, University of California, Los Angeles 1954.
› *Charles Sheeler*, Texts by Martin Friedman, Bartlett Hayes et al., exh. cat., Smithsonian Institution, Washington 1968.
› *Charles Sheeler: The Photographs*, Texts by Theodore E. Stebbins and Norman Keyes, exh. cat., Museum of Fine Arts, Boston 1987.
› *Charles Sheeler: The Paintings*, Texts by Carol Troyen and Erica E. Hirshler, exh. cat., Museum of Fine Arts, Boston 1987.
› Karen Lucic, *Charles Sheeler and the Cult of the Machine,* London 1991.

> *Charles Sheeler in Doylestown: American Modernism and the Pennsylvania Tradition*, Text by Karen Lucic, exh. cat., Allentown Art Museum 1997.

Cindy Sherman
1954 Glen Ridge, New Jersey
lives in New York

Up until 1990 photographic mise-en-scènes (with herself as the sitter) and fictional role playing were the core of Cindy Sherman's artistic work. Her themes and motifs were generally drawn from the mass media.

She became known in the early 1980s for her series *Untitled Film Stills* (1977–1980) which she made in Buffalo shortly after having completed her studies in painting and photography at the State University, City of New York in Buffalo. The 69 small-format, black-and-white photographs in this series are reminiscent of stills from films in the 1950s and early 1960s. They show Sherman in various guises playing different women, whose appearance, gestures, and facial expressions recall the stereotypical representations of women in those films. Although Cindy Sherman is not only the photographer, but also the director and protagonist in these painstaking scenarios, they are not self-portraits. She is simply using her own body as "material […] in order to illustrate personified feelings" (Sherman), in other words, as a model to portray the constructions of femininity purveyed by the mass media.

In 1980 Sherman started to use color photography and larger picture formats. In 1981, in response to a commission for a double-page spread in the journal *Artforum*, she produced a number of extremely long, horizontal color photographs for the series *Centerfolds*, in which Sherman herself poses, generally lying down in her studio, in the style of the foldouts in men's magazines. The female figures, filling the entire image, have an introspective air about them and seem to be less stereotyped than those in the *Untitled Film Stills*. In this series Sherman does without extravagant backgrounds and props, concentrating instead on atmospheric light effects and the frequently ambiguous facial expressions of the women she is playing. As she herself said in 1996 on the subject of these early works: "I conceived the

pictures as though something had just happened or was just about to happen in the next moment. The situation that I am presenting remains unclear. […] I encourage people to read something into it, and at the same time I reject simplistic interpretations."

Since the early 1980s, when Sherman's work was to be seen virtually simultaneously at the *documenta* and at the Biennials in Venice, New York, and Sydney, her photographs have been a focus of much art-historical debate, be it in discussions with a post-modernist, a feminist or even a psychoanalytical slant (to name but a few). Sherman, who titles all of her works with continuous numbers, has persistently distanced herself from any such attempts at interpretation and has repeatedly drawn attention to the openness of her photographic output.

In 1985 she started to work increasingly with masks, dolls, and fake body-parts, whose artificiality she openly exposes to view in her photographs. She no longer exclusively photographed herself in female roles and over the next years gradually abandoned the notion of using herself as a model.

Sherman was now drawing her inspiration for the ever more grotesque and gruesome appearance of her series from fairy tales (*Fairy Tales, Desasters,* 1985–1988), from portraiture in paintings (*History Portraits*, 1988–1990), pornographic pictures (*Sex Pictures*, since 1992), or horror films (*Horror Pictures*, 1995). Once again she undermines the imagery of the mass media in these works, radically confounding viewers' expectations and using her photographs as subversive "visual traps" (Wilfried Dickhoff).

Having produced the horror film, *Office Killer*, in 1997, Sherman returned to black-and-white photography two years later, making coarse-grained images of monstrously deformed dolls, which bring to mind the surreal photographs of Hans Bellmer and others. As Sherman herself said in an interview in 1999, these most recent works are again "about fear and death, about ugliness as opposed to beauty, about sexuality."

US

Exhibitions (Selected)
1979 Hallwalls, Buffalo, New York (solo exhibition)
1980 Contemporary Arts Museum, Houston (solo exhibition/cat.)
Metro Pictures, New York (solo exhibition)
1982 *documenta VII*, Kassel (cat.)

XL Biennale di Venezia, Venice (cat.)

Stedelijk Museum, Amsterdam (solo exhibition / tour / cat.)

1983 *Biennial Exhibition*, Whitney Museum of American Art, New York (cat.)

1984 Akron Art Museum (solo exhibition / tour / cat.)
Monika Sprüth Galerie, Cologne (solo exhibition)
5th Biennial of Sydney, Art Gallery of New South Wales, Sydney (cat.)

1985 *Cindy Sherman – Photographien*, Westfälischer Kunstverein, Münster (solo exhibition / cat.)

1987 Whitney Museum of American Art, New York (solo exhibition / tour / cat.)

1990 *Photography Until Now*, The Museum of Modern Art, New York (tour / cat.)

1994 *Cindy Sherman. Photoarbeiten 1975–1995*, Deichtorhallen, Hamburg (solo exhibition / tour / cat.)

1996 Museum Boymans-van Beuningen, Rotterdam (solo exhibition / tour / cat.)

1997 *Cindy Sherman. Wolfgang Hahn-Preisträgerin 1997*, Museum Ludwig, Köln

1999 *Cindy Sherman. Kaiserringträgerin der Stadt Goslar*, Mönchehaus Museum, Goslar (solo exhibition)
Cindy Sherman, The Museum of Contemporary Art, Los Angeles (solo exhibition / tour)

2000 *Cindy Sherman. Hasselblad Award Winner 1999*, Göteborg Museum of Art (solo exhibition / cat.)

Bibliography (Selected)

› *Cindy Sherman*, exh. cat., Contemporary Arts Museum, Houston 1980.
› *Cindy Sherman. Photographien*, Text by Marianne Stockebrand, exh. cat., Westfälischer Kunstverein, Münster 1985.
› *Cindy Sherman*, Texts by Els Barents and Peter Schjeldahl, 3rd edition (enlarged), Munich 1987.
› *Cindy Sherman. Untitled Film Stills*, Text by Arthur C. Danto, Munich 1990.
› *Cindy Sherman. History Portraits*, Text by Arthur C. Danto, Munich 1991.
› *Specimens*, ed. by Edit deAk ArTRANDOM, Kyoto 1991.
› *Cindy Sherman*, Texts by Thomas Kellein and Carla Schulz-Hoffmann, exh. cat., Kunsthalle Basel 1991.
› *Cindy Sherman. Arbeiten von 1975 bis 1993*, Texts by Rosalind Krauss and Norman Bryson, New York / Munich 1993.
› *Cindy Sherman*, ed. by Gisela Neven DuMont and Wilfried Dickhoff, Cologne 1995.
› *Cindy Sherman*, exh. cat., Museum Boymans-van Beuningen, Rotterdam 1996.

Stephen Shore

1947 New York
lives in Tivoli, New York

In the early 1970s Stephen Shore, William Eggleston, and Joel Meyerowitz—working quite independently of each other—were amongst the first American photographers to discover the potential of color photography as a means of artistic expression. Shore's work soon became known through exhibitions and publications, and he did much to raise the status of color photography, viewed by such influential art photographers as Walker Evans as "vulgar" and, for a long time, restricted almost exclusively to more practical areas like journalism and advertising.

Having already experimented in the darkroom at the age of six, he already starting taking photographs three years later. In 1961 Edward Steichen bought three pictures from the fourteen-year-old for the photographic collection of the Museum of Modern Art in New York. In the mid-60s, self-taught photographer Shore met Andy Warhol and produced numerous black-and-white prints in Warhol's Factory between 1965-67. These were first published in the late 1960s in a catalog about Andy Warhol. Stephen Shore's early success and his reputation as a "photographic boy wonder" (James L. Enyeart) were then confirmed by an exhibition at the Metropolitan Museum of Art in New York in 1971, which was the museum's first solo exhibition devoted to a living photographer.

At the age of 25, having grown up entirely in New York (and having recently started to work with color photography), Stephen Shore set out on his first extended trip by car. This lasted several weeks and took him through the backwoods and small towns of rural America, as far as Amarillo, Texas.

In his monograph *Uncommon Places* (1982), with 49 color pictures taken between 1973 and 1981 on journeys through North America, Shore describes how his "first view of America was framed by the passenger's window": it was a "shock" to him and the journey seemed to him to be going through "a flat nowhere

piece of the world." This first impression still seems to be reflected in many of his later, unspectacular shots of crossroads, filling stations, shopping centers or anonymous suburban housing, which Thomas Wagner has described as "topographies of the nameless and sensationless everyday."

Heinz Liesbrock has pointed out that "in his receptivity to the allure of everyday forms and their fleeting representation, as they appeared in pop art and conceptual art of the 1960s, […] he is decidedly a photographer of our time." His exploration of the American way of life, however, also recalls the 1930s photography of Walker Evans, whom Shore regards as a kindred spirit.

In 1972, on his trip to New Mexico, when he created his diary-like series *American Surfaces*, he was still using a small-format camera to capture momentary visual impressions, but since 1974 he has been using a camera with plates measuring 8 x 10 inches. He then presents the results in the form of contact prints, that is to say, as direct positive copies of the color negatives, which are remarkable for their unusually high level of detail. The peculiar fascination that radiates from many of his pictures is also due to the intense light and, at times, almost artificial-seeming colors, which are in themselves important aspects of Shore's vision as a photographer.

It is only on closer examination that his pictures also reveal his preference for a balanced pictorial structure, with a particular emphasis on verticals and horizontals and a pronounced interest in formal structures. Many of his pictures even seem like stage sets, where apparently isolated human beings look like actors playing walk-on parts.

In his volume of essays, *The Nature of Photographs* (1998), Shore vividly describes his self-image as a photographer: "Outside the controlled confines of the studio, a photographer is confronted with a complex web of visual juxtapositions that realign themselves with each step. […] In bringing order to this situation, a photographer solves a picture, more than composes one." This approach to the image and the results it has produced link Stephen Shore to Robert Adams, Lewis Baltz, and other participants in the exhibition *New Topographics* of 1975, establishing him as one of the leading American exponents of modern topographic photography.

Around 1980, when Shore lived for a considerable time in Montana, Texas, urban space became less important

to him as a motif and he started to make very much reduced images of the landscape. Since 1982, Stephen Shore has been teaching photography at Bard College in New York State.

US

Exhibitions (Selected)
1970 *Foto-Portret*, Haags Gemeentemuseum, Den Haag (cat.)
1971 The Metropolitan Museum of Art, New York (solo exhibition)
1972 Light Gallery, New York (solo exhibition)
1975 *New Topographics. Photographs of a Man-Altered Landscape*, George Eastman House, Rochester (tour/cat.)
 Galerie Schürmann und Kicken, Aachen (solo exhibition)
1976 The Museum of Modern Art, New York (solo exhibition)
1977 Kunsthalle Düsseldorf (solo exhibition/cat.)
 documenta VI, Kassel (cat.)
 American Photographers, Fotogalerie im Forum Stadtpark, Graz (tour/cat.)
1978 *Amerikanische Landschaftsphotographie 1860–1978*, Neue Sammlung, Munich (cat.)
 Mirrors and Windows. American Photography since 1960, The Museum of Modern Art, New York (tour/cat.)
1981 John and Mable Ringling Museum of Art, Sarasota, Florida (solo exhibition)
 The New Color, International Center of Photography, New York (tour/cat.)
1982 *Counterparts*, The Metropolitan Museum of Art, New York (tour/cat.)
1984 Art Institute of Chicago (solo exhibition)
1985 Center for Creative Photography, Tucson (solo exhibition)
1991 *The Pleasures and Terrors of Domestic Comfort*, The Museum of Modern Art, New York (tour/cat.)
1992 J. Paul Getty Museum, Malibu (solo exhibition)
1994 *Stephen Shore. Fotografien 1973 bis 1993*, Westfälischer Kunstverein, Münster (solo exhibition/tour/cat.)
1997 Nederlands Foto Instituut, Rotterdam (solo exhibition)
1999 *Stephen Shore. American Surfaces 1972*, Photographische Sammlung/SK Stiftung Kultur, Cologne (solo exhibition/tour/cat.)

Bibliographie (Selected)
› *Andy Warhol*, photographs by Stephen Shore et al., exh. cat., Moderna Museet, Stockholm 1968.
› *Uncommon Places*, Text by Stephen Shore, New York 1982.

› *The Gardens at Giverny. A View of Monet's World by Stephen Shore*, Introduction by John Rewald, Texts by Gerald van der Kemp and Daniel Wildenstein, New York 1983.

› *Stephen Shore. Fotografien 1973 bis 1993*, Texts by Heinz Liesbrock, Thomas Weski et al., exh. cat., Westfälischer Kunstverein Münster, Munich 1994.

› *The Velvet Years. Warhol's Factory 1965–67*, Text by Lynne Tillman, London 1995.

› *The Nature of Photographs*, Essays by Stephen Shore, Baltimore 1998.

› *Stephen Shore. American Surfaces 1972*, exh. cat., Photographische Sammlung/SK Stiftung Kultur, Cologne, Munich 1999.

Paul Strand

1890 New York

1976 Orgeval/France

More than any other American photographer of his day, Paul Strand shook off the fetters of "art photography." Up until the turn of the century it had been considered "artistic" to produce out-of-focus, romantically colored photography, which still owed much to painting. Paul Strand, on the other hand, in response to increasing industrialization, set out to come up with a pictorial language that better suited the age. Nowadays pictures such as *Wall Street* (1915), *Blind Woman* (1916) and *White Fence* (1916) are regarded as icons of modernist image-making.

Strand was born in 1890, the son of middle-class Jewish immigrants in New York. In 1904 his parents sent him to the Ethical Culture School, which pursued the declared intention of encouraging the integration of its pupils into American society. In 1909, through the photographer Lewis Hine, who was teaching at the school, Strand had his first contact with photography and, as part of his art lessons, visited well-known private galleries in New York. He soon lost any inhibitions when it came to making contact with famous artistic personalities, including "photo secessionists" Gertrude Käsebier or Alfred Stieglitz, who was exhibiting American and European avant-garde artists such as Marcel Duchamp and Francis Picabia in his gallery 291.

Strand became friends with Charles Sheeler; the two exhibited their work together and in the early 1920s they made the short film, *Manhatta* (1921).

At the same time Strand and Stieglitz became increasingly close, the latter having already been active for several years as a photographer, gallerist, and editor of the journal *Camera Work*. Stieglitz, a generation older than Strand, recognized and encouraged the talent of the younger man, publishing lengthy pictorial sequences in two issues of *Camera Work*, in October 1916 and June 1917, as well as putting on an equally successful solo exhibition of Strand's work. The images of New York presented here touched a nerve at the time. For Paul Strand and other like-minded artists, "city" and "culture" were symbols of the energy and optimism of industrialization. "Perceiving the city not only as an extraordinarily vibrant commercial center, this group—in the spirit of Walt Whitman—elevated New York's architecture, tempo, and cultural life to a spiritual plane" (Naomi Rosenblum).

In the 1920s Strand maintained his artistic autonomy by working as a cameraman for advertising spots and as a set photographer in the film industry. After the friendly contact between himself and Stieglitz had fallen apart in the late 1920s, and the film business had moved to the West Coast, Strand spent a number of years in Mexico, making his living through state-financed film projects. In 1943 he returned to New York and once again turned to photography. Following an exhibition at the Museum of Modern Art in New York (1945), he brought out his first book with Nancy Newhall in 1950, *Time in New England*, a photographic inventory combining architectural and portrait photography. His dissatisfaction with the way this volume was printed meant that he watched carefully over the entire production process in subsequent publications.

During the 1950s Strand changed his working methods and from then on only had prints enlarged for publication purposes and by assistants. By the time he died in 1976, he had published books on his journeys to Sicily, the Hebrides, Egypt, Ghana, and Romania, always focusing on the essence of the landscape, the inhabitants, and the architecture of the country in question. His images of plants from his garden in Orgeval/France (1973), where he lived for nearly twenty years, are the legacy of an artist constantly in search of formal perfection.

TS

Bibliography (Selected)

› *Camera Work*, New York, October 1916.

› *Camera Work*, New York, June 1917.

› *Photographs of Mexico*, Foreword by Leo Hurwitz, New York 1940.

› *Time in New England*, Texts selected by Nancy Newhall, New York/Oxford 1950.

› *Un Paese*, Text by Cesare Zavattini, Turin 1955.

› *Tir a'Mhurain*, Text by Basil Davidson, Dresden 1962.

› *Living Egypt*, Text by James Aldrige, Dresden 1969.

› *Paul Strand. A Retrospective Monograph. The Years 1915–1968*, New York 1970.

› *Ghana. An African Portrait*, Text by Basil Davidson, New York 1976.

› *Sixty Years of Photographs*, ed. by Calvin Tomkins, New York 1976.

› Robert Adams, *Paul Strand: Essays on his Life and Work*, New York 1987.

› *Paul Strand: Circa 1916*, Text by Maria Morris Hambourg, exh. cat., The Metropolitan Museum of Art, New York 1998.

Thomas Struth

1954 Geldern

lives in Düsseldorf

As a graduate of Bernd Becher's class at the Düsseldorf Academy of Art, where he studied from 1973–80, Thomas Struth has adopted a documentary approach to photography. Many of his fellow students, like Thomas Ruff and Candida Höfer, followed the same line, whereby the author of the picture retreats into the background and allows the subject matter to speak for itself. In the late 1970s, when he had stopped painting, Thomas Struth started to produce photographs of unspectacular "unconscious places": these images, keeping to a strict central perspective, showed immensely detailed, virtually deserted city streets. Since then, Thomas Struth has returned again and again to urban spaces as his subject matter, traveling abroad to this end and working increasingly in color since the 1990s.

In his work Struth combines a fine-tuned interest in aesthetics with a sociological awareness of the scenes he portrays: his aim is to produce "portraits of circumstances." In his view the visible world may be taken to stand for the conditions of human and social coexistence: an apartment block, depending on its appearance, may bear witness either to the lively, typically southern improvisations of its inhabitants or to the suppression of individual expression in profit-oriented societies. In addition, time seems to move at a different pace for the viewer gazing at one of Struth's richly detailed pictures: "The slow release of detail corresponds to the extensive study that Struth undertakes for each of his pictures, and it takes viewing into the gradual time of the periphery: The photograph takes sides against the velocities of the economic center" (Norman Bryson).

In the late 1980s, having done a certain amount of work on "the family" together with a psychoanalyst, Struth started to make portraits that are not only a contemporary response to one of the oldest themes in art, but which may also be regarded as essays on the connections and conflicts within any group. In this sense, since there is always a potential for comparison, each chapter of Struth's work has the capacity to transcend its actual subject matter and contribute to our understanding of the structures of human co-existence in different cultures. For Struth, his best-known works, the *Museumsbilder (Museum Pictures)* first shown in 1993, are primarily a commentary on the sheer inability of art to

reach a public that is perpetually rushing onward and jaded by the flood of sensations. For art historians, on the other hand, these pictures seem to provide the ideal material for protracted discussions on such issues as the essence of looking.

For a number of years now, Thomas Struth has been working increasingly with videos in order to draw greater attention to the time factor in a way that is impossible in a static photograph. Following individual video portraits where the subjects were filmed staring motionlessly into a camera for an hour, Struth and Klaus vom Bruch collaborated on the multiple projection *Berlin-Projekt* in 1999. During a number of journeys all over the world, each of the two artists, using an almost static camera, filmed lively street scenes, which were then edited into a forty-minute sequence. Struth feels liberated by the new technique: "When the camera does nothing, the viewer is at last free to follow his or her own thoughts, to let them roam hither and thither."

MF

Exhibitions (Selected)

1978 P.S.1, New York (solo exhibition)
1980 Galerie Rüdiger Schöttle, Munich (solo exhibition)
1986 *Standort Düsseldorf '86*, Kunsthalle Düsseldorf (cat.)
Gallery Shimada, Yamaguchi (solo exhibition)
1987 Galerie Max Hetzler, Cologne (solo exhibition/cat.)
Kunsthalle Bern (solo exhibition/cat.)
Westfälisches Landesmuseum, Münster (solo exhibition)
Prefectural Museum of Art, Yamaguchi (solo exhibition)
1988 Portikus, Frankfurt (solo exhibition/cat.)
1989 *Photo-Kunst*, Staatsgalerie Stuttgart (cat.)
1990 Marian Goodman Gallery, New York (solo exhibition/cat.)
1991 *Thomas Struth*, Gallery Shimada, Yamaguchi (solo exhibition/cat.)
1992 *documenta IX*, Kassel (cat.)
Hirshhorn Museum, Washington (solo exhibition)
1993 *Thomas Struth. Museum Photographs*, Hamburger Kunsthalle (solo exhibition/cat.)
Fotografie in der deutschen Gegenwartskunst, Museum Ludwig, Cologne (tour/cat.)
1994 *Strangers and Friends. Photographs 1986–1992*, Institute of Contemporary Arts, London (solo exhibition/tour/cat.)

1995 *Thomas Struth. Straßen. Fotografien 1976 bis 1995*, Kunstmuseum Bonn (solo exhibition/cat.)
1997 *Portraits*, Sprengel Museum Hannover (solo exhibition/cat.)
1998 Kunstmuseum Luzern (exhibition with Klaus vom Bruch/cat.)
1999 Centre National de la Photographie, Paris (solo exhibition/cat.)

Bibliography (Selected)

› *Unbewußte Orte/Unconscious Places*, Texts by Ulrich Loock, Friedrich Meschede et al., exh. cat., Kunsthalle Bern, Cologne 1987.
› *Portraits*, Interview with Benjamin H. D. Buchloh, exh. cat., Marian Goodman Gallery, New York 1990.
› *Museum Photographs*, Text by Hans Belting, Munich 1993.
› *Landschaften*, Text by Rupert Pfab, exh. cat., Achenbach Kunsthandel, Düsseldorf 1994.
› *Straßen. Fotografien 1976 bis 1995*, Texts by Christoph Schreier, Stefan Gronert et al., exh. cat., Kunstmuseum Bonn, Cologne 1995.
› *Portraits*, Texts by Thomas Weski, Norman Bryson et al., exh. cat., Stiftung Niedersachsen and Sprengel Museum Hannover, Munich 1997.
› *Still*, Texts by Guy Tosatto, Hripsimé Visser et al., exh. cat., Carrée d'Art Nîmes, Munich 1998.

Shomei Tomatsu

1930 Nagoya, Japan
lives in Nagasaki

In the 1950s Shomei Tomatsu was one of a number of Japanese photographers who started to turn their attention to contemporary developments such as the urbanization and industrialization of their country. This was also the time when the Japanese first began to openly confront their own recent history. Along with Kikuji Kawada, Tomatsu was one of the first to address the consequences of the American atom bombs dropped on Hiroshima and Nagasaki in 1945.

While he was studying for a degree in political economy, which he completed in 1954, Shomei Tomatsu had already started to take photographs exploring social is-

sues. He became a freelance photographer in 1956, and in 1959, together with Eikoh Hosoe, Akira Sato, and another three colleagues, he founded the VIVO photography agency. In 1961 he took part in the documentation *Hiroshima—Nagasaki*, commissioned by the Japan Council against Atomic and Hydrogen Bombs and distributed worldwide in book form. This led to Tomatsu's most important and best known group of works, dealing with the effects of the nuclear explosions in Nagasaki. In addition, since 1969 Tomatsu has photographed the American occupation of Okinawa, where he lived for a time. He became a professor at the Tokyo University of Art in 1966. His works were first shown in the West in 1974 at the New York Museum of Modern Art and the 1984 retrospective of his work in Graz was his first solo exhibition outside of Japan.

His work *11:02 Nagasaki* was presented in Tokyo as early as 1962; in 1966 the book of the same name was published. An enlarged edition appeared in 1995 with the title *Nagasaki 11:02, Aug. 9, 1945*—the exact date and time of the explosion in Urakami in the northern part of the city, which killed 70,000 people and injured as many again. Survivors are still suffering the effects of radiation today. Besides detailing facts of this kind, Tomatsu's work above all portrays the later consequences of the attack by showing wounded victims and publishing their diary entries and statements—focusing for instance on the teacher Sumako Fukuda who developed a severe skin condition in 1955. She received no assistance from the state, despite please for help, and had to look on as extravagant memorials were unveiled: "Why are we, the living victims, shoved aside like stray animals?" Her memoires were published in 1968, and she died in 1974. Other well-known photographs by Tomatsu from the 1960s show reminders of that tragic day: a melted bottle, a shattered statue, a watch that stopped at the moment that the bomb fell. For Tomatsu there are two times in Nagasaki: 9 August 1945, and the time after that—"neither must ever be forgotten."

Shomei Tomatsu's works are always fragmented, and despite their strongly symbolic aspect, require the viewer to read them in the light of social reality. This fine balance has led Tomatsu's work to have a powerful influence on Japanese photography in the second half of the 20th century. Thus, at the time when magazine reportage was coming into its own, Tomatsu played a major part in the demise of pictorialist notions of photography in favor of a more subjective, journalistic approach.

MF

Exhibitions (Selected)

1959 Fuji Fotosalon, Tokyo (solo exhibition)
Internationale Fotobiennale, Venice

1962 *11:02 Nagasaki*, Fuji Fotosalon, Tokyo (solo exhibition)

1974 *New Japanese Photography*, The Museum of Modern Art, New York (tour)

1976 *Neue Fotografie aus Japan*, Kulturhaus der Stadt Graz (tour)

1978 *Taiyo no empitsu/The Pencil of the Sun*, Nippon Seimei Hall, Nagoya (solo exhibition)

1984 *Shomei Tomatsu: Japan 1952–1981*, Forum Stadtpark, Graz (solo exhibition/tour/cat.)

1986 *Nagasaki*, Liberty Osaka (solo exhibition)
Zenei no Nippon 1910–1970, Musée National d'Art Moderne, Centre Georges Pompidou, Paris

1990 *Perspektief Zentrum voor Fotografie*, Rotterdam (solo exhibition)

1992 *SAKURA+PLASTICS*, Metropolitan Museum of Art, New York (solo exhibition)

1994 *Sengo Nippon no zeneibijutsu*, Yokohama Museum of Modern Art (tour)
ATOM, Nederlands Fotoinstituut, Rotterdam (tour)

1996 *Nagasaki 11:02*, Nagasaki Atomic Bomb Memorial (solo exhibition)
Interface, The National Museum of Modern Art, Tokyo (solo exhibition/cat.)

1999 *50 Years of Work by Shomei Tomatsu*, Tokyo Metropolitan Museum of Photography (solo exhibition/cat.)

Bibliographie (Selected)

› *11:02 Nagasaki*, Tokyo 1966.
› *Nippon*, Hong Kong 1967.
› *Après-Guerre*, Tokyo 1967.
› *I am a King*, Tokyo 1972.
› *Sparkling Winds—Okinawa*, Tokyo 1979.
› *Japan 1952–1981*, ed. by Camera Austria, Graz 1984.
› *Nagasaki 11:02. Aug. 9, 1945*, Tokyo 1995.
› *Interface*, exh. cat., The National Museum of Modern Art, Tokyo 1996.
› *Vision of Japan*, Tokyo 1998.
› *50 Years of Work by Shomei Tomatsu*, exh. cat., Tokyo Metropolitan Museum of Photography 1999.

Jeff Wall

1946 Vancouver

lives in Vancouver

Since the early 1980s Jeff Wall has been known world-wide for his light-boxes with large-format mise-en-scènes. The extraordinarily comprehensive list of exhibitions he has participated in gives an indication of his many-facetted output and the wide variety of interpretations it has inspired.

In his youth Jeff Wall was interested in painting, but by the age of 21 he felt painting had nothing more to offer. As an art history undergraduate at the University of British Columbia in Vancouver, where he is now a Professor, he studied classical painting and contemporary trends in art. His main interests were Dada, conceptual art, and cinema, which he admired for its aesthetic possibilities. As Wall himself has said, the turning point in his artistic work came in 1977: having achieved a new level of artistic awareness through studying Goya, Titian, and Velasquez, he suddenly saw the fascination of light-boxes for the first time. Skillfully bringing together these diverse influences, Wall made his first, luminous easel-paintings, with these early examples drawing directly on individual works of art by Manet, Delacroix, and others.

In the 1980s Jeff Wall ceased to explore the structure of art in this manner, and-partly with reference to social and political issues-started to produce work that was much more of its own time, initially depicting motifs reminiscent of the exponents of "street photography." Besides referring to different genres in art, these works also record his enduring interest in critical theory and Marxism. Wall approaches his work like a film director: his pictures are often complex constructions involving actors and requiring a small team behind the scenes; at times they are rehearsed down to the tiniest detail, and in the case of larger-scale scenarios may also involve video.

The contents of these (at times life-size) images are never obvious and it is hard to define any common denominator: posing as snapshots of the everyday, they are in fact visual explorations of modern life, drawing on the traditions of easel-painting. The scenes are often set on the margins of urban living and make restrained comment on aspects of the present—which Wall sees as deeply dramatic: "In the drama, the heavy weight of unfreedom is at the point of becoming visible… That implies that there is usually a crisis being depicted, a moment in which the personalities undergo an experience which places their existence in question. I'm trying to show this situation, this 'liminal' or threshold situation, in which a person is both himself and not himself at the same instant." Wall considers this threshold situation the seed of all change and growth.

Over the years he has taken various "classical" genres, such as the interior, portraiture, still lifes, and landscapes, and updated them for himself by means of modern technology. In his 1992 version of a contemporary history picture—his *Dead Troops Talk* alluding to the war in Afghanistan—Wall first used digital technology in order to manipulate the image, a modern-day equivalent to John Heartfield's use of montage, which Wall had studied very closely. In the mid-90s, Wall's mise-en-scènes started to become increasingly complex, while the contents became decreasingly specific, addressing the relationship of human beings to landscapes and architecture in more general terms. Wall also now made his first black-and-white prints. Even when Jeff Wall sets up obviously formal still lifes, he is still creating many-layered genre pictures of the post-industrial present that, in fact constitute a finely calibrated system of art-historical and social references.

MF

Exhibitions (Selected)

1978 Nova Gallery, Vancouver (solo exhibition)

1981 *Westkunst. Zeitgenössische Kunst seit 1939*, Fair Cologne (cat.)

1982 *documenta VII*, Kassel (cat.)

1984 *Jeff Wall: Transparencies*, Institute of Contemporary Arts, London (solo exhibition / tour / cat.)
Galerie Rüdiger Schöttle, Munich

1987 *Blow-up*, Württembergischer Kunstverein Stuttgart (tour / cat.)
Museum für Gegenwartskunst, Basel (solo exhibition)

1988 Westfälischer Kunstverein, Münster (solo exhibition / cat.)

1989 *Children's Pavilion*, Galerie Roger Pailhas, Marseille (exhibition with Dan Graham / tour / cat.)
Foto-Kunst, Staatsgalerie Stuttgart (tour / cat.)

1990 *Passages de l'image*, Musée National d'Art Moderne, Centre Georges Pompidou, Paris (tour / cat.)

1991 San Diego Museum of Contemporary Art (solo exhibition)

1992 Louisiana Museet, Humlebæk (solo exhibition/tour/
 cat.)
1993 *Dead Troops Talk*, Kunstmuseum Luzern (solo exhibi-
 tion/tour/cat.)
1994 Museo Nacional Centro de Arte Reina Sofia, Madrid
 (solo exhibition/cat.)
1995 The Museum of Contemporary Art, Chicago (solo exhi-
 bition/tour/cat.)
1996 Kunstmuseum Wolfsburg (solo exhibition/cat.)
1997 The Museum of Contemporary Art, Los Angeles (solo
 exhibition/tour/cat.)
 documenta X, Kassel (cat.)
1999 *Œuvres 1990-1998*, Musée d'Art Contemporain de
 Montréal (solo exhibition/cat.)

Bibliography (Selected)

› *Transparencies*, Interview with Els Barents, Munich
 1986.
› *Jeff Wall*, Texts by Jeff Wall and Andreas Thielemann,
 exh. cat., Westfälischer Kunstverein, Münster 1988.
› *Dead Troops Talk*, Text by Terry Atkinson, exh. cat.,
 Kunstmuseum Luzern, Basel 1993.
› *Space and Vision*, ed. by Helmut Friedl, Text by Jean-
 François Chevrier, exh. cat., Städtische Galerie im Len-
 bachhaus, Munich 1996.
› *Landscapes and other Pictures*, Foreword by Gijs van
 Tuyl, Texts by Jeff Wall and Camiel van Winkel, exh. cat.,
 Kunstmuseum Wolfsburg, Ostfildern 1996.
› *Jeff Wall*, Texts by Thierry de Duve, Arielle Pelenc et al.,
 London 1996.
› *Szenarien im Bildraum der Wirklichkeit. Essays und Inter-
 views*, ed. by Gregor Stemmrich, Dresden 1997.
› *Œuvres 1990–1998*, exh. cat., Musée d'Art Contem-
 porain de Montréal 1999.

Garry Winograd

1928 New York
1984 Mexico

Garry Winograd is credited with having captured typi-
cal images of American society in the 1960s, just as
Walker Evans did before him in the 1930s and Robert
Frank in the 1950s. At the 1988 retrospective *Figments
from the Real World*, John Szarkowski even declared
him to be the leading figure of his generation. Never-

theless, Winogrand's body of work has caused much
controversy amongst critics unable to agree whether
his work was guided by intuition or concept. There is no
clear-cut answer as to where this—at times manic—
photographer fits into the history of the medium.

After completing his military service in Georgia, Wino-
grand returned to New York in 1947 and enrolled at Co-
lumbia University to study painting. However, the pains-
taking, slow-moving labor that this involved did not
match up to his idea of art. Consequently, in 1949, he
transferred to the New School for Social Research,
where Alexey Brodovitch, himself a photographer and
the editor of the popular journal *Harper's Bazaar*, intro-
duced him to the world of professional photography.
For several years he then earned his living as a photo-
journalist working for magazines and picture agencies,
thereby evolving his own style of intuitive photography.
In 1954, together with his wife, he spent several months
traveling through the United States. During this trip he
took photographs without concentrating on any partic-
ular themes, but on his return was not happy with most
of the results. Nevertheless, two of his photographs
were shown in Edward Steichen's exhibition, *The Family
of Man*, in 1955. Over the next two decades Wino-
grand's chief mentor was John Szarkowski, the curator
for photography at the Museum of Modern Art in New
York. Between 1963 and 1970 Szarkowski included him
in no less than six of his shows, amongst which was the
programmatic exhibition *New Documents*—also includ-
ing works by Diane Arbus and Lee Friedlander—and his
first solo exhibition, *The Animals* (1969).

In 1964, 1969, and 1978 Winogrand was awarded the
coveted Guggenheim Fellowship. As part of his first
project he observed the daily coming and going at the
World's Fair which was taking place in New York at the
time. Five years later he examined "the effect of the
media on events." To his mind, the media do not merely
file reports but are themselves part of the events; the
media enable participants to make themselves and
their views publicly known. In pursuit of his artistic in-
terests, he would then mingle with the reporters at
election meetings, exhibition previews, strikes, and pro-
test rallies, and in 1977 he published the series *Public
Relations* in which he decodes the interconnections of
the media machine.

Garry Winogrand viewed the world as a stage where
the theater of life ran its course. He found his motifs in
the streets, above all in New York and later on in Los

Angeles. By using a powerful wide-angle lens, he would combine a number of different strands which would then spark off an "aesthetic accident" (Kenneth E. Silver). Despite this, his raw compositions appear planned and organized. Critics of his work complain that the people in his photographs—predominantly women—only play the part of objects or victims. And the same critics accuse him of relegating any interest in people to second position behind his inner need to respond purely as a photographer and to release the shutter. Perhaps this explains why the over 700,000 photographs that he took in the last five years of his life were found undeveloped and unfinished after his death.

TS

Exhibitions (Selected)

1955 *The Family of Man*, The Museum of Modern Art, New York (tour/cat.)
1963 *The Photographer's Eye*, The Museum of Modern Art, New York
1967 *Diane Arbus, Lee Friedlander, Garry Winogrand*, The Museum of Modern Art, New York
1969 *The Animals*, The Museum of Modern Art, New York (solo exhibition/cat.)
1972 Light Gallery, New York
1978 *Mirrors and Windows: American Photography since 1960*, The Museum of Modern Art, New York (cat.)
1979 *The Rodeo*, Alan Frumkin Gallery, Chicago
1980 Bibliothèque Nationale, Paris
 Garry Winogrand. Retrospective, Fraenkel Gallery, San Francisco
 Bruce Davidson and Garry Winogrand, Moderna Museet/Fotografiska Museet, Stockholm
 Garry Winogrand, Larry Clark and Arthur Tress, G. Ray Hawkins Gallery, Los Angeles
1983 *Masters of the Street: Henri Cartier-Bresson, Josef Koudelka, Robert Frank and Garry Winogrand*, The University of Massachusetts, Amherst
1984 *Recent Works*, Houston Center for Photography
1988 *Figments from the real World*, The Museum of Modern Art, New York (solo exhibition/tour/cat.)
1990 Hayward Gallery, London
1999 Fraenkel Gallery, San Francisco (solo exhibition/cat.)

Bibliography (Selected)

› *Toward a Social Landscape*, ed. by Nathan Lyons, George Eastman House, Rochester 1966.
› *The Animals*, Afterword by John Szarkowski, exh. cat., The Museum of Modern Art, New York 1969.
› *Women are Beautiful*, Text by Helen Gary Bishop, New York 1975.
› *Public Relations*, Text by Tod Papageorge, exh. cat., The Museum of Modern Art, New York 1977.
› *Mirrors and Windows*, ed. by John Szarkowski, exh. cat., The Museum of Modern Art, New York 1978.
› *Stock Photographs. The Fort Worth Fort Stock Show and Rodeo*, Text by Ron Tyler, Austin 1980.
› *Figments from the Real World*, Text by John Szarkowski, exh. cat., The Museum of Modern Art, New York 1988.
› *American Politicians*, exh. cat., The Museum of Modern Art, New York 1995.
› *The Man in the Crowd: The Uneasy Street of Garry Winogrand*, Texts by Fran Lebowitz and Ben Lifson, exh. cat., Fraenkel Gallery San Francisco, New York 1999.

Robert Adams

All exhibits:
from the series
The New West, 1974
Gelatin silver prints
Collection of the
Niedersächsische Sparkas-
senstiftung, Hanover
© Robert Adams

Farm road and cottonwood,
South of Raymer, undated
5 15/16 x 5 31/32 in
Fig. p. 299

Grazing land with pines,
Near Falcon, undated
5 11/32 x 5 15/16 in

Along Interstate 25, 1968
5 11/32 x 6 in
Fig. p. 300

Basement for a tract house,
Colorado Springs, undated
5 1/4 x 5 31/32 in

Newly occupied tract houses,
Colorado Springs, undated
5 3/4 x 5 15/16 in
Fig. p. 301

Jefferson County, undated
5 1/2 x 5 7/8 in

Pikes Peak Park, Colorado
Springs, undated
5 27/32 x 5 15/16 in

Colorado Springs, undated
5 1/32 x 5 1/16 in
Fig. p. 302

Out a front window, Longmont
undated
5 31/32 x 5 13/16 in

New subdivisions, Arvada
undated
5 3/16 x 5 5/16 in

The center of Denver,
ten miles distant, undated
5 11/32 x 5 27/32 in

Colfax Avenue, Lakewood
undated
5 13/16 x 5 15/16 in
Fig. p. 303

Nevada Avenue,
Colorado Springs, undated
5 13/16 x 5 15/16 in

Federal Boulevard,
Denver, undated
5 15/16 x 5 15/16 in
Fig. p. 306

Curtis Street, Denver
undated
5 31/32 x 5 11/16 in

Drugstore, Lakeside,
undated
6 x 5 31/32 in

The center of Denver,
four miles distant
undated
5 5/8 x 5 15/16 in

Outdoor Theater and
Cheyenne Mountain
undated
5 15/16 x 5 31/32 in
Fig. p. 307

Buffalo for sale, undated
5 15/32 x 5 15/16 in

From Lookout Mountain
undated
5 7/8 x 5 15/16 in
Fig. p. 308

Pikes Peak, undated
5 15/32 x 5 15/16 in
Fig. p. 309

Clear Creek, Near Idaho
Springs, undated
5 5/8 x 5 31/32 in

Pioneer cemetery,
Near Empire, undated
5 7/8 x 5 31/32 in

Diane Arbus

All exhibits:
Gelatin silver prints

Female Impersonators
in Mirrors, N.Y.C., 1958
7 5/8 x 5 in
Collection Goetz, Munich

Child Teasing Another,
N.Y.C., 1960
10 x 6 in
Collection Goetz, Munich
Photo: Raimund Koch,
New York
Copyright © 1960 The Estate
of Diane Arbus, LLC
Fig. p. 290

Hezekiah Trambles,
"The Jungle Creep", N.Y.C.
1960
8 3/4 x 5 7/8 in
Collection Goetz, Munich

Female Impersonator
On a Bed, N.Y.C., 1961
9 1/2 x 6 3/8 in
Collection Goetz, Munich
Photo: Raimund Koch, New
York
Copyright © 1979 The Estate
of Diane Arbus, LLC
Fig. p. 291

Two Female Impersonators
Backstage, N.Y.C., 1962
8 5/8 x 5 3/4 in
Collection Goetz , Munich

Child with a toy hand grenade in
Central Park, N.Y.C., 1962
14 3/4 x 14 3/4 in
The Museum of Contemporary
Art, Los Angeles, The Ralph
M. Parsons Foundation
Photography Collection
Photo: Brian Forrest
Copyright © 1970 The Estate
of Diane Arbus, LLC
Fig. p. 293

Xmas tree in a living room
in Levittown, L.I., 1963
14 3/16 x 14 9/16 in
The Museum of Contemporary
Art, Los Angeles, The Ralph
M. Parsons Foundation
Photography Collection
Photo: Brian Forrest
Copyright © 1967 The Estate
of Diane Arbus, LLC
Fig. p. 295

A family one evening
in a nudist camp, PA., 1965
14 9/16 x 14 3/8 in
The Museum of Contemporary
Art, Los Angeles, The Ralph
M. Parsons Foundation
Photography Collection
Photo: Brian Forrest
Copyright © 1972 The Estate
of Diane Arbus, LLC
Fig. p. 294

A young man in curlers at home
on West 20th Street, N.Y.C.
1966
15 1/8 x 14 11/16 in
The Museum of Contemporary
Art, Los Angeles, The Ralph
M. Parsons Foundation
Photography Collection

Identical twins, Roselle, N.J.
1967
14 1/2 x 14 9/16 in
The Museum of Contemporary
Art, Los Angeles, The Ralph
M. Parsons Foundation
Photography Collection

Hermaphrodite and a dog
in a carnival trailer, MD, 1970
14 1/8 x 14 3/16 in
The Museum of Contemporary
Art, Los Angeles, The Ralph
M. Parsons Foundation
Photography Collection
Photo: Brian Forrest
Copyright © 1971 The Estate
of Diane Arbus, LLC
Fig. p. 289

The King and Queen of a Senior
Citizens Dance, N.Y.C., 1970
14 1/2 x 14 3/16 in
The Museum of Contemporary
Art, Los Angeles, The Ralph
M. Parsons Foundation
Photography Collection
Photo: Brian Forrest
Copyright © 1971 The Estate
of Diane Arbus, LLC
Fig. p. 288

Untitled (3), 1970-1971
14 7/16 x 14 1/2 in
The Museum of Contemporary
Art, Los Angeles, The Ralph
M. Parsons Foundation
Photography Collection
Photo: Brian Forrest
Copyright © 1972 The Estate
of Diane Arbus, LLC
Fig. p. 297

Untitled (7), 1970–1971
14 5/16 x 14 5/16 in
The Museum of Contemporary
Art, Los Angeles, The Ralph
M. Parsons Foundation
Photography Collection
Photo: Brian Forrest
Copyright © 1972 The Estate
of Diane Arbus, LLC
Fig. p. 296

Eugène Atget

Asphalters, 1899-1900
Gelatin silver print
from dry plate
6 7/8 x 8 7/32 in
The Museum of Modern Art,
New York. Abbott-Levy
Collection. Partial Gift of
Shirley C. Burden
Copy Print © 2000
The Museum of Modern Art,
New York
Fig. p. 114

Pavers, 1899–1900
Albumen silver print
8 1/2 x 7 in
The Museum of Modern Art,
New York. Abbott-Levy
Collection
Partial Gift of
Shirley C. Burden

Asphalters, 1899–1900
Albumen silver print
7 x 9 3/8 in
The Museum of Modern Art,
New York. Purchase
Copy Print © 2000
The Museum of Modern Art,
New York
Fig. p. 113

*Hairdresser, Boulevard
de Strasbourg*, Paris ca. 1905
Albumen silver print
8 13/16 x 7 1/16 in
Private collection
Fig. p. 125

*Doorknocker at la
Madeleine*, 1907
Albumen silver print
8 9/16 x 7 3/16 in
Musée Carnavalet, Paris
© Photothèque des Musées
de la Ville de Paris/Joffre
Fig. p. 121

Hôtel Maufréon, Staircaise
1907
Albumen silver print
8 9/16 x 7 3/16 in
Musée Carnavalet, Paris
© Photothèque des Musées
de la Ville de Paris / Joffre
Fig. p. 120

Hôtel Maufréon, Staircaise
1907
Albumen silver print
8 17/32 x 7 1/32 in
Musée Carnavalet, Paris

The Market at Carmes
1910
Albumen silver print
8 13/32 x 6 15/16 in
Musée Carnavalet, Paris
© Photothèque des Musées
de la Ville de Paris/Joffre
Fig. p. 116

La Sorbonne, door, 1911
Albumen silver print
8 9/16 x 7 1/16 in
Musée Carnavalet, Paris

*20 rue de Varenne,
Doorknocker*, 1911
Albumen silver print
8 3/4 x 7 1/32 in
Musée Carnavalet, Paris
© Photothèque des Musées
de la Ville de Paris/Joffre
Fig. p. 123

Rue de l'Hôtel de Ville, 1921
Albumen silver print
8 7/8 x 7 3/32 in
Musée Carnavalet, Paris

*Montmartre, maison 2 rue
du Calvaire*, 1921
Albumen silver print
8 9/16 x 6 15/16 in
Musée Carnavalet, Paris

Rue Norvins, 1922
Albumen silver print
7 3/32 x 8 5/8 in
Musée Carnavalet, Paris
© Photothèque des Musées
de la Ville de Paris/Joffre
Fig. p. 118

*Shop sign
"Au franc buveur"*, 1922
Albumen silver print
9 x 7 1/32 in
Musée Carnavalet, Paris
© Photothèque des Musées
de la Ville de Paris/Joffre
Fig. p. 122

*Montmartre, corner of rue
St. Rustique*, 1922
Albumen silver print
8 5/16 x 7 1/16 in
Musée Carnavalet, Paris

*Grille Saint-Gervais
Saint-Protais*, 1922
Albumen silver print
8 5/8 x 7 1/16 in
Musée Carnavalet, Paris

Place du Tertre, 1922
Albumen silver print
7 3/16 x 8 17/32 in
Musée Carnavalet, Paris
© Photothèque des Musées
de la Ville de Paris/Joffre
Fig. p. 119

Rue de Nevers, 1924
Albumen silver print
8 3/4 x 7 3/32 in
Musée Carnavalet, Paris
© Photothèque des Musées
de la Ville de Paris/Joffre
Fig. p. 115

*Corner of rue St. Martin
and rue des Lombards*, 1924
Albumen silver print
8 5/8 x 7 in
Musée Carnavalet, Paris
© Photothèque des Musées
de la Ville de Paris/Joffre
Fig. p. 117

Shop sign "A la biche", 1925
Albumen silver print
6 3/4 x 8 7/8 in
Musée Carnavalet, Paris

Fête de la Villette, 1926
Albumen silver print
6 3/4 x 8 7/8 in
The Museum of Modern Art,
New York. Abbott-Levy
Collection. Partial gift of
Shirley C. Burden

Fête de Vaugirard, 1926
Albumen silver print
7 x 9 3/8 in
The Museum of Modern Art,
New York. Abbott-Levy
Collection. Partial gift
of Shirley C. Burden
Copy Print © 2000
The Museum of Modern Art,
New York
Fig. p. 127

*Naturalist, rue de l'Ecole de
Médecine*, 1926-1927
Albumen silver print by
Chicago Albumen Works, 1984
9 3/8 x 7 in
The Museum of Modern Art,
New York. Abbott-Levy
Collection. Partial Gift of
Shirley C. Burden
Copy Print © 2000
The Museum of Modern Art,
New York
Fig. p. 126

Francis Bacon

Study for Portrait of P. L., 1964
Oil on canvas
77 3/4 x 58 1/16 in
Sprengel Museum Hannover
© VG BILD-KUNST, Bonn 2000
Fig. p. 287

Conchita on display in front of "Her Majesty, Woman"
ca. 1931
11 x 8 5/8 in
The Museum of Contemporary Art, Los Angeles, The Ralph M. Parsons Foundation Photography Collection
Photo: Brian Forrest
Fig. p. 268

Kiki with her accordion player at the Cabaret des fleurs, rue de Montparnasse, ca. 1932
10 15/16 x 8 7/16 in
The Museum of Contemporary Art, Los Angeles, The Ralph M. Parsons Foundation Photography Collection
Photo: Brian Forrest
Fig. p. 269

Couple at the Bal des Quatre Saisons, rue de Lappe
ca. 1932
8 1/2 x 10 1/2 in
The Museum of Contemporary Art, Los Angeles, The Ralph M. Parsons Foundation Photography Collection
Photo: Brian Forrest
Fig. p. 270

Brothel Suzy, rue Grégoire-de-Tours / Saint Germain, ca. 1932
8 x 11 in
The Museum of Contemporary Art, Los Angeles, The Ralph M. Parsons Foundation Photography Collection
Photo: Brian Forrest
Fig. p. 271

Sailor's Girl, 1932
11 1/2 x 9 in
Museum Ludwig, Photography collection, Gruber Collection

Woman with spit curls at the bar of a bistro, rue de Lappe
ca. 1932
8 1/4 x 10 5/8 in
The Museum of Contemporary Art, Los Angeles, The Ralph M. Parsons Foundation Photography Collection

Waiting for clients, ca. 1932
10 7/8 x 8 5/8 in
The Museum of Contemporary Art, Los Angeles, The Ralph M. Parsons Foundation Photography Collection

The Bal de la "Montagne Sainte-Genevieve", ca. 1931
11 1/2 x 8 11/16 in
The Museum of Contemporary Art, Los Angeles, The Ralph M. Parsons Foundation Photography Collection

Larry Clark

25 works from the series
Tulsa, 1960s
Gelatin silver prints (1980)
13 prints 8 x 12 in
12 prints 12 x 8 in
Collection F. C. Gundlach
Photo: Elke Walford, Hamburg
© Larry Clark
Figs. p. 312–317

Edgar Degas

Musiciens à l'orchestre
1872
Oil on canvas
27 1/8 x 19 1/4 in
Städelsche Galerie im Städelschen Kunstinstitut, Frankfurt am Main
Fig. p. 129

Rineke Dijkstra

All exhibits:
c-print
© Rineke Dijkstra

Montemor, Portugal, 1 May 1994
47 1/4 x 39 3/8 in
Collection Ulla Katzorke
Fig. p. 260

Montemor, Portugal, 1 May 1994
47 1/4 x 39 3/8 in
Collection Ulla Katzorke
Fig. p. 261

Villa Franca, Portugal, 8 May 1994
47 1/4 x 39 3/8 in
Collection Ulla Katzorke
Fig. p. 263

Villa Franca, Portugal, 8 May 1994
47 1/4 x 39 3/8 in
Collection Ulla Katzorke

Julie, Den Haag, Netherlands, 29 February 1994
23 5/8 x 19 11/16 in
Museum Folkwang, Essen

Saskia, Harderwijk, Netherlands, 16 March 1994
23 5/8 x 19 11/16 in
Museum Folkwang, Essen

Tecla, Amsterdam, Netherlands, 16 May 1994
23 5/8 x 19 11/16 in
Museum Folkwang, Essen

William Eggleston

All exhibits:
Dye transfer prints
© 2000 Eggleston Artistic Trust

Tallahatchie County, Mississippi, 1969–1970
13 3/8 x 20 5/8 in
Rolf Hengesbach, Räume für neue Kunst
Fig. p. 222

Memphis, Tennessee
1969–1970
21 7/8 x 14 1/2 in
Hasselblad Center
Fig. p. 224

Sumner, Mississippi Cassidy Bayou in Background
1969–1970
14 1/2 x 21 7/8 in
Hasselblad Center
Fig. p. 225

Near Minter City and Glendora, Mississippi, 1969–1970
14 1/2 x 21 3/4 in
Hasselblad Center

Morton, Mississippi
1969–1970
13 3/8 x 8 7/8 in
Rolf Hengesbach, Räume für neue Kunst

Jackson, Mississippi
1969–1970
20 5/8 x 13 3/8 in
Rolf Hengesbach, Räume für neue Kunst

Memphis, Tennessee
ca. 1972
13 1/4 x 20 1/4 in
Museum Folkwang, Essen
Fig. p. 223

Greenwood, Mississippi
ca. 1972
21 3/4 x 14 1/2 in
Hasselblad Center
Fig. p. 230

Greenwood, Mississippi
1973
13 3/4 x 19 3/4 in
Collection Wilmar Koenig
Photo: Markus Hawlik
Fig. p. 229

Memphis, Brazer BQpit
1981
12 5/8 x 18 7/8 in
Museum Folkwang, Essen
Fig. p. 231

Sumner, Mississippi
undated
13 3/8 x 20 5/8 in
Rolf Hengesbach, Räume für neue Kunst
Fig. p. 221

Whitehaven, Mississippi
undated
10 3/4 x 16 3/4 in
Rolf Hengesbach, Räume für neue Kunst
Fig. p. 226

Lewis Baltz

Candlestick Point
1984–1988
72 Gelatin silver prints,
11 c-prints
each 6 5/8 x 9 in
Collection Siemens Kultur-
programm/Sprengel Museum
Hannover
© Lewis Baltz
Figs. p. 342–347

Bernd and Hilla Becher

All exhibits:
Gelatin silver prints
each 16 1/8 x 12 3/16 in
Lent by the artists
© Bernd und Hilla Becher

Blast Furnaces, USA
1. *Youngstown Ohio USA*
 1980
2. *Duquesne Pennsylvania
 USA*, 1980
3. *Johnstown Pennsylvania
 USA*, 1980
4. *Gadsden Alabama USA*
 1983
5. *Cleveland Ohio USA*, 1986
6. *Youngstown Ohio USA*
 1980
7. *Johnstown Pennsylvania
 USA*, 1980
8. *Cleveland Ohio USA*, 1980
9. *Youngstown Ohio USA*
 1981
10. *Gadsden Alabama USA*
 1983
11. *Pittsburgh Pennsylvania
 USA*, 1979
12. *Johnstown Pennsylvania
 USA*, 1980
13. *Mingo Junction Ohio USA*
 1986
14. *Cleveland Ohio USA*, 1986
15. *Steubenville Ohio USA*
 1986
Figs. p. 324–325

Blast Furnaces, Europe
1. *Duisburg Hamborn D*
 1994
2. *Lübeck Herrenwyk D*, 1983

3. *Ilsede/Hannover D*, 1984
4. *Siegen Eiserfeld D*, 1972
5. *Duisburg Hamborn D*
 1970
6. *Duisburg Hamborn D*, 1970
7. *Duisburg Ruhrort D*, 1970
8. *Charleroi Montignies B*
 1984
9. *Rombas Lorraine F*, 1984
10. *Rombas Lorraine F*, 1984
11. *Esch Alzette L*, 1979
12. *La Louviere B*, 1985
13. *Dillingen Saar D*, 1986
14. *Liège Ougree B*, 1986
15. *Longwy Senelle F*, 1986
Figs. p. 326–327

Max Beckmann

Ice Flow, 1923
Oil on canvas
18 11/16 x 23 7/16 in
Städelsches Kunstinstitut,
Frankfurt am Main; property
of the Städelscher Museums
Verein e.V.
Photo: Ursula Edelmann,
Frankfurt am Main
© VG BILD-KUNST, Bonn 2000
Fig. p. 157

*Self-Portrait with
Green Curtain*, 1940
Oil on canvas
29 3/4 x 21 3/4 in
Sprengel Museum Hannover
© VG BILD-KUNST, Bonn 2000
Fig. p. 430

Karl Blossfeldt

All exhibits:
Gelatin silver prints
Karl Blossfeldt Archiv
Ann and Jürgen Wilde, Zülpich
© VG BILD-KUNST, Bonn 2000

*Anthriscus silvestris
(wild chervil)*
Enlarged x 18, 1900–1926
23 15/32 x 9 11/32 in
Fig. p. 328

*Silphium perfoliatum
(compass plant)*
Enlarged x 25, 1900–1926
23 7/16 x 9 11/32 in
Fig. p. 329

*Equisetum arvense
(horsetail)*
Enlarged x 15, 1900–1926
23 9/16 x 7 11/32 in
Fig. p. 330

*Brachypodium distachyum
(two year old false bromegrass)*
Enlarged x 12, 1900–1926
23 15/32 x 7 11/32 in
Fig. p. 331

*Tritonia crocosmiflora
(iridaceae)*
Enlarged x 12, 1900–1926
23 7/16 x 9 9/32 in
Fig. p. 334

*Dipsacus laciniatus
(fuller's teasle)*
Enlarged x 12, 1900–1926
23 1/2 x 9 13/16 in
Fig. p. 335

*Eryngium bourgatii
(eryngo)*
Enlarged x 12, 1900–1926
23 17/32 x 11 13/16 in
Fig. p. 336

*Equisetum hyemale
(pewter wort)*
Enlarged x 30, 1900–1926
23 15/32 x 9 9/32 in
Fig. p. 337

*Equisetum hyemale
(pewter wort)*
Enlarged x 30, 1900–1926
23 15/32 x 9 11/16in

*Equisetum hyemale
(pewter wort)*
Enlarged x 30, 1900–1926
23 7/16 x 9 11/32 in

*Fraxinus quadrangulata
(ash)*
Enlarged x 20, 1900–1926
23 7/16 x 9 5/8 in

Christian Boltanski

*L'album de la famille D.,
1939-1964*, 1971
150 Gelatin silver prints
in metal frames
each 8 5/8 x 11 13/16 in
Collection Liliane & Michel
Durand-Dessert, Paris
© ADAGP, Paris
Fig. p. 401

Brassaï

(Gyula Halász)
All exhibits from
the series *Hidden Paris
in the Thirties*
Gelatin silver prints
© Gilberte Brassaï

*An Urinal on the
Boulevard Saint-Jacques*
ca. 1932
10 7/8 x 8 1/4 in
The Museum of Contemporary
Art, Los Angeles, The Ralph
M. Parsons Foundation
Photography Collection
Photo: Brian Forrest
Fig. p. 265

*Miss Diamonds, Bar de
la Lune, Montmartre*
ca. 1932
8 3/8 x 7 3/4 in
The Museum of Contemporary
Art, Los Angeles, The Ralph
M. Parsons Foundation
Photography Collection
Photo: Brian Forrest
Fig. p. 266

*Streetwalker near the
Place d'Italie*, ca. 1932
10 7/8 x 8 15/16 in
The Museum of Contemporary
Art, Los Angeles, The Ralph
M. Parsons Foundation
Photography Collection
Photo: Brian Forrest
Fig. p. 267

Walker Evans

All exhibits:
Gelatin silver prints
© Walker Evans Archive,
The Metropolitan Museum
of Art

License Photo Studio,
New York, 1934, printed later
9 7/8 x 8 in
Gift of Phyllis Lambert,
Montreal, 1982, National
Gallery of Canada, Ottawa

Penny Picture Display,
Savannah/Photographer's
Window Display, Birmingham,
Alabama, 1936
7 1/16 x 8 7/16 in
The J. Paul Getty Museum,
Los Angeles
Fig. p. 179

Faces, Pennsylvania Town
1936
4 13/16 x 7 1/16 in
Gift of Phyllis Lambert,
Montreal, 1982, National
Gallery of Canada, Ottawa

Negro Barber Shop Interior,
Atlanta, Georgia, 1936
7 1/2 x 9 3/8 in
Gift of Phyllis Lambert,
Montreal, 1982, National
Gallery of Canada, Ottawa

Joe's Auto Graveyard,
Pennsylvania, November 1935
printed later
8 x 9 15/16 in
Gift of Phyllis Lambert,
Montreal, 1982, National
Gallery of Canada, Ottawa

Roadside Gas Sign, 1929
4 3/4 x 7 7/8 in
Gift of Phyllis Lambert,
Montreal, 1982, National
Gallery of Canada, Ottawa
Fig. p. 181

Parked Car, Small Town,
Main Street, 1932
printed later
11 x 13 7/8 in
Gift of Phyllis Lambert,
Montreal, 1982, National
Gallery of Canada, Ottawa
Fig. p. 180

Coney Island Boardwalk,
New York City
ca. 1928–1929
8 1/2 x 4 3/4 in
Gift of Phyllis Lambert,
Montreal, 1982, National
Gallery of Canada, Ottawa

A Bench in the Bronx
on Sunday, 1933
6 x 8 7/8 in
Gift of Benjamin Greenberg,
Ottawa, 1981, National Gallery
of Canada, Ottawa

Torn Movie Poster
1930, printed later
9 15/16 x 8 in
Gift of Phyllis Lambert,
Montreal, 1982, National
Gallery of Canada, Ottawa

Allie Mae Burroughs, Wife
of a Cotton Sharecropper,
Hale County, Alabama, 1936
9 9/16 x 7 9/16 in
The J. Paul Getty Museum,
Los Angeles
Fig. p. 182

New York State Farm
Interior, 1931
5 3/4 x 7 7/8 in
Gift of Benjamin Greenberg,
Ottawa, 1981, National Gallery
of Canada, Ottawa
Fig. p. 183

Child in Backyard, 1932
printed later
9 7/8 x 7 15/16 in
Gift of Phyllis Lambert,
Montreal, 1982, National
Gallery of Canada, Ottawa

Girl in Fulton Street,
New York, 1929
6 11/16 x 5 3/8 in
The J. Paul Getty Museum,
Los Angeles

Interior of Negro Preacher's
House, Florida
1933, printed later
10 x 8 in
Gift of Phyllis Lambert,
Montreal, 1982, National
Gallery of Canada, Ottawa

42nd Street, New York, 1929
8 x 10 in
Gift of Phyllis Lambert,
Montreal, 1982, National
Gallery of Canada, Ottawa
Fig. p. 186

Citizen in Downtown Havana
1933, printed later
10 x 8 in
Gift of Benjamin Greenberg,
Ottawa, 1981, National Gallery
of Canada, Ottawa
Fig. p. 187

Negroes' Houses, Mississippi
March 1936, printed April 1969
8 x 10 in
National Gallery of Canada,
Ottawa

Interior Detail, West Virginia
Coal Miner's House, July 1935
printed later
10 x 8 in
Gift of Phyllis Lambert,
Montreal, 1982, National
Gallery of Canada, Ottawa
Fig. p. 188

Street Scene, Vicksburg,
Mississippi, March 1936
printed later
8 x 10 in
Gift of Phyllis Lambert,
Montreal, 1982, National
Gallery of Canada, Ottawa

World War I Monument on
Main Street, Mount Pleasant,
Pennsylvania, after July 1935
10 x 8 in
Gift of Benjamin Greenberg,
Ottawa, 1981, National Gallery
of Canada, Ottawa

Battlefield Monument,
Vicksburg, Mississippi
March 1936, printed later
8 x 10 in
Gift of Phyllis Lambert,
Montreal, 1982, National
Gallery of Canada, Ottawa

Havana Policeman, 1933
7 11/16 x 5 7/32 in
The J. Paul Getty Museum,
Los Angeles

Sons of the American Legion,
Bethlehem, Pennsylvania, 1935
6 9/16 x 7 3/16 in
The J. Paul Getty Museum,
Los Angeles

American Legionnaire,
Bethlehem, Pennsylvania,
November 1935, printed later
7 3/8 x 8 1/4 in
Gift of Phyllis Lambert,
Montreal, 1982, National
Gallery of Canada, Ottawa

Street Scene, Morgantown,
West Virginia, July 1935,
printed later
8 x 10 in
Gift of Phyllis Lambert,
Montreal, 1982, National
Gallery of Canada, Ottawa

Minstrel Showbill, 1936
10 x 8 in
National Gallery of Art,
Washington, Gift (Partial and
Promised) of Mary and David
Robinson

Posed Portraits,
New York City, 1931
8 1/4 x 6 7/8 in
Gift of Phyllis Lambert,
Montreal, 1982, National
Gallery of Canada, Ottawa

Couple at Coney Island,
New York, ca. 1928-1929
9 1/2 x 6 5/8 in
Gift of Phyllis Lambert,
Montreal, 1982, National
Gallery of Canada, Ottawa

Hudson Street Boarding
House, Detail, New York, 1931
printed later
8 x 10 in
Gift of Phyllis Lambert,
Montreal, 1982, National
Gallery of Canada, Ottawa

Arkansas Flood Refugee, 1937
7 11/16 x 5 1/16 in
The J. Paul Getty Museum,
Los Angeles

People in Summer, Ossining,
New York, 1930
7 7/8 x 4 15/16 in
Gift of Phyllis Lambert,
Montreal, 1982, National
Gallery of Canada, Ottawa

Street Scene, Bethlehem,
Pennsylvania, November 1935,
printed later
7 7/8 x 8 7/8 in
Gift of Phyllis Lambert,
Montreal, 1982, National
Gallery of Canada, Ottawa
Fig. p. 191

South Street, New York
1932, printed later
8 x 10 in
Gift of Phyllis Lambert,
Montreal, 1982, National
Gallery of Canada, Ottawa

Hillside Houses,
Bethlehem, Pennsylvania
November 1935, printed later
8 x 10 in
Gift of Phyllis Lambert,
Montreal, 1982, National
Gallery of Canada, Ottawa

Louisiana Plantation House
1935, printed later
8 x 10 in
Gift of Phyllis Lambert,
Montreal, 1982, National
Gallery of Canada, Ottawa

Roadside Houses for Miners,
Vicinity of Birmingham,
Alabama, December 1935
printed later
8 x 10 in
Gift of Phyllis Lambert,
Montreal, 1982, National
Gallery of Canada, Ottawa
Fig. p. 190

Jigsaw House at Ocean City,
New Jersey, ca. 1931–1933
5 7/8 x 7 7/8 in
Gift of Phyllis Lambert,
Montreal, 1982, National
Gallery of Canada, Ottawa

Country Store and Gas Station,
Selma, Alabama
January 1936, printed later
6 9/16 x 9 5/16 in
Gift of Phyllis Lambert,
Montreal, 1982, National
Gallery of Canada, Ottawa

Stamped Tin Relic
1929, printed later
8 x 10 in
Gift of Phyllis Lambert,
Montreal, 1982, National
Gallery of Canada, Ottawa

View of Easton, Pennsylvania
November 1935, printed later
18 x 9 15/16 in
Gift of Phyllis Lambert,
Montreal, 1982, National
Gallery of Canada, Ottawa

Church of the Nazarene,
Tennessee, 1936, printed later
7 15/16 x 8 15/16 in
Gift of Phyllis Lambert,
Montreal, 1982, National
Gallery of Canada, Ottawa

Wooden Church,
South Carolina, 1936
9 1/2 x 7 9/16 in
National Gallery of Art,
Washington, Gift (Partial and
Promised) of Mary and David
Robinson

Greek Temple Building,
Natchez, Mississippi
1936, printed later
7 7/8 x 10 in
Gift of Phyllis Lambert,
Montreal, 1982, National
Gallery of Canada, Ottawa

Frame Houses in Virginia
1936, printed later
7 3/8 x 8 in
Gift of Phyllis Lambert,
Montreal, 1982, National
Gallery of Canada, Ottawa

Frame Houses in Virginia
1936
5 11/16 x 5 1/2 in
Gift of Phyllis Lambert,
Montreal, 1982, National
Gallery of Canada, Ottawa

Butcher's Sign, Mississippi
March 1936
6 1/2 x 9 5/16 in
Gift of Benjamin Greenberg,
Ottawa, 1981, National Gallery
of Canada, Ottawa

Wooden Gothic House
near Nyack, New York, 1931
6 3/16 x 7 3/4 in
Gift of Phyllis Lambert,
Montreal, 1982, National
Gallery of Canada, Ottawa

Gothic Cottage, near
Poughkeepsie, New York
1932
4 1/4 x 5 3/4 in
Gift of Phyllis Lambert,
Montreal, 1982, National
Gallery of Canada, Ottawa

Photographer's Window
Display, Birmingham, Alabama
1936
9 15/16 x 8 in
National Gallery of Art,
Washington, Gift (Partial and
Promised) of Mary and David
Robinson

Subway Portrait, 1941
4 3/4 x 7 1/16 in
The J. Paul Getty Museum,
Los Angeles
Fig. p. 194

Subway Portrait, 1938–1941
5 x 7 5/8 in
The J. Paul Getty Museum,
Los Angeles
Fig. p. 195

Subway Portrait, 1938–1941
5 7/8 x 8 3/8 in
The J. Paul Getty Museum,
Los Angeles
Fig. p. 196

Subway Portrait, 1938–1941
5 13/16 x 8 3/8 in
The J. Paul Getty Museum,
Los Angeles
Fig. p. 197

Subway Portrait, 1938–1941
4 15/16 x 7 9/16 in
The J. Paul Getty Museum,
Los Angeles

Subway Portrait, 1938–1941
4 13/16 x 7 3/8
The J. Paul Getty Museum,
Los Angeles

Subway Portrait, 1938–1941
4 13/16 x 6 15/16
The J. Paul Getty Museum,
Los Angeles

Subway Portrait, 1938–1941
5 13/16 x 8 11/16
The J. Paul Getty Museum,
Los Angeles

Subway Portrait, 1941
4 27/32 x 6 in
The J. Paul Getty Museum,
Los Angeles

Patrick Faigenbaum

All exhibits from the series
Parallel Lives, Rome August
1987
Gelatin silver prints
© Patrick Faigenbaum

Gordien III
22 7/16 x 18 7/8 in
Lent by the artist
Fig. p. 385

Massimo
22 x 20 1/2 in
Collection d'Œuvre
Photographiques de la Caisse
des Depots, Paris
Fig. p. 386

Massimino
22 1/4 x 20 1/2 in
Collection d'Œuvre
Photographiques de la Caisse
des Depots, Paris
Fig. p. 387

Titus
18 7/8 x 15 3/8 in
Lent by the artist

Plotina
23 1/4 x 20 1/2 in
Collection d'Œuvre
Photographiques de la Caisse
des Depots, Paris

Enobarbe
20 1/2x 16 15/16 in
Collection d'Œuvre
Photographiques de la Caisse
des Depots, Paris

Hans-Peter Feldmann

*Photos taken from hotel
windows by Feldmann on
his travels*
1970s–1990s (selection)
Gelatin silver prints, c-prints
3 5/16 x 4 13/16–4 x 5 7/8 in
Lent by the artist
© VG BILD-KUNST, Bonn 2000
Figs. p. 391–395

Untitled, 1972–1973
Gelatin silver print
10 15/16 x 8 3/8 in
Private collection
Photo: Wolfgang Morell
© VG BILD-KUNST, Bonn 2000
Fig. p. 396

Untitled, 1972–1973
Nine pictures mounted on card
13 x 9 3/4 in
Private collection
Photo: Wolfgang Morell
© VG BILD-KUNST, Bonn 2000
Fig. p. 397

Untitled, 1972–1973
Nine pictures mounted on card
13 x 9 3/4 in
Private collection

Robert Frank

All exhibits from the series
The Americans
Gelatin silver prints
Addison Gallery of American
Art, Phillips Academy,
Andover, Massachusetts
© Robert Frank, Courtesy
Pace/McGill Gallery,
New York

*Parade–Hoboken,
New Jersey*, 1955/56
9 1/16 x 13 11/16 in
Photo: Robert Frank/Collection
Maison Européene de la
Photographie
Fig. p. 199

*City fathers–Hoboken,
New Jersey*, 1955/56
8 13/16 x 13 5/16 in
Photo: Robert Frank/Collection
Maison Européenne
de la Photographie
Fig. p. 201

Political rally–Chicago, 1955/56
12 15/16 x 8 7/16 in

*Funeral–St. Helena,
South Carolina*, 1955/56
13 7/8 x 9 1/8 in

Rodeo–Detroit, 1955/56
8 13/16 x 13 5/16 in

Movie premiere–Hollywood
1955/56
13 1/8 x 9 3/16 in
Photo: Robert Frank/Collection
Maison Européenne
de la Photographie
Fig. p. 217

Candy Store–New York City
1955/56
9 5/16 x 14 1/8 in

Motorama–Los Angeles
1955/56
9 1/2 x 14 in

New York City, 1955/56
12 3/4 x 8 7/8 in

Charleston, South Carolina
1955/56
9 15/16 x 14 13/16 in

Ranch Market–Hollywood
1955/56
9 3/8 x 14 1/4 in

Butte, Montana, 1955/56
9 1/2 x 14 3/8 in

*Yom Kippur–East River,
New York City*, 1955/56
9 1/2 x 14 1/4 in

*Fourth of July–Jay,
New York*, 1955/56
13 1/2 x 9 1/8 in

Trolley, New Orleans, 1955/56
9 3/4 x 15 in
Photo: Robert Frank/Collection
Maison Européenne
de la Photographie
Fig. p. 205

Canal Street–New Orleans
1955/56
8 15/16 x 13 11/16 in

*View from hotel window–
Butte, Montana*, 1955/56
9 3/16 x 14 1/16 in

*U.S. 91, leaving Blackfoot,
Idaho*, 1955/56
9 1/4 x 13 7/8 in
Photo: Robert Frank/Collection
Maison Européenne
de la Photographie
Fig. p. 207

St. Petersburg, Florida
1955/56
9 x 13 1/2 in

*Covered car–Long Beach,
California*, 1955/56
9 1/4 x 14 in

*Car accident–U.S. 66,
between Winslow and Flagstaff,
Arizona*, 1955/56
9 1/16 x 14 1/4 in

U.S. 285, New Mexico
1955/56
13 9/16 x 9 5/16 in

Santa Fe, New Mexico
1955/56
8 13/16 x 13 in

Bar–New York City, 1955/56
9 5/16 x 13 13/16 in
Photo: Robert Frank/Collection
Maison Européenne de la
Photographie
Fig. p. 209

Elevator–Miami Beach, 1955/56
10 x 14 7/8 in
Photo: Robert Frank/Collection
Maison Européenne de la
Photographie
Fig. p. 211

Drive-in movie–Detroit, 1955/56
9 7/8 x 14 7/8 in

*Mississippi River, Baton Rouge,
Louisiana*, 1955/56
9 3/8 x 14 3/8 in

*St. Francis, gas station, and
City Hall–Los Angeles*, 1955/56
8 13/16 x 13 5/8 in

*Crosses on scene of highway
accident–U.S. 91, Idaho*
1955/56
14 3/4 x 9 13/16 in

Assembly line—Detroit
1955/56
9 11/16 x 14 5/16 in

Convention hall—Chicago
1955/56
8 7/8 x 13 7/16 in

Cocktail party—New York City
1955/56
8 15/16 x 13 5/8 in

Beaufort, South Carolina
1955/56
9 5/8 x 14 1/2 in

Funeral—St. Helena,
South Carolina, 1955/56
9 5/16 x 13 3/16 in
Photo: Robert Frank/Collection
Maison Européenne de la
Photographie
Fig. p. 203

Television studio—Burbank,
California, 1955/56
8 11/16 x 13 1/16 in

Los Angeles, 1955/56
14 5/16 x 9 1/2 in
Photo: Robert Frank/Collection
Maison Européenne
de la Photographie
Fig. p. 215

Charity ball—New York City
1955/56
13 1/4 x 8 1/2 in

Cafeteria—San Francisco
1955/56
13 7/16 x 9 in

Drug store—Detroit, 1955/56
13 3/8 x 8 15/16 in

Coffee shop, railway station—
Indianapolis, 1955/56
9 5/16 x 13 15/16 in

San Francisco, 1955/56
9 1/2 x 14 5/16 in

Belle Isle, Detroit, 1955/56
8 3/4 x 13 3/4 in

Detroit, 1955/56
8 11/16 x 13 1/4 in

Public park—Ann Arbor,
Michigan, 1955/56
9 3/16 x 13 11/16 in

U.S. 90, en route to Del Rio,
Texas, 1955/56
14 13/16 x 9 5/8 in
Photo: Robert Frank/Collection
Maison Européenne de la
Photographie
Fig. p. 219

Lee Friedlander
All exhibits:
Gelatin silver prints
Collection of the
Niedersächsische Sparkassen-
stiftung, Hanover
© Lee Friedlander

Philadelphia, 1965
7 1/2 x 11 1/4 in
Fig. p. 426

NYC, 1966
7 1/2 x 11 1/4 in
Fig. p. 427

NY State, 1966
7 1/2 x 11 1/4 in

Madison, Wisconsin, 1966
7 1/2 x 11 1/4 in
Fig. p. 428

New City, 1967
7 9/16 x 11 1/4 in
Fig. p. 429

Colorado, 1967
7 1/2 x 11 1/4 in

Buffalo, 1968
7 1/2 x 11 3/16 in

Philadelphia, 1968
11 1/4 x 7 1/2 in

Rt. 9W, NY, 1969
7 9/16 x 11 1/4 in

Canyon de Chelly, 1983
12 x 8 in
Fig. p. 433

New York City, 1994
14 3/4 x 14 5/8 in
Fig. p. 434

Tokyo, 1994
10 3/16 x 10 3/16 in
Fig. p. 431

Tokyo, 1994
10 3/8 x 10 3/16 in

New City, 1996
10 1/2 x 10 1/8 in
Fig. p. 437

Montreal, 1997
14 7/8 x 14 11/16 in
Fig. p. 435

Odessa, Texas, 1997
14 13/16 x 14 11/16 in

Paris, 1997
10 1/4 x 10 3/16 in

Montreal, 1997
10 1/4 x 10 1/4 in

Gallup, 1998
14 13/16 x 14 11/16 in

Washington D.C., 1998
14 13/16 x 14 11/16 in

Bernhard Fuchs
All exhibits:
c-prints
Lent by the artist
© Bernhard Fuchs

Herr Ö., St. Peter, 1994
12 3/16 x 10 in
Fig. p. 351

Helfenberg, Waldhäuser, 1994
11 3/8 x 9 7/8 in

Traberg, Waldschlag, 1996
12 x 9 7/16 in
Fig. p. 353

St. Stephan a. W., 1997
11 x 8 7/8 in
Fig. p. 352

Traberg, Waldschlag, 1997
10 13/16 x 8 1/2 in
Fig. p. 353

Renate, Haslach a. d. Mühl
1997
11 1/8 x 8 15/16 in

Helfenberg, 1998
12 3/8 x 9 1/16 in
Fig. p. 355

Wünschendorf, 1998
11 3/8 x 8 5/8 in

Frau M., Bad Leonfelden,
Dietrichschlag, 1998
12 x 8 1/4 in

Helfenberg, Ahorn, 1999
9 7/8 x 12 3/8 in

Alberto Giacometti
Figurine, 1960/1961
Bronze
26 3/4 in
Sprengel Museum Hannover
© VG BILD-KUNST, Bonn 2000

Dan Graham
Split-level Two Home Homes,
Jersey City, N.J., 1966/96
c-print mounted on
museum card
52 3/8 x 40 3/16 in
Collection Siemens
Kulturprogramm/Sprengel
Museum Hannover
© Dan Graham

View Interior, New Highway
Restaurant, Jersey City, N.J.
1967
2 c-prints mounted
on museum card
39 3/4 x 47 3/4 in
Collection Siemens
Kulturprogramm/Sprengel
Museum Hannover
© Dan Graham
Fig. p. 341

Andreas Gursky
All exhibits:
c-prints
81 1/8 x 132 1/4 in
Lent by the artist
© VG BILD-KUNST, Bonn 2000

99 Cent, 1999
Fig. p. 453

Toys 'R' US, 1999
Fig. p. 455

Chicago Board of Trade II,
1999
Fig. p. 457

Vilhelm Hammershøi

Interieur (Sunny Room)
1905
Oil on canvas
19 9/16 x 15 3/4 in
Staatliche Museen zu Berlin,
Nationalgalerie
Fig. p. 149
© Staatliche Museen zu
Berlin–Preussischer Kultur-
besitz, Nationalgalerie

David Hockney

A Hollywood Garden, 1966
Acrylic on canvas
72 x 72 in
Hamburger Kunsthalle
Photo: Elke Walford, Hamburg
© David Hockney
Fig. p. 244

Martin Honert

Photo, 1993
Epoxy resin, wood and
paint Chair with figure:
height 42 1/8 in Table:
31 1/8 x 52 3/8 x 33 7/8 in
Collection Landesbank Baden-
Württemberg, Stuttgart
© VG BILD-KUNST, Bonn 2000
Fig. p. 399

Edward Hopper

Manhattan Bridge Loop, 1928
Oil on canvas
35 x 60 in
Addison Gallery of American
Art, Phillips Academy, Andover,
Massachusetts.
Gift of Stephen C. Clark, Esq.
© Addison Gallery of American
Art, Phillips Academy, Andover,
Massachusetts,
All Rights Reserved
Fig. p. 185

City Sunlight, 1954
Oil on canvas
28 3/16 x 40 1/8 in
Hirshhorn Museum and Sculp-
ture Garden, Smithsonian Insti-
tution, Gift of the Joseph H.
Hirshhorn Foundation, 1966.
Fig. p. 305

Axel Hütte

Furka, Switzerland, 1995
Diptych
c-prints
each 80 3/4 x 63 3/4 in
Private collection
© Axel Hütte
Figs. p. 348–349

Jasper Johns

Grey Target, 1958
Encaustic on canvas
12 x 12 in
Private collection, Courtesy
Sonnabend Gallery
© V.A.G.A., New York
Fig. p. 193

On Kawara

All exhibits:
Liquitex on canvas
Kunstmuseum St. Gallen,
acquired from the
Marie Müller-Guarnieri-
Stiftung
© On Kawara, New York

TODAY Series
NOV. 18, 1966
Text verso: "I collected
the painted days"
8 x 10 in

TODAY Series
NOV. 26, 1966
Text verso: "Army won the
20-7 victory over Navy today
before a crowd of 100.000 at
John F. Kennedy Stadion
in Philadelphia, U.S.A."
8 x 10 in
Fig. p. 402

TODAY Series
DEC. 3, 1966
Text verso: "A baby crying
through history"
10 x 13 in

TODAY Series
DEC. 28, 1966
Text verso: "Communist
China today exploded its
fifth atomic device"
8 x 10 in
Fig. p. 403

Ellsworth Kelly

Two Panels: Red Yellow
1971
Acrylic on canvas
109 x 79 7/8 in
Westfälisches Landesmuseum
für Kunst und Kultur-
geschichte, Münster
Photo: Rudolf Wakonegg and
Sabine Ahlbrand-Dornseif
Fig. p. 229
© Ellsworth Kelly/Courtesy Leo
Castelli Gallery, New York

Franz Kline

August Day, 1957
Oil on canvas
92 1/8 x 78 in
Collection Lohmann Hofmann,
Courtesy Hachmeister, Münster
© VG BILD-KUNST, Bonn 2000
Fig. p. 323

Kurt Kocherscheidt

The Black Sea I + II
1991
Oil on canvas
each 78 3/4 x 63 in
Morat-Institut für Kunst und
Kunstwissenschaft, Freiburg
im Breisgau
© Elfi Semotan-Kocherscheidt,
Vienna
Figs. p. 450–451

Roy Lichtenstein

Little Aloha, 1962
Acrylic on canvas
44 1/8 x 42 1/8 in
Sonnabend Collection
© VG BILD-KUNST, Bonn 2000
Fig. p. 237

Albert Marquet

*View of the Pont Saint Michel in
Paris*, 1912
Oil on canvas
25 5/8 x 31 7/8 in
Staatliche Kunsthalle Karlsruhe
© VG BILD-KUNST, Bonn 2000
Fig. p. 145

Agnes Martin

Untitled, No. 17, 1980
Gesso, acrylic, graphite,
canvas
72 x 72 in
Kunsthalle Bielefeld
Photo: Marcus Schneider
© 2000 Agnes Martin
Fig. p. 311

Boris Michailov

By the Ground, 1991
Diptychs from the series
(Selection)
Gelatin silver prints, toned
each 6 1/2 x 23 3/8 in
Lent by the artist
© Boris Michailov
Figs. p. 282–285

Giorgio Morandi

Natura morta, ca. 1955/56
Oil on canvas
14 3/4 x 13 3/4 in
Sprengel Museum Hannover
© VG BILD-KUNST, Bonn 2000
Fig. p. 365

Bruce Nauman

none sing, neon sign, 1970
Ruby red and cool white
glass tubing
44 x 31 x 14 in
Private collection, courtesy
Sonnabend Gallery
© VG BILD-KUNST, Bonn 2000
Fig. p. 227

Nicholas Nixon

All exhibits:
Gelatin silver prints
© 2000 Nicholas Nixon

The Brown Sisters, 1975–1999
each 7 5/8 x 9 5/8 in
Collection of the Nieder-
sächsische Sparkassenstiftung,
Hanover
Figs. p. 405–413

Bebe and I, Lexington, 1998
7 7/8 x 9 5/8 in
Lent by the artist
Fig. p. 415

Bebe and I, Lexington, 1998
9 5/8 x 7 5/8 in
Lent by the artist
Fig. p. 416

Sam, Lexington, 1998
9 5/8 x 7 5/8 in
Lent by the artist
Fig. p. 417

Bebe and I, Marseille, 1998
9 5/8 x 7 5/8 in
Lent by the artist
Fig. p. 418

Clementine, Brookline, 1999
9 5/8 x 7 5/8 in
Lent by the artist
Fig. p. 419

Sam and Bebe, Lexington, 1997
9 5/8 x 7 5/8 in
Lent by the artist

Sam and I, Lexington, 1998
9 5/8 x 7 5/8 in
Lent by the artist

Pablo Picasso

Inclined Head of a Woman
1906
Oil on canvas
20 1/16 x 15 9/16 in
Staatsgalerie Stuttgart
© Succession Picasso, Paris,
VG BILD-KUNST, Bonn 2000
Fig. p. 439

Sigmar Polke

All exhibits:
Gelatin silver prints
The J. Paul Getty Museum,
Los Angeles
© Sigmar Polke

Untitled (Düsseldorf), 1969
6 17/32 x 8 29/32 in
Fig. p. 238

Untitled (Düsseldorf), 1969
6 23/32 x 8 29/32 in
Fig. p. 239

Untitled (Düsseldorf), 1969
6 22/32 x 8 7/8 in

Untitled (Hamburg), 1970
7 1/32 x 9 11/32 in
Fig. p. 233

Untitled (Düsseldorf), 1970
5 1/32 x 6 15/16 in
Fig. p. 234

Untitled (Geneva), 1970
9 5/32 x 6 11/32 in
Fig. p. 235

Untitled (Düsseldorf), 1970
4 15/16 x 6 31/32 in

Untitled (Geneva), 1970
7 1/16 x 9 3/8 in

Untitled (Lucerne/Cologne)
1971
7 1/16 x 9 3/8 in

Odilon Redon

*Still-life of flowers
in green jug*
1866/68
Oil on canvas
13 1/4 x 9 7/8 in
Staatliche Kunsthalle Karlsruhe
© Odilon Redon
Fig. p. 333

David Reed

276 (for Nicholas Wilder)
1988
Oil and alkyd on canvas
24 x 102 in
Collection Barbara and
Howard Morse
© David Reed
Fig. p. 425

Albert Renger-Patzsch

All exhibits:
Gelatin silver prints
Albert Renger-Patzsch Archiv
Ann and Jürgen Wilde, Zülpich
© VG BILD-KUNST, Bonn 2000

*Hohenburgstraße at the Main
Station Embankment
in Essen*, 1928
8 7/8 x 6 9/16 in

Outskirts of Essen, 1928
6 11/16 x 8 7/8 in
Fig. p. 158

Essen Bergeborbeck, 1929
6 11/16 x 9 in
Fig. p. 156

"Eiserne Hand" in Essen, 1929
8 5/8 x 6 1/4 in
Fig. p. 163

*Miners' Houses in
Essen-Stoppenberg*, 1929
6 3/8 x 8 3/4 in

Country Road near Essen, 1929
6 11/16 x 8 7/8 in

*The "Victoria Mathias" Colliery
of RWE in Essen*, 1929
8 15/16 x 6 9/16

Street in Oberhausen, 1931
16 11/16 x 9 in

*Oberhauserstraße in
Essen-Bedingrade*, 1932
8 7/8 x 6 1/2 in
Fig. p. 161

Street in Essen, 1932
6 1/2 x 8 3/4 in

Houses in Essen-Segeroth, 1932
8 15/16 x 6 9/16 in
Fig. p. 160

*The "Germania" Colliery
in Dortmund-Marten*, 1935
6 1/8 x 8 7/8 in
Fig. p. 159

Gerhard Richter

Untitled, 1970
Oil on canvas
78 3/4 x 118 1/8 in
Sprengel Museum Hannover
© Gerhard Richter
Fig. p. 253

Judith Joy Ross

10 works from the series
*Portraits at the Vietnam
Veterans Memorial,
Washington, D.C., 1983–1984*
Gelatin silver prints
each 9 5/8 x 7 5/8 in
Collection of the Niedersäch-
sische Sparkassenstiftung,
Hanover
© Judith Joy Ross
Figs. p. 366–373

Mark Rothko

*Untitled
(Light Plum and Black)*, 1964
Oil on canvas
81 x 69 in
Galerie Beyeler
© Kate Rothko-Prizel &
Christopher Rothko/
VG BILD-KUNST, Bonn 2000
Fig. p. 213

Thomas Ruff

All exhibits:
c-prints
© VG BILD-KUNST, Bonn 2000

Portrait M. V. / B. E., 1991
15 9/16 x 11 5/8 in
Collection Bernd F. Künne
Fig. p. 257

Portrait R. M. / B. E., 1991
15 9/16 x 11 5/8 in
Collection Bernd F. Künne
Fig. p. 257

Portrait C. K. / B. E., 1991
15 9/16 x 11 5/8 in
Collection Bernd F. Künne
Fig. p. 257

Portrait M. B. / B. E., 1991
15 9/16 x 11 5/8 in
Collection Bernd F. Künne
Fig. p. 257

Portrait R. H. / B. E., 1991
15 9/16 x 11 5/8 in
Collection Bernd F. Künne

Portrait L. C. / B. E., 1991
15 9/16 x 11 5/8 in
Collection Bernd F. Künne

Portrait, 1998
82 11/16 x 64 15/16 in
Courtesy Mai 36 Galerie
Zürich
Fig. p. 255

Portrait, 1999
82 11/16 x 64 15/16 in
Courtesy Mai 36 Galerie
Zürich
Fig. p. 254

Ed Ruscha

*Every building on
the Sunset Strip*, 1966
Book with fold-out
(Offset print)
7 1/16 x 5 11/16 x 1/2 in
Collection Siemens
Kulturprogramm
© Ed Ruscha
Figs. p. 130–131

August Sander

All exhibits:
Gelatin silver prints
© Die Photographische
Sammlung/SK Stiftung Kultur
August Sander Archiv,
Cologne; VG BILD-KUNST,
Bonn 2000

Peasant Family, 1911/12
6 1/2 x 9 1/16 in
Private collection
Abb. 165

*Mother and Daughter,
Farmer's and Miner's Wives*
1912
8 1/16 x 5 27/32 in
Private collection
Photo: Wolfgang Morell
Fig. p. 169

Young Farmers, Westerwald
1914
9 1/8 x 6 11/16 in
Die Photographische
Sammlung/SK Stiftung Kultur,
Cologne
Fig. p. 166

Bourgeois Family, 1923
9 1/16 x 6 9/16 in
Private collection

The Gentleman Farmer, 1924
9 5/8 x 7 1/4 in
Private collection
Photo: Wolfgang Morell
Fig. p. 168

Bourgeois Children, 1925
9 1/8 x 6 5/16 in
Private collection

*The Painter
(Anton Räderscheidt)*, ca. 1926
9 1/16 x 6 11/16 in
Private collection
Photo: Wolfgang Morell
Fig. p. 173

Prizewinner, 1927
8 5/8 x 6 5/16 in
Private collection

Pastry Cook, 1928
9 3/8 x 5 15/32 in
Die Photographische
Sammlung/SK Stiftung Kultur,
Cologne
Fig. p. 167

Master Locksmith, 1928
9 1/16 x 5 11/16 in
Die Photographische
Sammlung/SK Stiftung Kultur,
Cologne

*Farmer's Girl,
Westerwald*, 1928
11 3/16 x 8 3/8 in
Die Photographische
Sammlung/SK Stiftung Kultur,
Cologne

Unemployed, 1928
9 3/16 x 5 13/16 in
Die Photographische
Sammlung/SK Stiftung Kultur,
Cologne

Berlin Coal Carriers, 1929
9 3/8 x 6 5/8 in
Die Photographische
Sammlung/SK Stiftung Kultur,
Cologne

*Workers Council from
the Ruhrgebiet*, 1929
6 3/16 x 8 3/4 in
Die Photographische
Sammlung/SK Stiftung Kultur,
Cologne

Boxer, 1929
8 5/8 x 5 13/16 in
Die Photographische
Sammlung/SK Stiftung Kultur,
Cologne

City Children Vienna, 1930
11 3/8 x 9 1/16 in
Private collection
Photo: Wolfgang Morell
Fig. p. 174

*Blind Miner and
Blind Soldier*, ca. 1930
11 x 8 5/8 in
Die Photographische
Sammlung/SK Stiftung Kultur,
Cologne

*Basalt Quarry in the
Siebengebirge*, 1930s
6 5/8 x 4 3/4 in
Private collection

Lawyer, 1931
11 x 7 7/8 in
Die Photographische
Sammlung/SK Stiftung Kultur,
Cologne
Fig. p. 170

Girl in Circus Trailer, 1932
6 3/4 x 4 3/4 in
Private collection
Photo: Wolfgang Morell
Fig. p. 175

Forest, ca. 1935
9 3/16 x 6 7/8 in
Private collection
Photo: Wolfgang Morell
Fig. p. 357

Forest, ca. 1935
9 3/8 x 7 1/16 in
Private collection

Forest, ca. 1935
9 1/4 x 6 7/8 in
Private collection
Photo: Wolfgang Morell
Fig. p. 356

National Socialist, ca. 1935
8 3/4 x 6 9/16 in
Private collection

*Victim of Persecution,
Cologne*, ca. 1938
11 5/16 x 8 7/8 in
Die Photographische
Sammlung/SK Stiftung Kultur,
Cologne

*Victim of Persecution,
Cologne*, ca. 1938
11 1/2 x 8 7/16 in
Die Photographische
Sammlung/SK Stiftung Kultur,
Cologne
Fig. p. 177

Confirmand, Cologne, 1927
8 7/8 in x 6 in
Private collection

Oskar Schlemmer
*Towards each other
in a space*, 1928
Oil on canvas
39 1/16 x 29 5/16 in
Sprengel Museum Hannover
© 2000 Oskar Schlemmer,
Archive and Family Estate,
I-28824 Oggebbio
Fig. p. 171

Michael Schmidt
Waffenruhe (Ceasefire)
1985–1987 (Selection)
Gelatin silver prints
19 11/16 x 15 3/4 in,
23 5/8 x 19 11/16 in,
35 7/16 x 27 9/16 in
Collection of the Niedersäch-
sische Sparkassenstiftung,
Hanover, © Michael Schmidt
Figs. p. 361–363

Women, 1997–1999
(Selection)
Gelatin silver prints
each 23 7/16 x 19 9/16 in
Collection of the Niedersäch-
sische Sparkassenstiftung,
Hanover, © Michael Schmidt
Figs. p. 440–449

Carl Schuch
*Two Wild Ducks with
Enamel Pot*, 1880/82
Oil on canvas
24 1/2 x 31 in
Morat-Institut für Kunst
und Kunstwissenschaft,
Freiburg im Breisgau
Fig. p. 389

Thomas Schütte
Untitled, 1999
Clay, glazed, 5 parts
Height: 33 1/2 to 60 5/8 in
Collection of the Niedersäch-
sische Sparkassenstiftung,
Hanover
Photo: Helge Mundt, Hamburg
© VG BILD-KUNST, Bonn 2000
Fig. p. 375

Charles Sheeler
All exhibits:
Gelatin silver prints
The Lane Collection, Courtesy
of Museum of Fine Arts,
Boston. Reproduced with
permission. © 1999 Museum
of Fine Arts, Boston. All Rights
Reserved.

*Doylestown House–Stove,
Horizontal*, 1917
6 1/2 x 9 1/4 in
Fig. p. 150

Doylestown House–Stove
1917
9 1/8 x 6 3/8 in

*Doylestown House–
Downstairs Window*, 1917
9 7/16 x 6 3/8 in
Fig. p. 151

Side of White Barn, 1917
7 5/16 x 9 5/16 in
Fig. p. 155

Doylestown House–Stairwell
1917
9 1/8 x 6 1/2 in

*Doylestown House–
Stairs from Below*, 1917
8 5/16 x 5 7/8 in
Fig. p. 153

*Doylestown House–
Open Window*, 1917
9 1/2 x 7 in

*Doylestown House–
Stairway with chair*, 1917
9 3/8 x 6 1/2 in
Fig. p. 152

*Doylestown House–
Closet, Stairs*, 1917
9 3/8 x 6 7/16 in

New York, Temple Court
1920
9 3/8 x 7 5/8 in

Manhatta–Men in Boaters
1920
3 7/8 x 5 1/8 in

*Manhatta–Through
a Balustrade*, 1920
4 x 5 3/8 in
Fig. p. 144

Manhatta–Rooftops, 1920
3 7/8 x 5 1/8 in

*New York, Buildings
in the Shadows*, 1920
9 1/2 x 7 1/2 in
Fig. p. 146

New York, Park Row Building
1920
9 1/2 x 7 in
Fig. p. 147

*New York, Broadway
at Fortieth Street*, ca. 1920
9 1/2 x 6 1/2 in

Pulverizer Building–Ford Plant
1927
10 x 8 in
Fig. p. 321

*Blast Furnace and Dust
Catcher–Ford Plant*, 1927
9 3/8 x 7 7/16 in
Fig. p. 320

Bleeder Stacks–Ford Plant
1927
9 5/16 x 7 7/16 in

*Criss-Crossed Conveyors–
Ford Plant*, 1927
10 x 8 in
Fig. p. 319

*Ladle on a Hot Metal Car–
Ford Plant*, 1927
9 5/16 x 7 7/16 in

Slag Buggy–Ford Plant
1927
9 3/4 x 7 1/2 in

Cindy Sherman
Untitled # 93, 1981
c-print
24 x 48 in
Collection Goetz, Munich
Photo: Raimund Koch
© Courtesy of the artist
and Metro Pictures
Fig. p. 421

Untitled # 96, 1981
c-print
24 x 48 in
Skarstedt Fine Art, New York
© Courtesy of the artist and
Metro Pictures
Fig. p. 423

Stephen Shore
All exhibits:
from the series
Uncommon Places
c-prints
Collection of the Nieder-
sächsische Sparkassenstiftung,
Hanover
© 1982 Stephen Shore

*Second Street, Ashland,
Wisconsin, July 9, 1973*
7 5/8 x 9 5/8 in
Fig. p. 241

*Church and Second Streets,
Easton, Pennsylvania, June 20,
1974*
7 5/8 x 9 5/8 in

*Wilde Street and Colonization
Avenue, Dryden, Ontario,
August 15, 1974*
7 5/8 x 9 5/8 in

*Holden Street, North Adams,
Massachusetts, July 13, 1974*
7 5/8 x 9 5/8 in
Fig. p. 243

*Proton Avenue, Gull Lake,
Saskatchewan, August 17, 1974*
7 5/8 x 9 5/8 in

*Second Street East and
South Main Street, Kalispell,
Montana, August 22, 1974*
7 5/8 x 9 5/8 in

*Ginger Shore, Flagler Street,
Miami, Florida, November 12,
1977*
7 5/8 x 9 5/8 in

*Trail's End Restaurant,
Kanab, Utah, August 10, 1973*
7 5/8 x 9 5/8 in

Michael and Sandy Marsh,
Amarillo, Texas, September 27,
1974
7 5/8 x 9 5/8 in

West Ninth Avenue, Amarillo,
Texas, October 2, 1974
7 5/8 x 9 5/8 in

Presidio, Texas,
February 21, 1975
7 5/8 x 9 5/8 in
Fig. p. 242

Meeting Street, Charleston,
South Carolina, August 3, 1975
7 5/8 x 9 5/8 in
Fig. p. 245

Coronado Street, Los Angeles,
California, June 21, 1975
7 5/8 x 9 5/8 in

El Paso Street, El Paso, Texas,
July 5, 1975
7 5/8 x 9 5/8 in

Cumberland Street, Charleston,
South Carolina, August 3, 1975
7 5/8 x 9 5/8 in
Fig. p. 248

La Brea Avenue and Beverly
Boulevard, Los Angeles,
California, June 21, 1975
7 5/8 x 9 5/8 in
Fig. p. 246

Kingman, Arizona,
July 2, 1975
7 5/8 x 9 5/8 in

Sutter Street and Crestline
Road, Fort Worth, Texas,
June 3, 1976
7 5/8 x 9 5/8 in

Moore Haven, Florida,
November 15, 1977
7 5/8 x 9 5/8 in

Key Largo, Florida,
November 10, 1977
7 5/8 x 9 5/8 in

Flagler Street, Miami, Florida,
November 12, 1977
9 5/8 x 7 5/8 in

Tampa, Florida,
November 17, 1977
7 5/8 x 9 5/8 in

Graig Nettles, Fort Lauderdale,
Florida, March 1, 1978
7 5/8 x 9 5/8 in

Merced River, Yosemite
National Park, California, August
13, 1979
7 5/8 x 9 5/8 in
Fig. p. 139

North Black Avenue, Bozeman,
Montana, January 16, 1981
7 5/8 x 9 5/8 in

Volker Stelzmann

For R. D. (Rudi Dutschke)
1980/81
Mixed media, hardboard
44 5/8 x 48 in
Private collection
© VG BILD-KUNST, Bonn 2000
Fig. p. 279

Paul Strand
All exhibits:
Photogravure print from
Camera Work
Aperture Foundation Inc.,
Paul Strand Archive

Fifth Avenue and 42nd Street,
New York, 1915
5 x 6 1/2 in
© 1971 Aperture Foundation
Inc., Paul Strand Archive
Fig. p. 139

Porch Shadows, Twin Lakes,
Connecticut, 1916
9 5/8 in x 6 5/8 in
© 1971 Aperture Foundation
Inc., Paul Strand Archive
Fig. p. 140

Wall Street, New York, 1915
5 3/16 x 6 7/16 in
© 1971 Aperture Foundation
Inc., Paul Strand Archive
Fig. p. 141

Untitled, 1916
8 13/16 x 6 1/2 in
© 1981 Aperture Foundation
Inc., Paul Strand Archive
Fig. p. 142

Blind Woman, New York
1916
8 13/16 x 6 1/2 in
© 1981 Aperture Foundation
Inc., Paul Strand Archive
Fig. p. 143

Thomas Struth
All exhibits:
© Thomas Struth/Courtesy
Galerie Max Hetzler, Berlin

Crosby Street, New York,
Soho, 1978
Gelatin silver print
17 5/16 x 22 in
Thomas Struth, Courtesy
Galerie Max Hetzler, Berlin

Dey Street, New York
1978
Gelatin silver print
11 13/16 x 15 3/4 in
Thomas Struth, Courtesy
Galerie Max Hetzler, Berlin
Fig. p. 135

Düsselstraße, Düsseldorf
1979
Gelatin silver print
17 5/16 x 22 in
Thomas Struth, Courtesy
Galerie Max Hetzler, Berlin
Fig. p. 134

Street near Charleroi,
Charleroi, 1980
Gelatin silver print
15 15/16 x 23 in
Thomas Struth, Courtesy
Galerie Max Hetzler, Berlin
Fig. p. 133

Hofgraben, Munich, 1981
Gelatin silver print
17 5/16 x 22 in
Thomas Struth, Courtesy
Galerie Max Hetzler, Berlin
Fig. p. 132

People on Fuxing Dong Lu,
Shanghai, 1997
c-print
34 5/8 x 44 1/16 in
Collection Bernd F. Künne
Fig. p. 137

Musée du Louvre I, Paris
1989
c-print
72 1/16 x 92 1/8 in
Private collection
Fig. p. 251

Kunsthistorisches Museum III,
Wien, 1989
c-print
57 1/16 x 73 5/8 in
Private collection

Shomei Tomatsu
All exhibits:
from the series
Nagasaki 11:02, August 9, 1945
Gelatin silver prints
Lent by the artist
© Shomei Tomatsu

Wristwatch dug up in
Uenomachi, 0.7 kilometers
from the hypocenter, 1961
13 5/16 x 12 15/16 in
Fig. p. 377

Deformed statues of angels
from Urukami Cathedral,
0.6 kilometers from the
hypocenter, 1961
13 3/4 x 12 7/8 in
Fig. p. 378

Bottle melted by heat rays
and fire, 1961
13 9/16 x 12 7/8 in

Oura neighborhood, 1961
14 3/8 x 12 9/16 in

Ms. Fukuda, 1962
16 7/8 x 11 1/2 in
Fig. p. 379

Sumako Fukuda
Born on 23rd March 1922.
When the atom bomb fell on
Nagasaki on 9th August 1945,
Sumako Fukuda was in the

523

Nagasaki Teacher Training College for Boys (1.7 km from the epicentre). Her parents and her elder sister were at home in Sakamoto-cho (0.7 km from the epicentre) and were killed outright.

The first symptoms of contamination appeared in 1955. The changes to her skin were diagnosed as the after-effect of the atom bomb. From then on she had to be hospitalized time and time again. Her autobiography, *Warenaoikiteari*, was published in 1968. She received the 9th Tamura Prize for Literature in 1969. Sumako Fukuda died on 2nd April 1974.

On 2nd August 1975, a memorial inscribed with her poems was inaugurated in the Heiwa-koen.

Sumako Fukuda: "'Run to the mountain!' says a voice like a teacher's. We turn toward the entrance and go out on the street. The electric lines are all torn and hanging down. The houses are in rubble and some are already on fire. From beneath one of the houses comes a voice crying for help. Out on the road, there are people in a terrible state: people walking with their skin hanging off them like old rags, people with their bodies all red and swollen, deadly wounded people desperately trying to walk. Already they seem to have lost their humanity and look more like a macabre procession of ghosts. Naked students run past us shouting deliriously, 'It's hot! It's hot!'"

Urakami neighborhood with Mount Iwaya in the distance
1961
13 1/4 x 13 1/4 in

Partitioned housing in Oura, 1962
10 13/16 x 15 13/16 in
Fig. p. 380

Jichu Chinese primary school, now a Confucian shrine, 1963
11 15/16 x 15 5/8 in

Oura open-air market, 1962
15 7/8 x 10 11/16 in

Around Nagasaki Harbor, 1961
13 11/16 x 13 5/8

Senji Yamaguchi, of Urakami, 1962
17 1/16 x 12 in

Senji Yamaguchi
Born on 3rd October 1930.
On 9th August, Senji Yamaguchi was working in the Mitsubishi munitions factory (1.2 km from the epicentre) when the atom bomb fell. He suffered serious burns from the explosion. Surgical operations were performed on his burns at the Nagasaki University Clinic in 1953. Following the first international nuclear disarmament conference, Senji Yamaguchi became a committed member of the campaign for nuclear disarmament.
In 1961, his wife opened a beauty salon and he helped her to run it.
In 1968, he passed his civil engineering examination and opened an architect's office. He is a member of the executive committee of one of Japan's associations of atom bomb victims.
Senji Yamaguchi: "I was exhausted and I looked for somewhere to sit. I was barefoot and wearing only a pair of underpants... I was thirsty too because of all those people around me shouting for water. Nearly all of them were burnt black on their hands, chests or faces. These faces were unre-

cognizable and the eyes and the teeth seemed to float there. You could not tell who was a man or a woman. All this made me think of my own hands and feet. I was not surprised to see my body was as black as everyone else's."

A treaty signed in 1855 between Japan and the Netherlands, with the seal of Donker Curtius, the last Captain of the Dutch Company on the island of Dejima, off of Nagasaki, 1963
11 11/16 x 15 in

Sukesaku Suetsugu, of Urakami, 1961
16 7/8 x 12 1/16 in

Sukesaku Suetsugu
Born on 1st June 1899.
On 9th August 1945, Sukesaku Suetsugu was working in the Mitsubishi-Heiki munitions factory (1.4 km from the epicentre) when the atom bomb was dropped on Nagasaki. The pressure from the explosion threw him through the air, breaking his hip. His family was at home in Zeniza-cho (1.6 km from epicentre). Three of his children were killed outright.
In 1953, Sukesaku Suetsugi's condition worsened to such an extent that he could not even go to the toilet anymore. He died in 1969.
Sukesaku Suetsugu: "I can't tell you the suffering we went through. For four years, my wife managed to support us by growing vegetables because I was too sick in bed to do anything. But life got worse and worse and so I forced myself to get up and I went to the employment office looking for a job as a day worker. But what with my legs and hips being so weak, all I could get was a job looking after tools.

The pay was the same as that they gave the laborers, who then looked down on me because they thought I had it easy. Every time I said something to them, they just ignored me. Since I got affected by the A-bomb my life's been terrible. I've had twenty one-years of nothing but suffering."

Mr. Suetsugu's house, 1961
16 7/8 x 12 1/16 in

Kiyomi Urakawa and her daughters, Urakami, 1961
12 5/8 x 15 1/4 in

Kiyomi Urakawa
Born on 1st January 1916.
On 9th August 1945, Kiyomi Urakawa was in Zeniza-cho (1.6 km from epicentre) when the atom bomb fell on Nagasaki. She was unconscious for 13 days. Her parents and four brothers—altogether six members of her family—were killed.
She married in 1946.
Her third daughter, Shizuka, was born on 8th February 1954.
In 1957, Shizuka underwent an operation for a malignant eye tumour.
Kiyomi Urakawa: "It was when I was breast-feeding Shizuka that I realized there was something wrong with one of her eyes. It was red and congested and wet with tears. As I looked closer I saw that it was cloudy and the color of mud. The specialist said that she had a form of eye cancer and that she would die if she didn't have an operation soon. Of course I took her straight to the hospital. After the operation the surgeon said that Shizuka's illness was most likely hereditary, a result of my exposure to atomic radiation when the A-bomb was dropped."

Kiyomi and Shizuka Urakawa
1961
11 1/2 x 15 15/16 in
Fig. p. 381

An image of Christ used as a "fumi-e", 1963
Gelatin silver print
15 7/8 x 10 3/4 in
Fig. p. 382

Tsuyo Kataoka from Urakami
1961
12 3/16 x 16 7/8 in
Fig. p. 383

Tsuyo Kataoka
Born on 17th January 1921. On 9th August 1945, Tsuyo Kataoka was working in the Mitsubishi-Heiki munitions factory (1.4 km from the epicentre) when the atom bomb was dropped on Nagasaki. Thirteen members of her family were killed.
In 1951, she was employed as a cleaner at the Nagasaki University Clinic.
Her mother died in 1962.
In 1981, Tsuyo Kataoka heard the Pope's Hiroshima speech and thereupon decided to join the peace movement.
As a representative of Japan's atom bomb victims, Tsuyo Kataoka read out an appeal for peace at the Nagasaki Peace Rally in 1984.
She underwent a stomach operation in 1993.
Tsuyo Kataoka: "I've no idea how I got away from the factory. The bomb had completely destroyed it. I've no idea either how I got to the path between the fields. I was delirious. I came to the Urakami River, and it was there, for the first time, that I saw hell on earth. There were hundreds and hundreds of people all on top of each other, and all dead. After a short while I couldn't see anymore. My wounds hurt so

much that I rolled over on the ground, scratching the earth as if I was a dog. Because I was blind I couldn't do anything, and so I stayed there in the open for three days and three nights, somewhere between life and death."

Fukue Island, Goto Archipelago, 1963
16 x 11 5/8 in

Tsuyo Kataoka at her family's graves, Urakami, 1961
11 7/16 x 15 5/8 in

All excerpts from:
Nagasaki, 11:02, August 9, 1945, Photographs by Shomei Tomatsu, Tokyo 1995

Ludwig Georg Vogel
Portrait of a Youth
ca. 1810
Oil on canvas
17 15/16 x 14 3/4 in
Kunsthalle Bremen
Fig. p. 259

Jeff Wall
The Old Prison, 1987
Cibachrome—slide
27 9/16 x 90 1/8 in
Galerie Johnen & Schöttle, Cologne
© Jeff Wall
Fig. p. 359

Andy Warhol
Campbell's Soup Can (Turkey Noodle), 1962
Silkscreen on canvas
20 1/16 x 16 1/8 in
Sonnabend Collection
© 2000 Andy Warhol Foundation / ARS, New York
TM Licensed by Campbell's Soup Co.
Fig. p. 189

Garry Winogrand
All exhibits from the series
Public Relations
Gelatin silver prints
© The Estate of Garry Winogrand/Courtesy Fraenkel Gallery, San Francisco

Hard Hat Rally, New York, 1969
9 x 13 7/16 in
Collection Siemens Kulturprogramm/Sprengel Museum Hannover

Apollo 11 Moon Shot, Cape Kennedy, Florida, 1969
11 x 14 in
Fraenkel Gallery, San Francisco
Fig. p. 275

Peace Demonstration, Central Park, New York, 1969
11 x 14 in
Fraenkel Gallery, San Francisco

Hard Hat Rally, New York
1969
11 x 14 in
Fraenkel Gallery, San Francisco
Fig. p. 276

Peace Demonstration, Central Park, New York, 1970
8 5/8 x 13 3/16 in
Collection Siemens Kulturprogramm/Sprengel Museum Hannover
Fig. p. 277

Tenth Anniversary Party, Guggenheim Museum, New York, 1970
8 1/2 x 12 5/8 in
The Museum of Contemporary Art, Los Angeles
The Ralph M. Parsons Foundation Photography Collection

Muhammad Ali—Oscar Bonavena Press Conference, New York, 1970
8 7/16 x 12 11/16 in
The Museum of Contemporary Art, Los Angeles
The Ralph M. Parsons Foundation Photography Collection
Photo: Brian Forrest
Fig. p. 274

Opening, Frank Stella Exhibition, The Museum of Modern Art, New York, 1970
8 7/16 x 12 11/16 in
The Museum of Contemporary Art, Los Angeles
The Ralph M. Parsons Foundation Photography Collection
Photo: Brian Forrest
Fig. p. 281

Reopening, Waldorf-Astoria, Peacock Alley, New York, 1971
8 1/2 x 12 3/4 in
The Museum of Contemporary Art, Los Angeles
The Ralph M. Parsons Foundation Photography Collection

Women's Liberation March, New York, 1971
11 x 14 in
Fraenkel Gallery, San Francisco

Presidential Candidates' Press Conference, Providence, RI
1971
11 x 14 in
Fraenkel Gallery, San Francisco
Fig. p. 280

Elliot Richardson Press Conference, Austin, TX, 1973
8 13/16 x 13 3/16 in
Collection Siemens Kulturprogramm/Sprengel Museum Hannover
Fig. p. 273

Authors

Heinz Liesbrock was born in 1953 in Duisburg. He studied Art History, American Literature, and German Literature at Bochum, Swansea, and Washington D.C. From 1986 to 1992 he was an art critic, after which he became Director of the Westphalian Kunstverein in Munster. He has organized the following exhibitions: *Die Wahrheit des Sichtbaren, Edward Hopper und die Fotografie*, Essen Folkwang Museum, 1992; *Fragen an vier Bilder, Stephen Shore, Fotografien 1973 bis 1993*; *Die Unersetzbarkeit des Bildes, zur Erinnerung an Max Imdahl, Der vorbehaltlose Blick*; Serge Spitzer, *Reality Models*; Gary Hill, *Midnight Crossing*, all at the Westphalian Kunstverein. He has published on American art and literature and on contemporary art, inter alia, *Edward Hopper. Das Sichtbare und das Unsichtbare*, 1992; *Die Suche nach dem Menschen. Raymond Chandlers Sprachkunst*, 1993.

Gerry Badger is a photographer, architect, and photographic critic. He has written extensively for the photographic press, and has curated a number of exhibitions, including *The Photographer as Printmaker* (1980) for the Arts Council of Great Britain, and *Through the Looking Glass: Postwar British Photography* (1989) for the Barbican Arts Center, London. His own work is in a number of public and private collections, including The Museum of Modern Art, New York, The Victoria and Albert Museum, London, The Arts Council of Great Britain Collection, and The Bibliothèque Nationale, Paris. He currently teaches history of photography at Brighton University.

Thomas Wagner was born in 1953 in Mannheim. He studied German literature and philosophy at Heidelberg and the University of Sussex, Brighton. Since 1991 he has been Fine Art Editor at the *Frankfurter Allgemeine Zeitung*. From 1995 to 1997 he was Visiting Professor of Art History at the Akademie der bildenden Künste in Nuremberg, where since 1999 he has been Honorary Professor of Art Criticism. He has published extensively on contemporary art and art criticism. Most recently: *Schrift an der Wand, Frankfurter Brief, Entenschlaf. Eklipse. Anmerkungen zu drei Arbeiten von Lothar Baumgarten*, 1997.

Peter Waterhouse was born in 1956 in Berlin. He studied at universities in Vienna and Los Angeles. He writes poetry, prose fiction, and essays, and translates from English and Italian (inter alia, Allen Ginsberg, Michael Hamburger, Gerard Manley Hopkins, Biagio Marin, Andrea Zanzotto). Recent publications: *Die Geheimnislosigkeit, ein Spazier- und Lesebuch*, 1996; *E 71, Mitschrift aus Bihac und Krajina*, 1996; *Im Genesis-Gelände, Versuch über einige Gedichte von Paul Celan und Andrea Zanzotto*, 1998; *Lobreden auf den poetischen Satz* (with R. Gernhardt and A. Duden), 1998. Recent translations: Michael Hamburger, *Todesgedichte*, 1998; Michael Hamburger, *Das Überleben der Erde*, 1999; Biagio Marin, *In Memoria. Der Wind der Ewigkeit wird stärker* (translated in collaboration with M. Fehringer and R. Caldura).

Thomas Weski was born in 1953 in Hanover. After a photographic apprenticeship he studied Visual Communications at the University of Kassel. From 1987 to 1992 he was curator of the Siemens Kulturprogramm in Munich, where he was responsible for the Siemens Photo Project, and after that for Michael Schmidt's photographic project *Ein-heit (Un-ity)*. Since 1993 he has been Curator of Photography and Media at the Hanover Sprengel Museum. In 1993 he received the Charles Pratt Memorial Award of the Center for Creative Photography, University of Arizona, Tucson, USA. From 1996 to 1997 he was Guest Lecturer in Photography in the Department of Fine Art at the College of Art and Design in Hanover. He has published numerous articles related to exhibitions and projects in the field of contemporary photography, inter alia "The Photographer's Contract" in: Thomas Struth, *Portraits*, Munich, 1997; "The Tender-cruel Camera" in: *Hasselblad Award 1998: William Eggleston*, Gothenburg, 1999; and "I guess I hate answers" in: John Baldessari, *While something is happening here, something else is happening there, Works 1988–1999*, Cologne, 1999.

The exhibition at the Städel, Frankfurt / Main,
is supported by

Sparkasse Landesbank LBS Sparkassen Versicherung

**Sparkassen-Kulturstiftung
Hessen-Thüringen**

Unternehmen der ś Finanzgruppe